D1481796

The Earth in Our Hands

Photos from the International Space Station

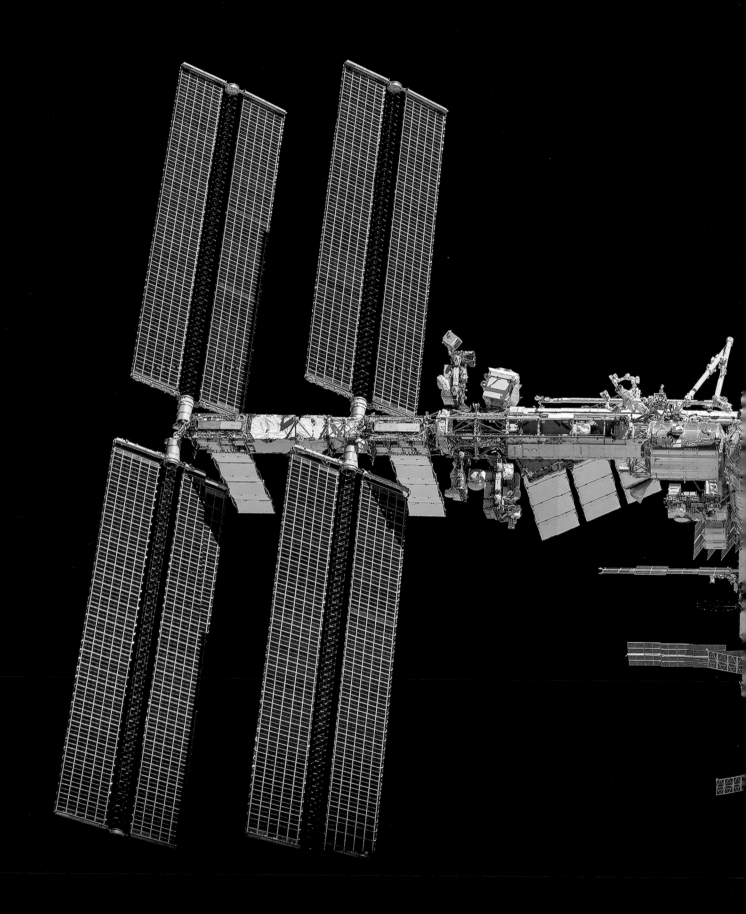

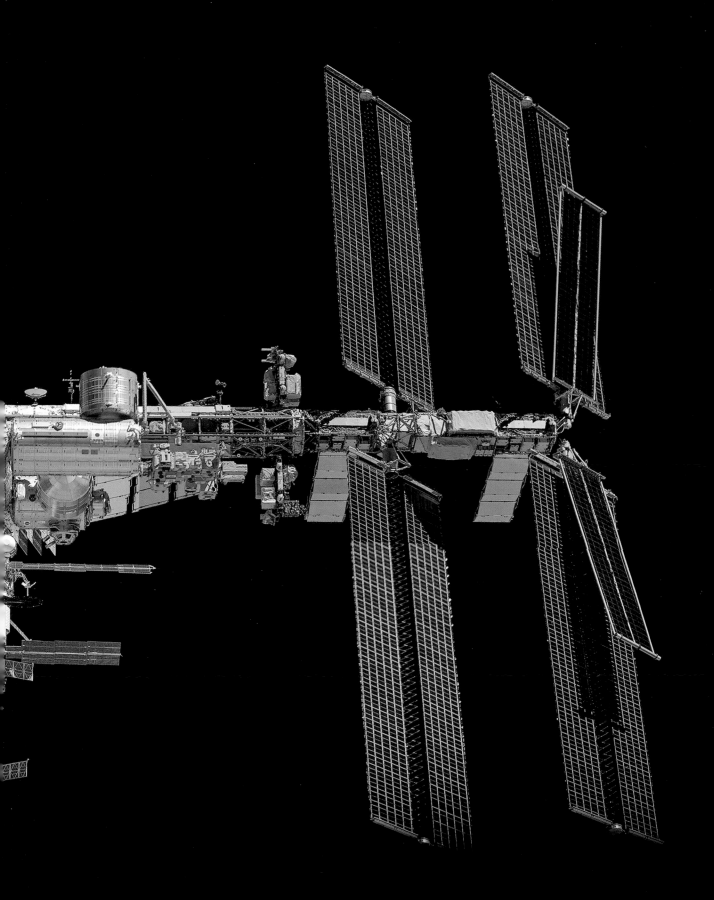

A FIREFLY BOOK

Published by Firefly Books Ltd 2023
First published by Editions Flammarion/E.S.A. © 2022
English edition © Firefly Books Ltd. 2023
Photos © E.S.A./NASA - Thomas Pesquet
Translation © Nancy Foran 2023
Original title *La Terre Entre Nos Mains*

All rights reserved. No part of this publication may be reproduced, stored in a retrieval system,
or transmitted in any form or by any means, electronic, mechanical, photocopying, recording or
otherwise, without the prior written permission of the Publisher.

First printing

Library of Congress Control Number: 2023933403

Library and Archives Canada Cataloguing in Publication
Title: The Earth in our hands / Thomas Pesquet.
Other titles: Terre entre nos mains. English
Names: Pesquet, Thomas, author.
Description: Includes index. | Translation of: La Terre entre nos mains.
Identifiers: Canadiana 20230177263 | ISBN 9780228104445 (hardcover)
Subjects: LCSH: Earth (Planet)—Photographs from space. | LCSH: Outer space—Pictorial works.
| LCSH: Space photography. | LCGFT: Photobooks.
Classification: LCC QB637 .P4713 2023 | DDC 525.022/2—dc23

Published in Canada by
Firefly Books Ltd.
50 Staples Avenue, Unit 1
Richmond Hill, Ontario
L4B 0A7

Published in the United States by
Firefly Books (U.S.) Inc.
P.O. Box 1338, Ellicott Station
Buffalo, New York
14205

Printed in China

Design: Olivier Marty / ip-3.fr
Typesetting: Pierre Brissonnet
Photoengraving: Les Caméléons

All royalties from this book, including the
original French and international editions, will
be donated to the charity Restos du Coeur.

Photo credits:
© ESA/NASA, Thomas Pesquet
Page 26 © Ashish Sharma, SpaceX
Page 345 © ESA/NASA, Thomas Pesquet, Melanie Cowan
Page 43: Dune © Frank Herbert, 1965.
Page 339: The Little Prince by Antoine de Saint-Exupéry

Cover: The curvature of the Earth p. 48
Previous page: Exterior of the ISS
Next page: Crew Dragon
Page 13: Thomas Pesquet and his photographic
equipment

We acknowledge the financial support
of the Government of Canada.

esa

The Earth in Our Hands

Photos from the International Space Station

Thomas Pesquet

FIREFLY BOOKS

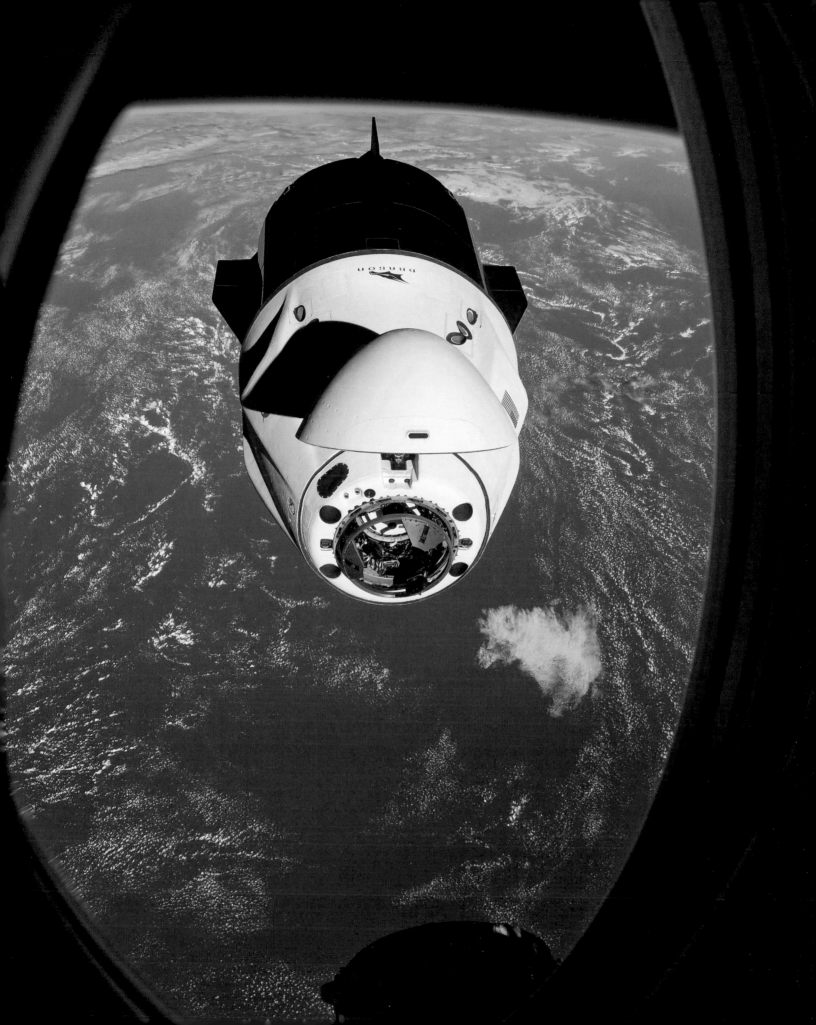

What experience is more magical? What adventure could surpass that of traveling into space? To go there again! This book was born out of the undiminished— perhaps even intensified — wonder I experienced with my second mission orbiting Earth.

Spending nearly 200 days aboard the International Space Station (ISS) is first and foremost an extraordinary scientific adventure. The station is a state-of-the-art laboratory that covers an area the size of a soccer field and has a volume similar to that of a jumbo jet. Scientists from all over the world take full advantage of the space environment, particularly weightlessness, to have research carried out by astronauts, obtaining results that would be unattainable on Earth. Every day, the crew, in cooperation with the control center and laboratories, undertake intricate experiments in physiology, fluid mechanics, materials physics, cell biology, immunology, neurology, the list goes on. Astronauts are the eyes and ears of the teams on the ground, but they are also often the guinea pigs for experiments that are as complex as they are innovative, designed to advance research and knowledge. Better alloys, vaccines, more effective medical treatments, new technologies, more resistant plants: The list of benefits that has resulted from this work is long. A significant part of our activity also consists of preparing future missions. Today's studies aboard the ISS are making tomorrow's missions to the Moon and Mars possible.

In addition to these scientific pursuits, our daily life is punctuated by the maintenance and logistical tasks that are essential to operating and maintaining the spacecraft and ensuring its proper functioning. These activities are also essential to making human life possible in the most inhospitable environment imaginable: total emptiness and extreme temperatures some 250 miles (400 km) above planet Earth. If we add the two and a half hours of daily exercise that are vital to stay in shape as well as other less frequent but still demanding tasks, such as space walks and the arrival and departure of supply vessels, there is very little time left for photography!

However, all astronauts have the same reaction when they witness the beauty of Earth: They try to capture it. Since the advent of digital photography, it seems every astronaut returns from space with a large collection of photos. It's often on a Sunday evening or during a rare moment of leisure in the Cupola — our panoramic window that offers the best view of the ISS itself (that's its purpose) but also of Earth and the stars — that the clicks are made. The curve of the Earth in the early morning, snow-capped mountains in the distance, intriguing shapes in the middle of a desert, the bright colors of a sea or vegetation, everything invites you to point your camera and try to do justice to nature's spectacle. After a few months, you know the planet by heart, and it's possible to identify the area of the globe over which you're traveling at a glance. You first take fairly generic photos: coastlines, mountain ranges, countries. With a little more effort and time, you start to find more specific targets, such as a favorite city or natural or human-made site. You find yourself zooming in on these subjects with a bigger lens. Finally, if you are lucky enough to spend many weeks on board, which usually occurs over several missions, and dedicate your free time to photography, you begin to capture more difficult shots at night (such as cities that are tiny points of light in the distance, impossible to capture clearly at first), original compositions, long exposures, shots of the stars and the Milky Way and time-lapse sequences.

I caught the photography bug during my first mission, and it spread to my crew during my second one. Between us, we took half a million photos. We documented our activities, of course, but the vast majority were views of planet Earth — I've counted over 245,000 of my own.

I decided to post these photos daily during my stay aboard the ISS, in order to share the spectacular beauty of Earth with as wide an audience as possible but also, and above all, to exhibit our planet's fragility. Like my fellow astronauts, I was deeply moved when observing Earth from a distance. It is an oasis of beauty, certainly, but also threatened and damaged in places. Its fragility was laid bare. The only star suitable for human life for tens of light years has desperately limited resources and is

sheltered within an atmosphere as thin as a soap bubble. Its current state of balance seems so unstable... Already, during my first mission, the harmful effects of human activity and the consequences of climate change had attracted my attention, and I've tried to alert people to these global threats. During my second visit, four years later, I watched helplessly as hurricanes followed one another ever more rapidly in the Gulf of Mexico and fires became more and more devastating in southern Europe, Canada and California. The visible increase in extreme weather events, which we know is linked to climate change, has convinced me that we have not done enough to protect our planet.

Of course, space agencies have for many years been on the front line when it comes to studying climate change. It is from space, thanks to a global fleet of satellites, that we measure the melting of ice, the increase in sea temperatures, the concentration of greenhouse gases in the atmosphere and all other climate variables on a global scale. Without this stream of accurate, empirical data, it would be impossible to understand or know what to do. Without science, we would simply be lost when faced with the magnitude of these global challenges.

It is, however, important to complement these vital empirical studies with a more emotional perspective. We are, after all, emotional beings, and our feelings speak to us as much as our logic. With this book, rather than trying to share my entire photographic account of 200 days in orbit — a real mission impossible — or compiling a collection of scientific data, I want to create a lovingly detailed portrait of Earth. I hope to share this profound feeling, so difficult to fully grasp, with as many people as possible. In so many ways, we live on an island of life and beauty that is unique but fragile, threatened and lost in the hostile immensity of the cosmos.

You will also meet some of my fellow travelers. My American, Japanese and Russian colleagues are featured, since an adventure is rarely experienced alone. The ISS is not only a technological feat, it's a model of international cooperation,

where differences are overcome in the service of the common quest for knowledge and space exploration. The Russian Soyuz and Progress spacecrafts coexist with the American Crew Dragon and Cygnus crafts; the Japanese laboratory module Kibō is next to the European lab Columbus and the Canadian robotic arm. Every day, astronauts of different nationalities face dangerous missions together, help each other and share moments of friendship and camaraderie, forgetting their differences.

This book invites everyone to observe Earth from space: to glimpse a ballet of clouds over the ocean; to fly over regions as remote as they are beautiful, such as the Sahara, the Himalayas and the Australian outback; to linger for a while and admire familiar landscapes (from a very different perspective!), only to be transported to the other side of the world... Take a step back, and contemplate our cities and borders from higher up and further away.

Like the orbit traced by the International Space Station, our journey begins at sunrise and flies over all of the wonders the planet has to offer before taking a rest at nightfall, under the stars. And like any true journey, it ends with a trip back home.

I hope this book will help you appreciate the beauty of our planet, but my dearest wish is that it will convince everyone once and for all of the need to act on Earth's behalf. Because today more than ever, the future of Earth, our future, is in our hands.

Thomas Pesquet

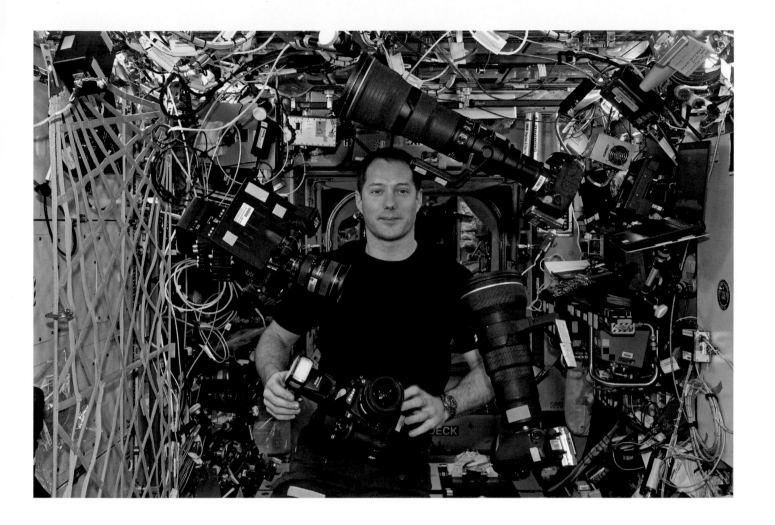

This book was produced in partnership with the European Space Agency (ESA).

These pictograms help locate at a glance each photograph by continent or theme, with captions providing further details and explanations.

 Africa Oceania

 North and Central America Astronomical Concepts

 South America Life on Board the ISS

 Asia Environmental Issues

 Europe Stars in Our Eyes

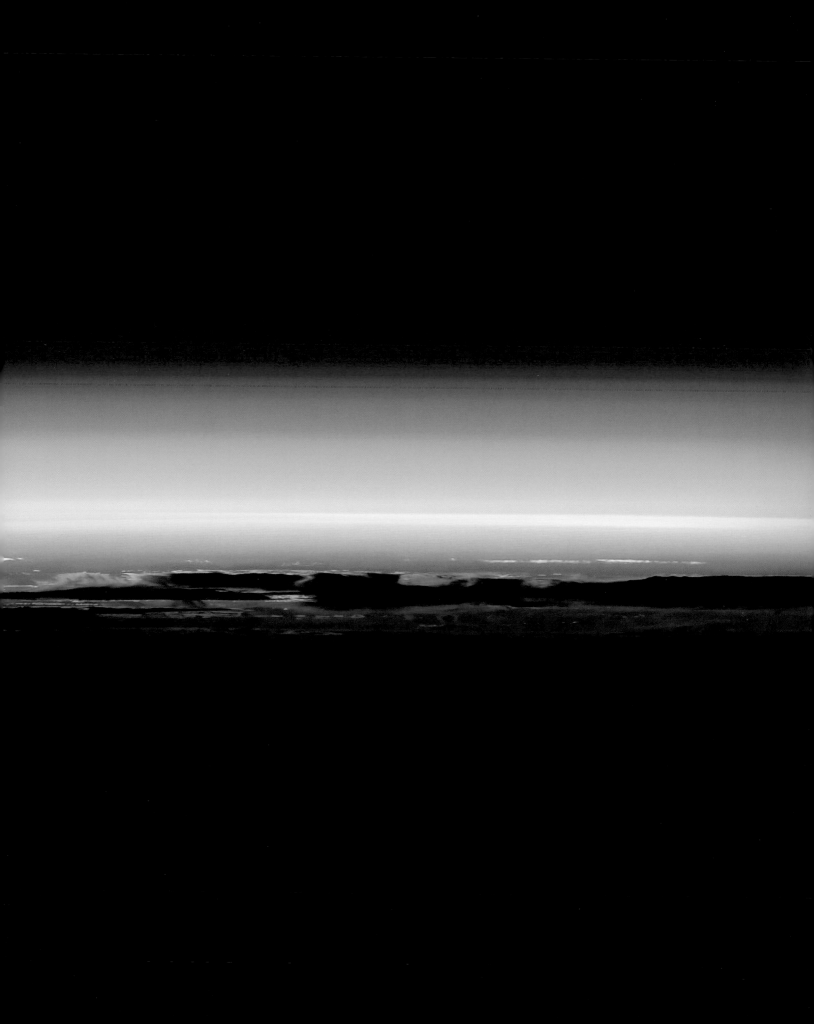

Dawn and Auroras

Sunrise on Earth
The colors warm up slowly at
first, and then it's the big show: a
spectacle worthy of the explosive
nuclear reaction at work in the Sun.
The power that is released makes
life possible on our planet as well as
on the International Space Station,
which runs entirely on solar energy.

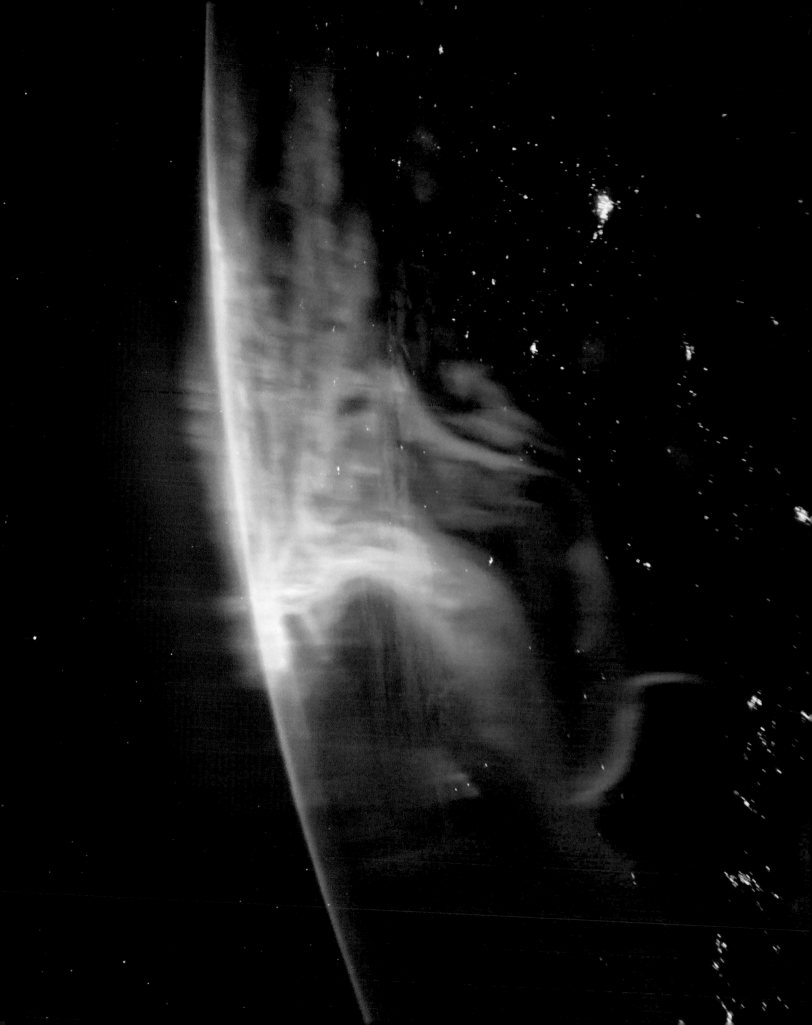

Our journey begins at daybreak. I should probably say "at daybreaks," since as the ISS completes each of its orbits around the Earth, there are up to 16 phases of light and darkness in each 24-hour period. Traveling 250 miles (400 km) from Earth, the words "day" and "night" take on slightly different meanings...

The intense rhythm aboard the space station puts a strain on the body and mind, but it also offers some great rewards. The rising Sun at dawn, always in front of the bow of our ship (since the space station's orbit has us passing by the lighted side of the Earth, to meet the Sun), and the setting Sun systematically at our stern provide dazzling, interesting and sometimes poignant images of our planet.

Each daybreak is unique. Viewed from space, the transition from darkness to light is spectacular. The horizon seems to gradually catch fire and then, within seconds, all of the colors fade, going from deep blue to bright white as the Sun's rays hit our windows, well before touching the ground under our feet (a bit like how a mountain peak lights up before the valley).

It is a show as incredible as the polar auroras (aurora borealis at the North Pole and aurora australis at the South Pole), which are born when particle-laden solar winds meet the magnetosphere and thermosphere (Earth's protective shields), triggering wonderment even after 200 days in space. I defy anyone to tire of it!

Next page
Dreamworld
If you get your head really close to a window on the ISS, you can observe the Earth slowly passing by and forget the structure around you. It is an incredible feeling: You feel as though you are flying alone in space, without a ship, like in a dream.

Aurora
When solar winds, with their charged particles, hit the Earth's atmosphere, they offer up a truly magical experience: auroras.

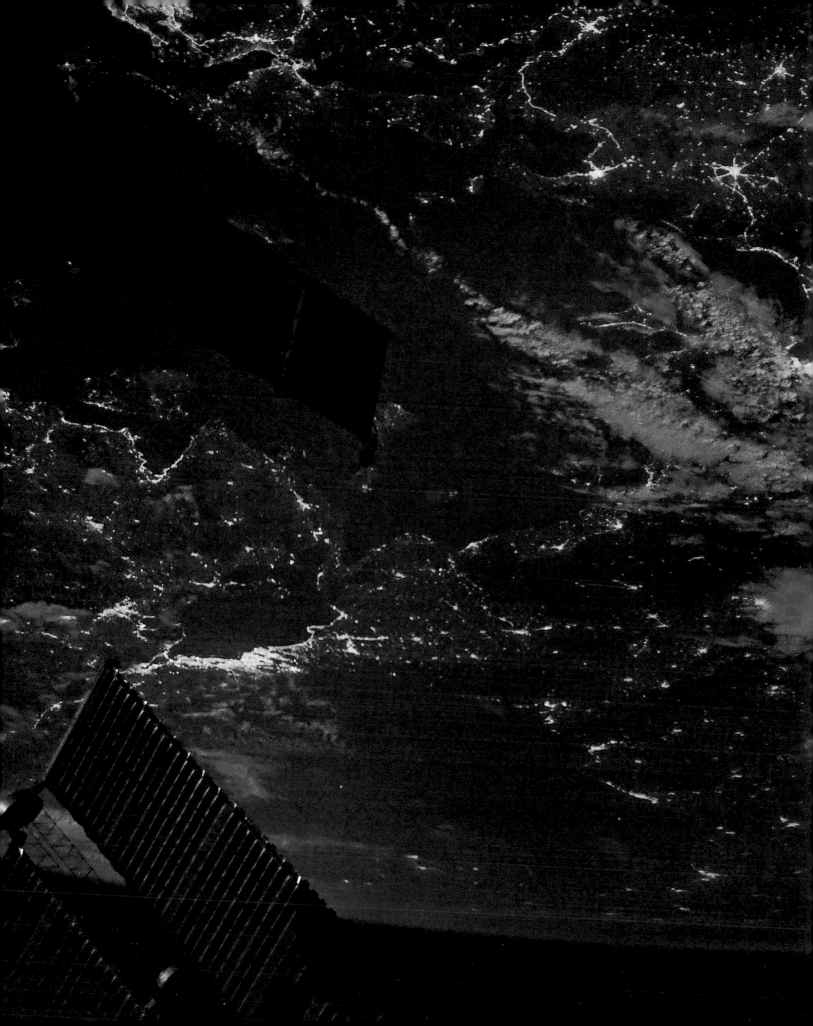

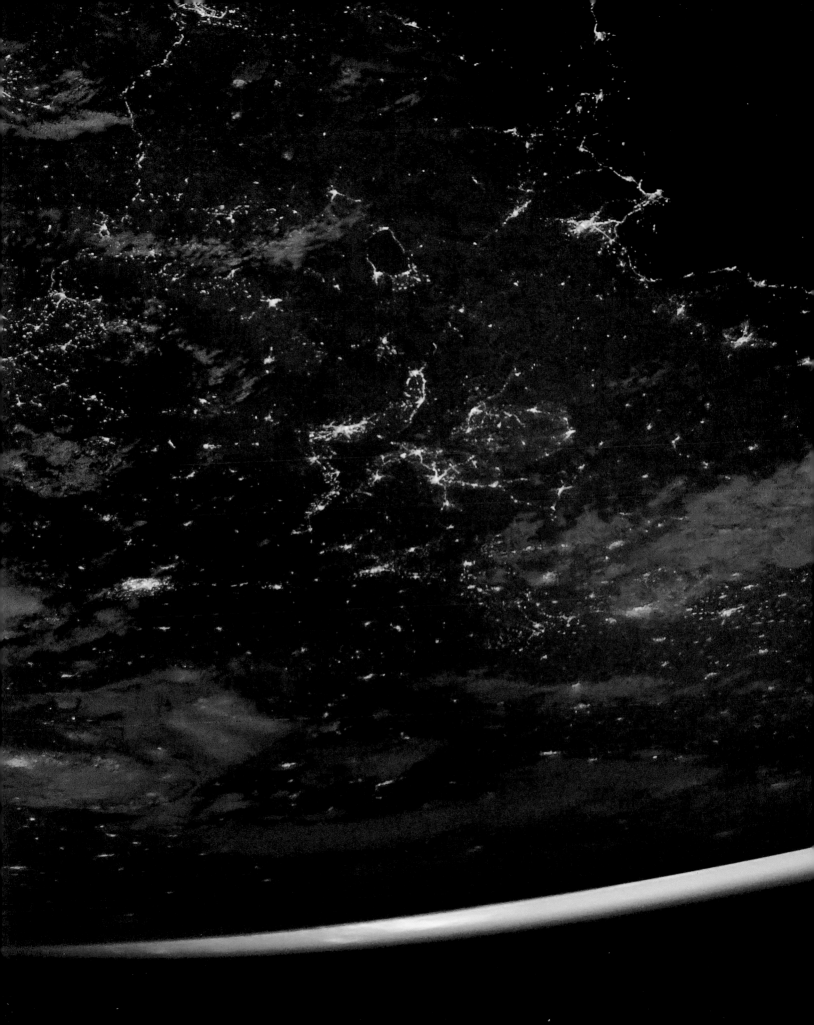

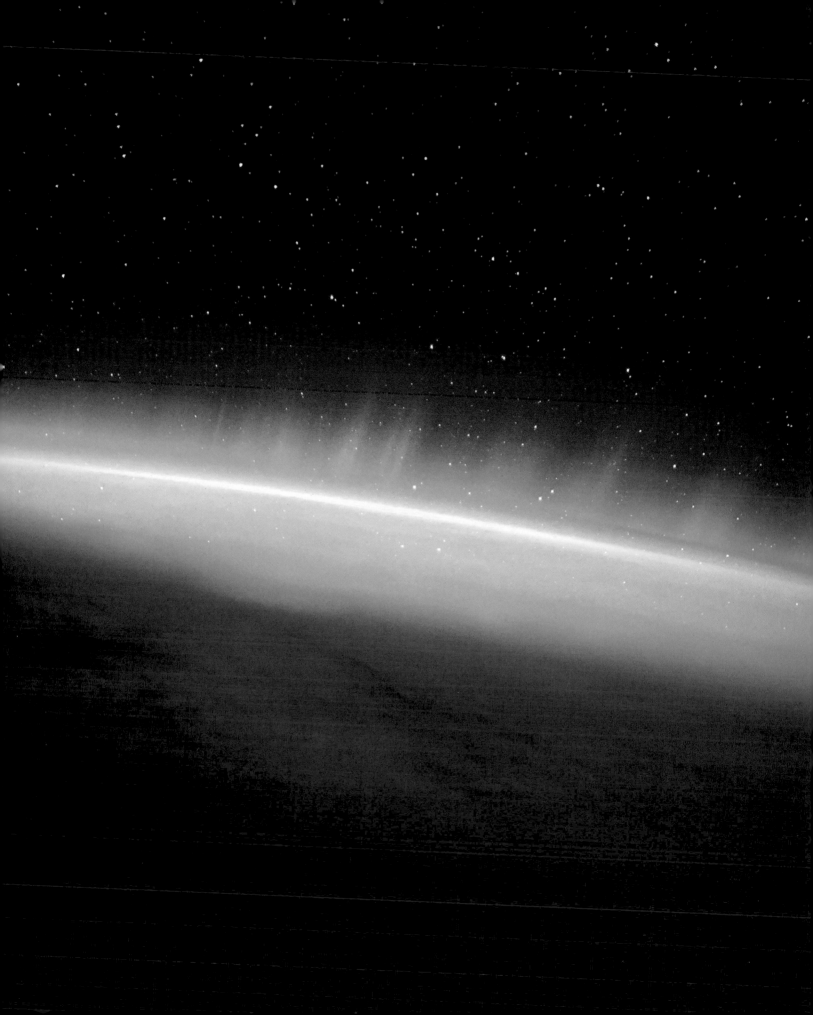

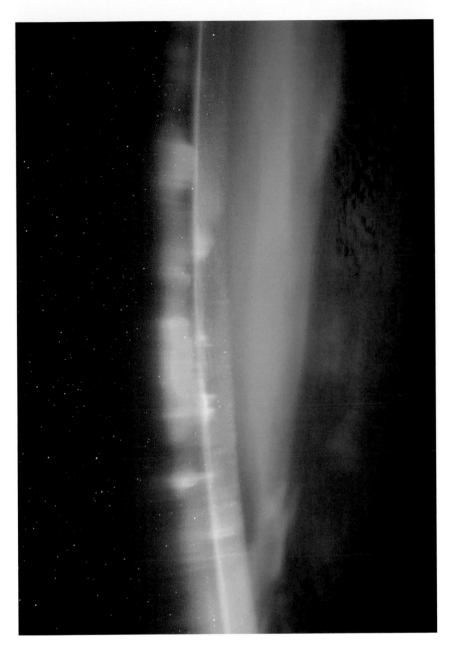

Celestial Colors
Where do the brilliant hues of the auroras come from? Green is the most common color — created when solar winds hit oxygen in the atmosphere between 60 and 185 miles (100–300 km) above sea level — but nothing is ever truly common in these magnificent natural spectacles! Some auroras turn from pink to red, for example, when nitrogen is present in larger quantities. This same process creates the Sun's neon glow.

Awake and Amazed
When this aurora appeared, our American teammate Megan McArthur had been on the lookout inside the Cupola, our observation window, and she called out to the rest of the crew, like the lookout at the top of the mast of a ship. Everyone who was still awake joined her. The green waves rolling under the station looked ready to engulf the Earth. I had never seen such a sight. I apologized to crewmates for blocking the window with my camera, but I just had to snap a souvenir!

Next page
Luminous Waves
Here the Moon is high and very bright, illuminating the clouds and giving this aurora an almost blue-green color, as the ISS's robotic arm awaits its next mission.

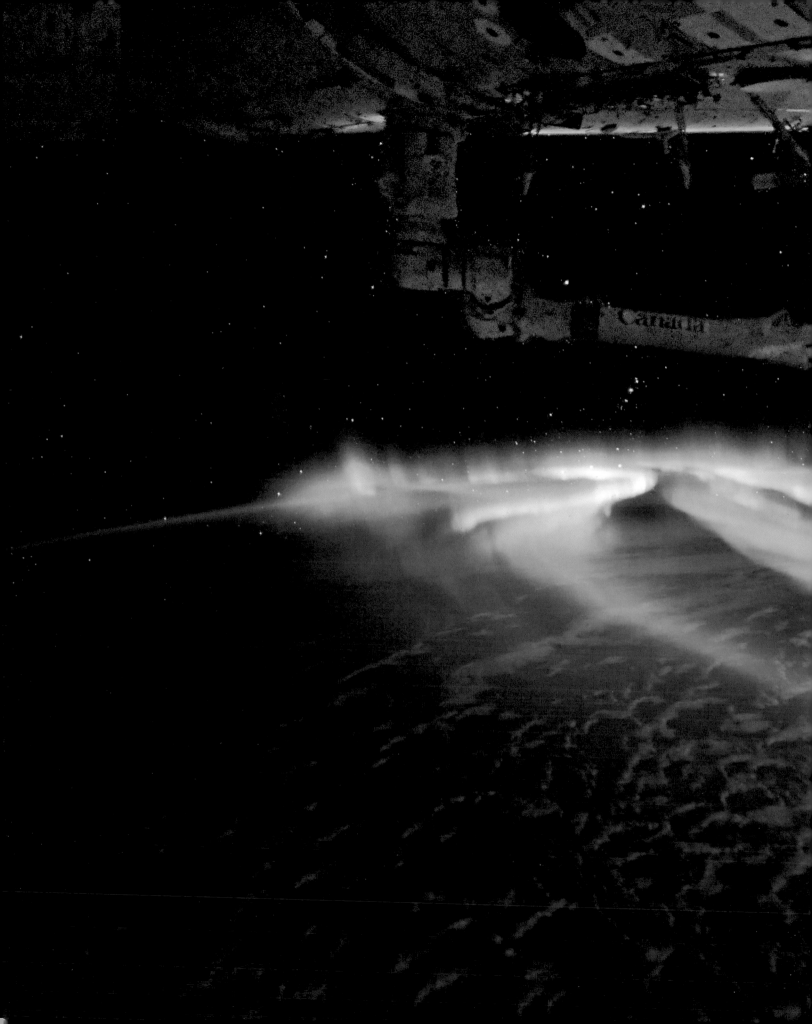

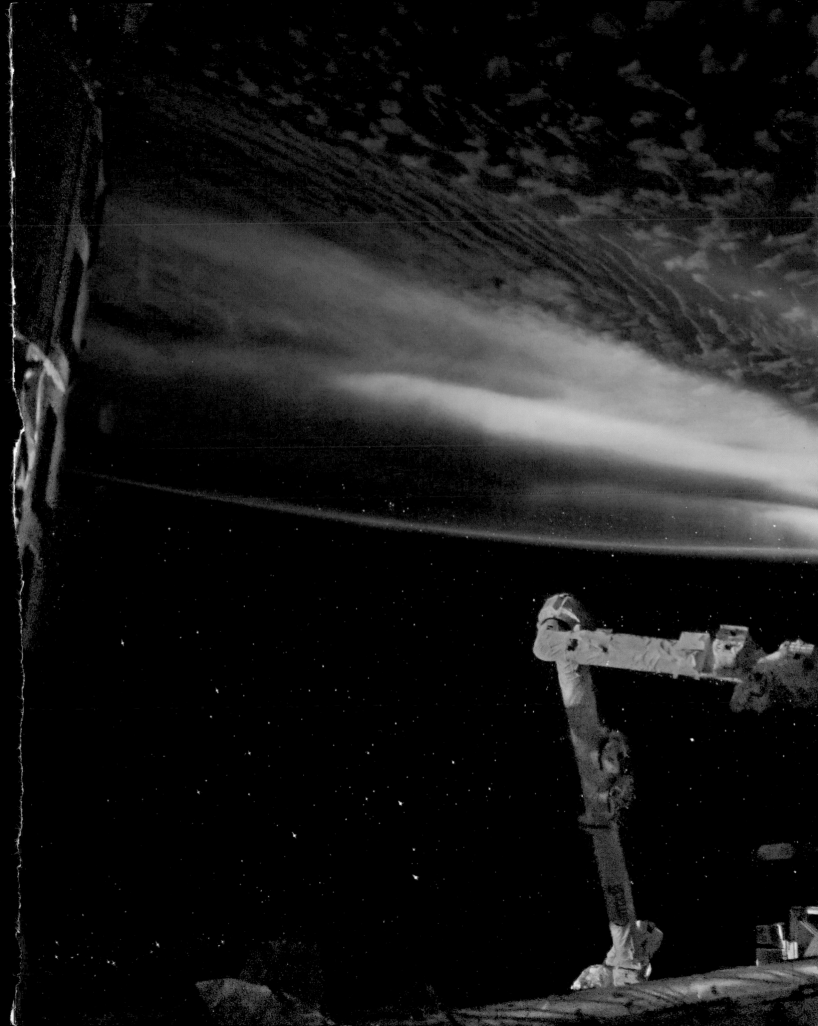

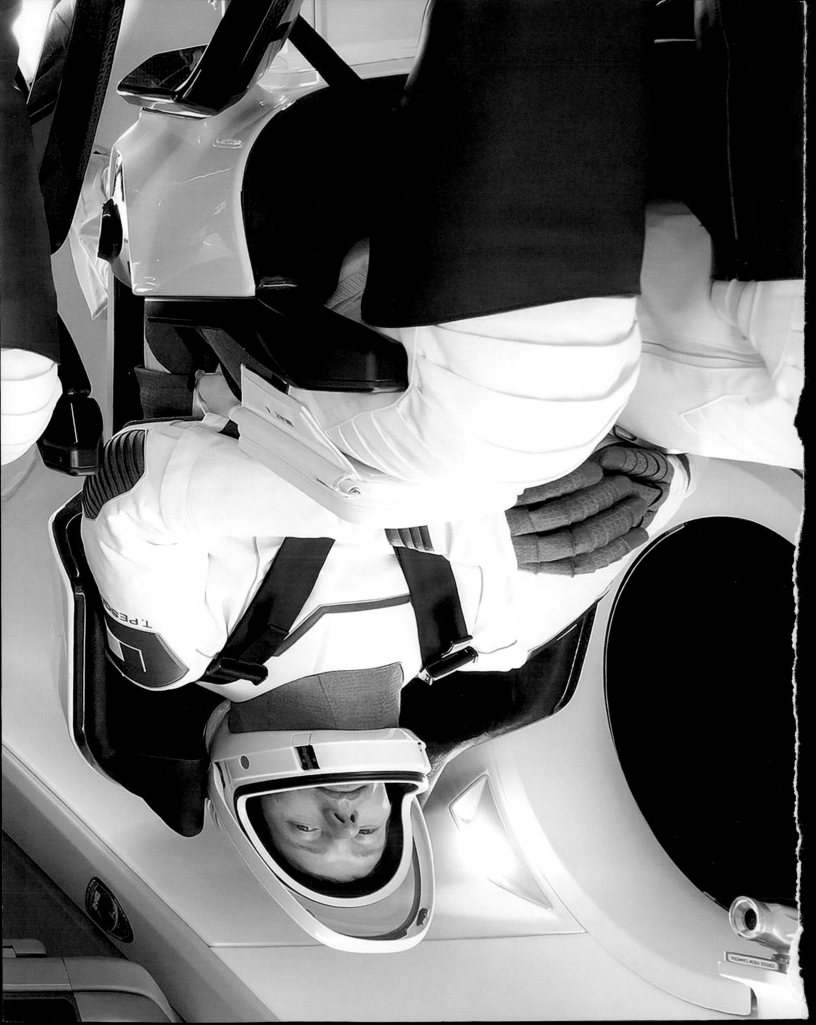

My Crewmates
My colleagues aboard the Crew
Dragon were far from being first
timers. Megan McArthur has flown
farther than any of us, all the way
to the Hubble Space Telescope at
an altitude of around 370 miles
(600 km). Shane Kimbrough is a
veteran of three space missions and
nine space walks. Aki Hoshide has
flown on three different spacecrafts.

The Crew

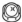

Speed

Here, a Soyuz spacecraft is docking at a Russian module. I took this photo in low light with a long exposure, which helps illustrate our speed, as the Earth and clouds are frozen in place in the background.

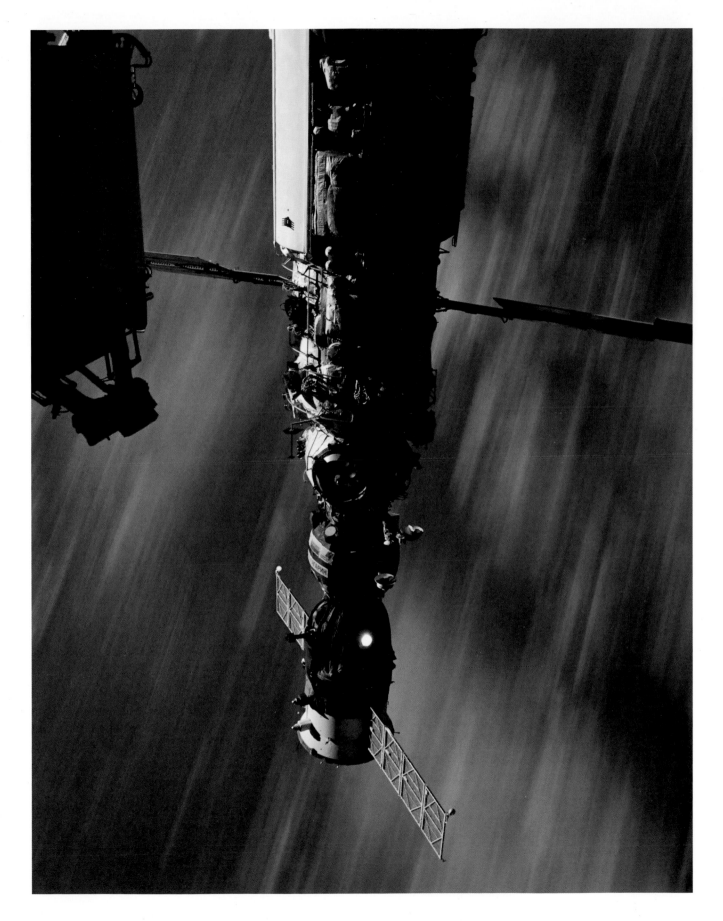

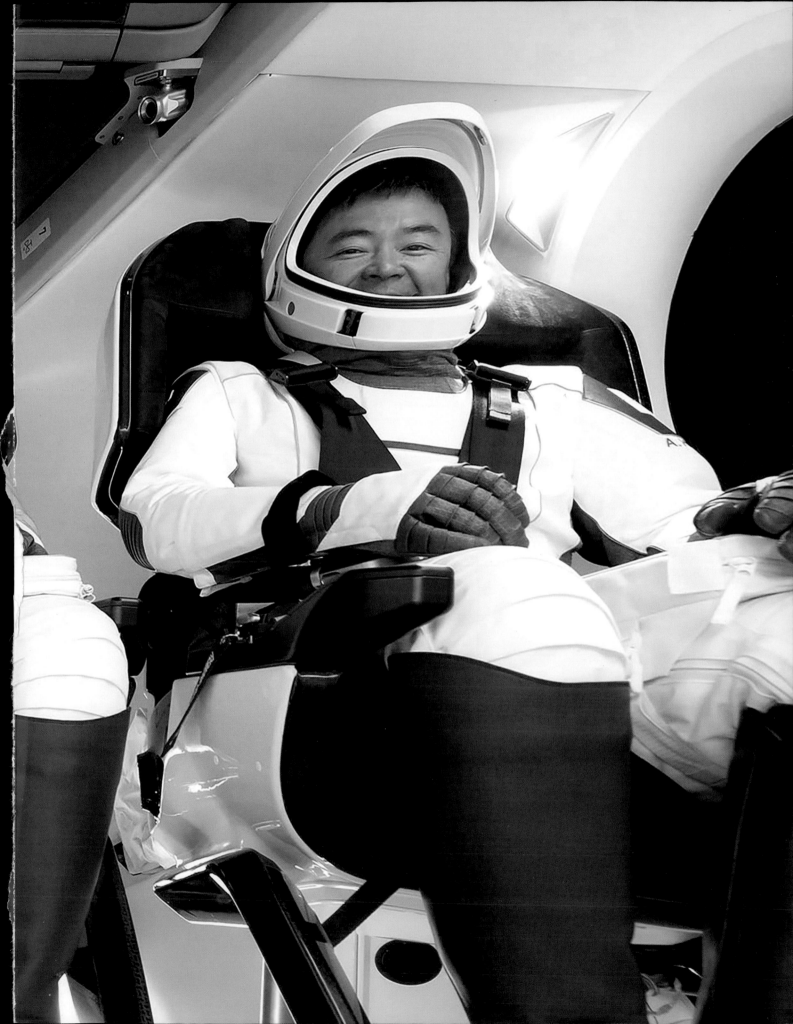

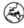

Europe Under the Stars
This is Germany by night, along with the Alps and northern Italy. You can also see Cologne, with its famous cathedral and two towers so high that they're visible from dozens of miles away during the day. On a more personal note, Cologne is home to the European Astronaut Center, where I started my career as an astronaut in 2009.

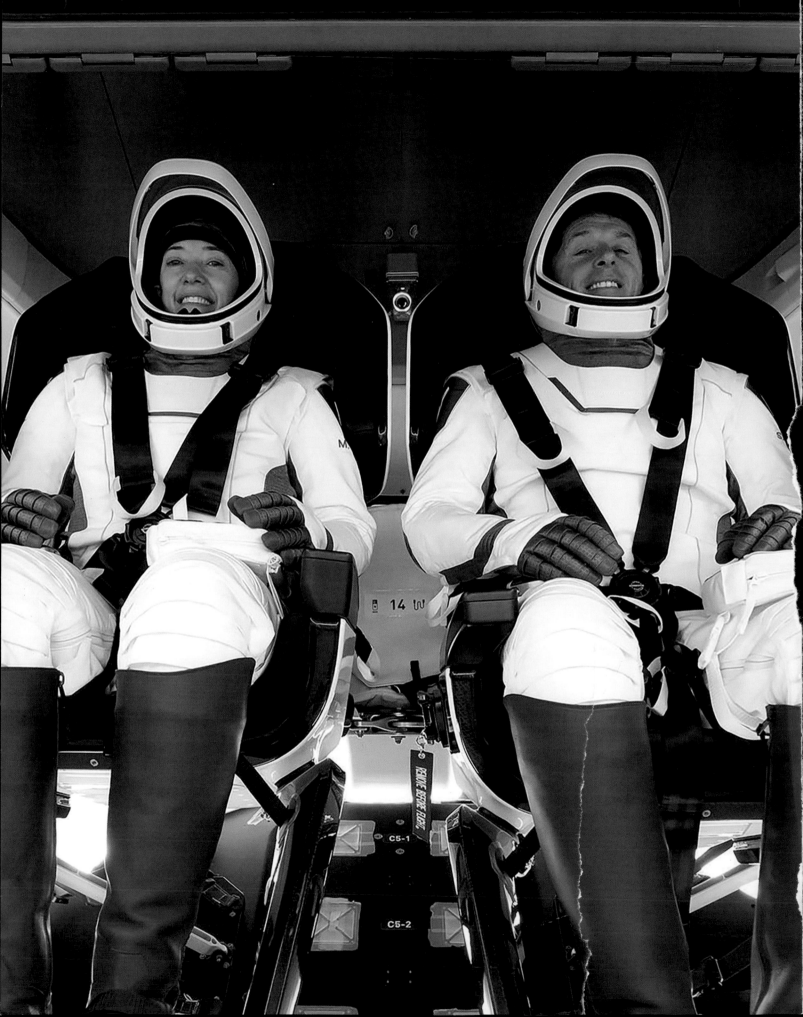

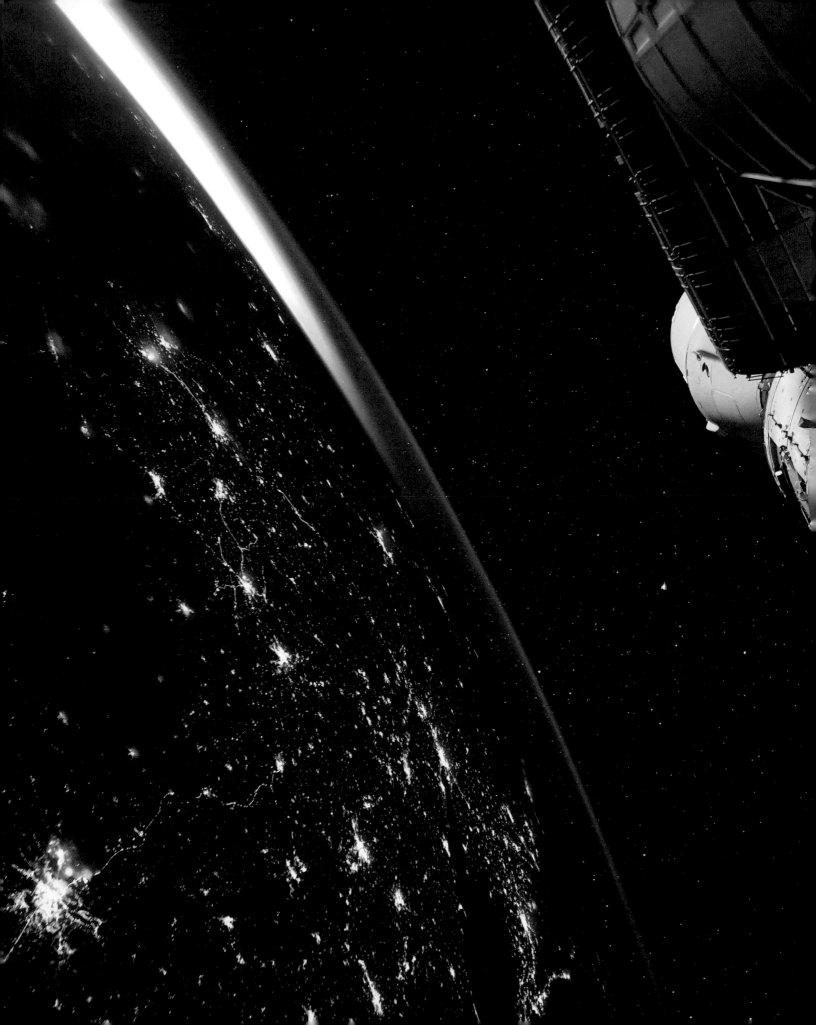

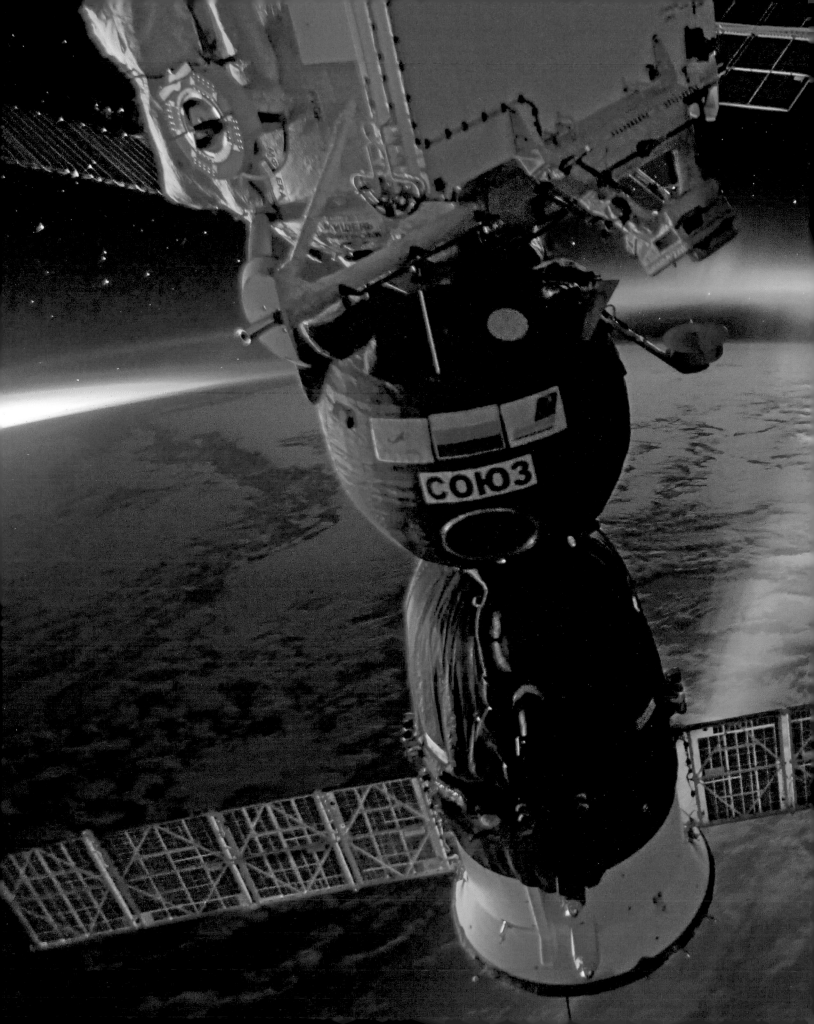

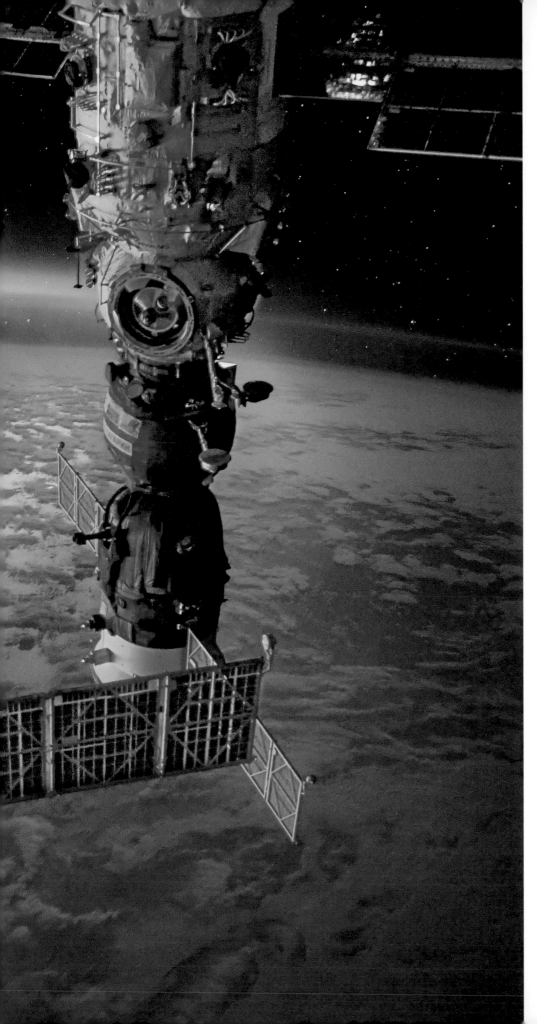

Blue Aurora
Always captivating, blue and purple auroras are often difficult to discern in dark skies. These bluish shades, resulting from the presence of helium and hydrogen, are heralding the sunrise. They reverberate magnificently off the Soyuz spacecraft, which is itself a phenomenon. It has been in use, in its various versions, since 1967.

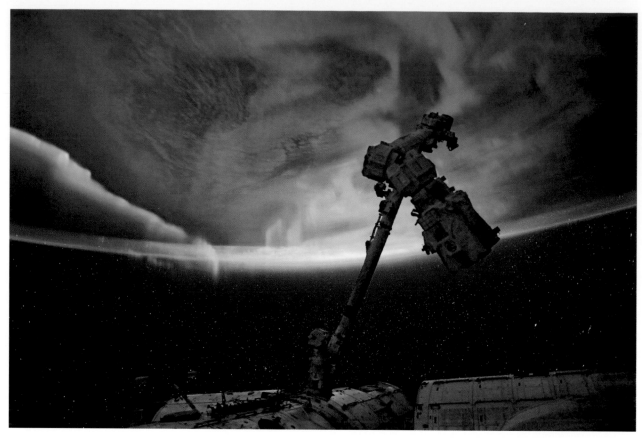

Green Suns
With its dancing green flames,
this breathtaking aurora gives the
impression that the Earth is on fire.

**Every Day Has Its Dawn — and
Sometimes Its Auroras**
The Alpha mission was exceptionally
rich in polar auroras, both in number
and intensity. Their frequency varies
in relation to solar activity, which
bombards ionized particles in the
Earth's atmosphere, about 93 million
miles (150 million km) from the Sun.

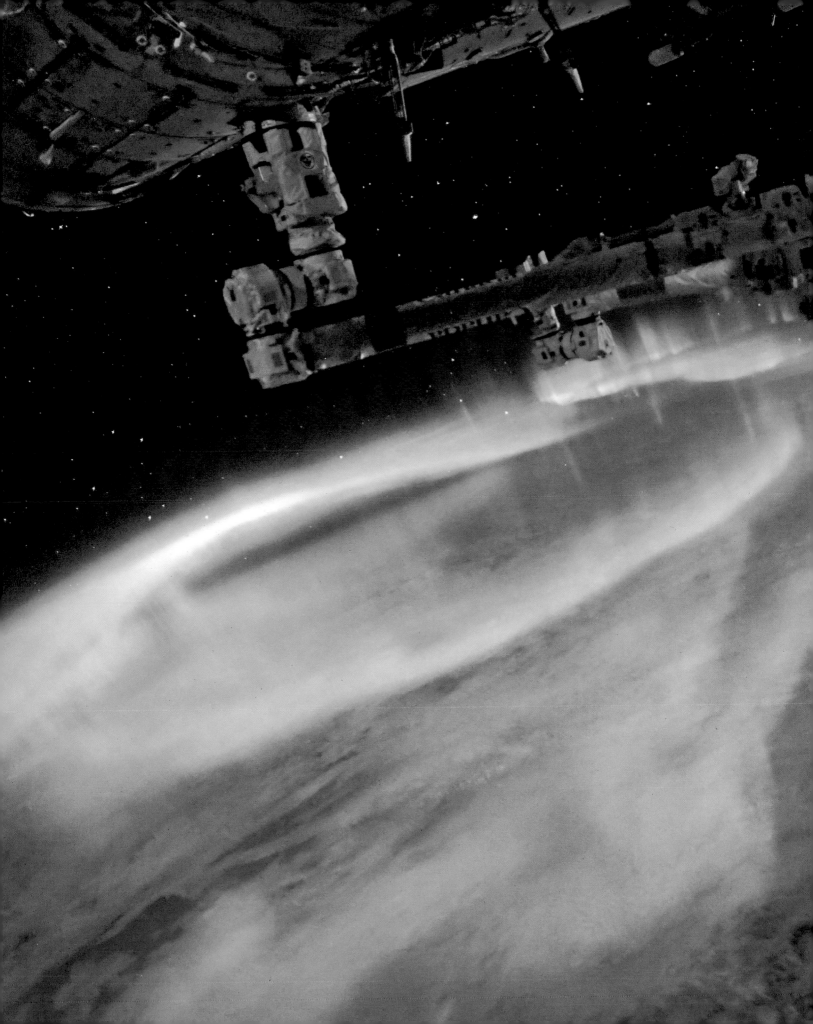

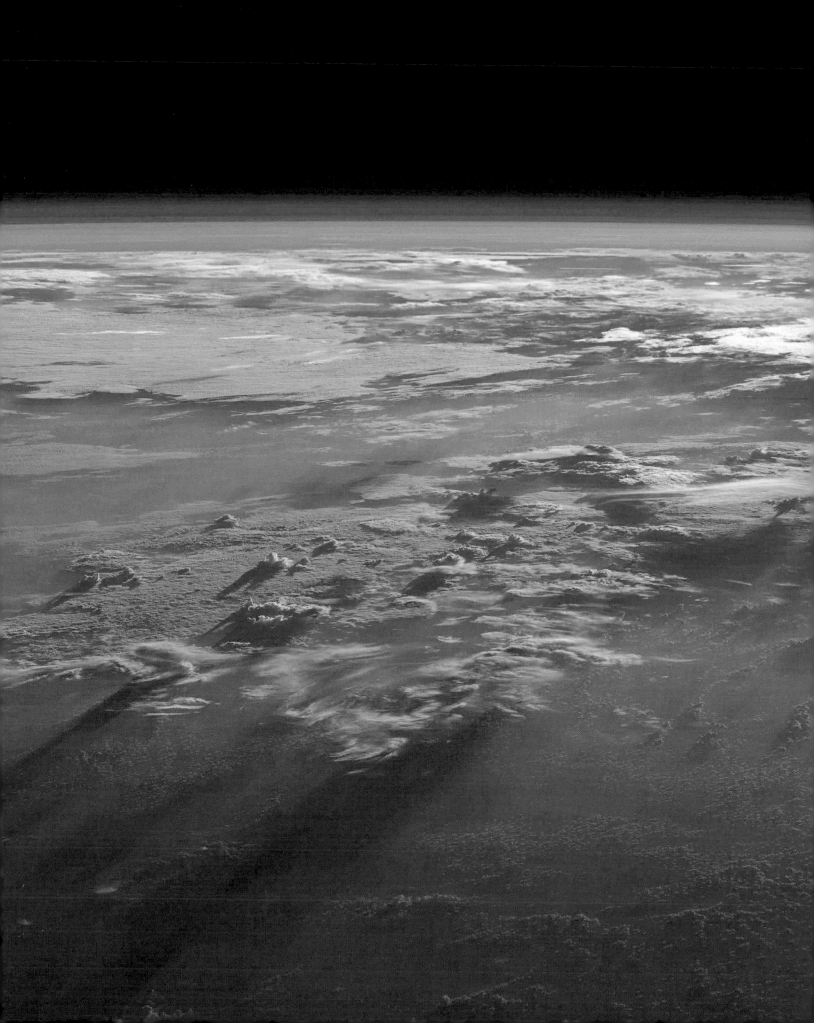

Five Shades of Atmosphere
This gradient displays each layer of our atmosphere, creating an incredibly soothing blue marble effect.

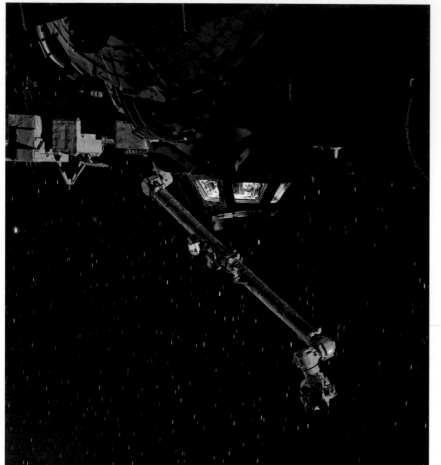

One for the Collection

I was passing through the Cupola at the perfect moment to take this photo of the Russian segment of the ISS. This image may, in fact, be a collector's item, since this DC1 module has since been detached from the ISS after 20 years of faithful service. Its replacement? The more modern MLM laboratory, which is nicknamed Nauka ("science" in Russian).

Traveling Companion

A photo can sometimes make you dizzy! Cygnus NG-15, an automated freighter that resupplied us, is about to leave with our waste, soon to be destroyed along with the craft itself by being burned up in the atmosphere. The craft was caught by the ISS's robotic arm, docked and then, its mission complete, was released a few weeks later. The maneuver is nowhere near as easy as it sounds, with both vehicles flying just over 30 feet (10 m) apart at speeds of 17,000 miles per hour (28,000 km/h).

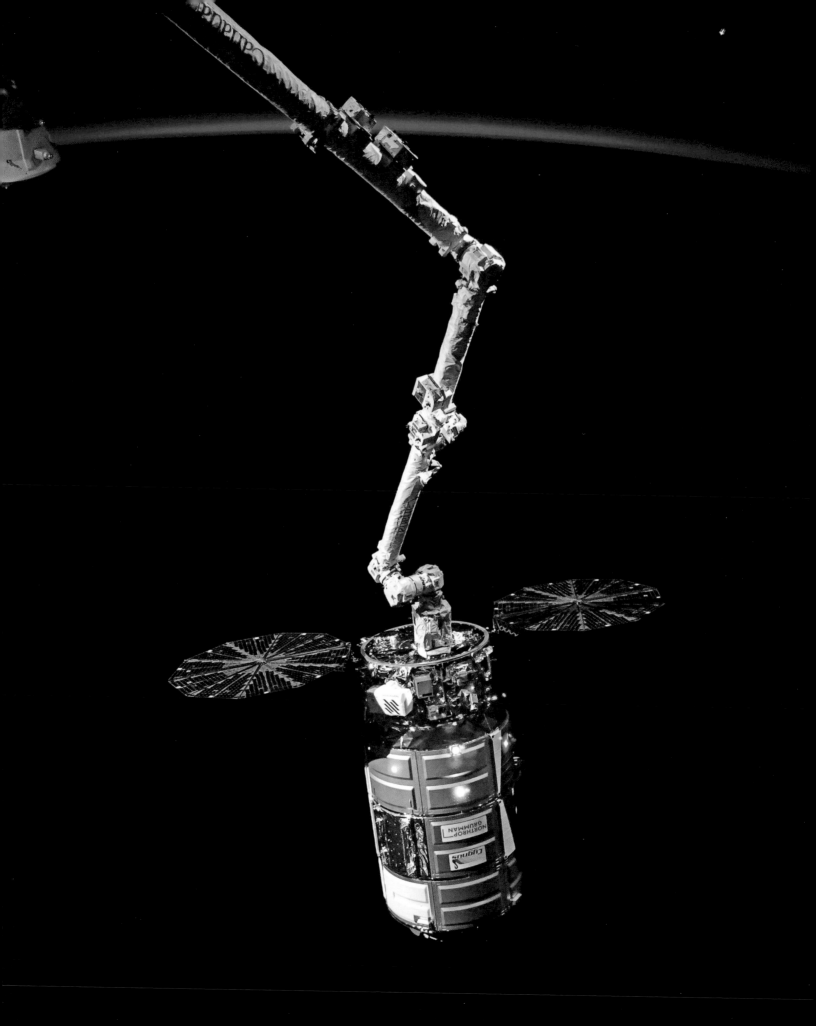

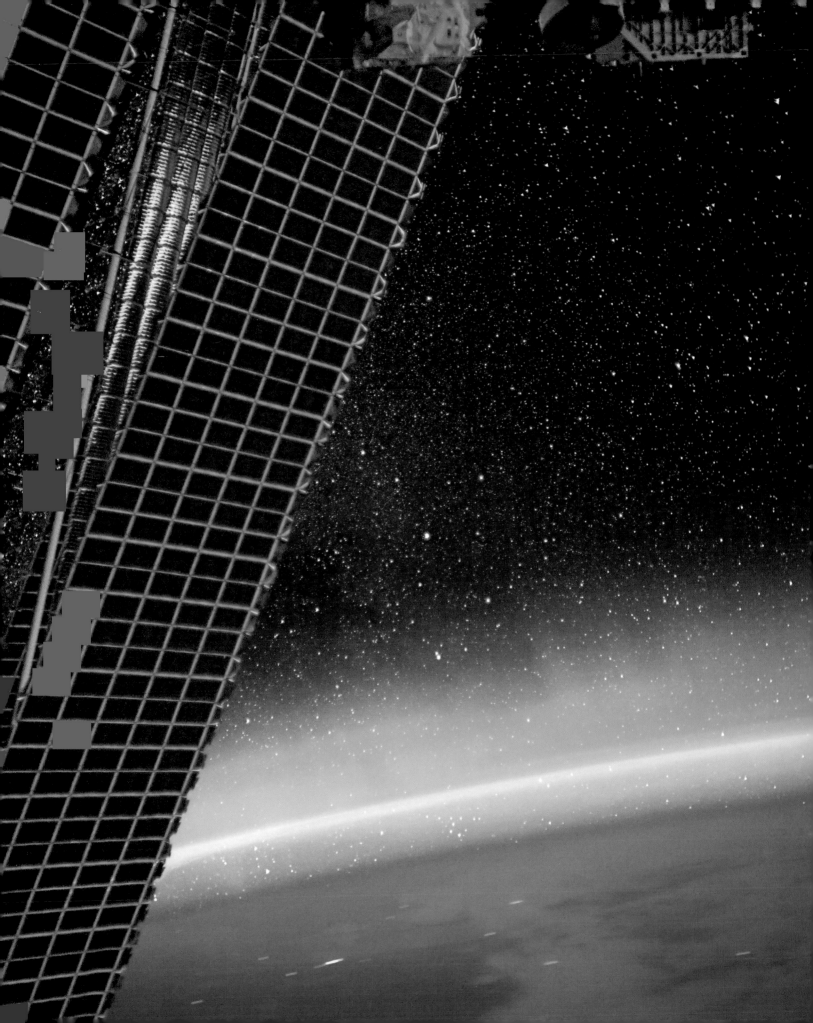

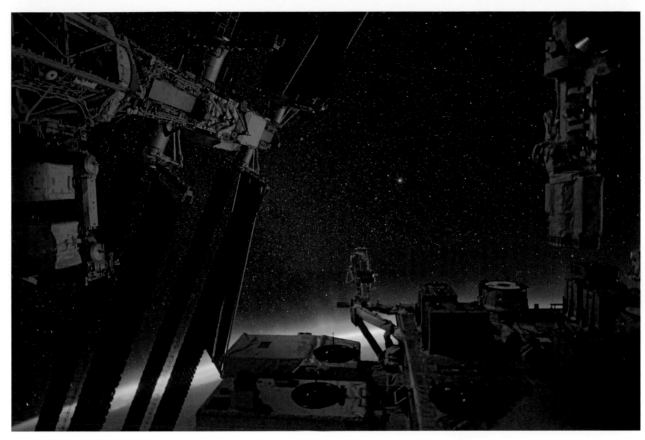

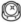

Kibō: Our Office in Space
When you look through a window
at night and let your eyes get
accustomed to the darkness, millions
of stars appear (as pictured here,
in the Milky Way). The spectacle is
breathtakingly beautiful. You realize
that you are on board a spaceship
that is sailing through the cosmos
(a fact I didn't always fully realize...).
Of course, from the station, we often
photograph the Earth, immense,
magnificent and right in front of
us through most of the windows.
Here we also see in the foreground
the JEM (Japanese Experiment
Module), nicknamed Kibō (希望,
meaning "hope"). With its pressurized
module, robotic arm and scientific
experiments arranged on the outer
platform, it is an essential part of the
ISS and crucial for research. Kibō is,
in a way, our space office — with a
stunning view.

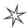

Beyond Logic
"Deep in the human unconscious
is a pervasive need for a logical
universe that makes sense, But the
real universe is always one step
beyond logic." — Frank Herbert,
Dune (1965)

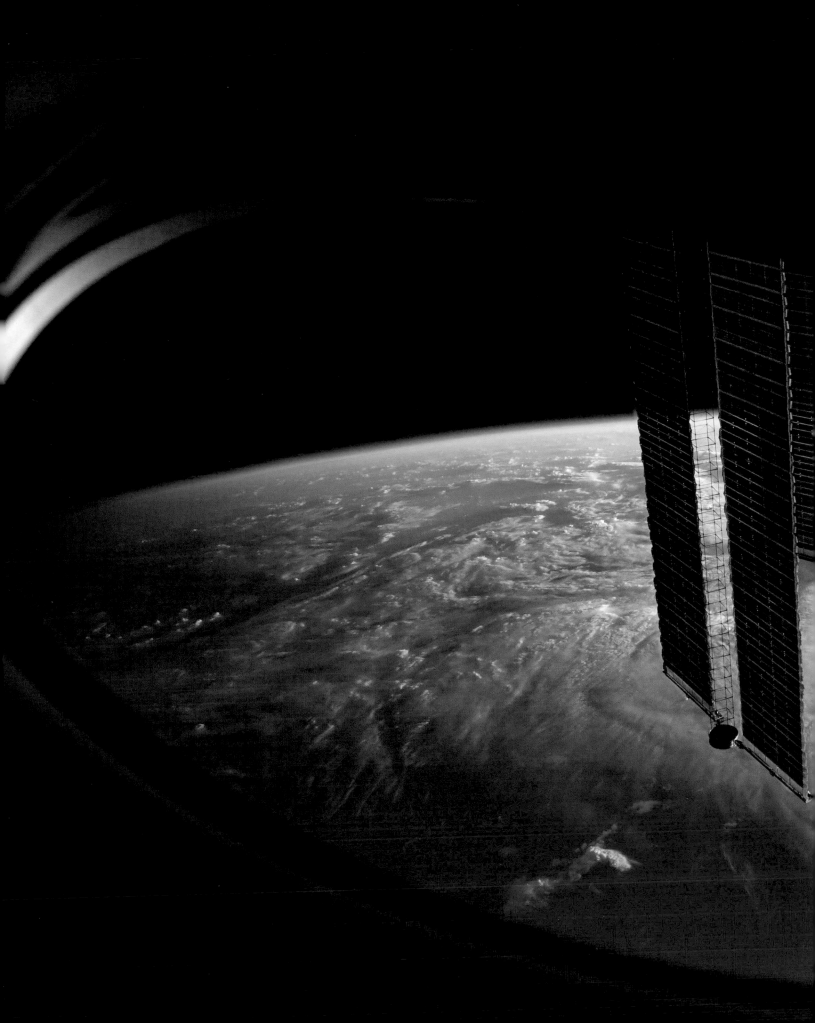

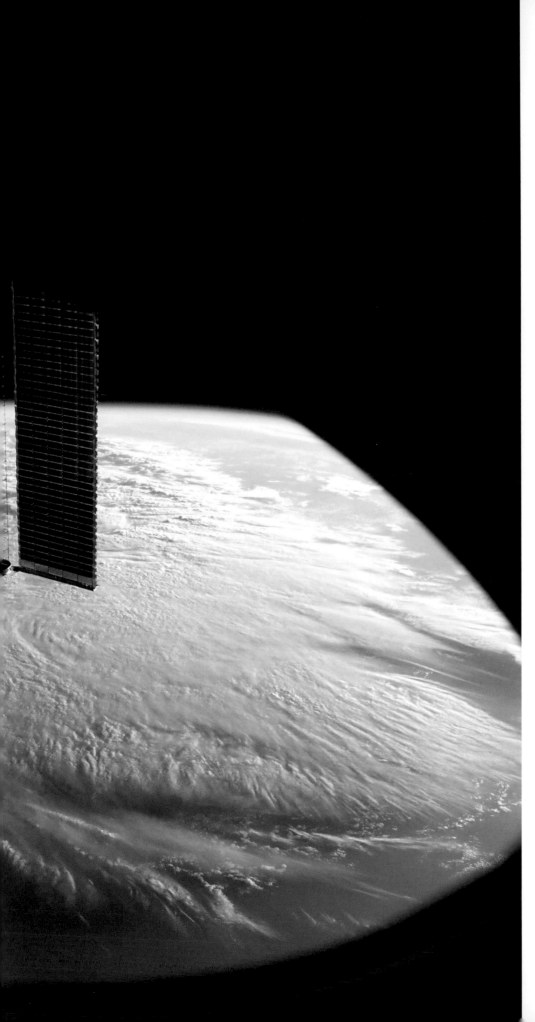

Through the Window
Seeing the ISS structure through a
window is always impressive. It is
so huge and complex! We get used
to the term "space station," but we
never really understand the reality it
represents. The solar panels, majestic
and just over 130 feet (40 m) away,
remind us of this.

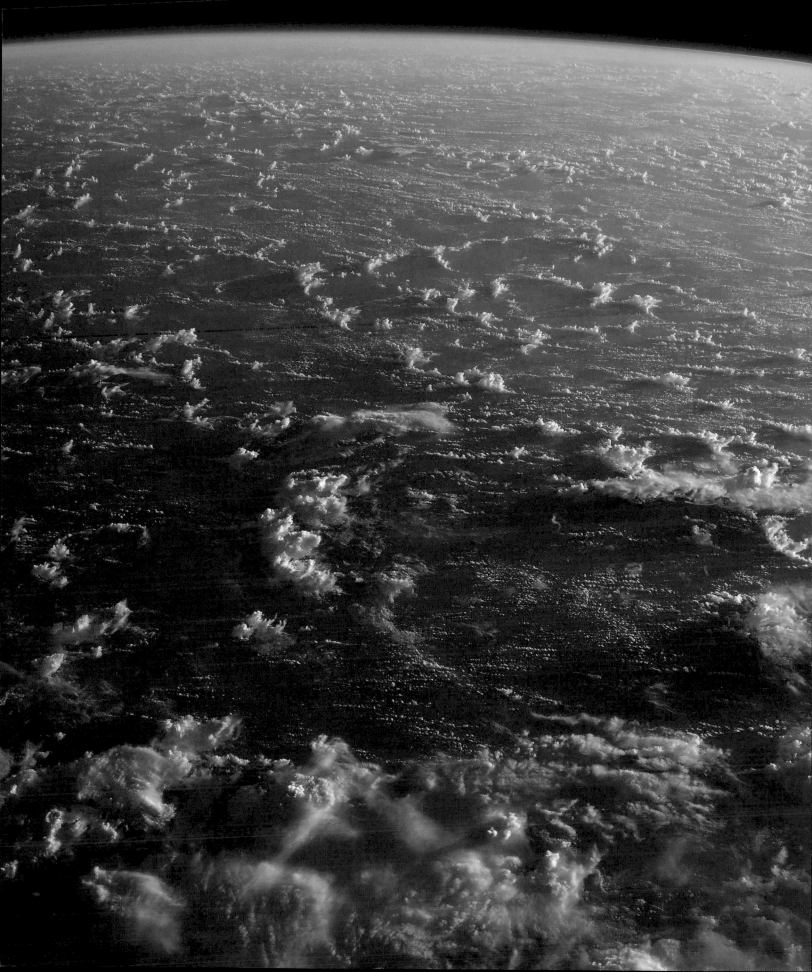

The Blue Marble

As Far as the Eye Can See...
Even with a clear view for thousands of miles in all directions, there is sometimes no land in sight. So alone, one can better understand the excitement, fear and courage of generations of maritime explorers...

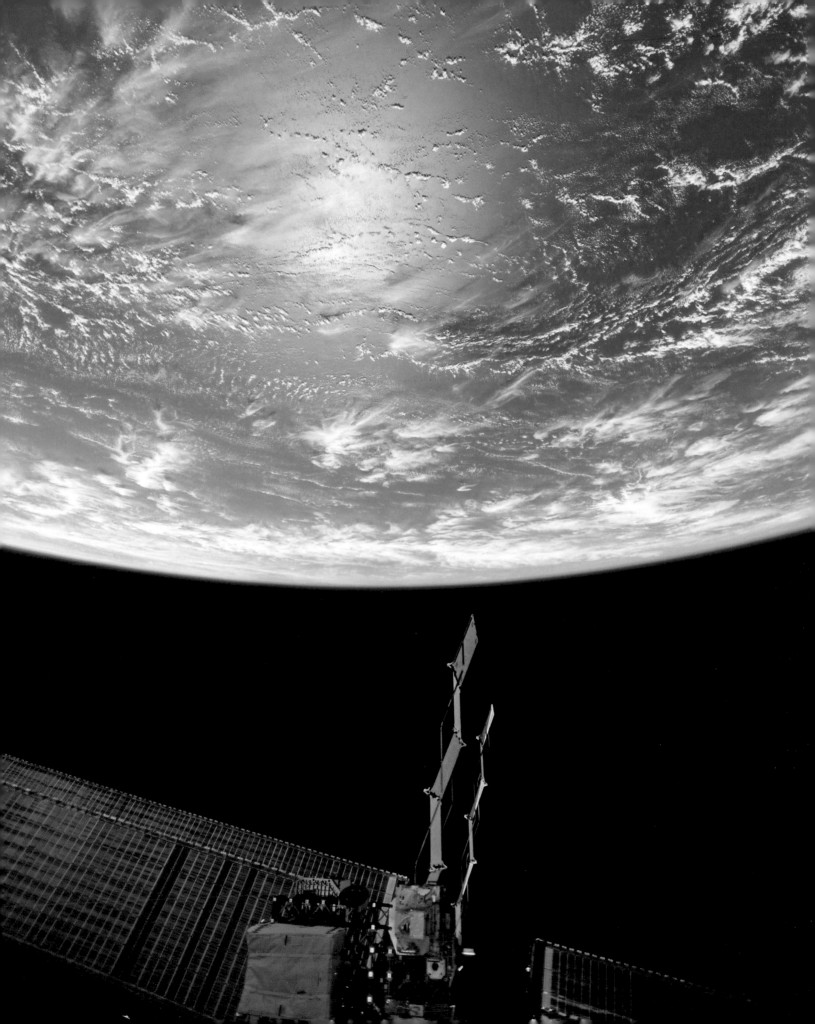

The concept of the "blue marble," referring to Earth, was popularized by the Apollo 17 astronauts. When they saw our planet for the first time from a distance, during an orbit around the Moon, they thought it looked like a glass marble.

In 1972, these astronauts named a magnificent photograph that inspired many to dream of space travel. *The Blue Marble* is the first photograph of an Earthrise, a unique perspective of our planet — as fragile as an oasis in the emptiness of space. Since then, we have never tired of taking photos of it! Some even consider this photo to be the catalyst for ecological awareness.

This view of Earth is also one of the first amazing sights that astronauts see through the window at the beginning of a mission. Everyone understands that the long-distance journey has begun and, with it, the chance to admire our planet from every angle.

When you think about it, it's funny that our planet is named Earth, since 71 percent of its surface is covered by oceans. These waters reflect the blue in the Sun's light spectrum, creating the color immediately recognizable from space.

Next page
Our Balcony in Space
Our balcony may be small, but the view is amazing! This photo was taken during a space walk that was almost easy compared to the two previous ones, which had been rather eventful. We were feeling a mixture of exhaustion and relief: We'd just installed two new solar panels, and they were working as anticipated. Time to take a minute and enjoy the view!

In Relief
The curvature of the Earth always stands out perfectly on the black background of the cosmos.

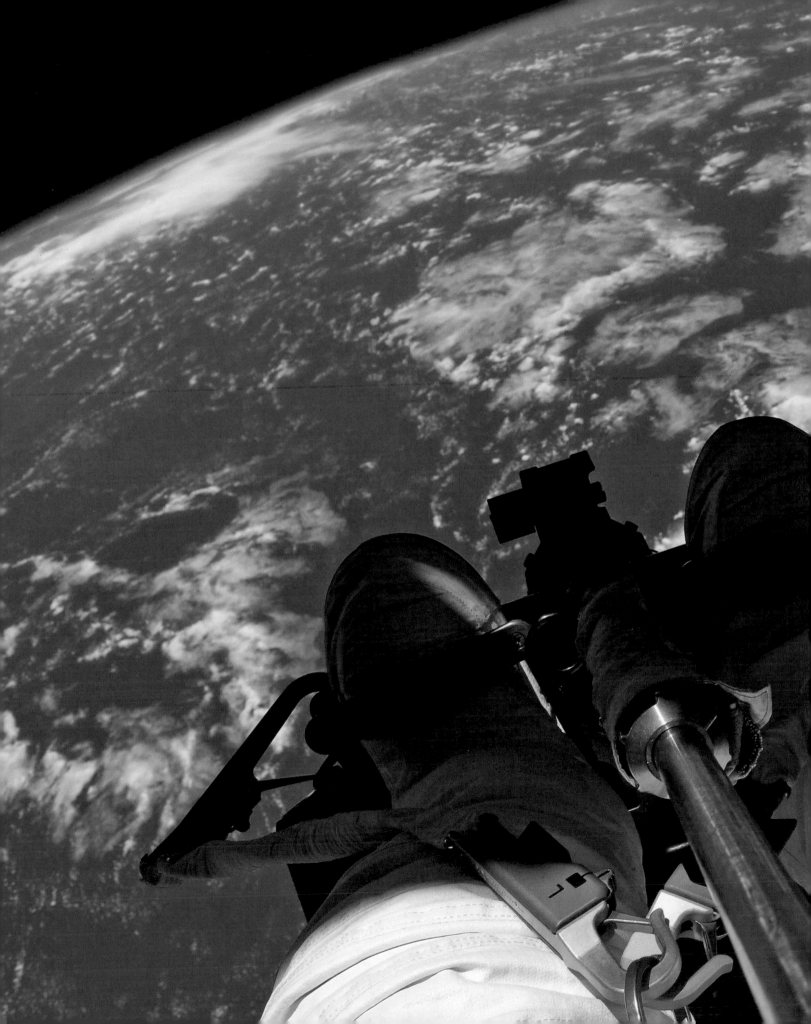

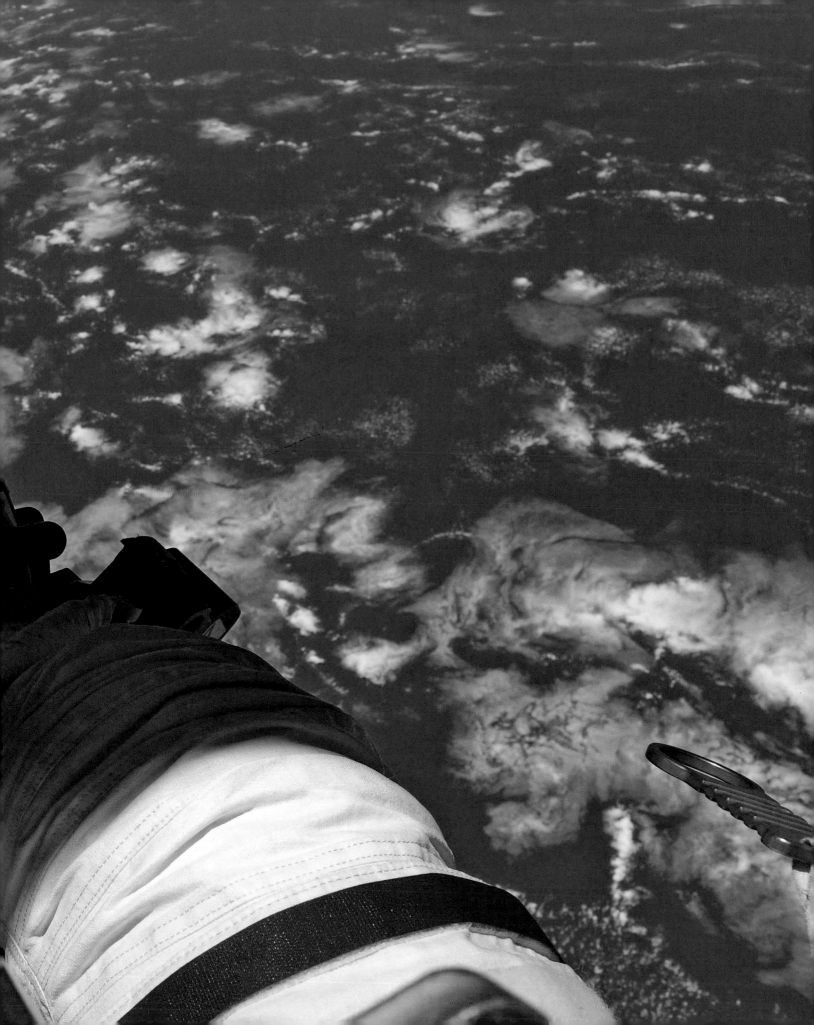

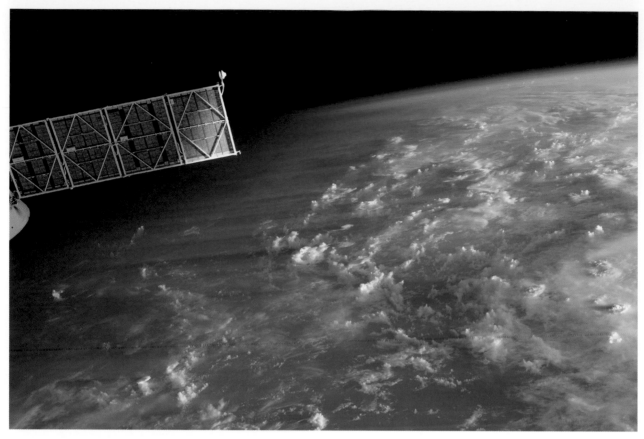

The Terminator
With the exception of the poles, the terminator passes around the entire globe twice a day, at sunrise and sunset. I'm not referring to a robot from the future though. In astronomy, the terminator is the line that separates the light and dark sides of a celestial object (in our case, Earth). I like to contemplate this zone, where the day always seems to be absorbed by the night.

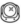

From Dusk to Dawn
Here is another photo taken while flying over the terminator. The Progress cargo craft is proudly displayed, next to the Soyuz MS-18. This Soyuz is very similar to the one that brought me back to Earth during my previous Proxima mission. However, it has a little something extra: It is named Yuri Gagarin (Ю.А. Гагарин), after the first human to reach low Earth orbit, 60 years ago. I wonder if Yuri was thinking the same thing as today's astronauts when contemplating our planet. After all, its sunsets and clouds have changed little since then.

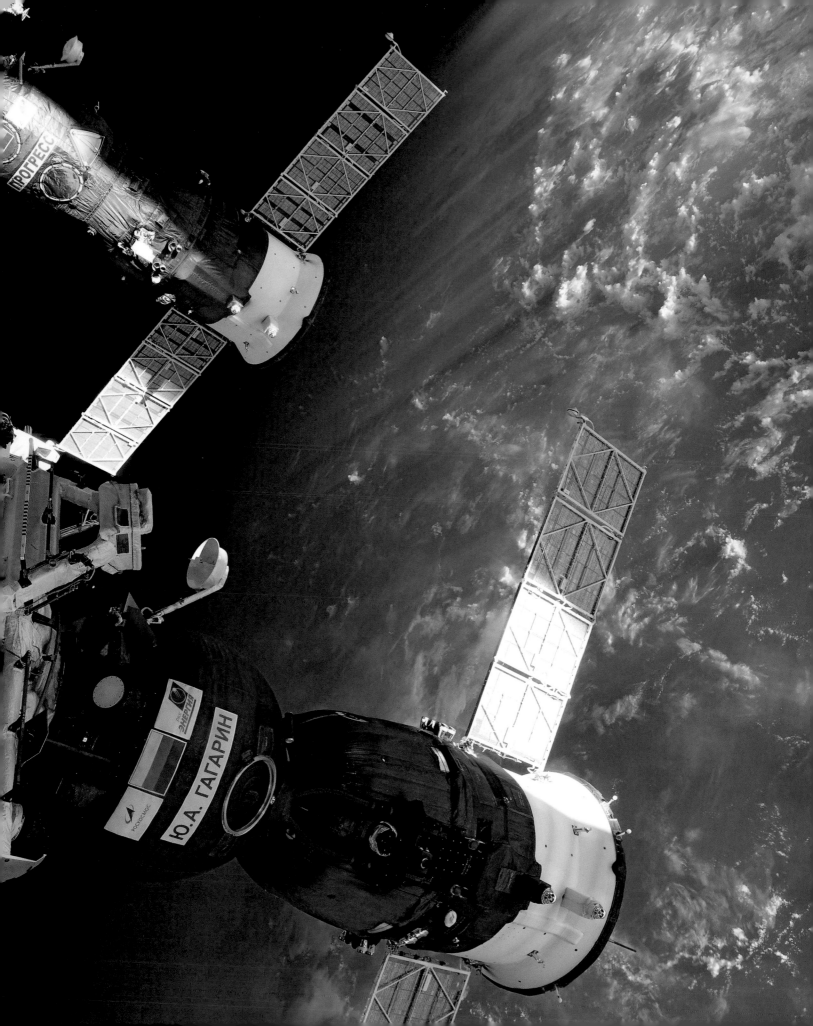

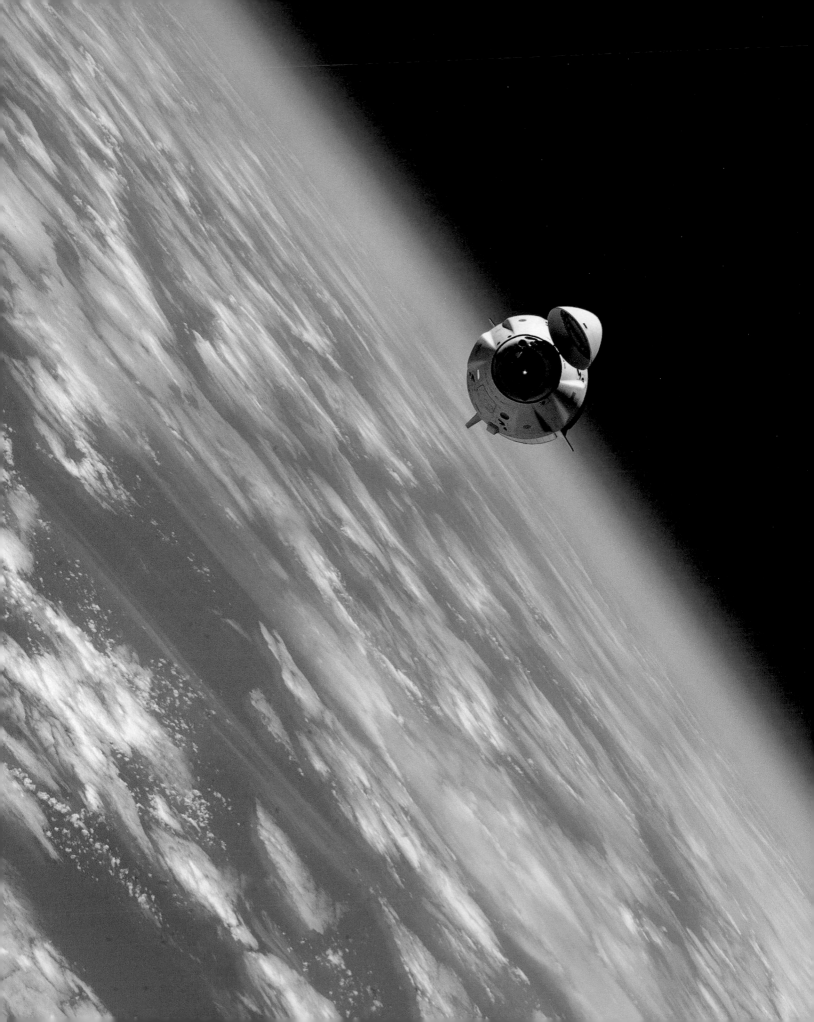

A Dragon Soaring Above the Clouds

Vital on board the ISS, this Dragon cargo ship, a crewless version of the capsule that brought us to the station, is supplying us with materials, equipment, food, water and oxygen. It left loaded with samples, which were the results of our scientific experiments.

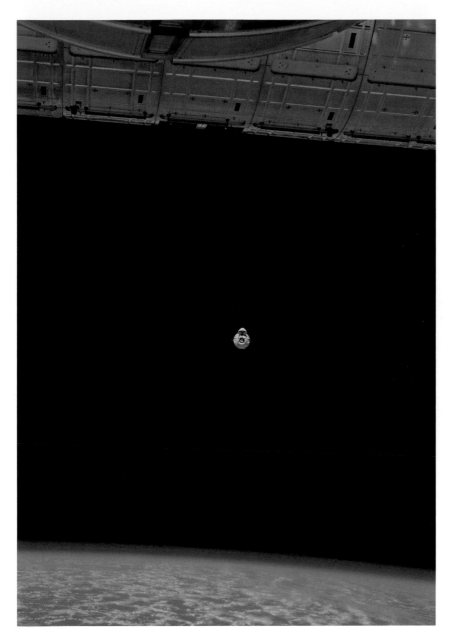

Hello Dragon!

To reach and leave the ISS, everything depends on the SpaceX Crew Dragon, which is equipped with a Falcon 9 launcher during its outbound flight. During these delicate and dangerous maneuvers, it is not easy to enjoy the scenery! Much like our liftoff, our return to Earth must have been a spectacular show. It wasn't a bad show from the inside, either. The 3,450°F (1,900°C) heated plasma illuminated the interior of the Dragon with pink light, before the windows, completely charred, became opaque.

At that moment, we were alone in the universe, especially since no communication could pass through the ball of plasma that engulfed the capsule. One almost forgets the enormous pressure the body feels, 4 or 5 Gs, the equivalent of several hundred pounds. The Dragon goes from 17,000 to 350 miles per hour (28,000 to 560 km/h) when it enters Earth's atmosphere, before opening its parachute. Watching the Crew Dragon calmly and carefully approach the ISS, that excitement seems distant in every possible way.

Next page

Compare and Contrast

On one side we see the blue of the ocean, and on the other the ocher of the Sahara, so glowingly red that you could easily think you were looking at Mars. Two faces of our Earth, always surprising and fascinating.

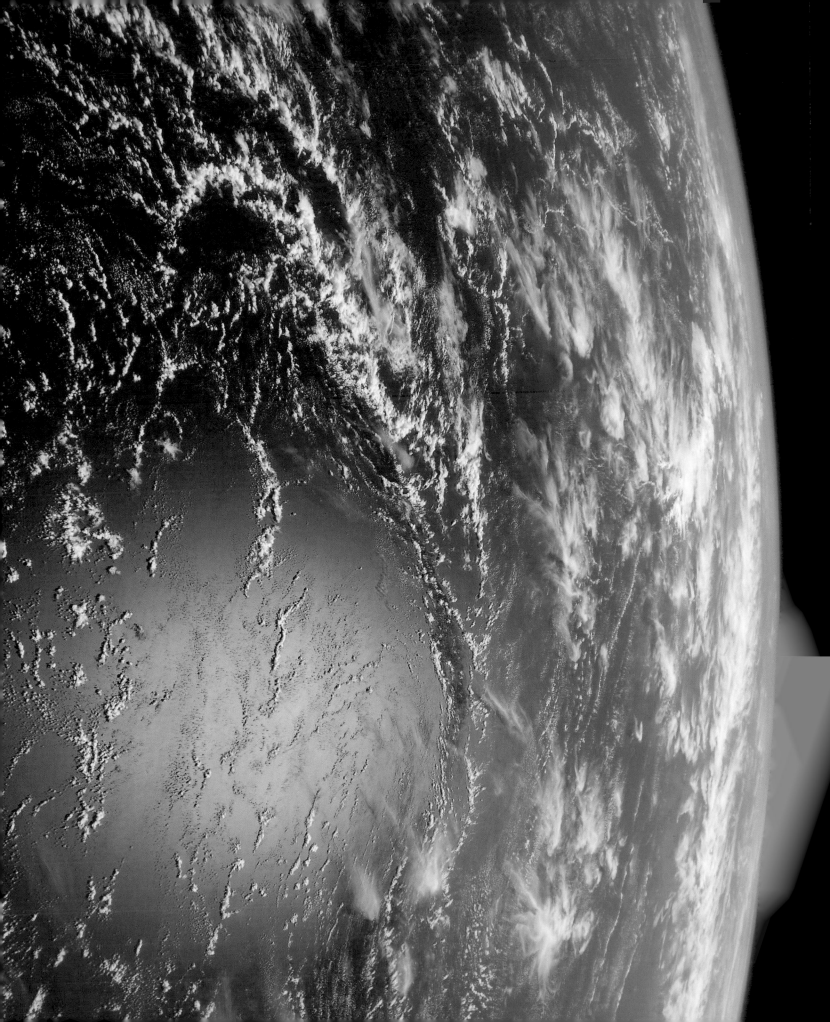

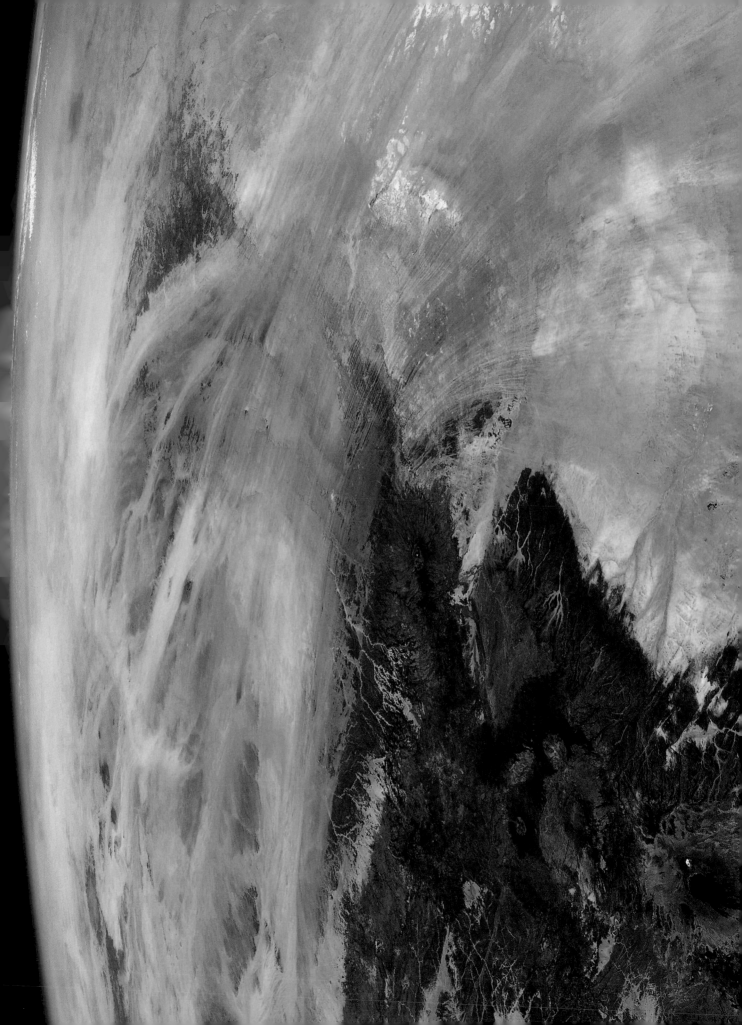

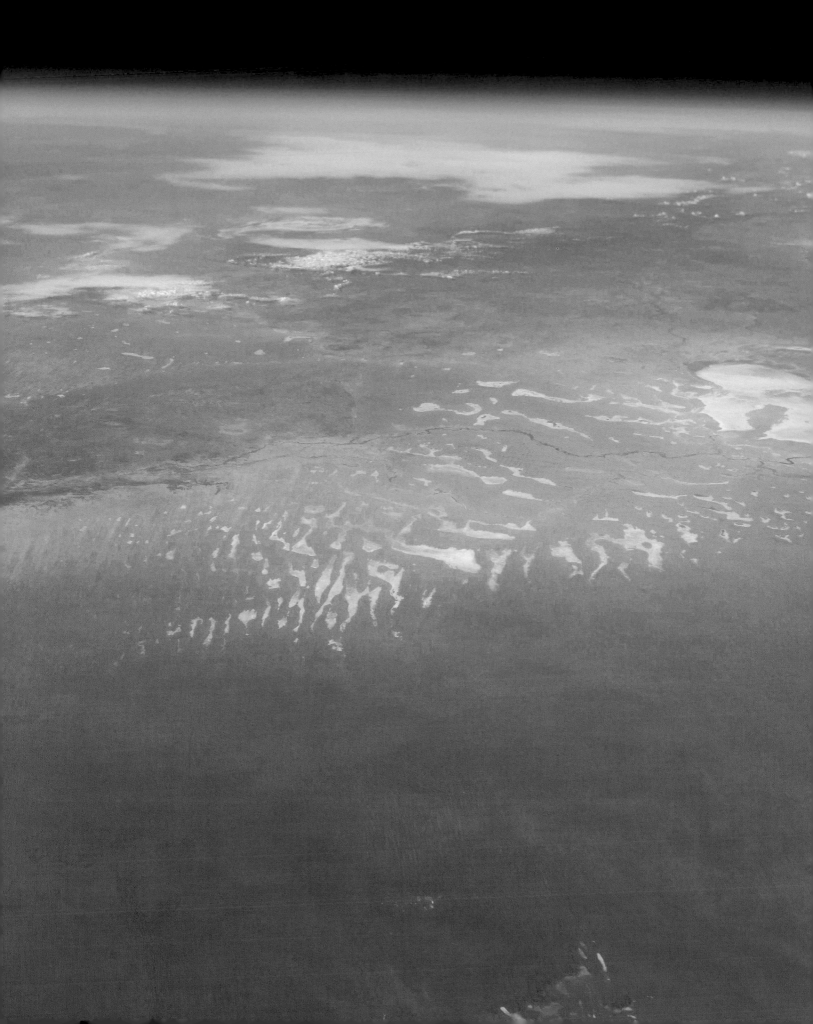

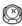

Desert Crossing

In the distance, a desert blends into the blue horizon. In the foreground, Crew Dragon Endeavour is docked at the station. The Crew Dragon is not only used to get us to and from the ISS, it's also our rescue vehicle in case of emergency.

2,969,920 square miles (7,692,060 km²)

Australia is a country-continent whose vastness is rarely accurately reflected on standard world maps. Here, the red of the outback melts into the blue of the sky.

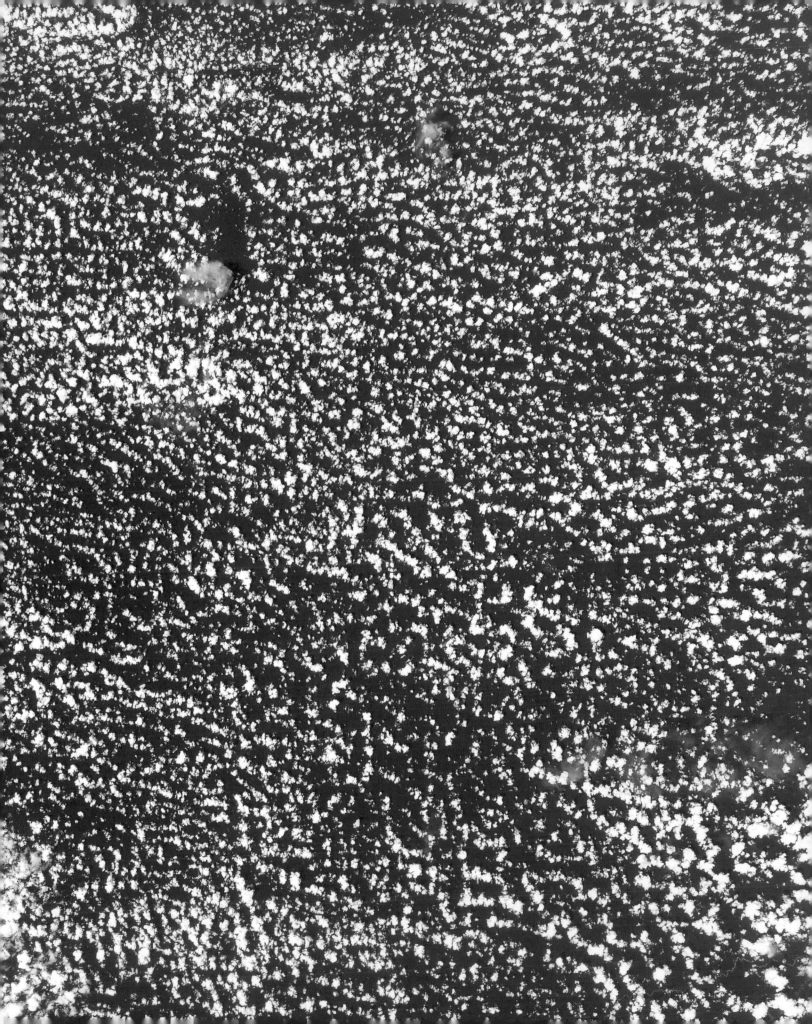

Clouds

Pointillism
The clouds are painted on the emerald background of the Amazonian canopy with a multitude of white strokes. It is difficult to see the lush vegetation of the largest equatorial forest in the world, so discreet behind its semi-permanent veil of clouds and misty peaks.

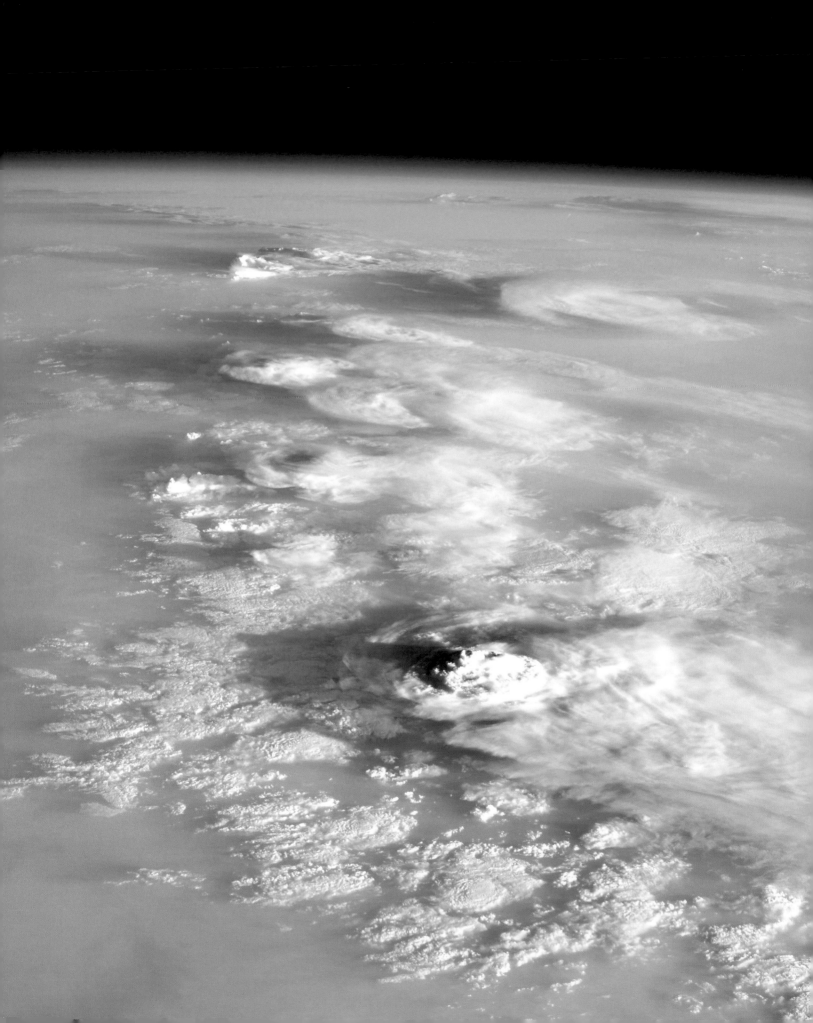

Clouds are much more than the little fluffy shapes that adorn simple sketches and landscape paintings: NASA's Aqua satellite (which has been observing the Earth's water cycle since 2002) has allowed us to confirm that two-thirds of our planet is usually under clouds. Contrary to popular belief — and our childhood drawings — gray-white skies are the rule and clear blue skies the exception, limited to a few geographical areas such as the Sahara.

From space, we can admire the surprisingly poetic aerial parade of what Aristotle called "aqueous meteors." Nature knows how to create any clouds it wants or needs through condensation or by lifting air masses loaded with humidity, from cirrus clouds at high altitudes to majestic vertical cumulus clouds. Like an artist, nature can weave tapestries of stratus clouds over several hundred square miles. The shapes and textures seem limitless, but what could be more magical than watching a storm cloud form from the ISS?

From the windows of the space station, we can also observe extreme phenomena and how their frequency and severity are increasing with climate change. Among the dramatic side effects of human activities, megafires have marked the last few years: California, Provence, Maghreb, Amazonia, Greece, Indonesia, Congo... No region of the world seems to have escaped these terrifying columns of smoke that can be seen with the naked eye from space. Moreover, areas that were once thought to be safe, such as Brittany and my native Normandy in France, are seeing increased fire risk with hotter and drier summers. These photos, sometimes dreamlike, also testify to this troubling reality.

Word Clouds
"Whom do you love best? do tell, you enigma [...] I love clouds... clouds that go by... out there... over there... marvelous clouds!" Surely Baudelaire could not have imagined that his *Little Poems in Prose* would ever apply to astronauts admiring overhanging clouds!

A Nest of Clouds
With the ocean and clouds in the background, the Soyuz MS-19, which was bringing three colleagues back to Earth, looks more like a dragonfly than a spacecraft. Its dimensions are modest and the conditions on board rather spartan. Imagine spending two days in the back of a van or cargo truck that spins around. And I know what I'm talking about! I flew in this model for my first mission.

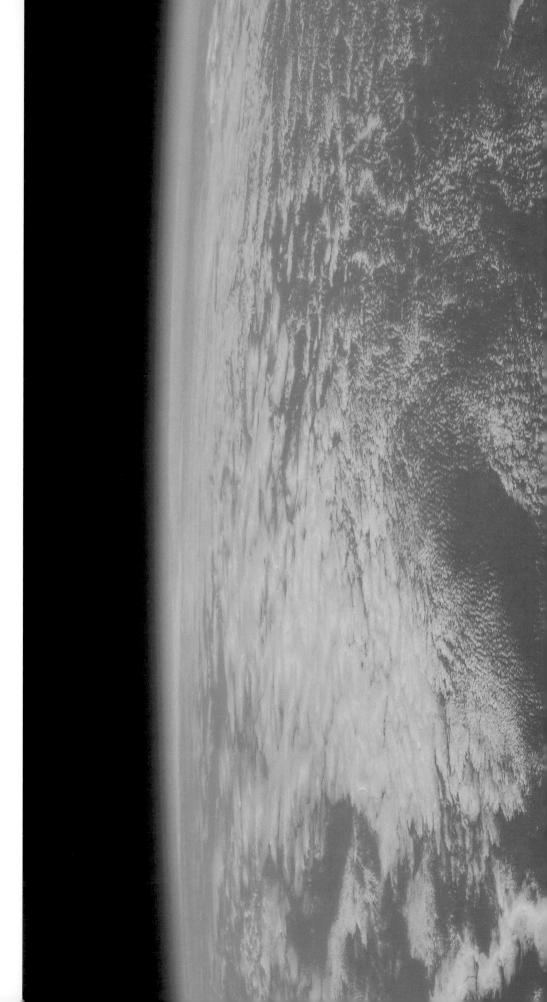

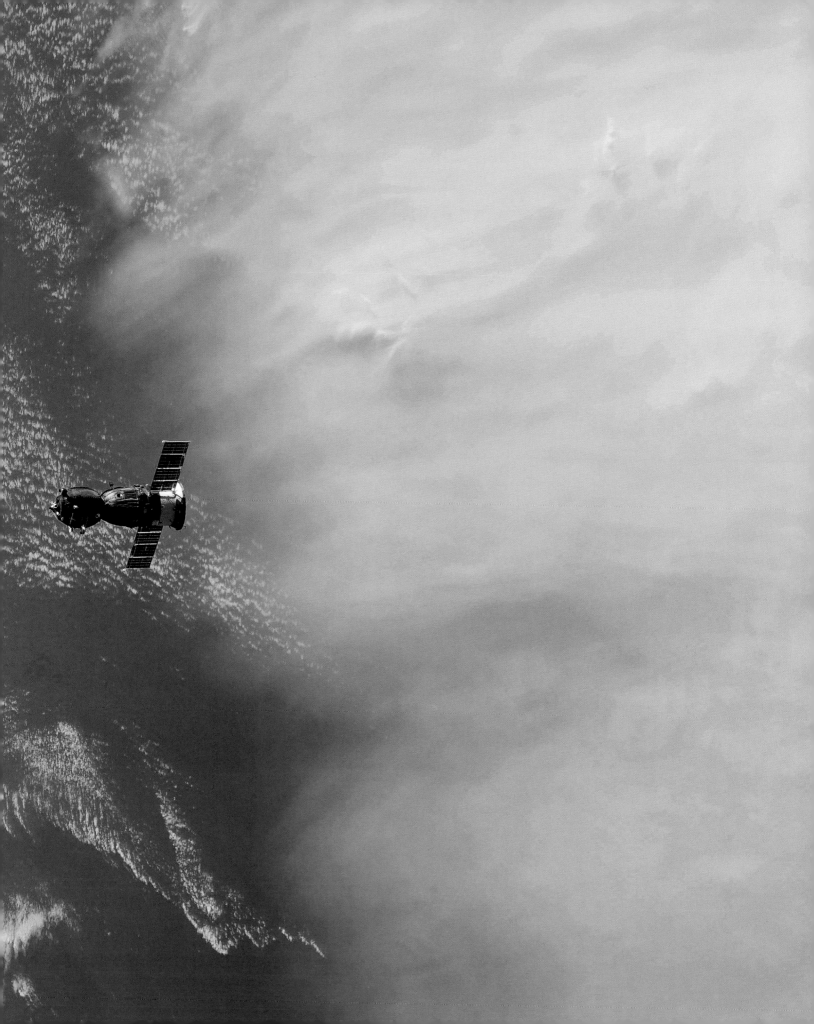

The Automated Dragon
Watching the arrival of a spacecraft (here, the CRS-22 supply ship) is always a very special moment. A tiny dot follows us, gets bigger and bigger, starts to maneuver around us and seems to stop before finally approaching to dock. It is called Dragon, but its black and white coloring always reminds me of an orca.

A White Wall
This cloud compendium should delight any weather fan.

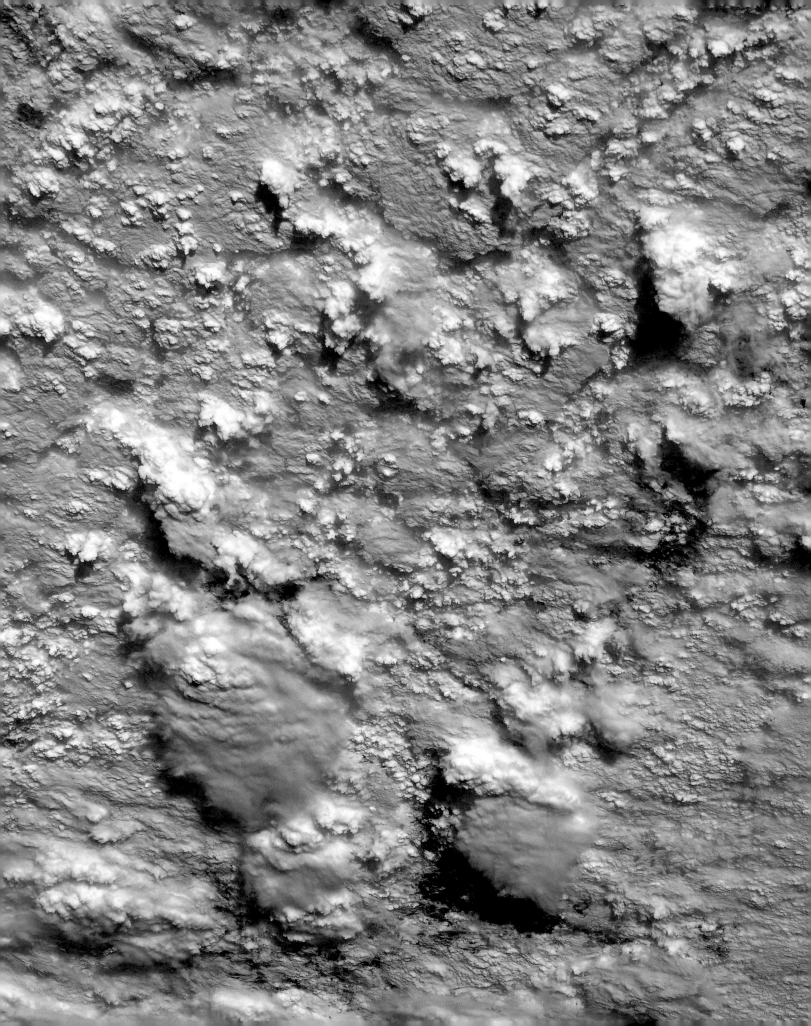

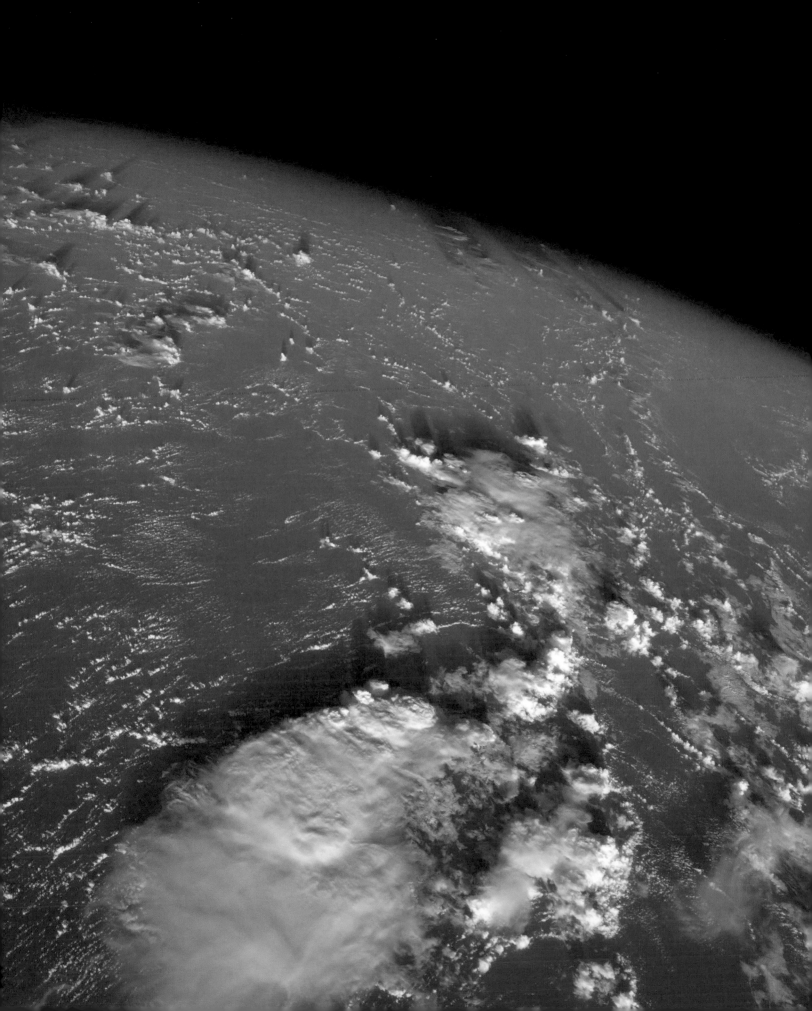

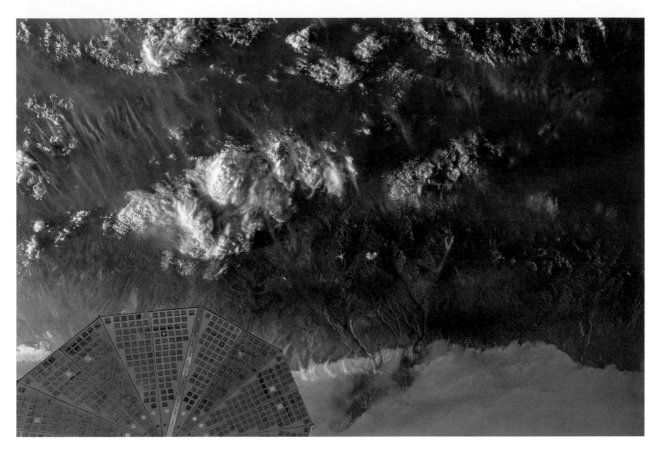

Race Against the Night
Even the highest peaks are inevitably caught by the night. When the rotation of the Earth puts them back in the light, they will be the first to be touched by the Sun's rays — a question of geometry.

Ghostly Clouds
If you're afraid of the dark, the passage to the dark side of the Earth is the stuff of nightmares. We fly at a dizzying speed toward a darkness that seems to engulf the entire landscape and even the clouds in the sky, whose whiteness contrasts, even more than usual, with the emptiness of space.

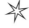

Next page
A Trick of the Eye
Vast fields covered with cattle? No, clouds over the ocean. This is the most frequent background aboard the ISS. The blue planet is not stingy when it comes to optical illusions!

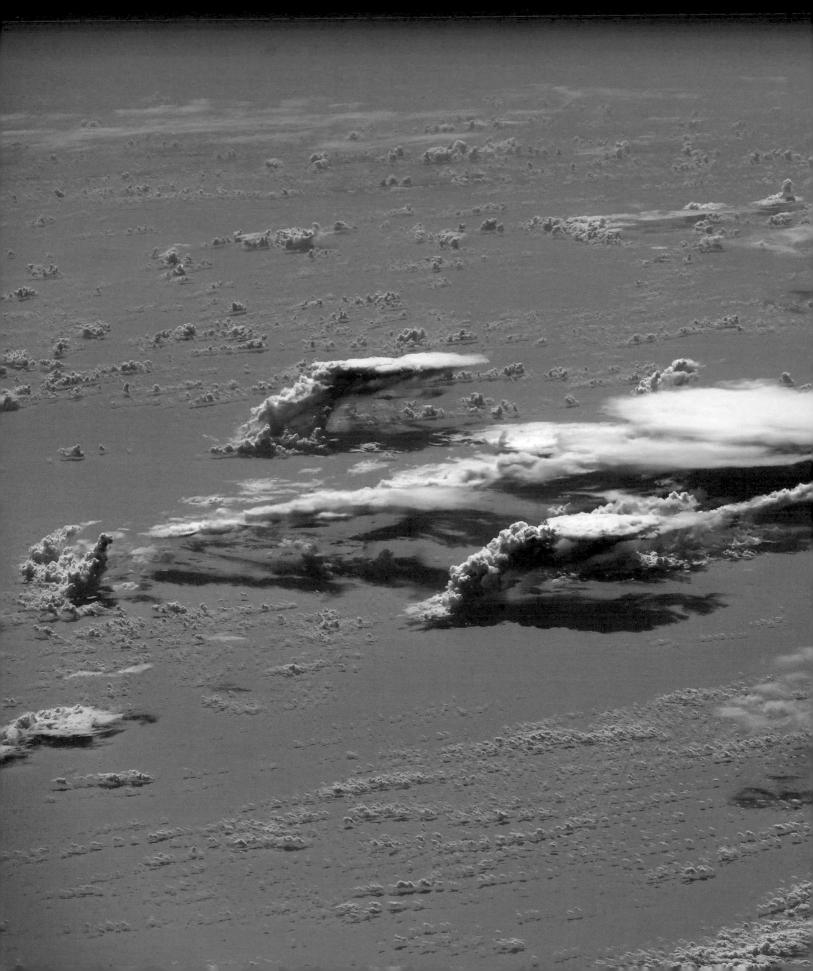

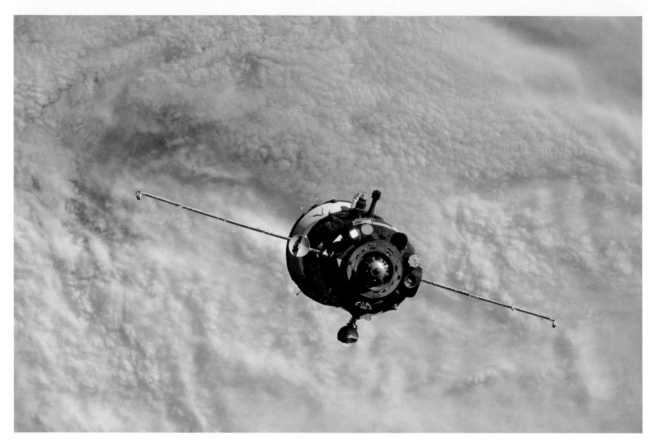

Through the Clouds
Crossing the clouds is just a formality for the various spacecraft that make regular trips to the ISS, such as this Soyuz MS-19. The ships operate in an extreme environment. Not surprisingly, the equipment wears out, just like on a car, plane or any other vehicle, and can often only be used for a single flight before needing maintenance. Astronauts usually travel back from the ISS in the same capsule that brought us up, and after landing, the craft is almost completely reused by SpaceX and can fly many more times, mission after mission. Only the ISS never descends. It is a technical feat to maintain it in situ, in the most inhospitable environment possible.

Next Page
Pulling Back the Curtain
On San Nicolas Island, part of the Channel Islands archipelago off the coast of California, it looks like the clouds are parting like a curtain to let someone land or take off from this airport — a pilot's dream!

Between Sea and Sky
From the space station, it sometimes takes a keen eye to avoid mistaking a close-up of raging waves for clouds.

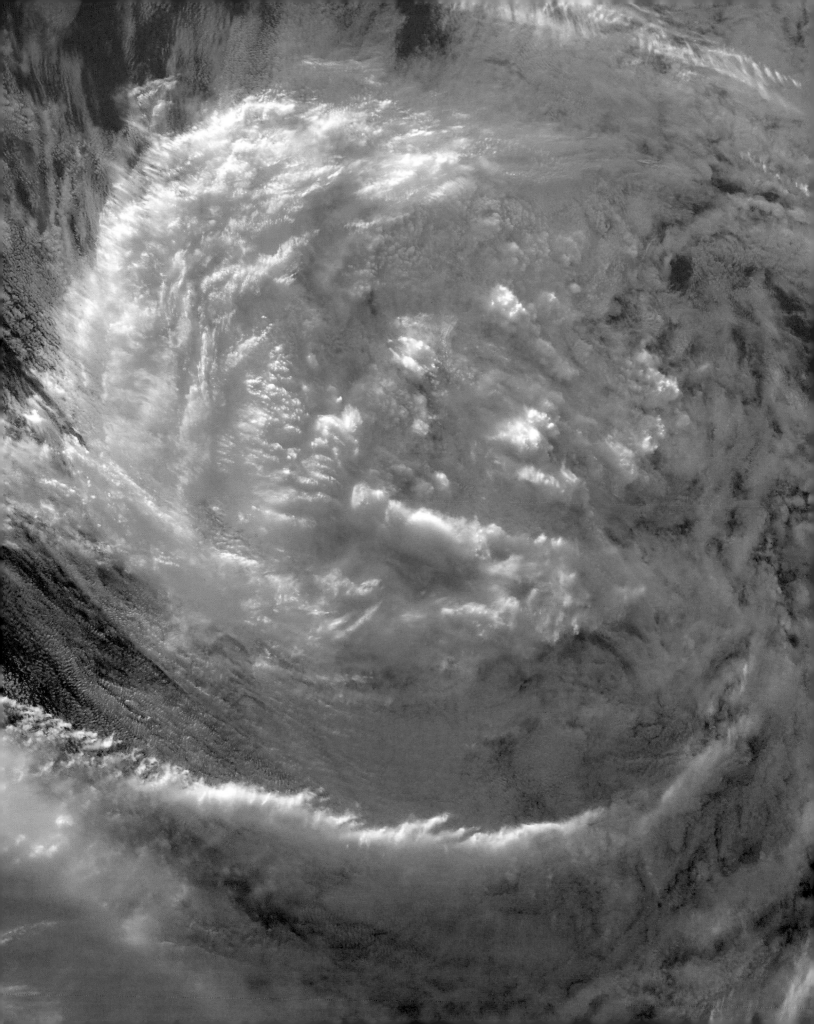

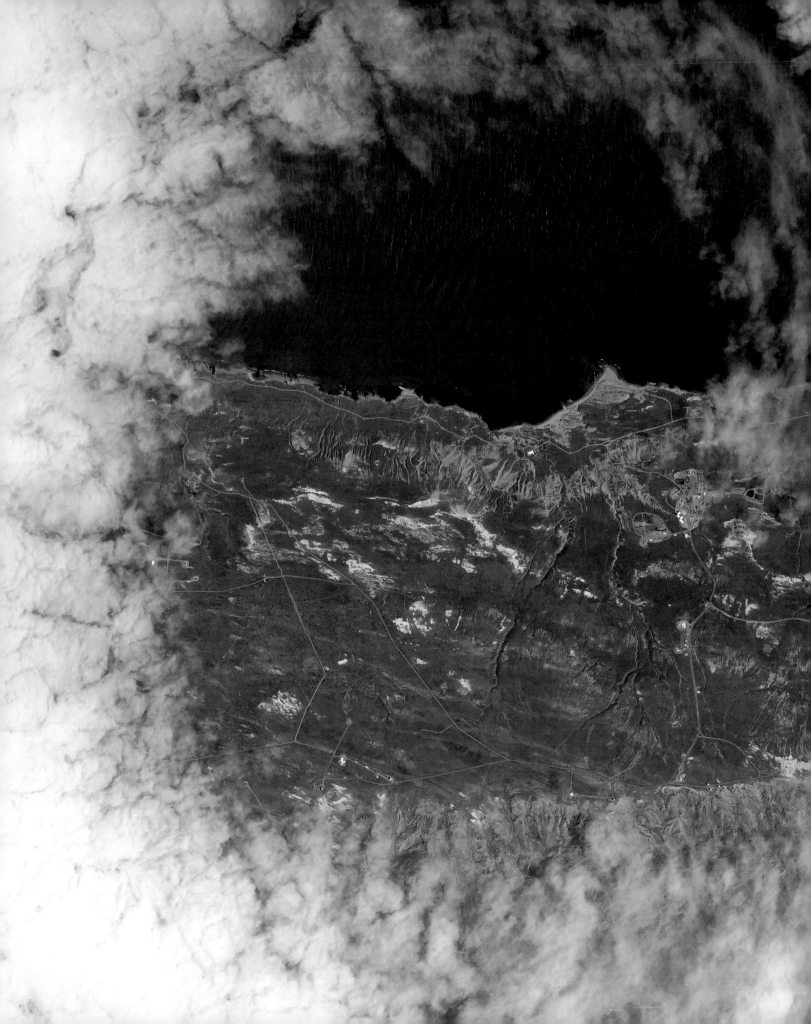

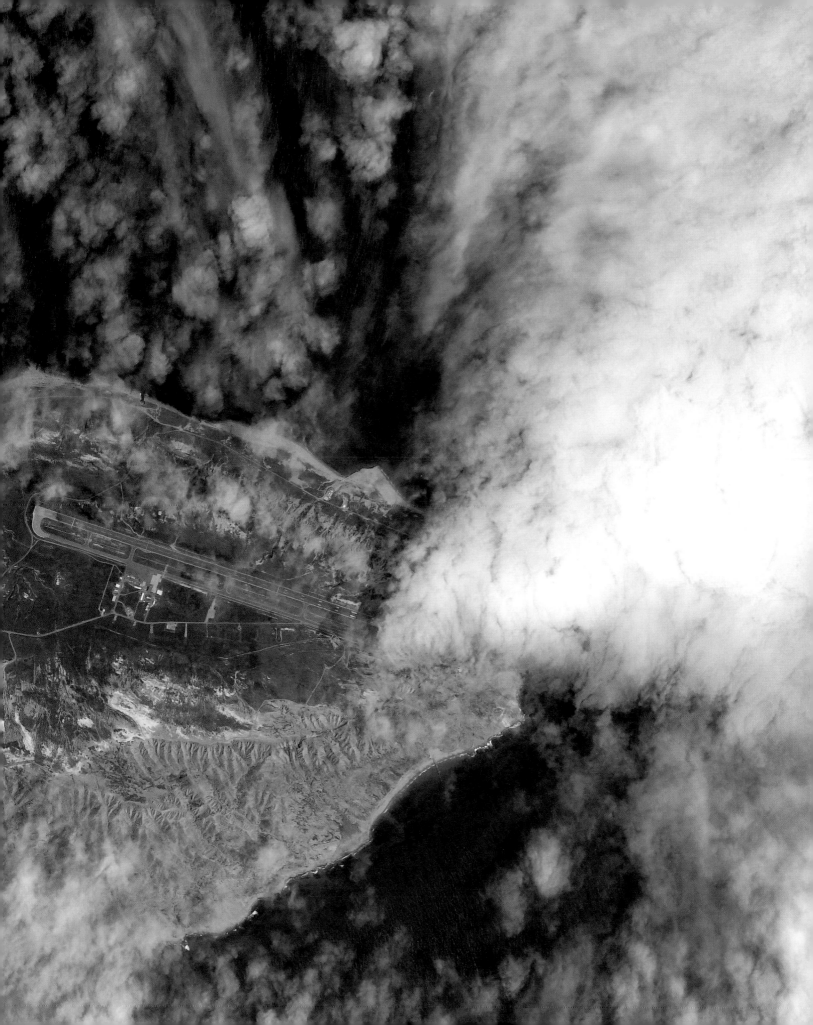

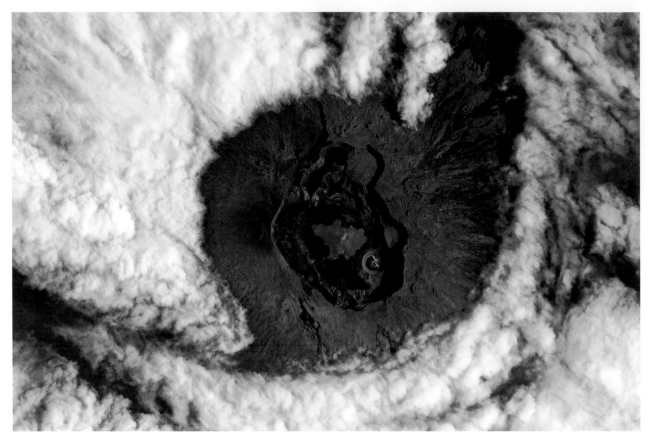

Enchanted Islands
A chance opening in the clouds
allows us to admire the Galápagos
Islands, an uninhabited volcanic
archipelago that is home to the
largest turtles in the world and the
only marine iguanas on the planet,
which look even more punk than their
land-based cousins. Not surprisingly,
it is a biodiversity paradise and is
listed as a UNESCO World Heritage
Site. Even this haven for wildlife,
however, has not been spared
the effects of global warming and
pollution due to human activities,
particularly tourism.

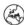

The Sky over Your Head
These clouds seem to be clustering
over Corsica, an island off the coast
of France, just like on a weather map.
But why don't clouds just fall on our
heads? Because the rising air that
created them continues to keep the
water droplets in suspension.

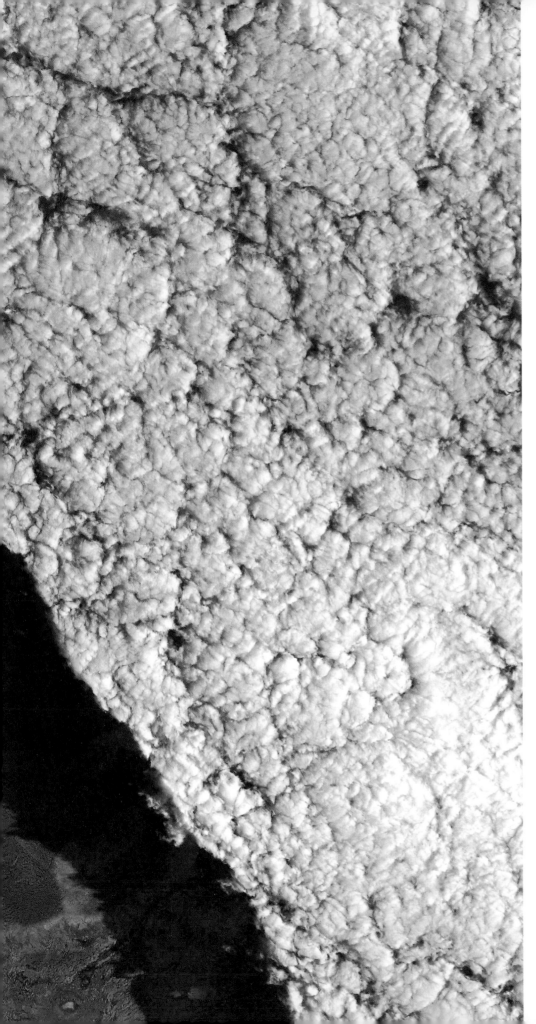

Red Light

Even a veritable canopy of clouds glows red as it passes over the scorching Australian outback. No dwellings are visible. Flying over this country-continent always gives one the impression of observing the origins of the Earth.

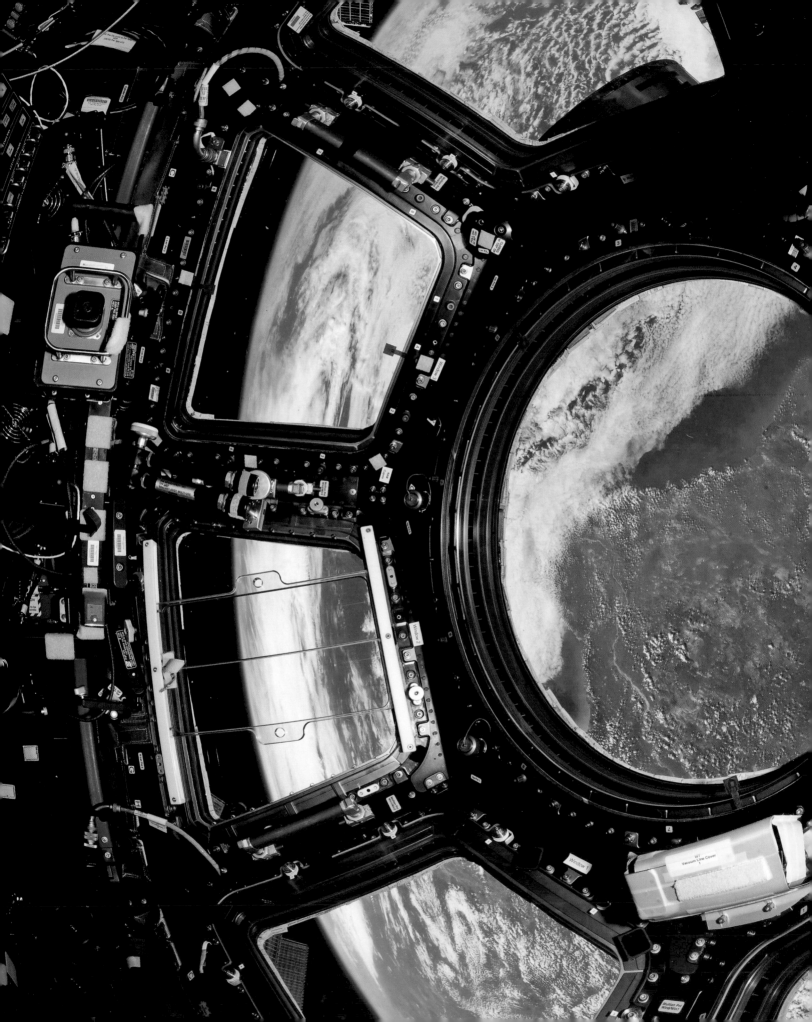

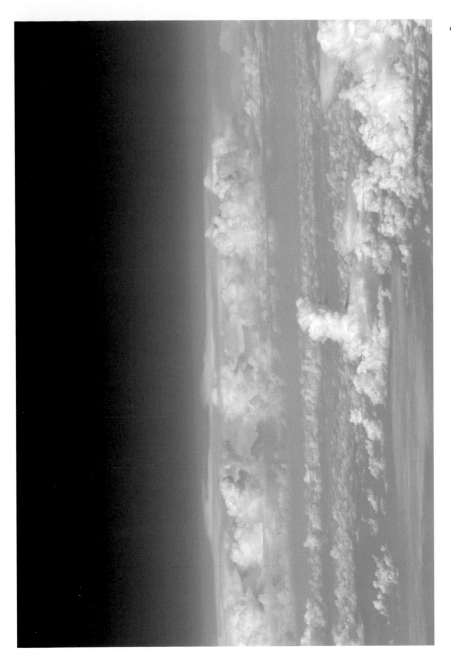

An Extraterrestrial View of the Clouds
Our blue planet's clouds are basically composed of water. The clouds on Saturn and Jupiter, however, are made of ammonia, and Venus's clouds are made of sulfuric acid and sulfur dioxide. I can't even imagine what those clouds might look like. I am simply too familiar with the clouds on Earth, so fluffy and serene.

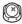

Around the World in 90 Minutes
The ISS circles the globe every 90 minutes. After spending a day with your head in gray scientific equipment, imagine how many clouds, landscapes and other incredible views you are tempted to photograph from the Cupola!

Target: Moon
The Cupola's windows are protected by anti-scratch panels that are... quite scratched (perhaps by astronauts handling their cameras a little too roughly?), which complicates photography with the longest focal lengths. One of the windows is less damaged than the others, so I was delighted when the Moon appeared within its frame!

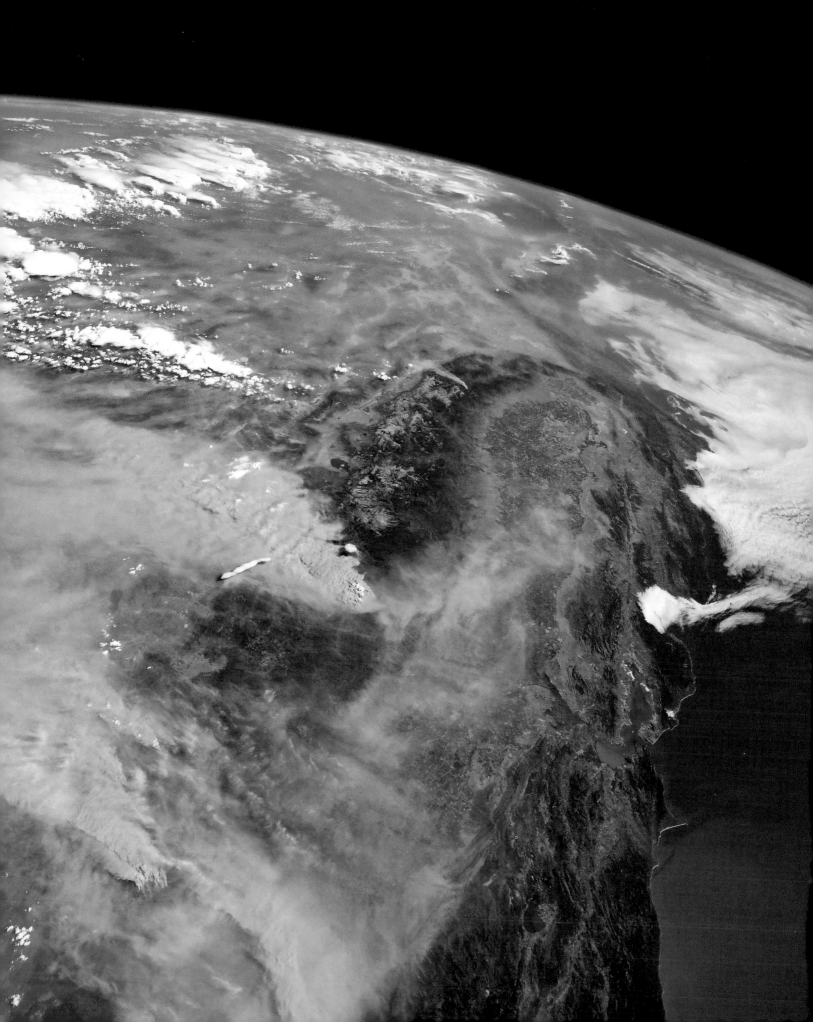

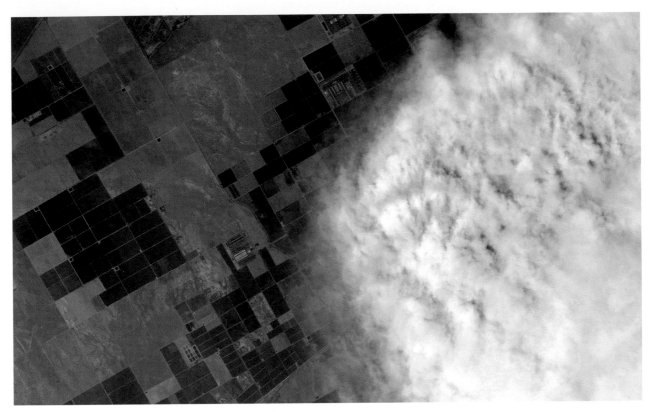

A Looming Threat
It felt like the end of the world as we watched the smoke billow relentlessly across the Northern California plain toward San Francisco and its bay.

Megafires
Images we hate to see. Pictured here is California, near Sequoia National Park, smothered in smoke. Entire regions are sometimes engulfed by smoke and ash, which can rise into the stratosphere.

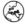

Next page
A Black Plume
We also had the opportunity to watch live from space the awakening of a volcano on the island of La Palma in the Canary Islands.

At night we could see bright lava flows that set the forest on fire, while during the day an impressive black plume of smoke floated above the white clouds.

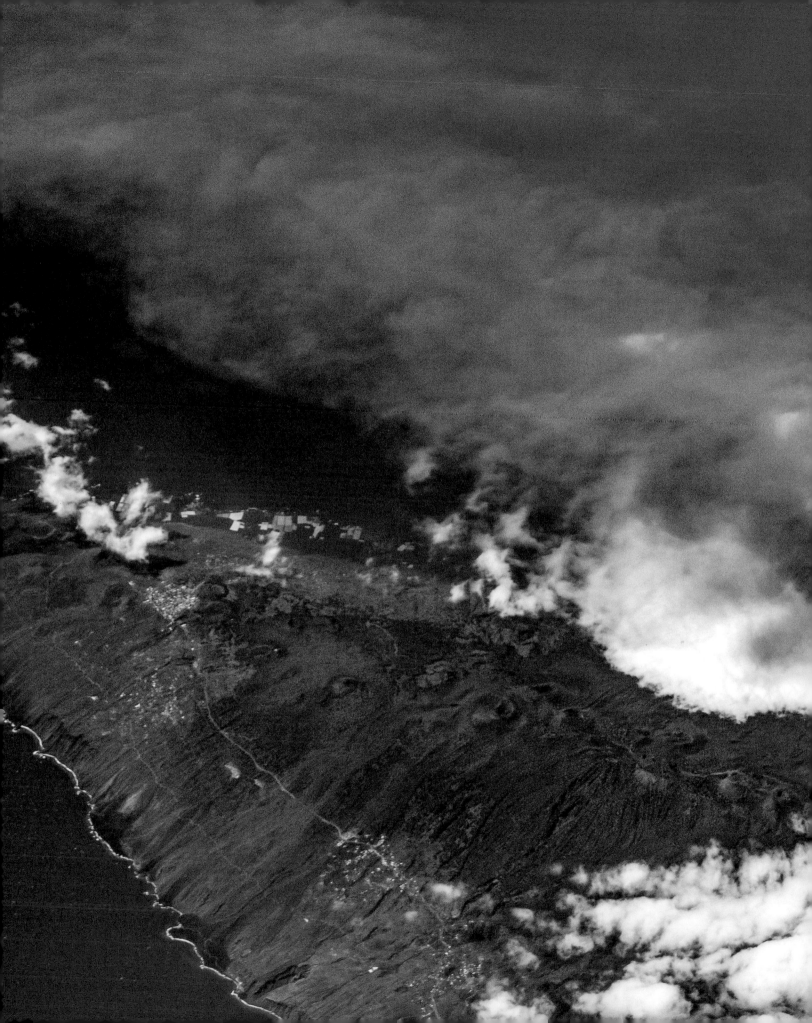

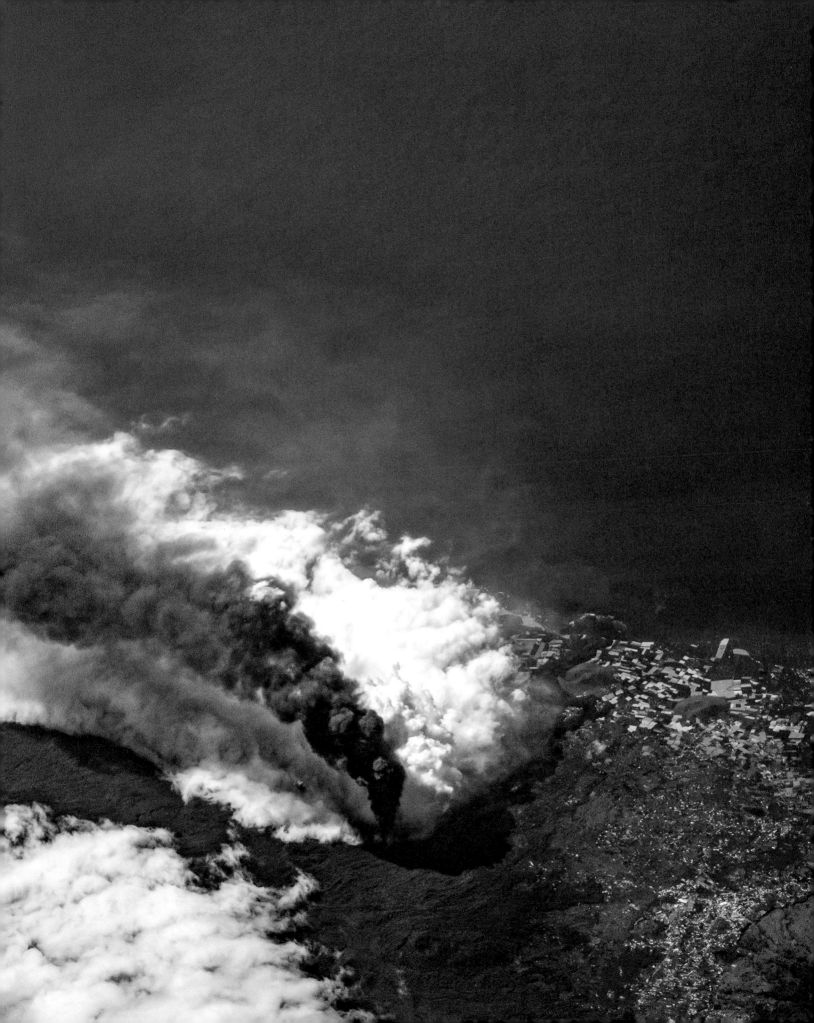

The Peloponnese on Fire
Columns of smoke from the most devastating fires can spread across the seas — I've seen them go from Greece across the Mediterranean to France! Astronauts aren't the only ones who can observe megafires from space: Satellites are some of the best data-collection and monitoring tools we have, and they are particularly useful in helping rescue efforts in remote areas.

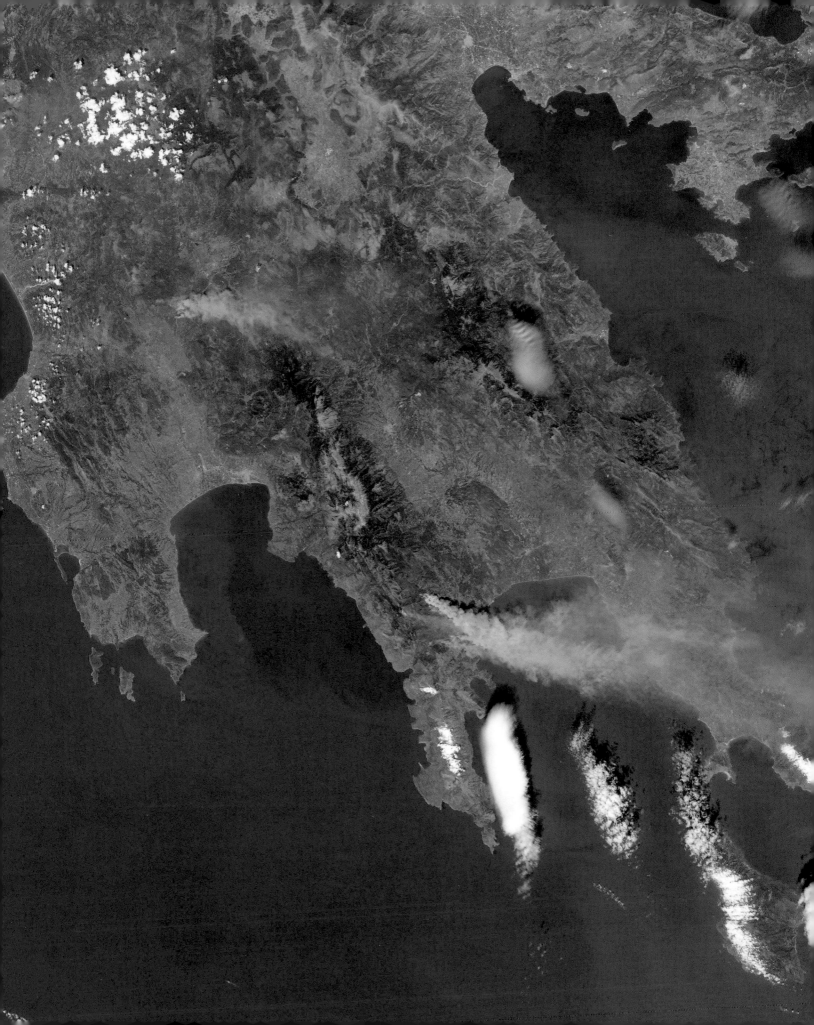

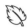

A National Park in Flames
The Alpha mission took place during the northern hemisphere summer and was marked by alarming fires in many regions. Pictured here is, again, a region near Sequoia National Park in California. For the first time, I was able to observe not only the smoke but also the flames themselves, which gives an idea of their size.

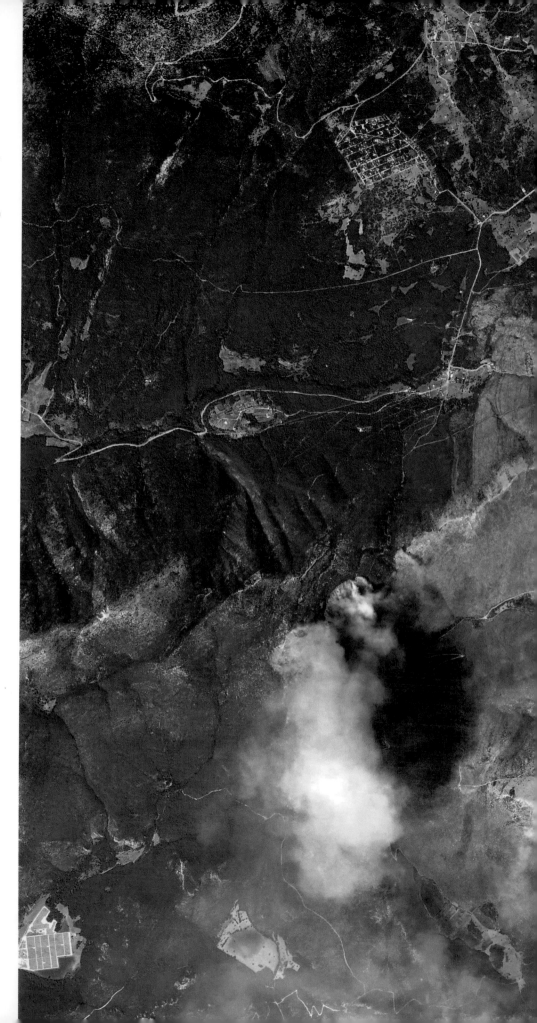

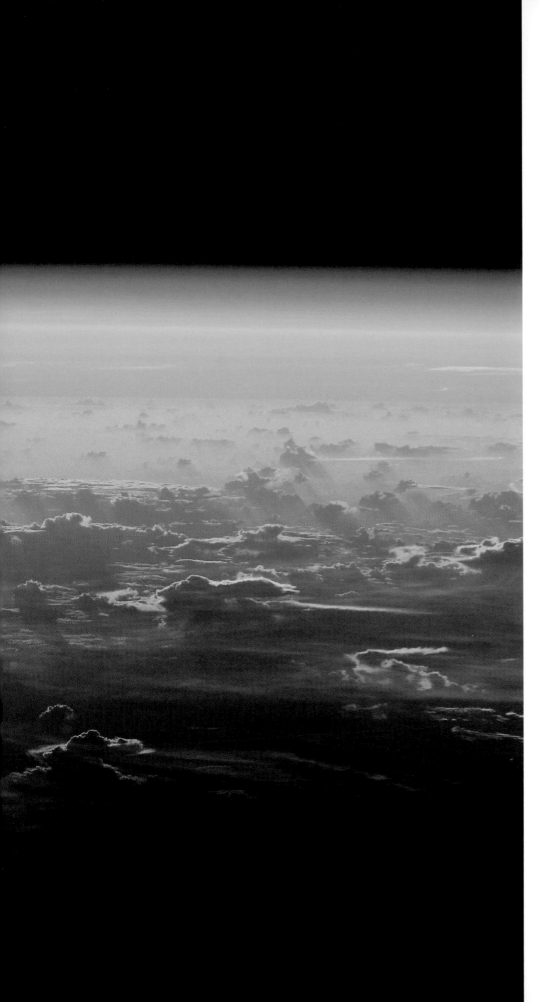

Earth's Rooftop

The lowest cloud levels (excluding haze and fog) are located at an altitude of about 1 mile (2 km), well below the altitude of planes, while the highest levels, generally found over the tropics, rise to around 11 miles (18 km). This makes quite a difference when viewing clouds from the ground, but less so when viewing them from space. We have not finished studying clouds and don't yet fully understand their climatic interactions.

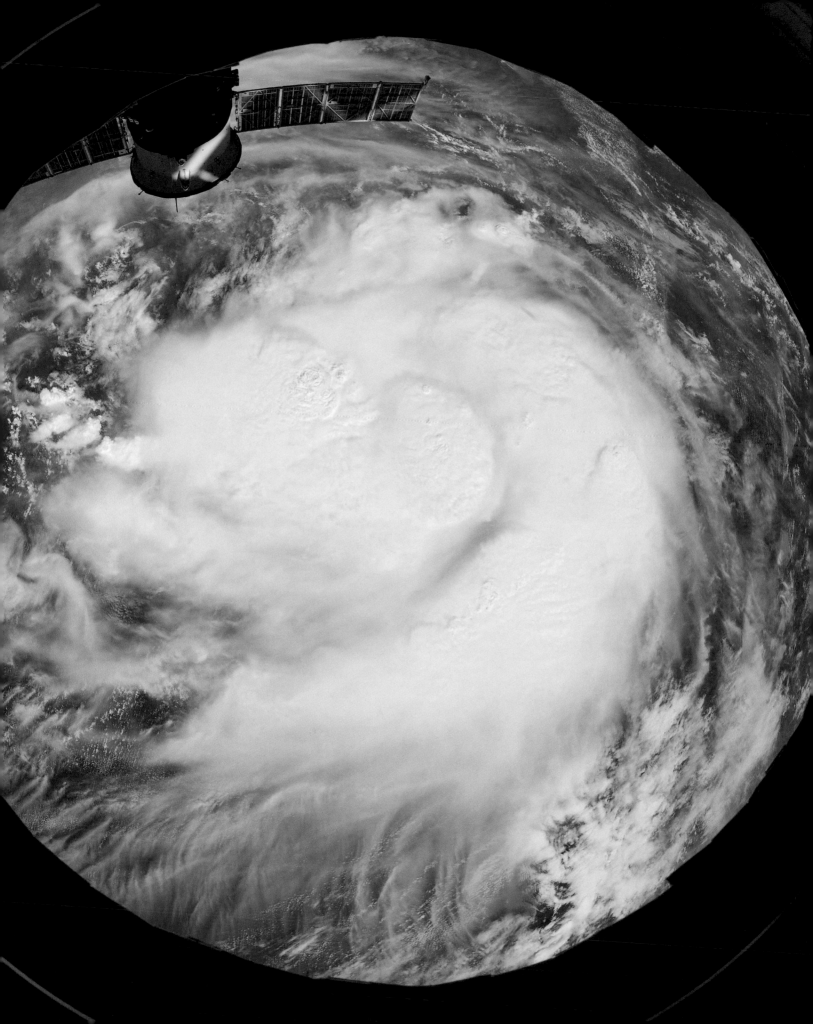

Storms

Faster, Stronger, Higher
This is a sight that breaks your heart and makes you call out for your colleagues so they can join you at the window... Hurricane Elsa (which swept through the Caribbean, Venezuela and the eastern coasts of Canada and the United States) sadly broke records for its size and severity. Sadder still, climatologists predict these records will soon be broken yet again.

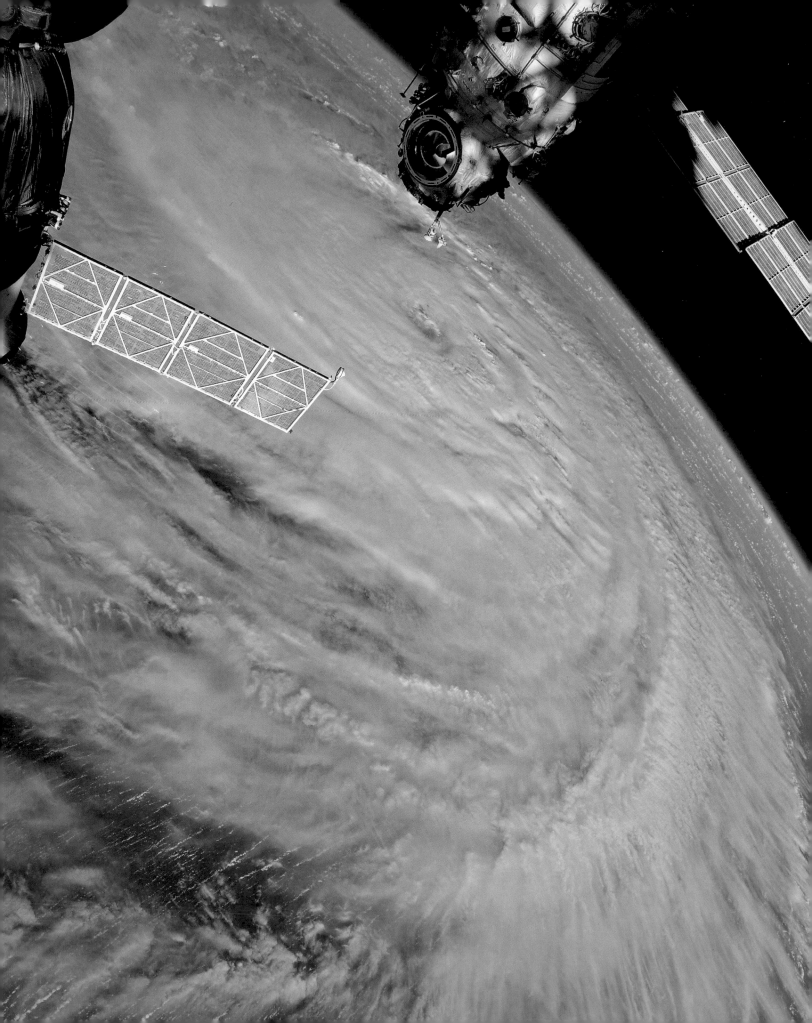

Whether you are more scientifically or artistically inclined, storms are always fascinating, with their spectacular forms, devastating potential and relentless and unpredictable nature. Humans have always tried to protect themselves from storms, but it was not until the end of the 19th century that the first documented and consistent observation network was set up to forecast them. This was the work of a Frenchman, Louis Froc, who earned the nickname "the father of typhoons."

Our knowledge and tools have greatly improved since then, for the greater good of all, but some phenomena still remain a mystery. This is why the International Space Station is equipped with an actual storm chaser, outside the European laboratory.

Flying over a storm at night is an unforgettable experience, at once beautiful and disturbing, as though you're swimming at night in dark waters, ignorant of what's lurking in the depths. You can imagine the clouds covering the city lights and giving the dark ground a woolly appearance, and then, quite randomly, a ball of light bursts out here or there, outlining the clouds, until now completely imperceptible in the darkness.

There is no mystery, however, when we observe the increasingly fast succession of extreme meteorological phenomena from space, whether with the naked eye or by satellite. Hurricanes are becoming more frequent and happening earlier each year, covering larger and larger areas and, most disturbingly, becoming ever more destructive. It is true that storms are and have always been an integral part of the terrestrial ecosystem, contributing, in particular, to forests' natural regeneration. Scientists, however, have proven that their ever-increasing frequency and magnitude are the direct results of global warming. How long will our planet — with its fragile flora and fauna and, of course, ever-increasing human population — be able to withstand these devastating storms?

Huracan
We are now familiar with hurricanes being referred to by a first name. This is Hurricane Larry. "Hurricane" is the term used for storms that form in the North Atlantic and Northeast Pacific. The name derives from the fearsome deities Hurican (a Caribbean god) and Huracan (a Mayan god of storms and chaos). In Eastern Asia, the same phenomenon is called a typhoon, while in the South Pacific and Indian Ocean they are called cyclones.

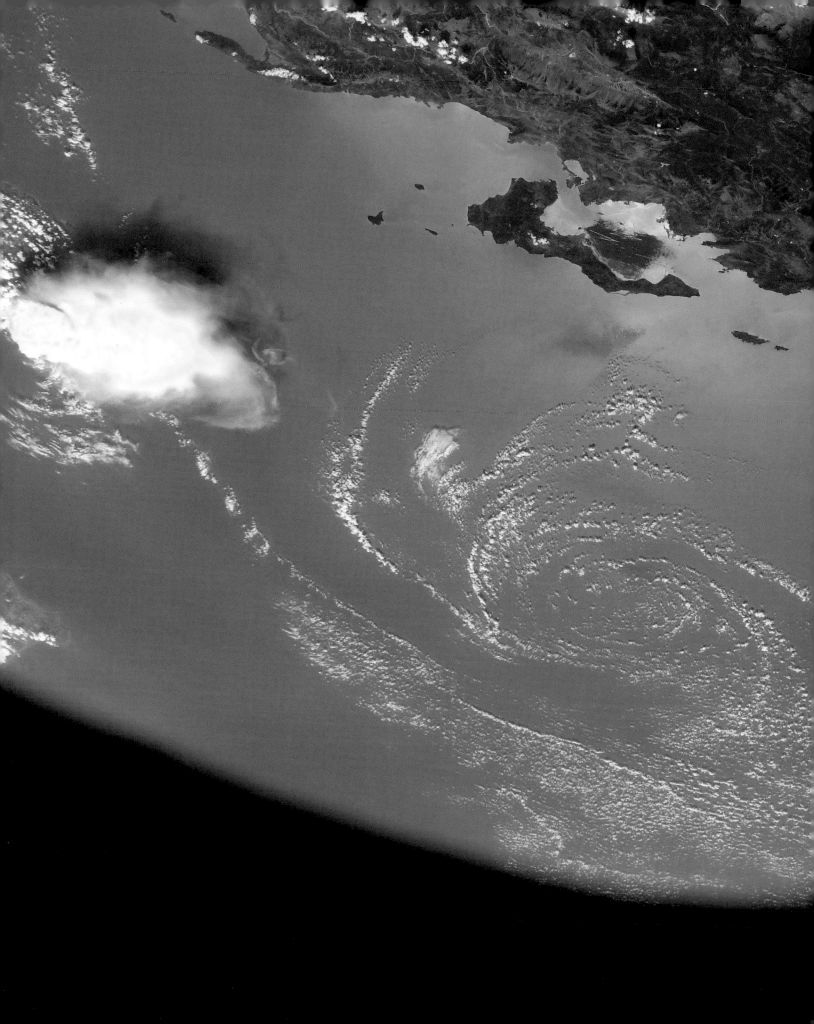

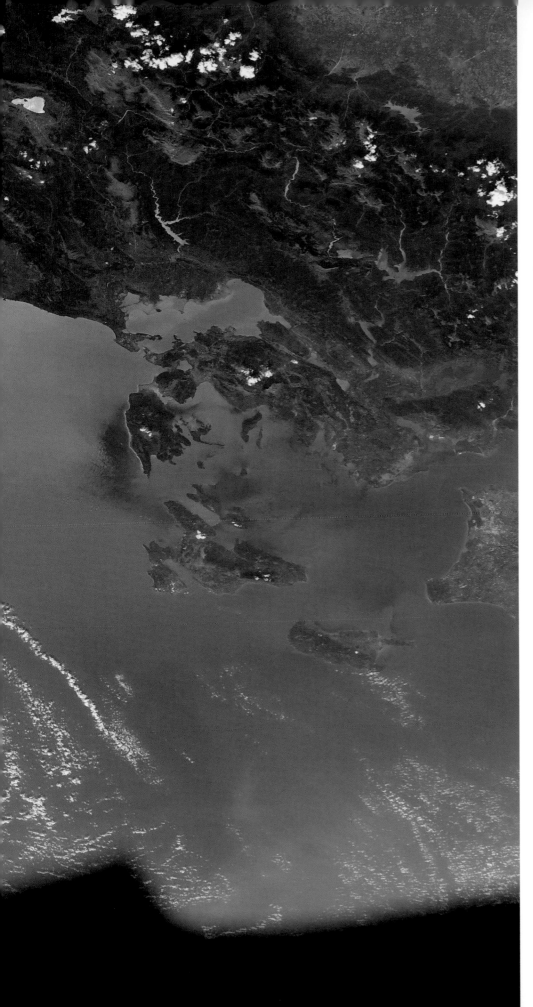

Family Photo
Clouds swirl over the Mediterranean.
All kinds of clouds — cirrus, cumulus,
stratus — are grouped together in this
family photo, casting their shadows
on the mountains, coastline and sea.
There's no need to worry, however.
The weather seems quite calm.

In the Eye of the Storm
Flying over the eye of a hurricane is dangerous in a plane, but quite safe in a space station. Expressions aside, the eye of a hurricane is actually a very calm zone. However, it's diameter of about 20 to 40 miles (30 to 60 km) is surrounded by a wall of stormy cumulonimbus clouds and particularly violent winds. It is best not to venture inside the eye of a hurricane. In this photo, Hurricane Ida is approaching the coast along the Gulf of Mexico.

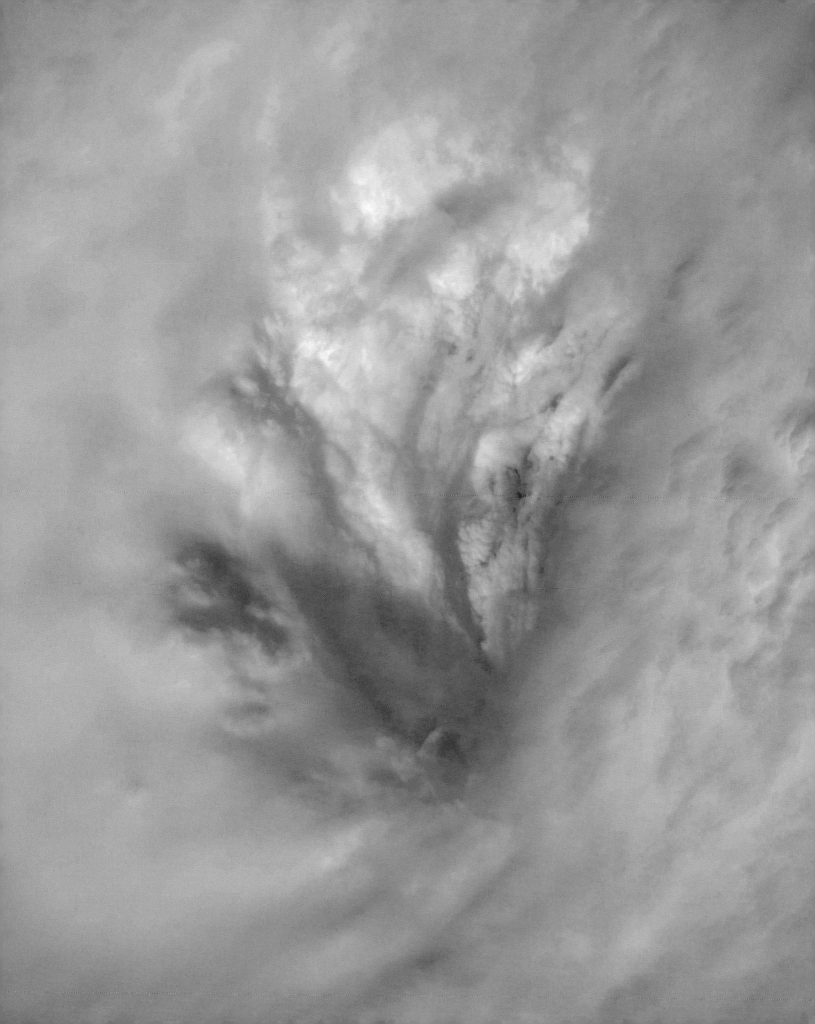

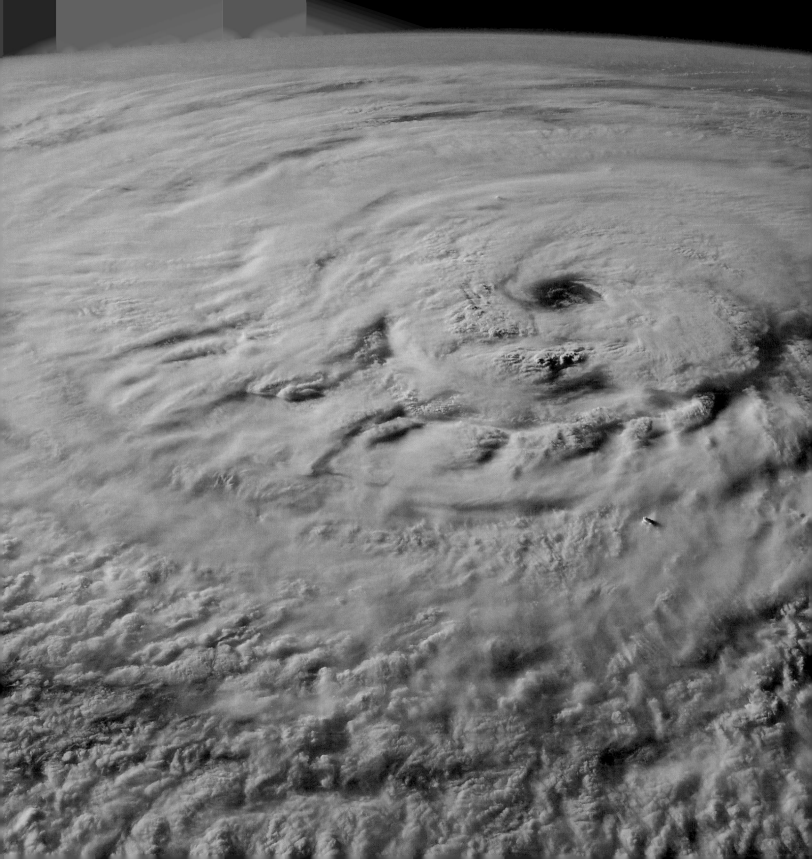

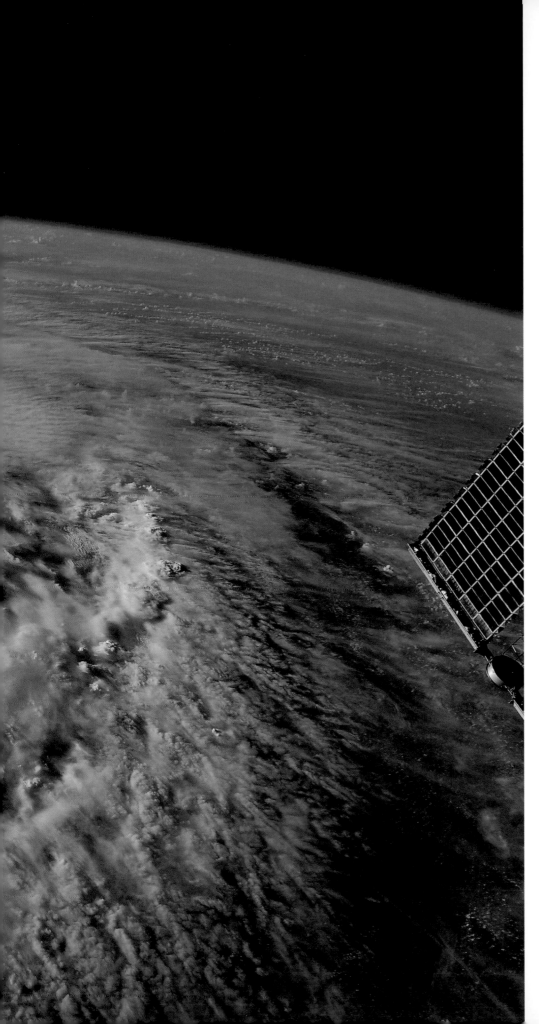

Critical Mass

Impossible to frame all of Hurricane Larry in just one of the Cupola's windows — it overflows! I had never seen a storm of this size. And yet its partner, Ida, had preceded it by only a few days. No sooner was Ida weakening, we could see Larry forming further out at sea.

103

Whipped Cream
Hurricane Ida almost looks like a big bowl of whipped cream here. One could almost forget that along the wall that surrounds a storm's eye, formidable mesovortices are forming. These mini but ultrapowerful whirlwinds will likely unleash numerous tornadoes further inland.

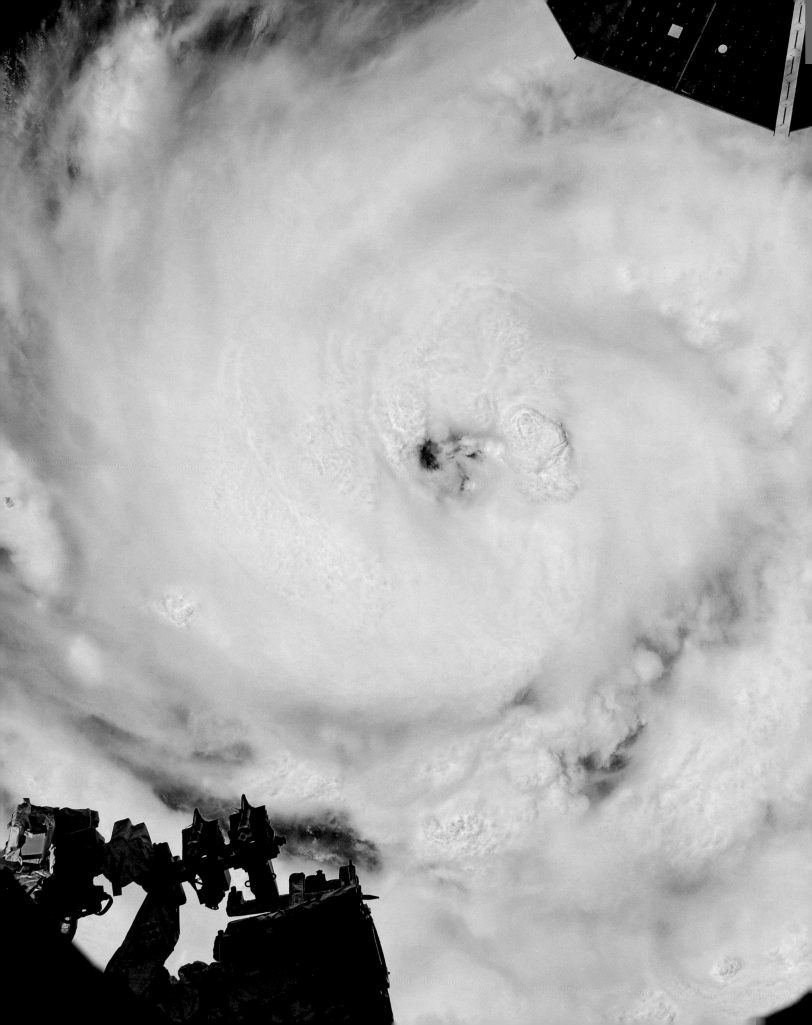

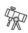

Clockwise and Counterclockwise
Hurricanes and cyclones rotate in a specific direction: Clockwise when they sweep through the northern hemisphere, and counterclockwise in the southern hemisphere. A dark story of geometry that Hurricane Ida is demonstrating here.

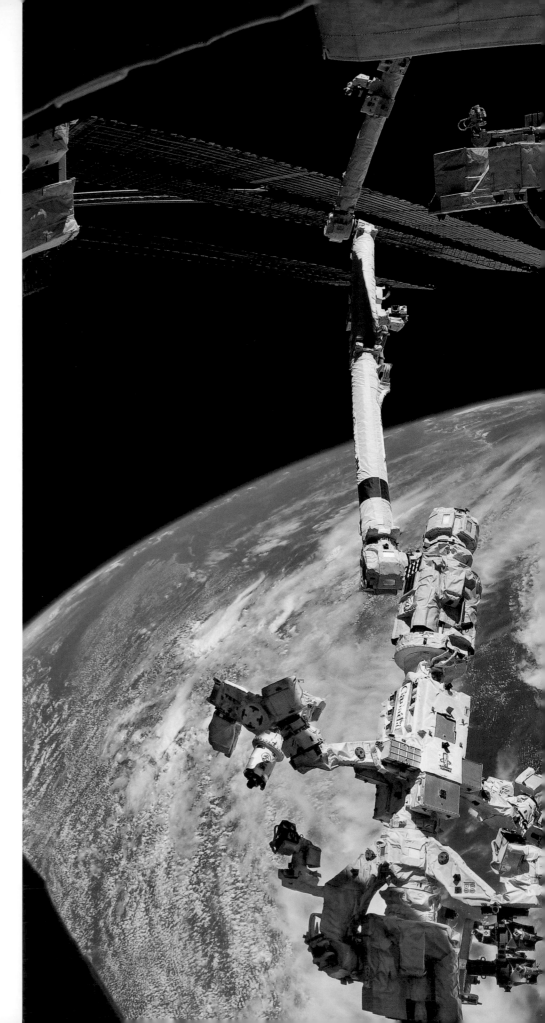

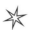

Storm Chasers

Thunderstorms are like fireworks in space, as nature showcases its power. There is nothing more spectacular than to see, from above, the intense flashes that seem to shake huge cloud masses as they pass through them, clouds that are themselves very real concentrations of electrical power. The city lights seem quite humble by comparison. To better understand them, the European Space Agency (ESA) has installed a "storm chaser" outside the ISS. The ASIM instrument is designed to study lightning and other transient light phenomena and their interactions with gamma waves emitted by the Earth's upper atmosphere and climate. It shoots 720 photos per minute, which is certainly much faster than me!

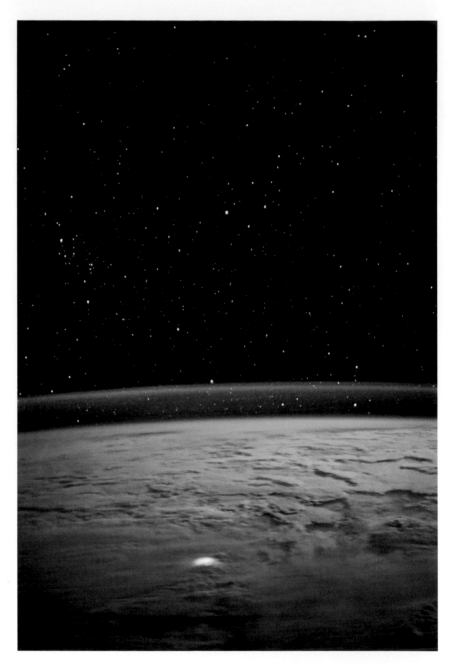

Flashes of Light

A surprising flash of light over Asia, glowing so brightly it even pierces through the clouds, illuminates fishing boats at sea. According to my Japanese colleague Aki Hoshide, the fluorescent green dots are created by projectors used by ships to catch squid, which are fond of luminescent plankton.

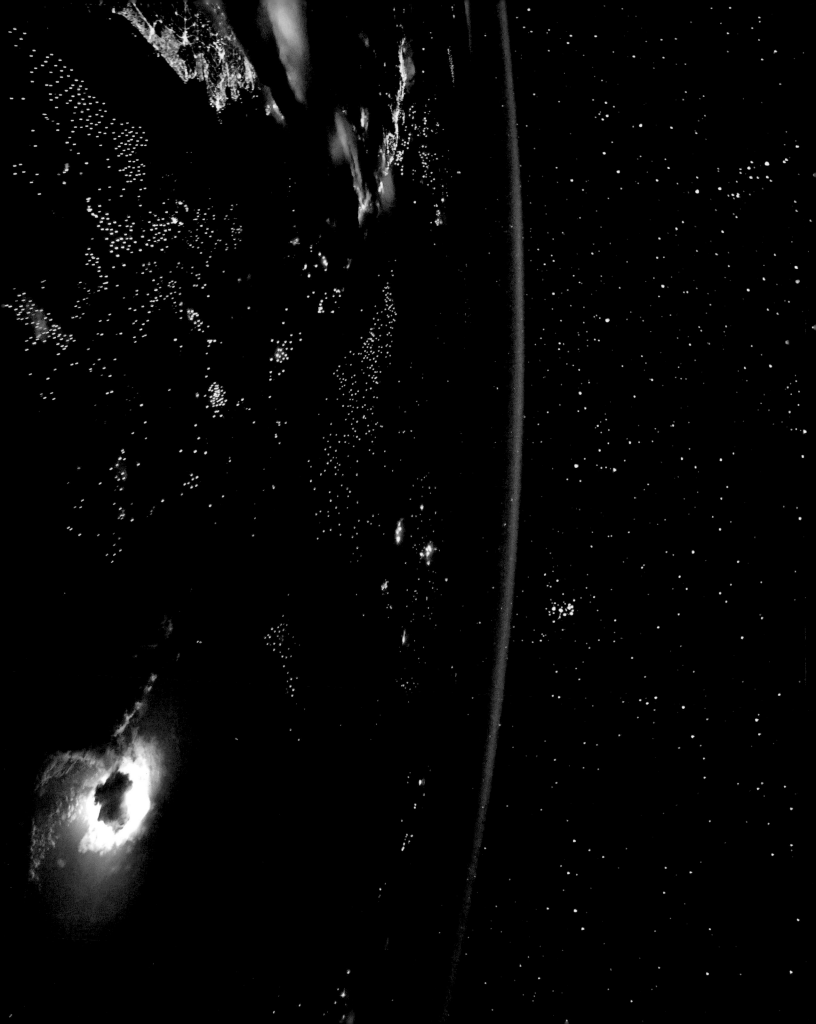

Safari

During my first mission, I never managed to take a night photo of a thunderstorm, for the simple reason that the duration of a lightning flash doesn't give you much time to aim, focus and take the photo... So I changed tactics during the Alpha mission: I aimed at an area of intense thunderstorms with a preset focus that I thought would be appropriate, and I took several random shots, hoping to be lucky enough to catch a lightning bolt splitting the sky as I pressed the shutter button. A bit of a DIY approach, but it worked! Meanwhile, my colleague Andy Mogensen succeeded in photographing blue jets, which is inverted lightning (i.e., lightning flashing upward) during his mission in 2015, as part of the well-named THOR experiment. This phenomenon, which is not completely understood, owes its specific color to the concentration of nitrogen in the upper atmosphere. The ISS is a particularly well-suited outpost for these observations, thanks to its orbit that is inclined at 52 degrees to the equator and to the variety of views it offers in all directions.

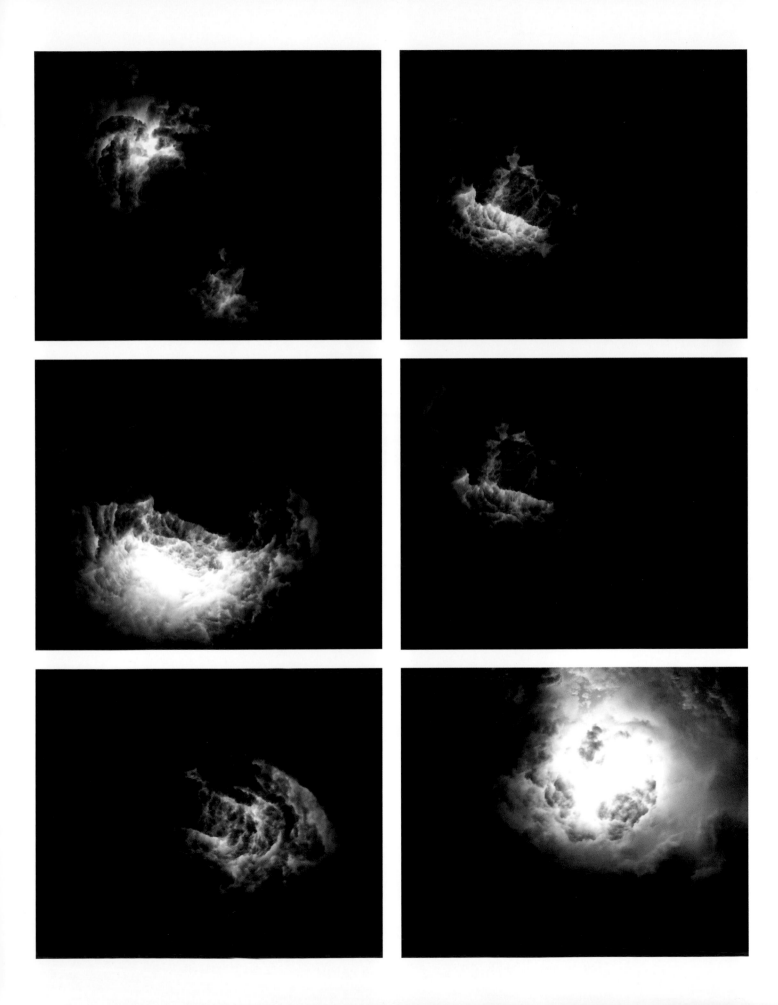

Cygnus, Graceful as a Swan
The Cygnus craft is the king of the photobomb! Not surprising given its dimensions: This supply ship (for air, equipment and food), which sits at the end of the telescopic Canadarm, is 21 feet (6.36 m) high and 10 feet (3 m) in diameter.

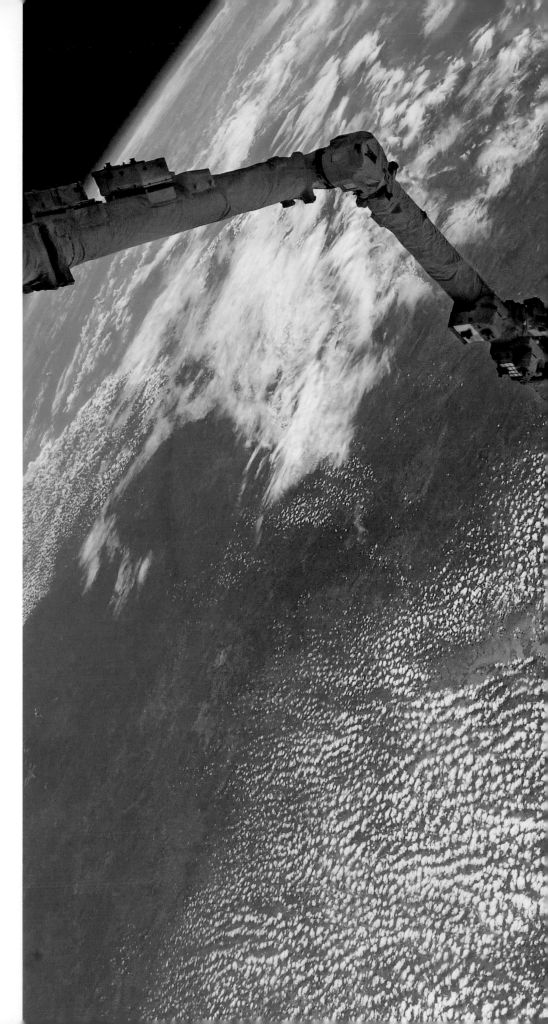

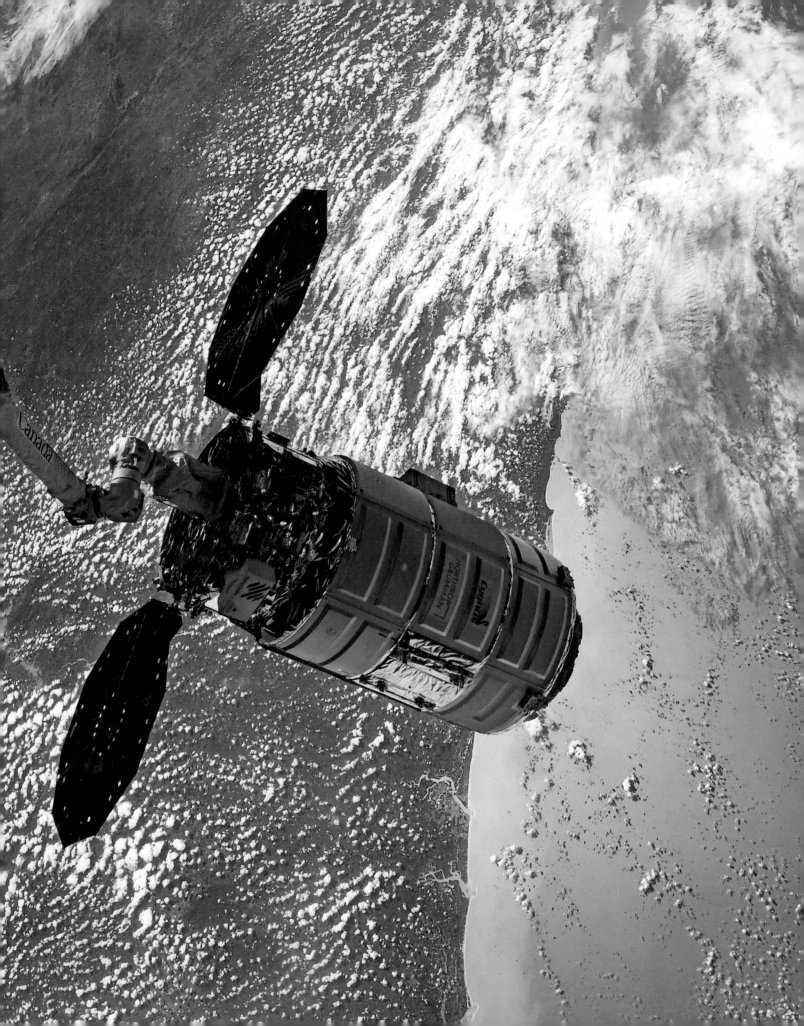

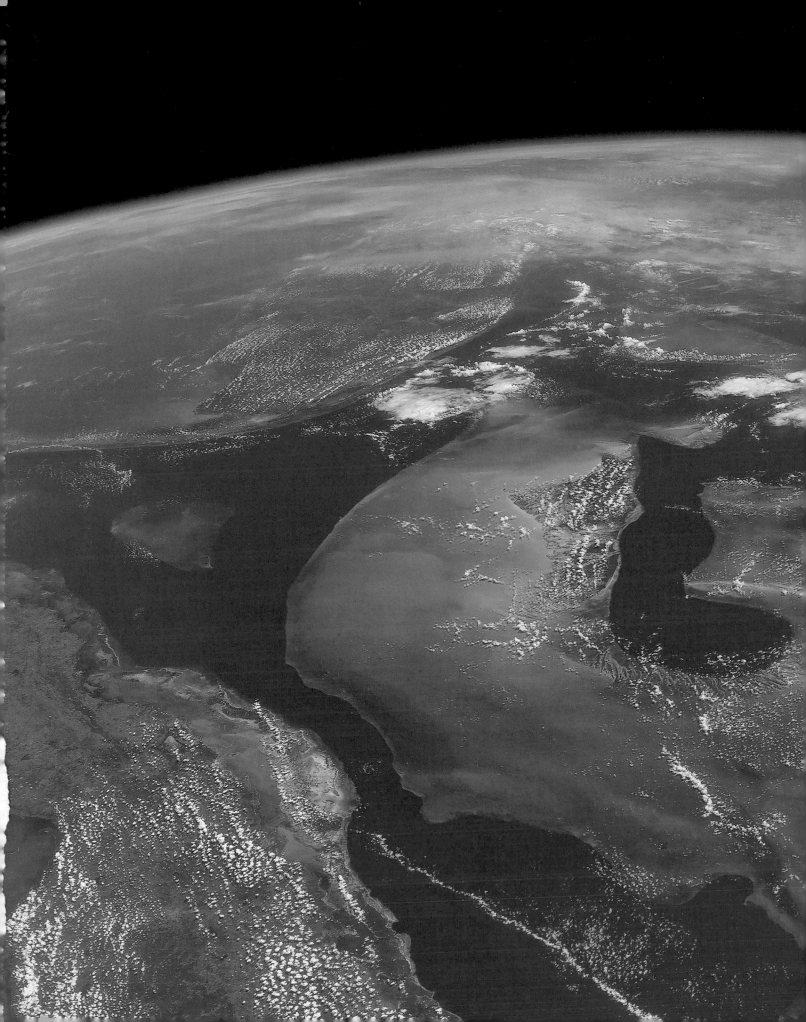

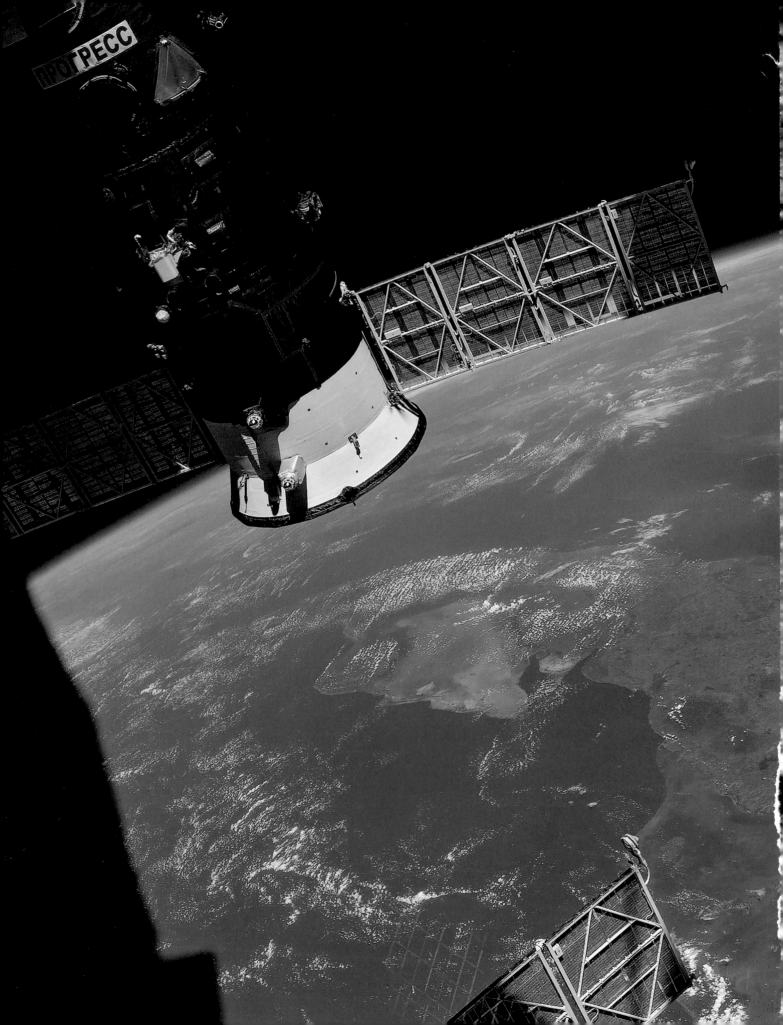

PANORAMA

The Bahamas

Off the coast of Florida, the Bahamas form an arc of 700 islands and islets scattered across an oceanic expanse of over 100,000 square miles (260,000 km²). When viewed from space, their infinite shades of blue create one of the most beautiful landscapes on our planet.

My Reading Nook
The working days are very long on the ISS, and we often work on weekends as well. However, over the course of a 200-day mission, there are still moments of rest, when everyone can take a little time to enjoy their favorite pastimes or personal projects: keeping a journal, watching a movie or TV show, calling friends and family on the phone, reading (like I'm doing here in the Cupola) and, of course, taking photos!

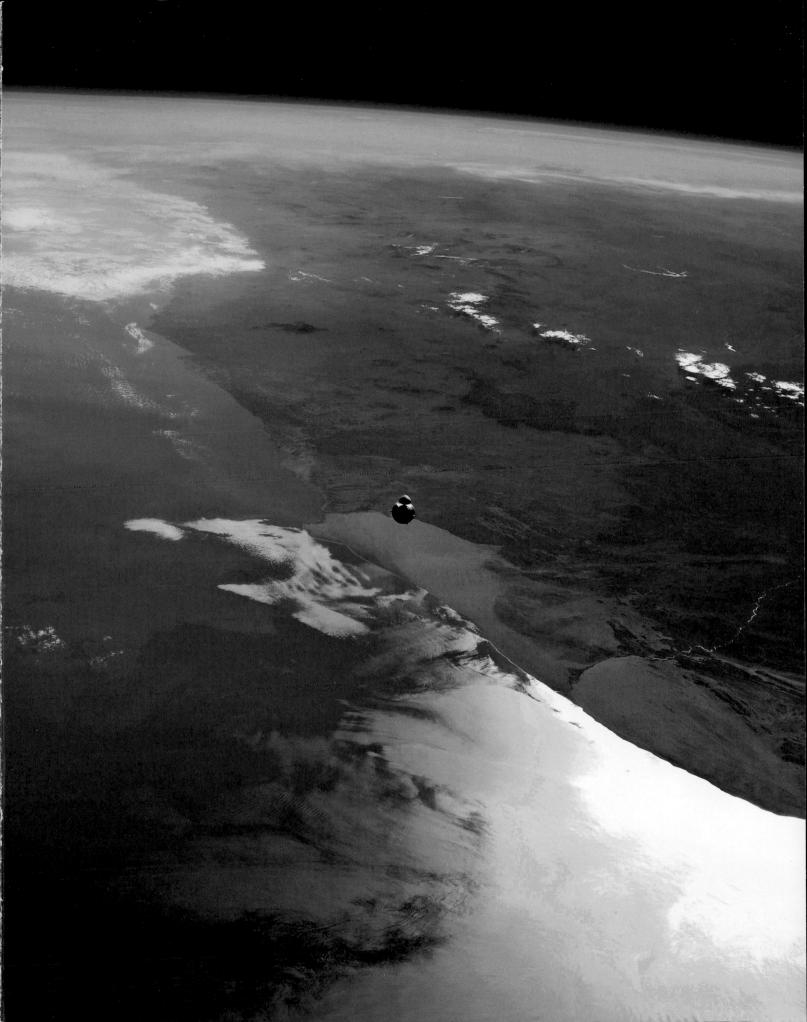

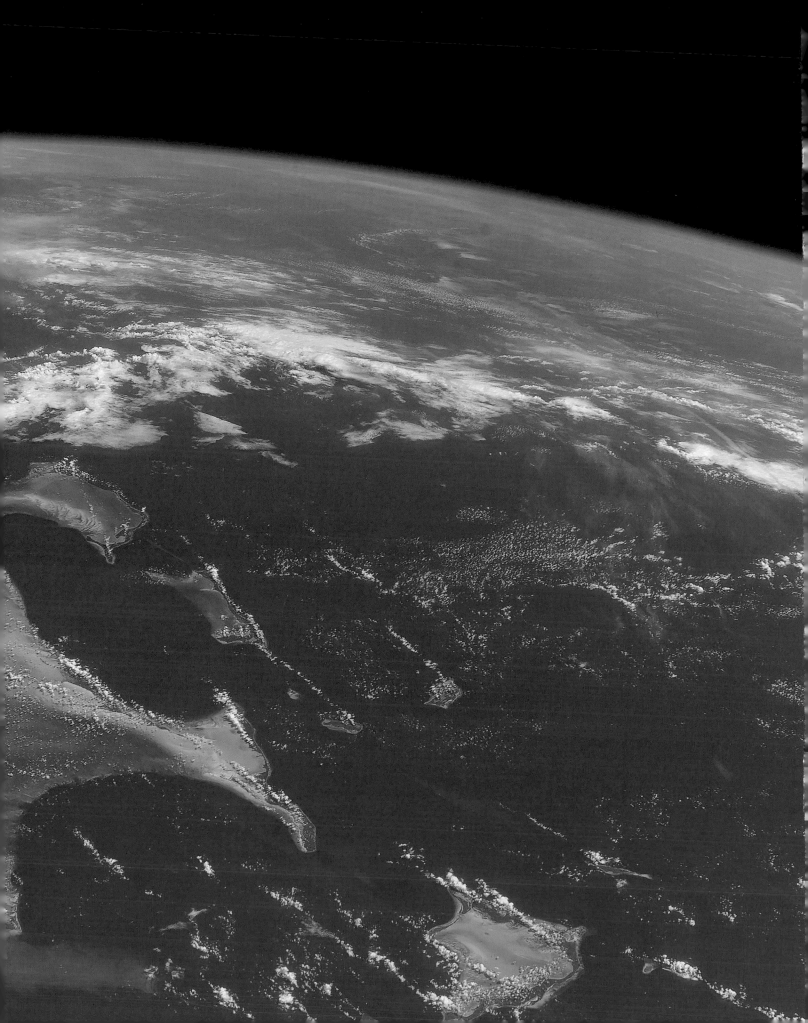

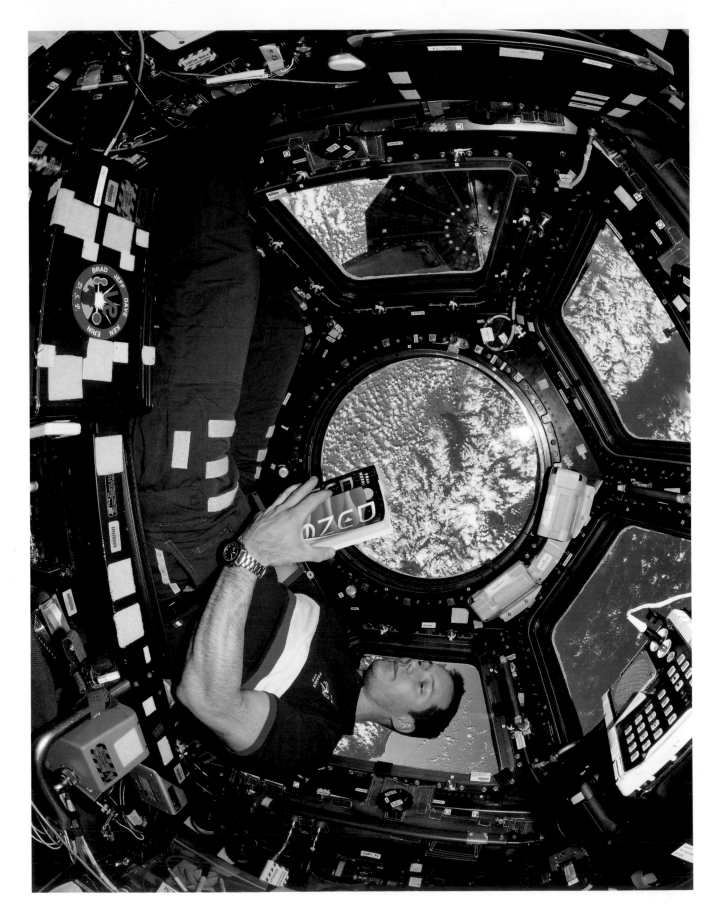

Into the Great Wide Open
A moment to myself at the window: there are breathtaking views everywhere as the Dragon cargo craft approaches the ISS over Namibia. One thing's for sure, the view from my office in France is very different indeed!

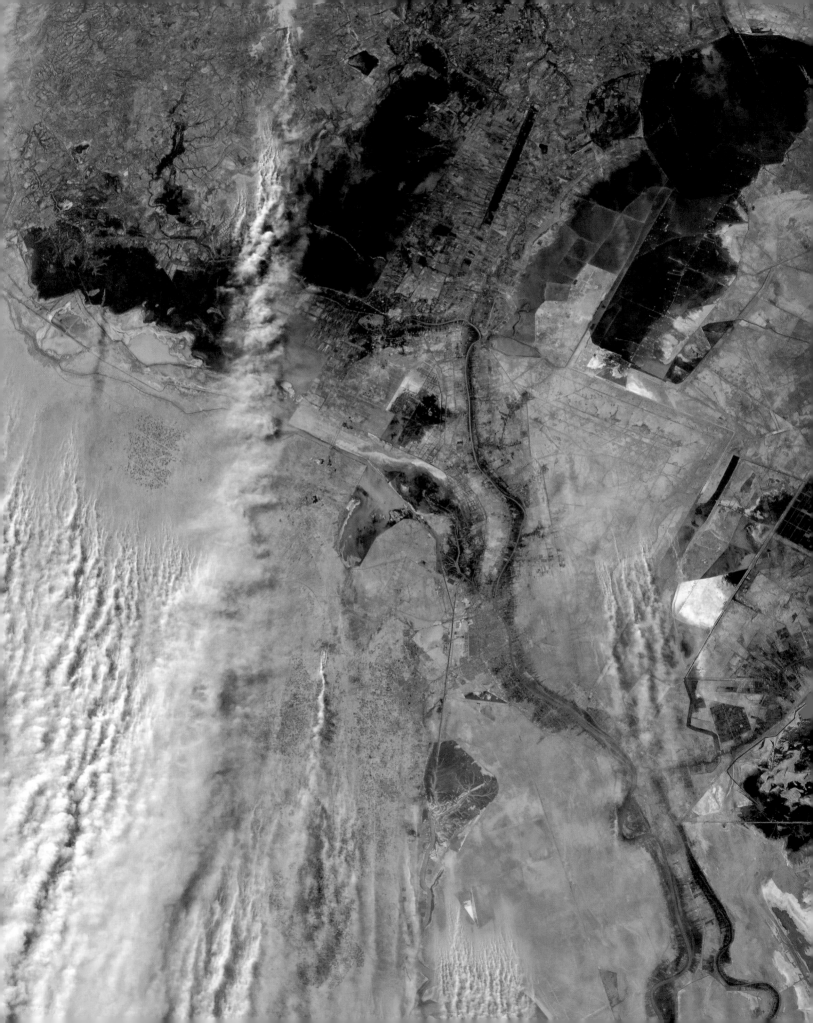

Sandstorms

Sandstorms can be found in both cold and hot deserts, from the Gobi Desert to India's Thar Desert and in the vast expanses of North America. They often seem to appear out of nowhere, as though a huge mouth is blowing out enormous clouds, but the phenomenon is a bit more complex. First, some sandstorms are actually dust storms, created when strong winds sweep not sand but soil from parched ground. Sandstorms and dust storms can also vary greatly in size and strength, and the sand and dust can travel over very short or very long distances, and everywhere in between. The particles can be pushed or even lifted and carried by the winds, sometimes traveling several thousand miles. When a thin layer of sand from the Sahara covers cars in Europe, it is because a high-pressure system is anchored over Central Europe and particle-laden winds from the south are blowing toward Spain, Italy, France and sometimes even further north. This same Saharan sand can cross the Atlantic, creating a dreaded haze over the West Indies, making the air almost unbreathable. Pictured here, the sparse plumes of smoke from drilling wells are dwarfed by a sandstorm along the border between Iraq and Iran.

Next page
Dust Clouds

Sandstorms and dust storms are being intensified and are becoming more frequent due to desertification, deforestation and overgrazing. The air pollution they create also has health consequences for those who live nearby, and these storms can also negatively affect biodiversity.

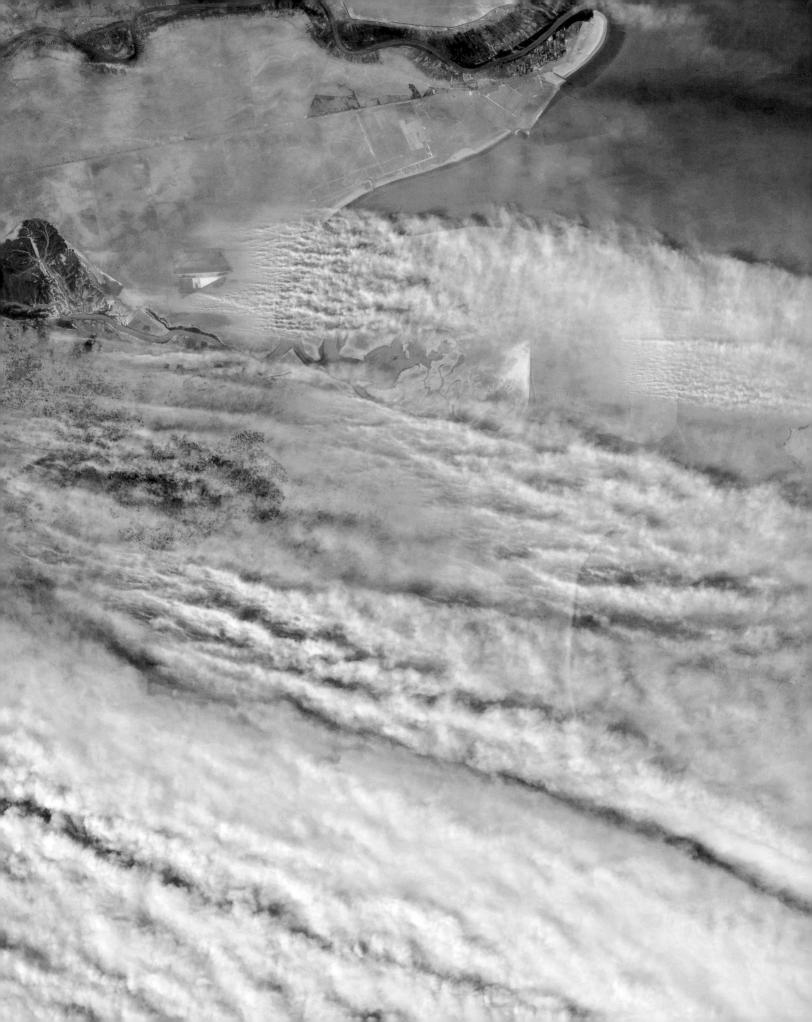

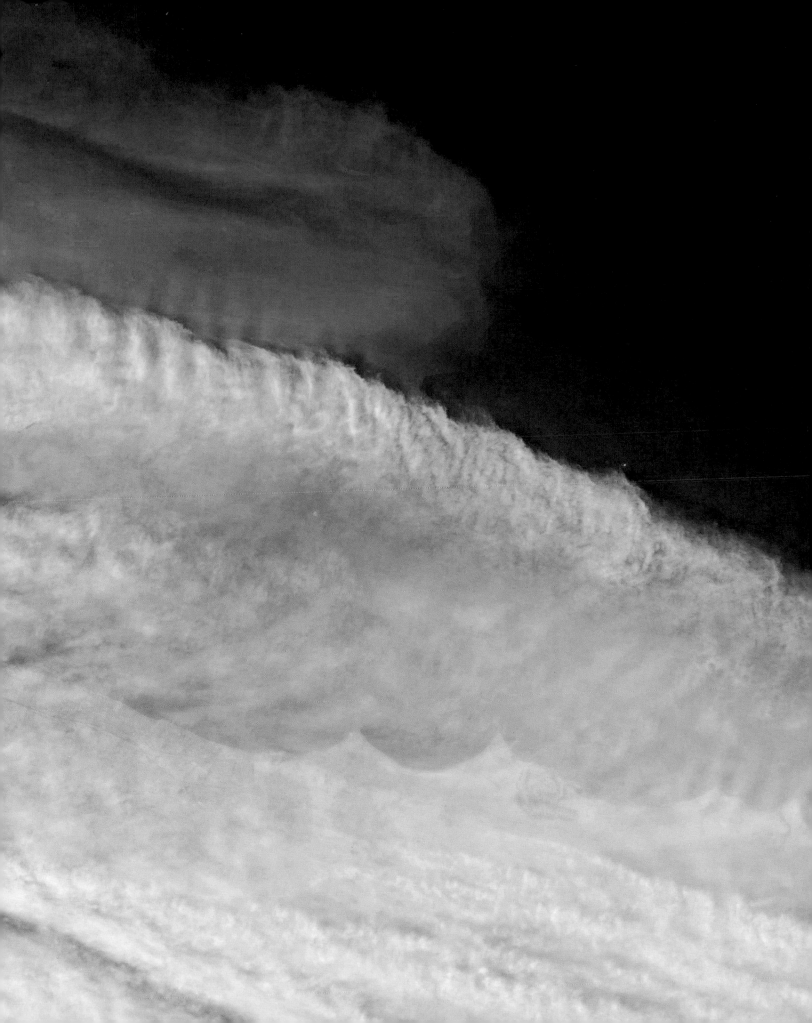

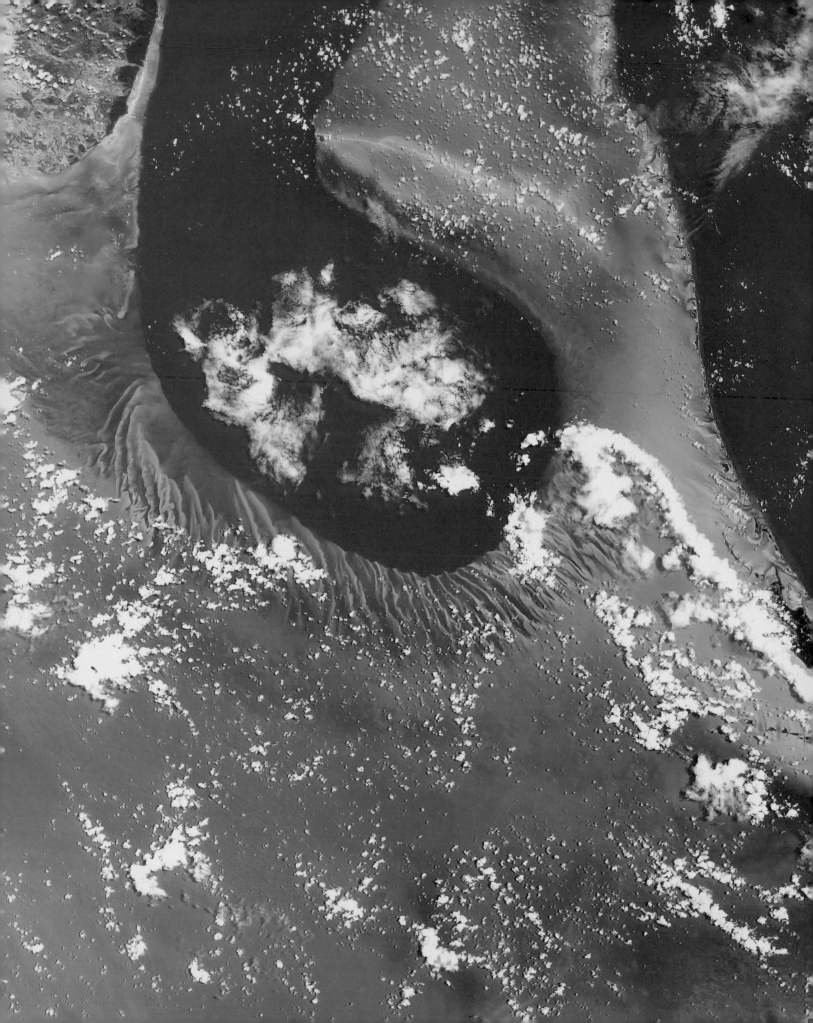

Seas and Oceans

The Bahamas
When it comes to wonders visible
from space, this region and its waters
of a thousand shades of blue are
high up on just about everyone's list.
Just ask any astronaut returning from
a mission!

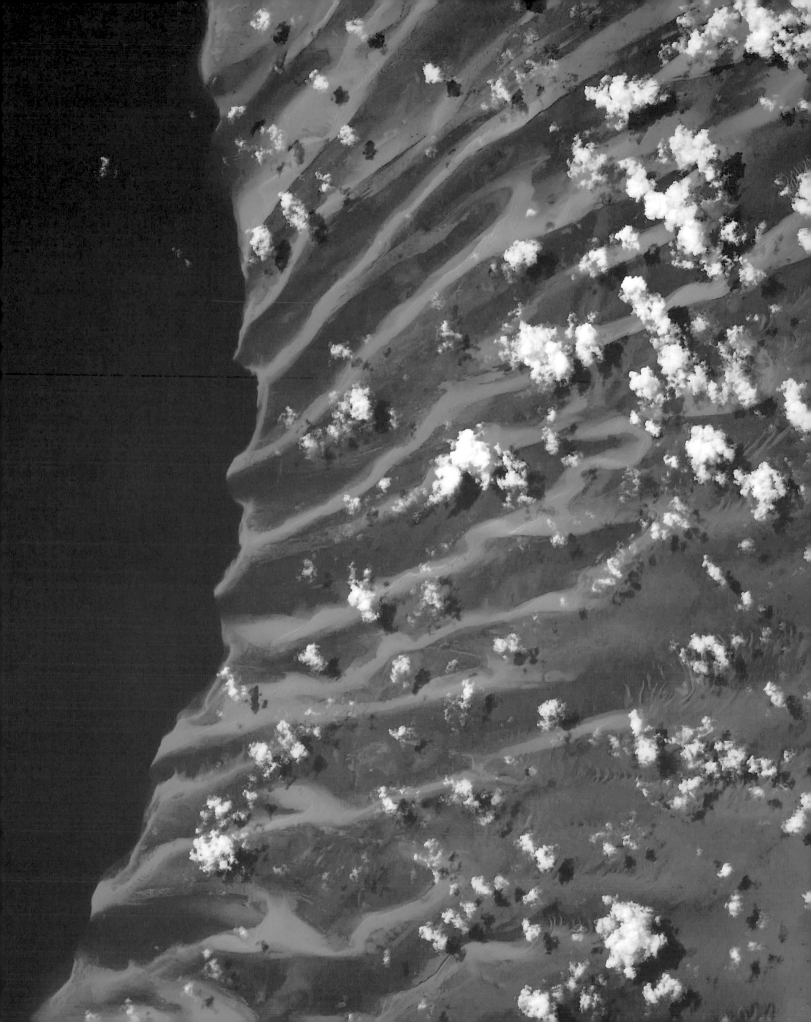

Each sea seems to have its own language, its own features, its own colors and even its own character. There are serene seas, tormented seas, joyful seas... Some, like the Celtic Sea, are open to the ocean, while others are closed, like the Dead Sea and the Caspian Sea, which resemble large salt lakes.

From space, the visual diversity of seas puts on a show that one could contemplate forever without ever seeing it the same way twice. From Homer to Jacques-Yves Cousteau, people have never ceased to explore, attempt to understand, depict and discuss seas and oceans. Space observation is now writing a new chapter in these adventure stories.

While seas and oceans inspire us to dream, they are also essential to life on Earth. Human beings exist in symbiosis with these bodies of waters, which together with the atmosphere form an indivisible whole: our ecosystem.

Seas absorb just under half of the solar radiation that reaches our planet but over 90 percent of the total warming. In practical terms, this means that the seas are essential to cooling the planet when our atmosphere traps too much solar radiation due to greenhouse gases.

While the overheating currently being experienced on our planet is threatening marine ecosystems, such as coral reefs, human activities such as overfishing are destroying the biomass. Measured from space, these devastating effects regularly exceed all forecasts. And in the future, how will we ever deal with the magnitude of flooding caused by melting polar ice?

Fortunately, it seems that we are listening more closely to the scientists who are reminding us that beyond the diversity of the seas, there is one immense, interconnected ocean that is essential to the good health of our blue planet. We must now mobilize our resources and implement solutions to preserve our seas and oceans — and ourselves along with them.

Turquoise Alchemy
In the Bahamas, the tides sculpt iridescent flecks into the sand and seaweed, which mix their yellows and greens into the familiar blues of the waves. The alchemy of these reflections of light gives the water its turquoise and emerald hues. The water's depth goes from a few feet in the clearest areas to 650 feet (200 m) in the deepest "blue holes."

Next page
Hide-and-Seek
The Hawaiian Islands, covering more than 10,000 square miles (28,000 km²) in the Pacific, have plenty of space in which to play hide-and-seek with the clouds. Without perhaps looking like it, Hawaii is also one of the best sites on the planet for observation via telescope. Its isolation and the altitude of the volcanic islands offer excellent protection from light pollution.

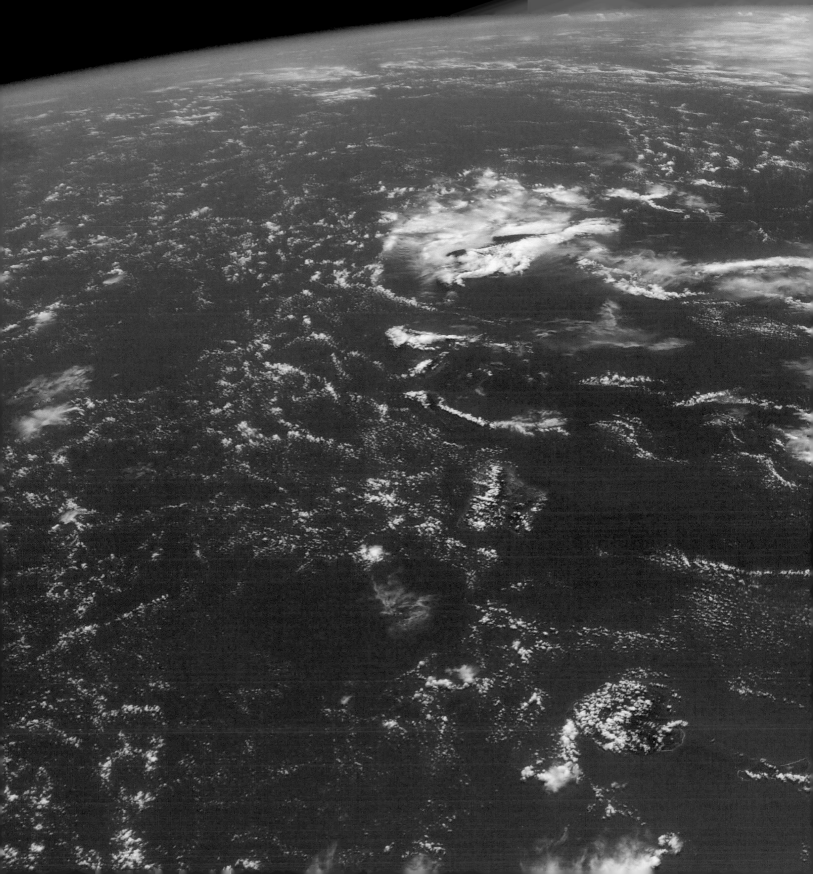

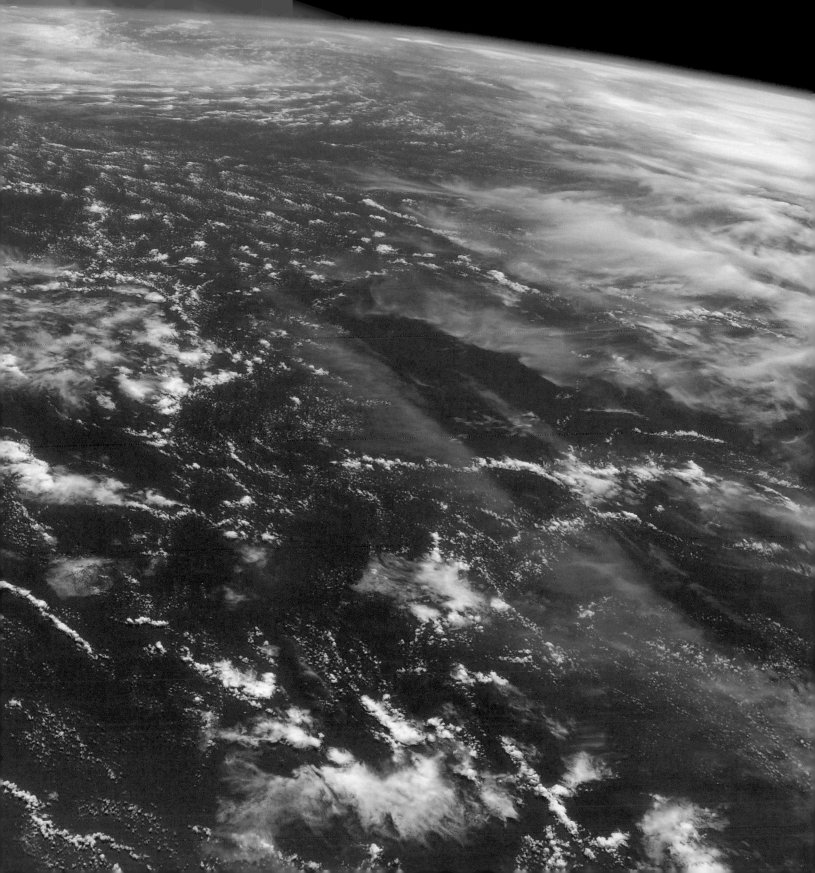

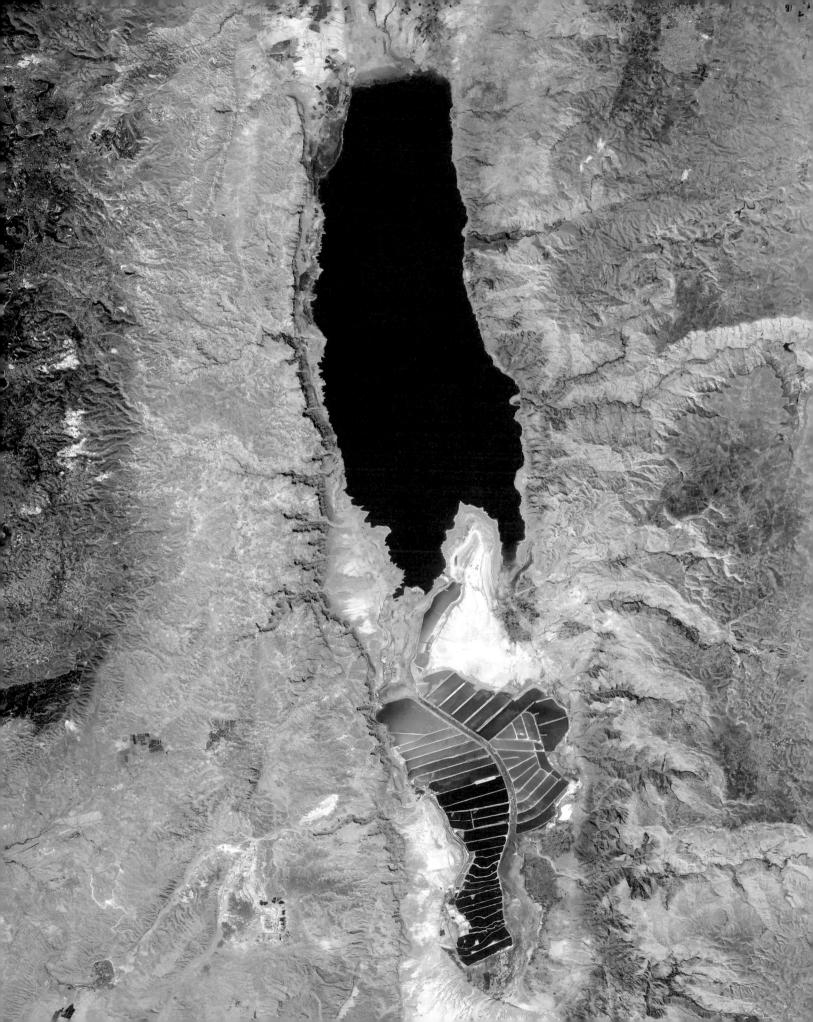

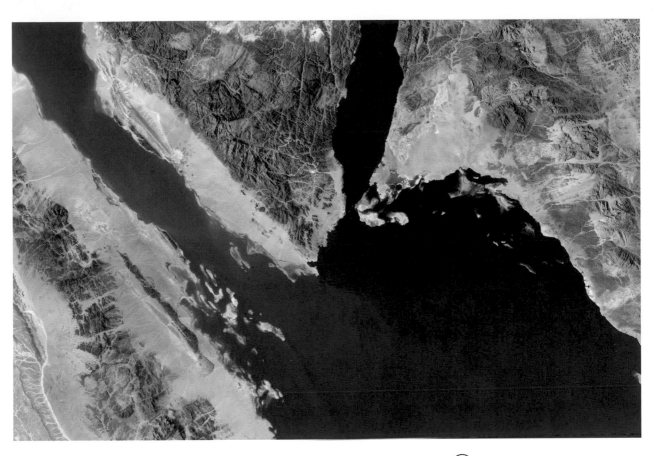

Take It with a Grain of Salt
It is called the Dead Sea because the salt concentration is so high (nearly 2½ pounds per gallon, or 275 g/L, of water) that fish and algae cannot survive, but some plankton and extremophilic bacteria do. I remember swimming as best I could in the Dead Sea: Half of my body floated out of the water, a bit like being on a surfboard. In this photo, we can see the peculiar shapes and colors of marshes — salt marshes, of course — to the south.

Red and Blue
Its shades of blue are enough to make just about any other sea envious, so why is it called the Red Sea? Historical and etymological explanations exist, but the scientific reason is the regular bloom of algae (a cyanobacterium) that colors the water shades of amaranth and ocher. Among its other astonishing physical and chemical properties, one sometimes forgets the high salinity of the Red Sea, at 5 ounces per gallon (41 g/L). It's certainly much lower than that of the Dead Sea but much higher than, for example, the Mediterranean Sea. It's therefore easier to float in the Red Sea compared to other seas (in accordance with Archimedes' principle).

Biomass

In the Middle Ages, the Adriatic Sea was known as one of the "seven seas," an expression still common today. Shaped like a huge lake, it's more than 400 miles (700 km) long and 125 miles (200 km) wide, and it is troubled by major ecological challenges.

Its narrowness makes it vulnerable to agricultural, industrial and urban pollution from the Po River, but its biggest challenge is overfishing, which in recent decades has led to a worrying disappearance of its biomass, i.e., all of the many and various species that live in it.

However, there is reason to hope, thanks to agreements negotiated between authorities, fishermen and environmentalists to drastically reduce overfishing. Among these initiatives is the protected Jabuka/Pomo Pit. Measuring around 12,000 square miles (3,000 km²), it provides habitat in which hake and langoustines can reproduce, helping to restore the biomass.

The Adriatic Sea is fast becoming a center of environmental experiments, where ecological solutions that could save other threatened seas in the future are being developed.

Next page
Generational Reconstruction
Pictured here is Huahine in the Society Islands, which are part of French Polynesia. The territory is on the front line of climate change and is part of the UN's Small Island Developing States (SIDS), group, which was established at the Rio Earth Summit in 1992. These regions are particularly vulnerable to rising sea levels, among other threats. As with the Great Barrier Reef off the coast of Australia, the disappearance of coral in these areas is a testament to the devastating domino effects of overheated oceans. There is, however, a glimmer of hope: Young Polynesians are helping to propagate coral, repairing some of the damage caused by global warming.

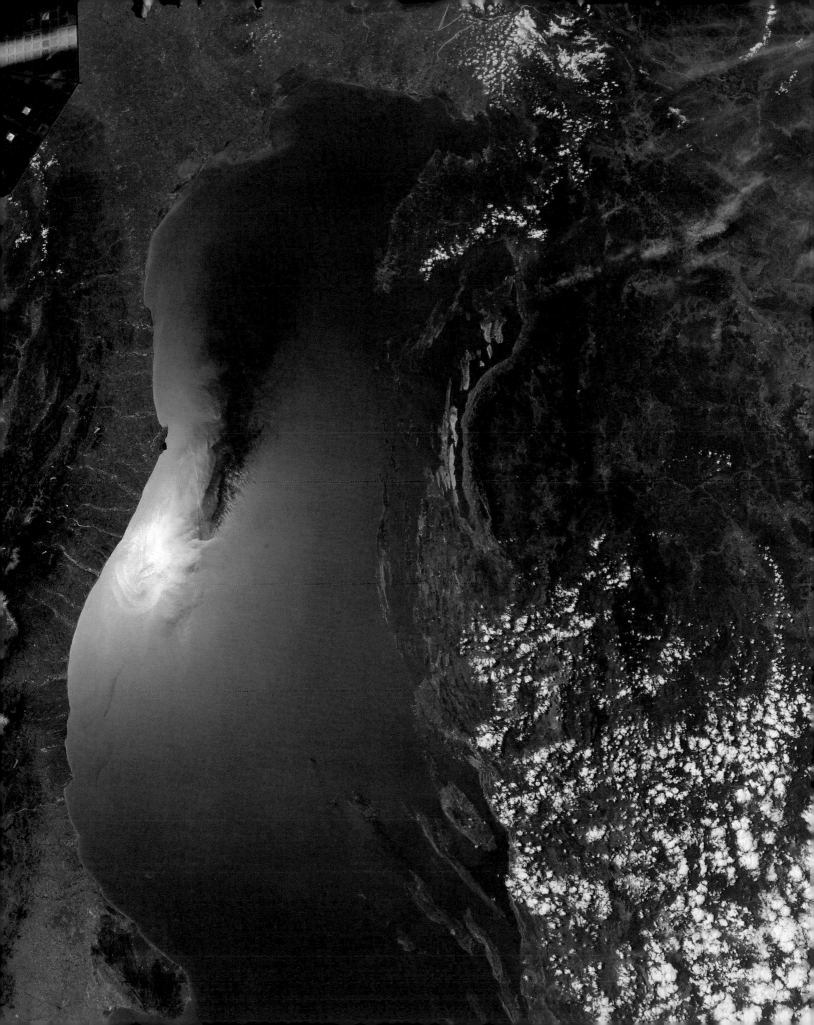

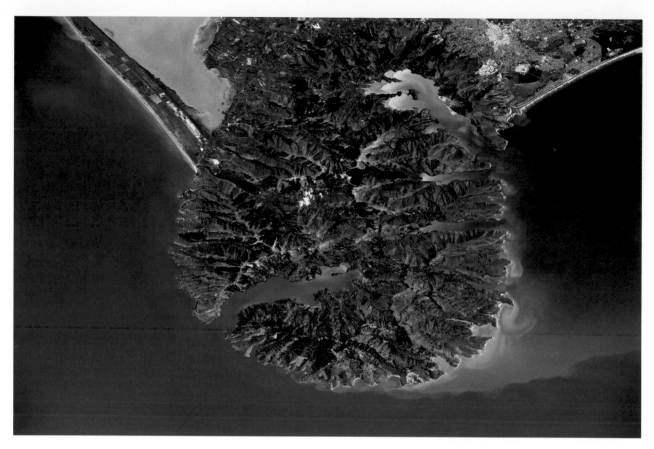

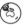

A Well-Kept Secret
New Zealand, which for a long time remained a wild and secret landscape, is a territory that remained untouched by humans for a very long time. The Maori People settled there, notably on the Banks Peninsula, shown here, barely a thousand years ago.

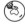

New Zealand
Pictured here are New Zealand's Marlborough Sounds and their bewitching tangle of fjords. For many, the landscape evokes Norway and its fjords, but a geographer will tell you that the Marlborough Sounds have more in common with the submerged valleys off the coast of Brittany, in France.

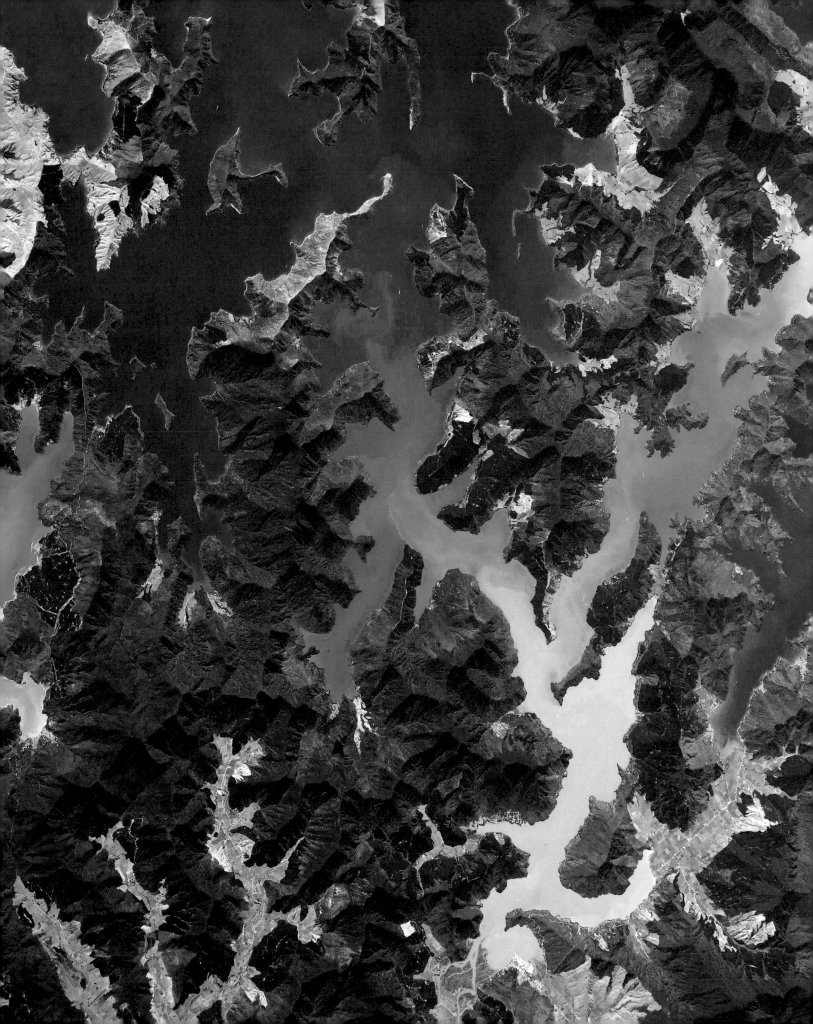

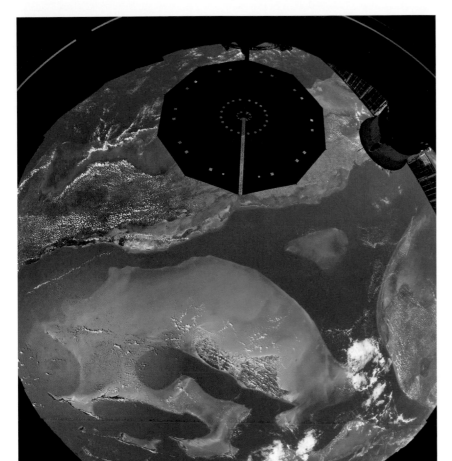

Blue Dream
This wide-angle photo distorts the image a little, but it's hard to fit all of the colors of the Bahamas into a single window of the Cupola!

At the End of the Desert
The history of the Red Sea fascinates me. It was a coveted route by many great empires over centuries, and it now hides environmental jewels where one least expects them! When flying over the desert, you would never suspect that the seemingly endless sand leads to these magnificent coral reefs and, perhaps most surprisingly, a mangrove.

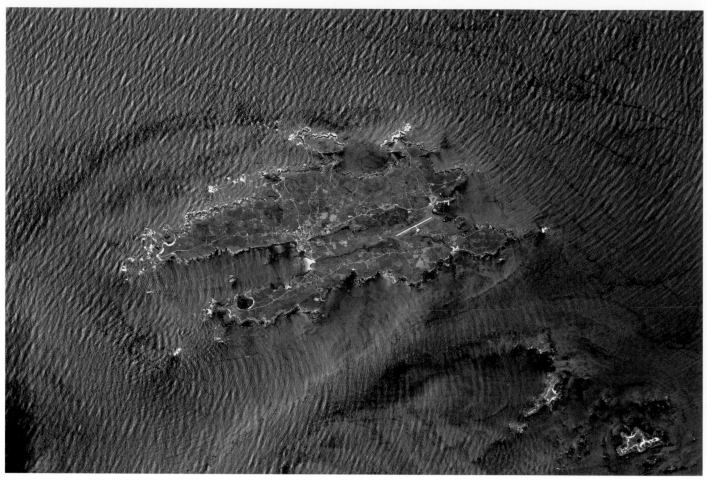

Ushant

Even from space, we can sense the strong currents (such as the terrible Fromveur Passage) that make the Celtic Sea, which opens to the Atlantic, so dreaded by sailors. The island of Ushant, off the coast of France, is nicknamed "shipwreck island."

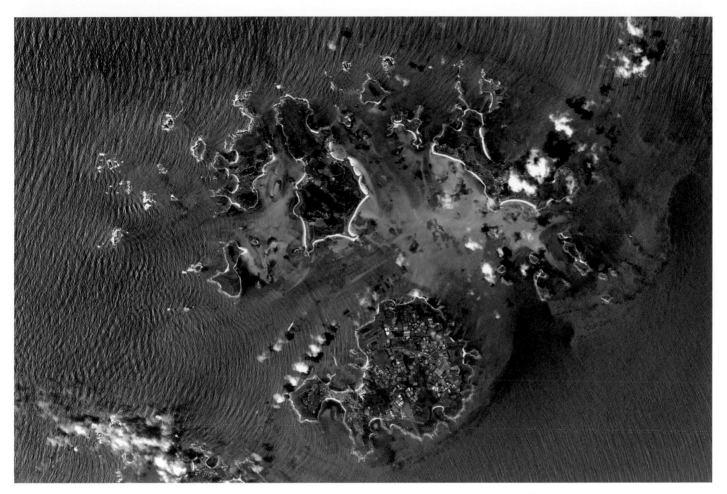

Isles of Scilly
The Isles of Scilly share the Celtic Sea with the island of Ushant. The region has Celtic roots, hence the sea's name. The area off the French coast, near Ushant, is called the Iroise Sea.

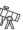

Water Reserves

While the International Space Station provides sweeping views, there are still things we cannot observe, even from that high perch, such as the Earth's core. The latest scientific research supports the hypothesis that the Earth's mantle contains large quantities of water, about five times the volume of all of the world's oceans. Even without considering that wider context, I find this Dragon supply ship to be tiny in comparison to the immensity of the ocean! The blue planet is far from having revealed all of its mysteries...

Coasts

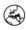

Safran
France's Atlantic coast is a stunning saffron color and seems to almost melt into the water. The effect is created by sediments and muds, particularly those that flow from the Gironde estuary.

More than half of the world's population lives along a coast. By 2035, this figure could reach 75 percent. This phenomenon is even more evident when viewed from space: Coastlines fascinate, attract, inspire and are increasingly shaped by the human hand. Economic activities, transportation infrastructures such as ports and airports, and residential areas are often concentrated along coasts. Even on a moonless night, astronauts can always distinguish the coastlines of the continents, thanks to the luminous outline of coastal cities and towns. Not surprisingly, most of the world's major cities are located in coastal areas.

Coastlines are above all a link between land and sea — the scientific term is "ecotone" — and play a vital role in our climate. To confirm this, one need only think of mangroves. In these ecosystems, vegetation and fauna live in symbiosis with the seas and oceans, and they play a significant role in the Earth's ecology, acting as carbon sinks (that are even more efficient than forests!), barriers against storms and floods, soil filters and stabilizers (through their labyrinth of roots), nurseries for biodiversity and more.

Nevertheless, the world's coastlines face a multitude of threats: erosion, which has, for example, caused the cliffs of Normandy in France to retreat several feet in recent decades; rising water levels and, with them, the salinization of deltas; overfishing; pollution (such as oil spills); and careless urbanization have all had dramatic consequences for social, cultural and, of course, age-old economic activities.

The perspective from space is particularly useful when it comes to monitoring coastlines and anticipating the actions that could be taken to combat the effects of global warming and pollution. Detecting oil spills and monitoring coastlines for changes, water temperature and acidity, wave heights and algae blooms are all essential observations that are constantly being transmitted by a fleet of satellites, which are veritable sentinels orbiting above our heads.

The Fall Guy
In the Strait of Hormuz, there is an airport that faces the sea in a valley on the jagged coastline. I don't dare imagine the complicated trajectory one would have to achieve in case of engine failure… For astronauts, the return to land seems somewhat less demanding in some respects. You don't have to think much about the landing: Once the parachute is open, you simply fall into the water.

Next page
The Biosphere
Guinea-Bissau offers a textbook case of the intermingling of land and sea. At the mouth of the Geba River, opposite the capital Bissau, we can see the archipelago known as the Bijagós Islands. In 1996, UNESCO classified Bijagós as a biosphere reserve. The archipelago is home to a plethora of rare species, including hippopotamuses, manatees and turtles, and many species of migratory birds winter there. Guinea-Bissau's flora is not to be outdone, with lush mangroves covering almost 10 percent of the country's surface — a world record!

Even the Sun has invited itself to the party of colors in this photo, adding its silver highlights along the top of the image. Space photography involves its own particular techniques. Depending on the time of day and the position of the station, the Sun either hinders or helps to achieve the desired effects.

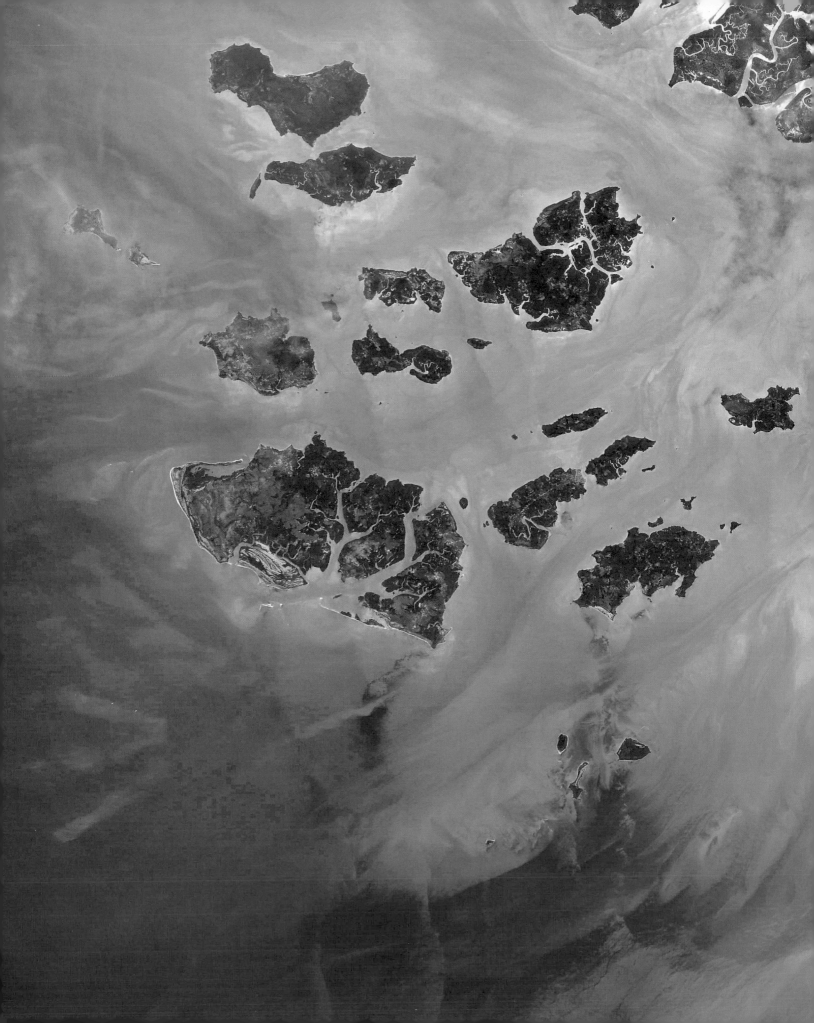

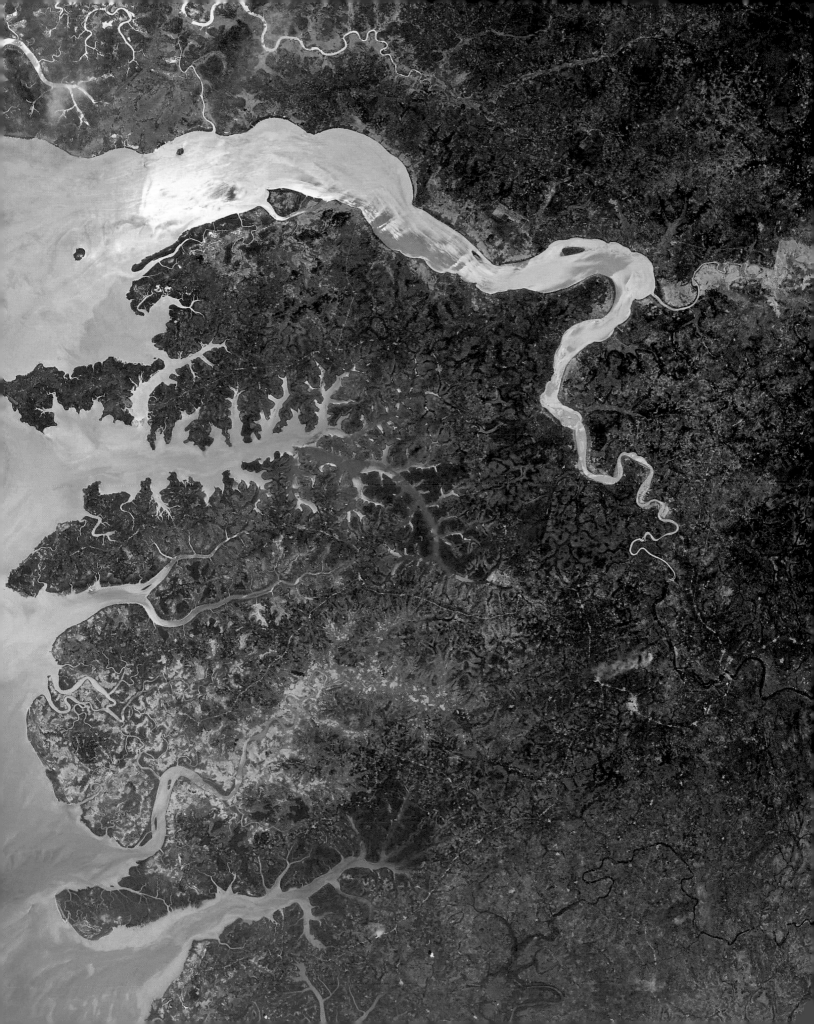

Mangroves
When the Sun's rays reach a delta, the whole coastline starts to sparkle. It is a spectacle I tried to capture while flying over this mangrove in Tanzania, which undoubtedly harbors a rich biodiversity and precious resources for the local populations.

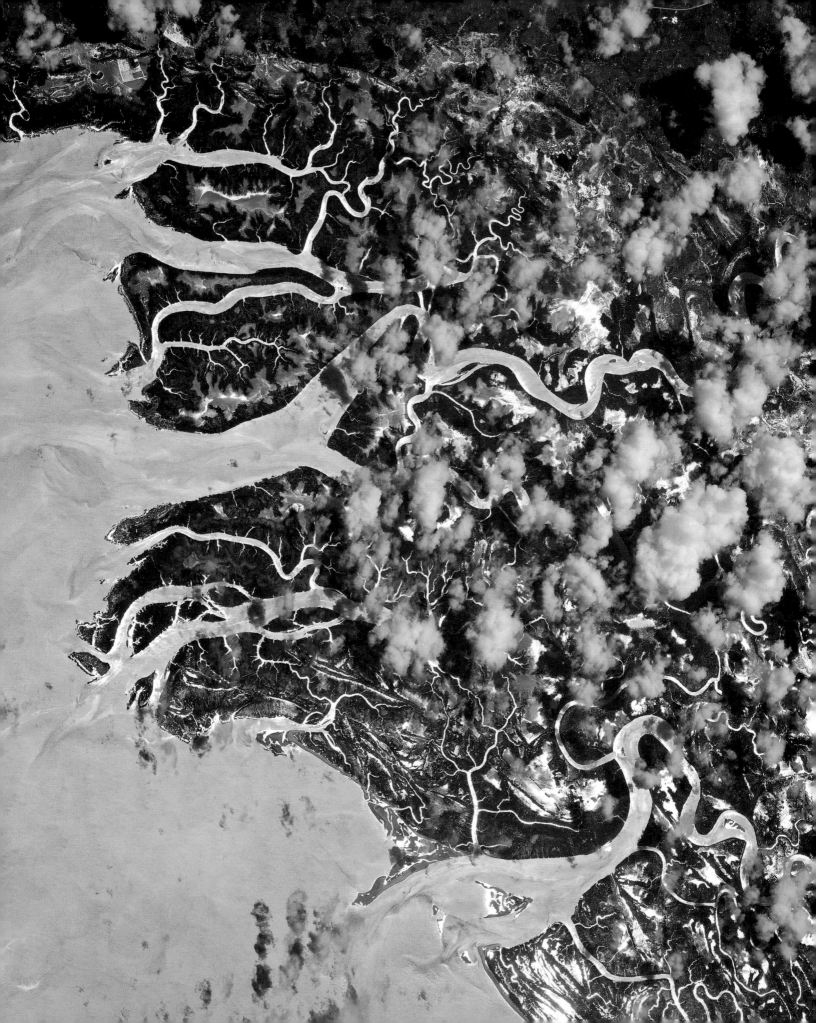

It's a Cape, It's a Peninsula...
The peninsula jutting out from
Conakry, the capital of Guinea, in
West Africa, is quite conspicuous
from space. It seems to almost
hesitate between the mainland
and the ocean, stretching from the
coastal wetlands to the Loos Islands,
which are mostly reached by *kounki*,
a long, colorful canoe-like boat.

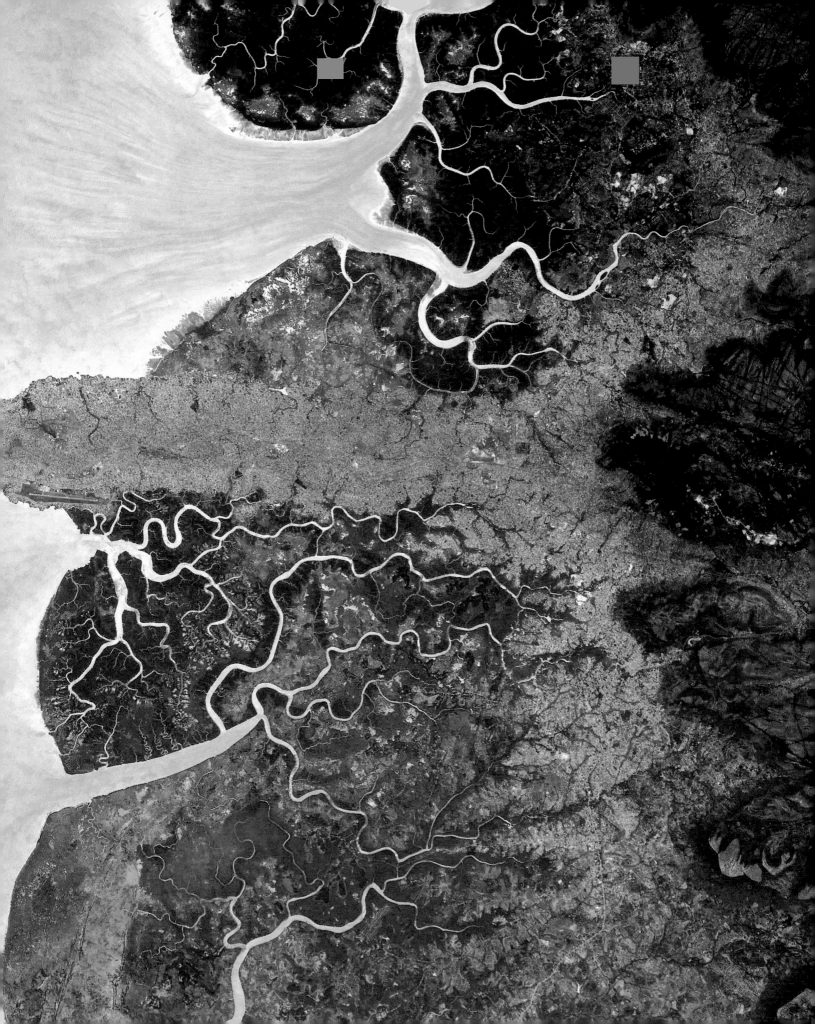

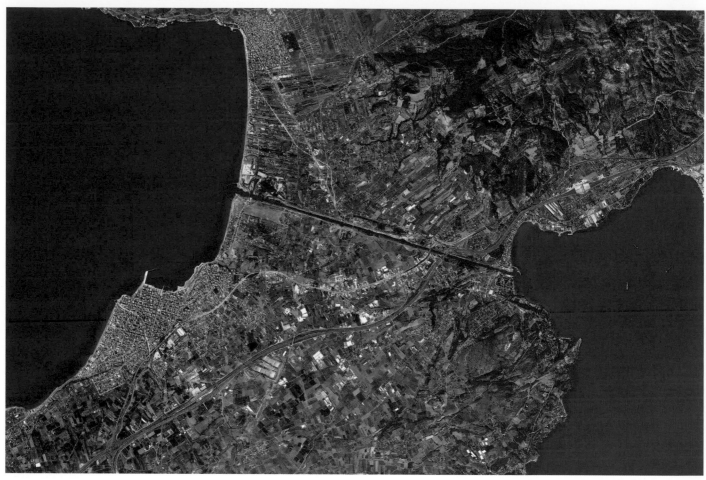

Through the Land
The Corinth Canal slices like a sword
through the isthmus of the same
name. The canal's impressive walls
far exceed the height of the ships
that cross it. It is only visible to the
naked eye from space if you know
exactly where to look. One of the
advantages of long trips in space is
that you end up knowing the planet
by heart!

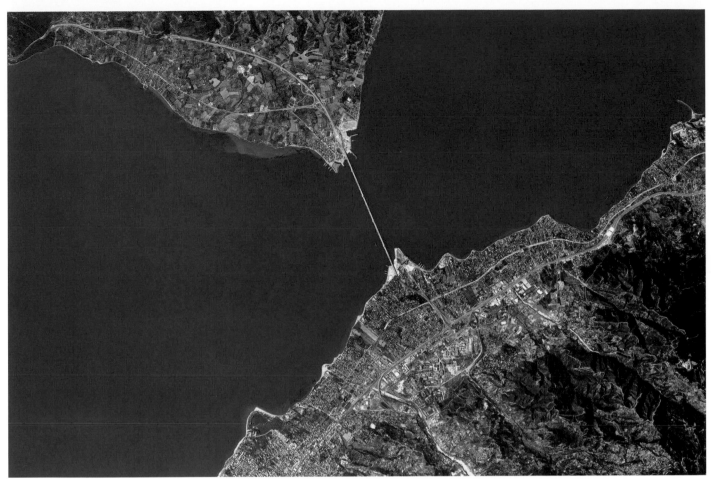

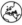

Through the Sea

About 100 miles (150 km) from the previous photo, at the other end of the Gulf of Corinth, the Rion-Antirion Bridge cuts through the sea just as the canal cuts through the land.

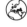

Next page

A Point in the Bay

Between Brittany and Normandy, and at the border between sea and land, France's iconic Mont-Saint-Michel is unmissable, casting its shadow on the sands that surround it and topped with a large abbey. Other marvels that dot the bay's maritime and terrestrial landscapes include its sandy and muddy banks, mudflats crossed by channels, grasslands and salt marshes, with their various plants adapted to salt water. These very natural zones contrast with the lowlands and their uniform agricultural lots. At a glance, one can often distinguish the works of humans from the works of nature!

157

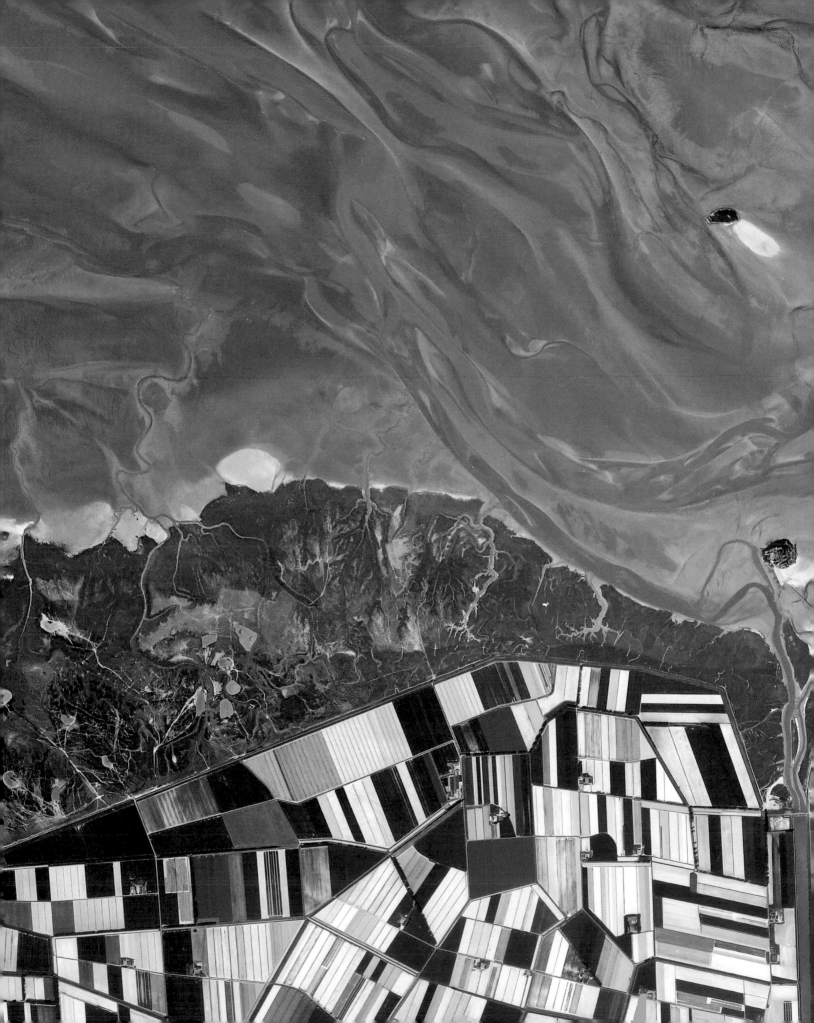

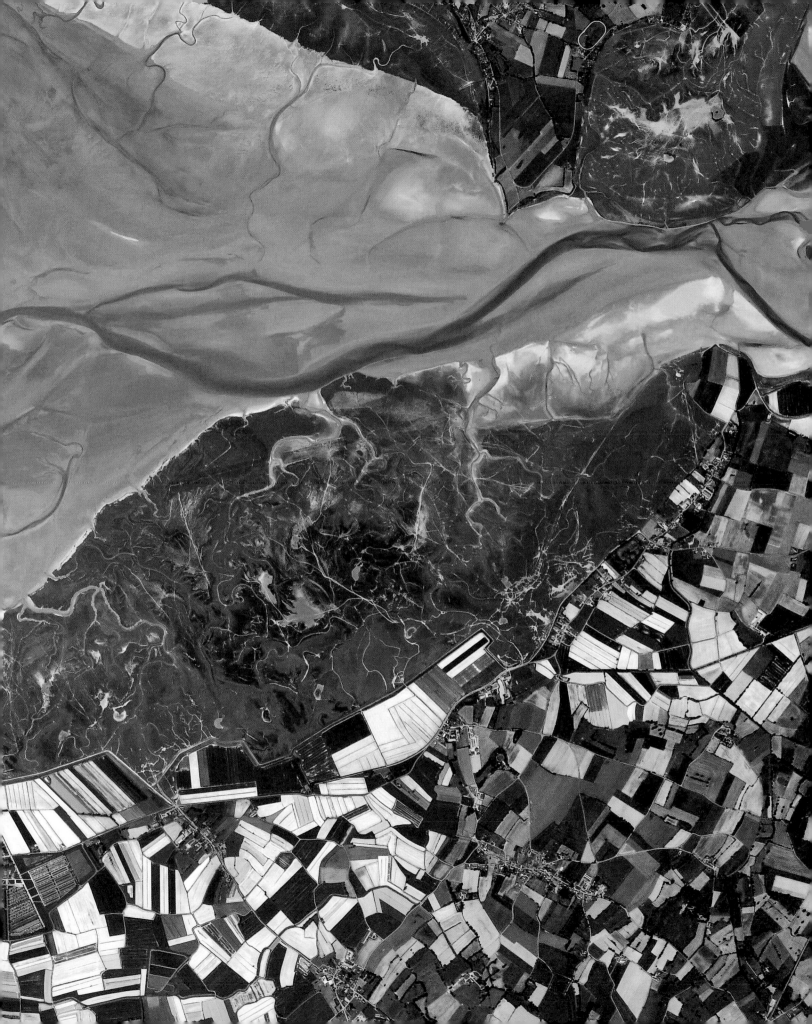

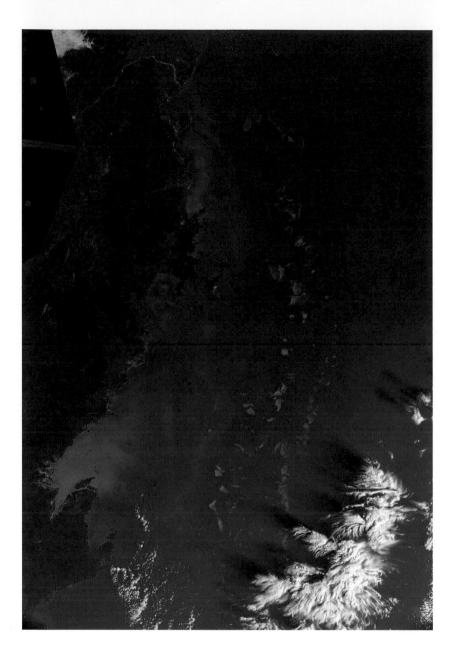

A Domino Effect
The Great Barrier Reef is one of
the few underwater structures
visible to the naked eye from space.
It stretches like a spine along the
eastern coast of Australia. It is,
in fact, a living structure, and it is
already paying a price for global
warming: The micro-algae that
give the corals their color and,
more importantly, provide them
with the nutrients they need to live
are being killed off by rising ocean
temperatures. This causes the coral
to bleach. If this process is not
quickly reversed, biodiversity is lost,
fishing resources are reduced and
the coastline's natural protection
disappears. It's a real domino effect.
Thanks to satellites, we can now
map and assess the health of coral
reefs more efficiently. Faced with
such urgency, there is no lack of data
(and the data from the European
Copernicus program are available
free of charge), but rather a lack of
time and people to process the data
— and bring the conclusions to the
attention of decision-makers.

Polders
Every time I zoom in on the
Netherlands, I think with a smile
of the saying I learned from my
colleague André Kuipers: "God
created the world, the Dutch created
the Netherlands." A good part of
the land in this photo was indeed
reclaimed from the sea, little by little
and over the course of centuries.
These lowlands are called polders.

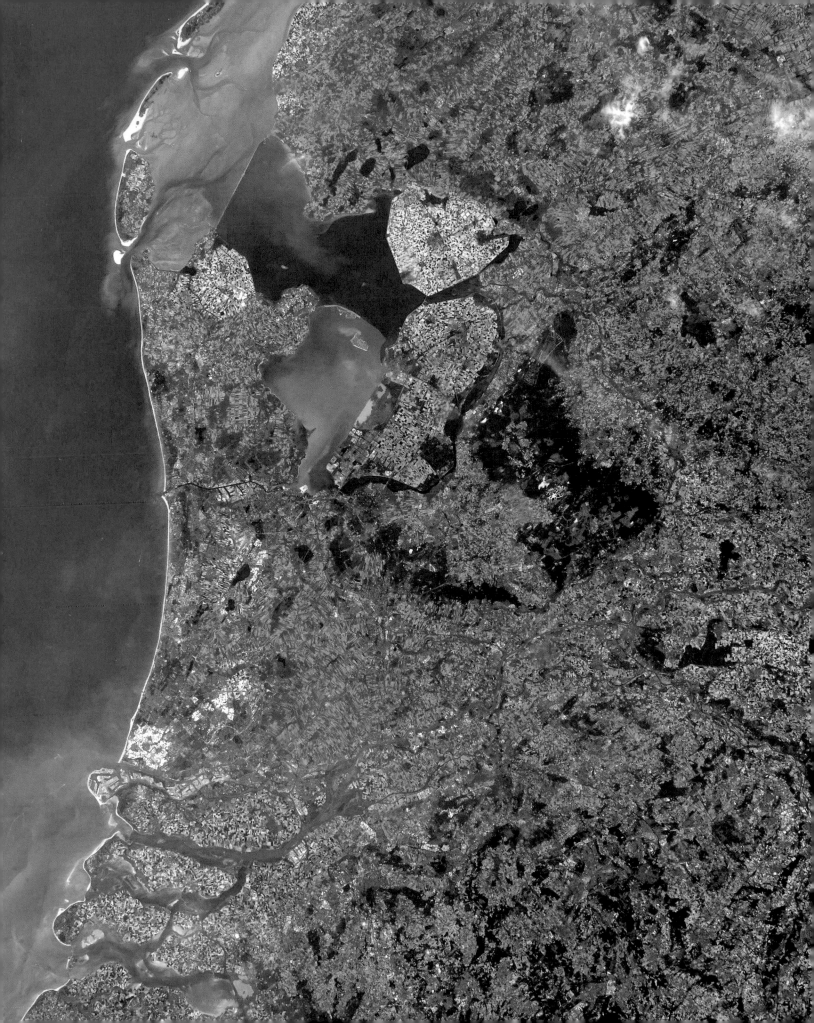

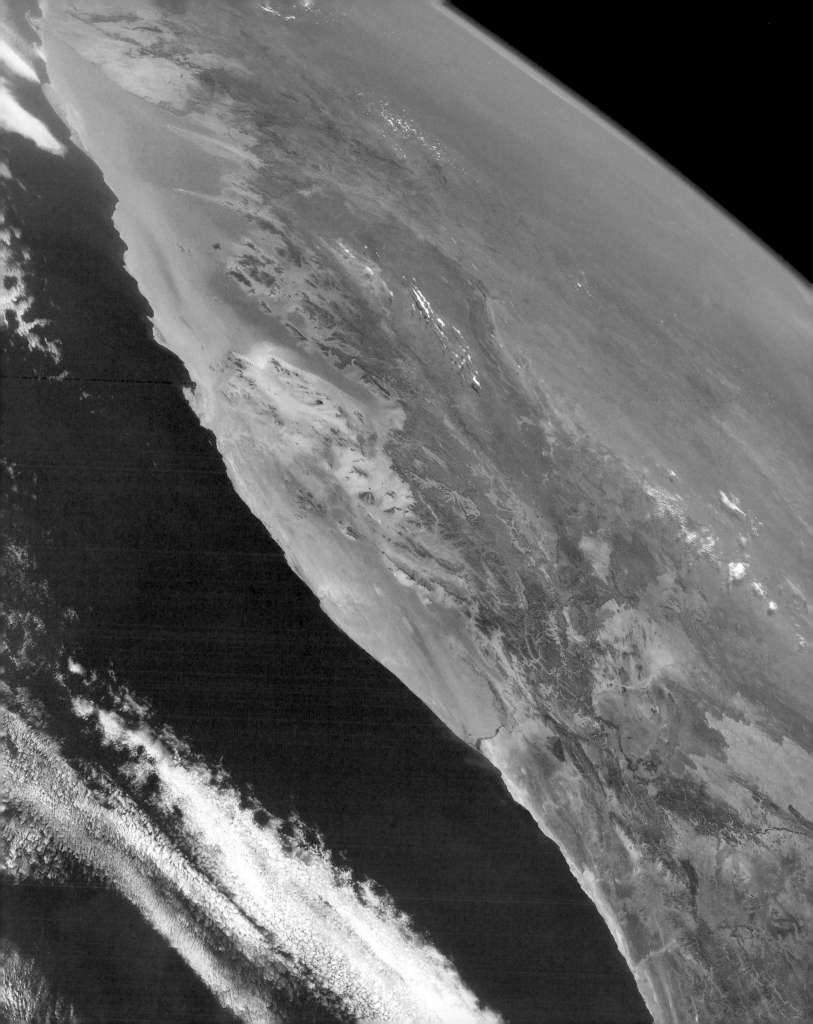

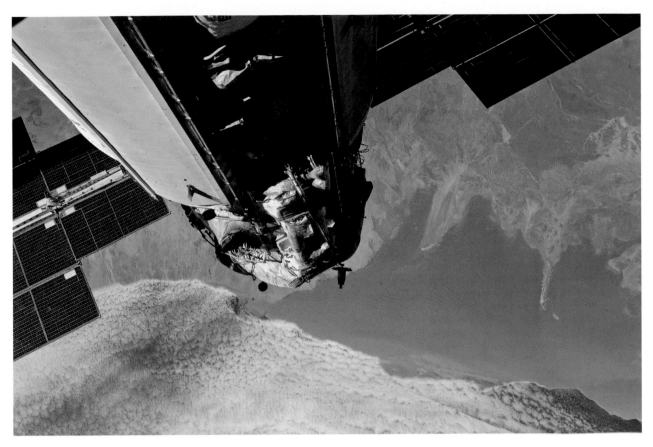

Upside Down
The arrival of the MLM module (aerospace engineers are rather fond of acronyms) has opened new photographic — and photogenic — possibilities on board the ISS. It reaches toward Earth like an inverted tower and can almost make one dizzy, such as when watching these Namibian dunes seemingly slip into the Atlantic.

Diagonal
The orange dunes along the Namibian coast contrast sharply with the blue of the Atlantic Ocean. This view is always welcomed with pleasure, after having flown over so much water and clouds!

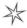

Zoom Record
Artificial islands, Emirates version!
Dubai has three of these custom-built
islands, each one more elaborate
and unusual than the next. I took this
photo of the Palm Jumeirah with a 2x
doubler on an 800-mm lens, so with
a 1600-mm focal length. This is the
highest magnification we can achieve
on the ISS! You can distinguish yachts
in the marina and even the huge
water park at the top of the palm
tree.

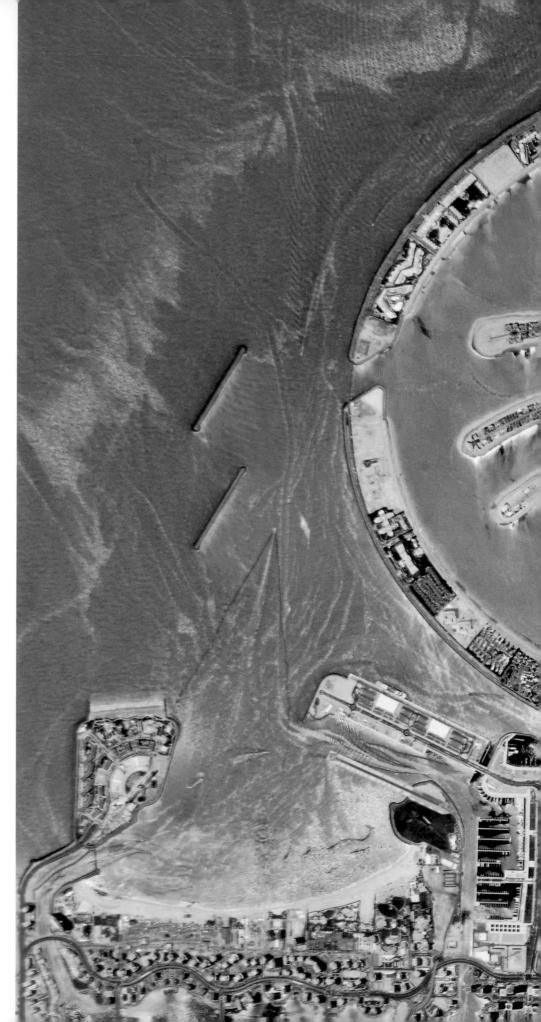

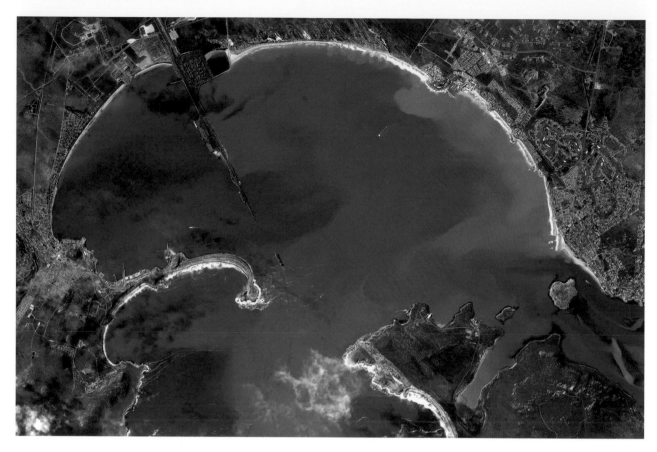

A Stitch in Time
The port terminal on the Bay of Saldagne in South Africa juts into the water like an iron-red hand on a blue clock face.

Next page
The View from the Station
This photo was taken by my colleague Piotr while the Soyuz MS-18 was being relocated. It shows the ROSA solar panels that we installed over the course of three space walks.

Pearl Harbor
You can actually see the US Navy ships at anchor in this photo of Pearl Harbor, just west of Honolulu on the Hawaiian island of Oahu. The narrow channel protects the shallow bay on the sea side; the December 7, 1941, attack on the naval base came from the air. The site remains an important strategic site: Today it houses the US Indo-Pacific Command, which oversees the entire Indo-Pacific region, an area covering more than half the planet.

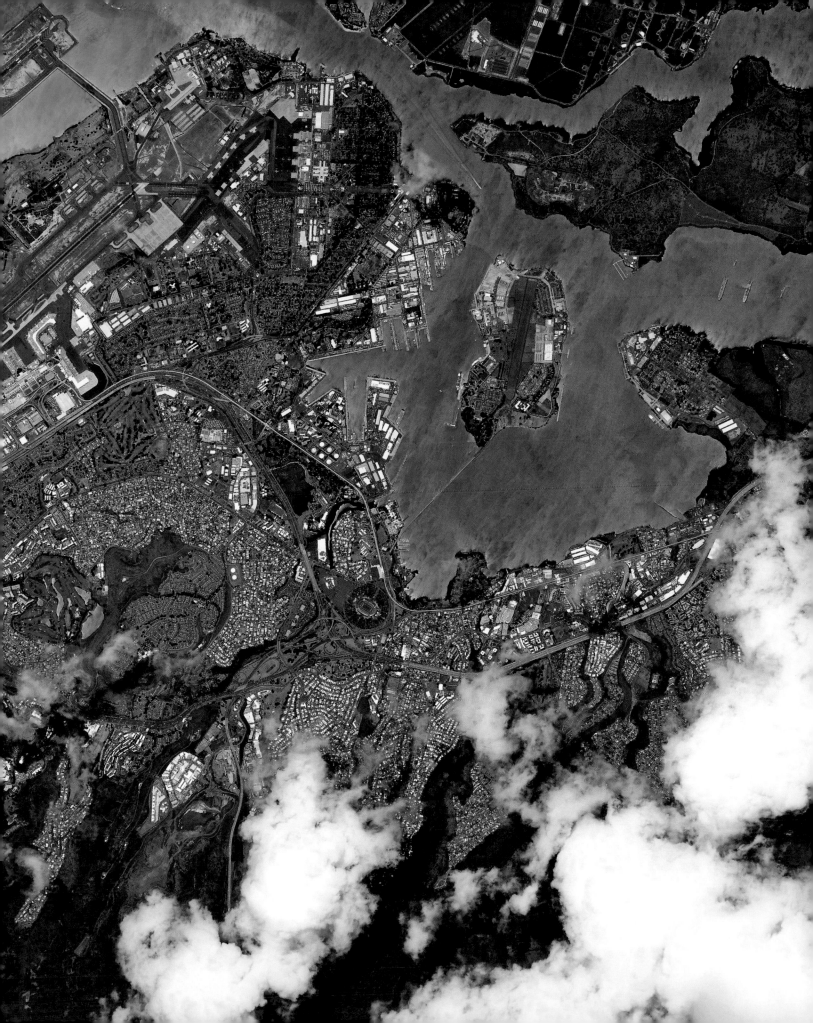

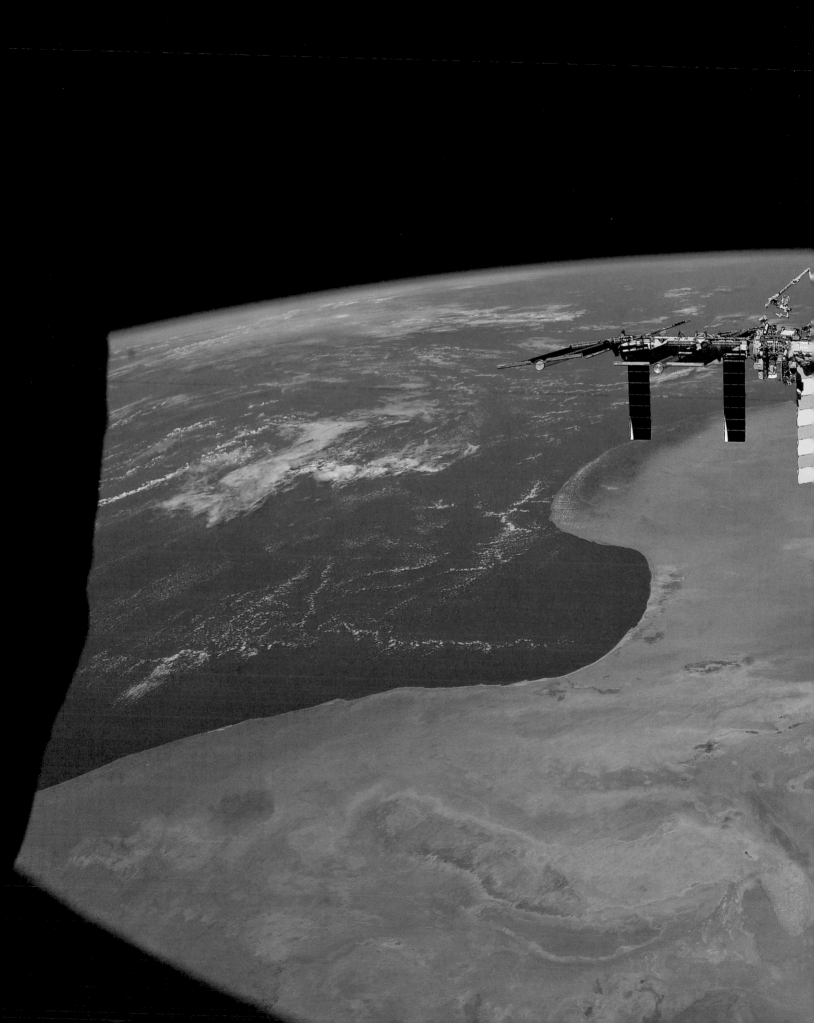

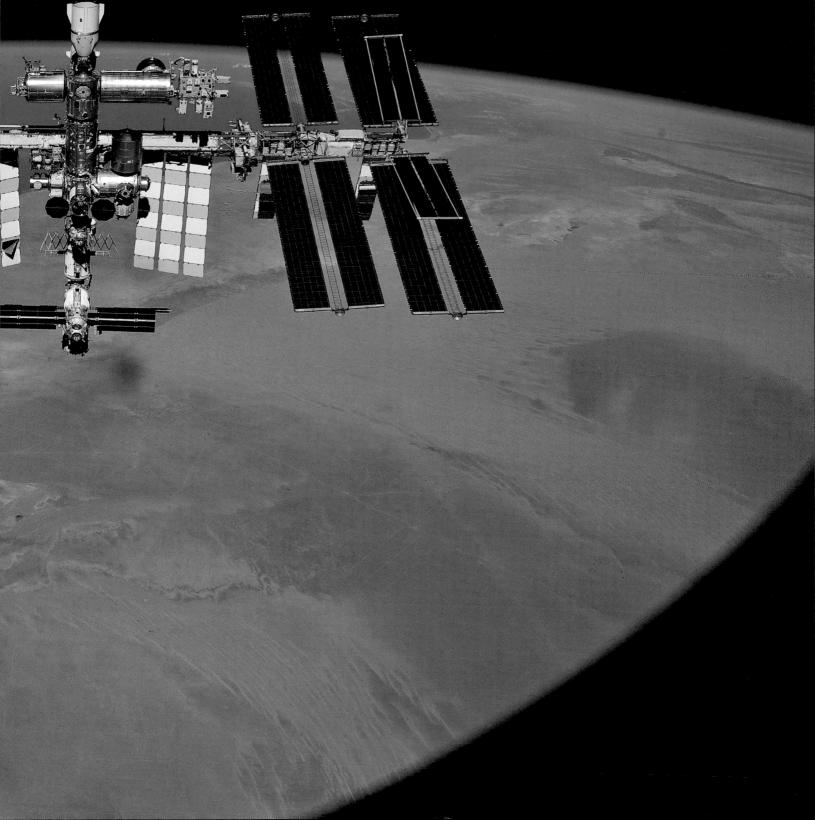

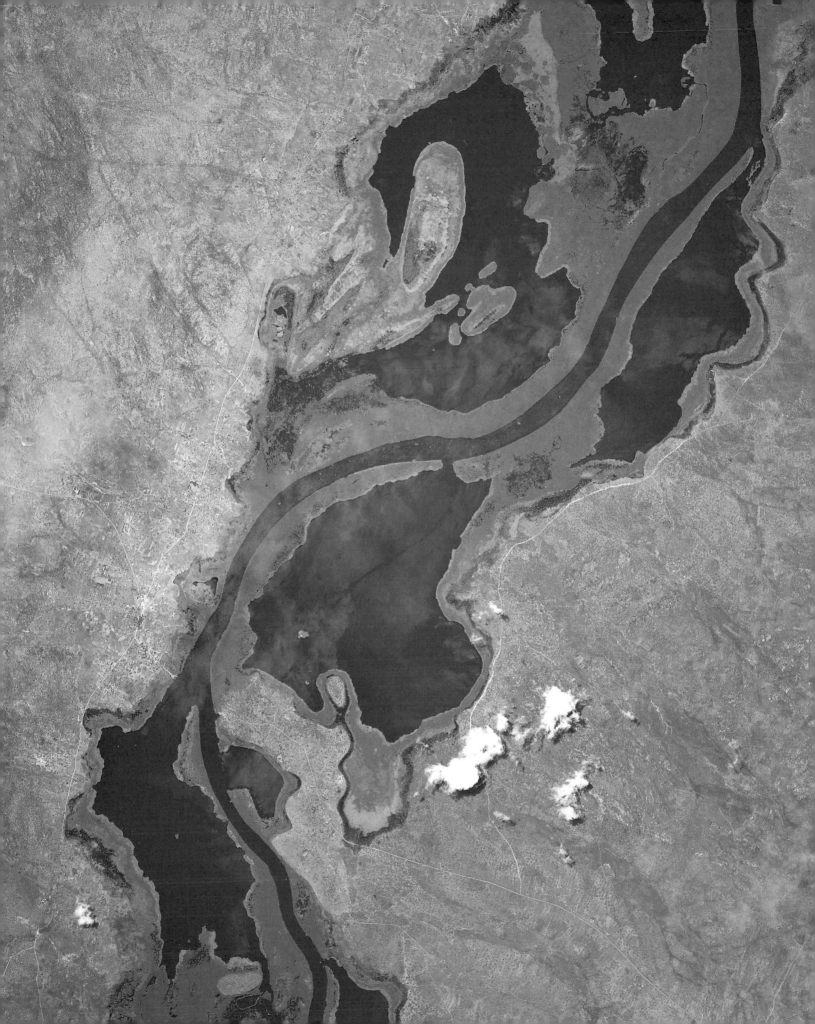

Rivers

White Nile, Blue Nile, Green Nile
The White Nile flows through an oasis of greenery and canals in the heart of East Africa. Further north in Khartoum, it joins the Blue Nile, which is darker because it is richer in silt, before crossing vast stretches of desert.

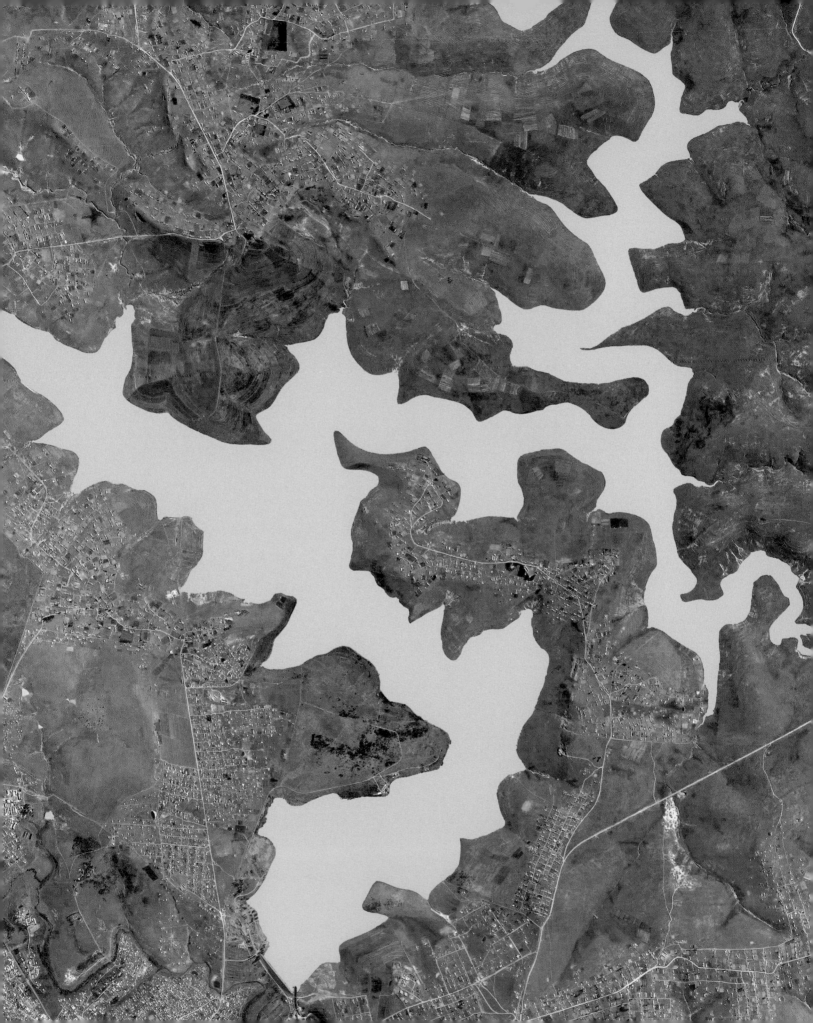

The crews aboard the International Space Station have two things in common with the rivers that flow across the Earth: We are constantly in motion and never sleep. This is as true for the Norman Veules, which flows into the English Channel after a journey of barely a mile, as it is for the giants that are 6,500 times longer, such as the Nile, the Yangtze and the Amazon. Freshwater bodies (rivers, lakes, streams and the like) represent only one percent of the water on the Earth's surface. And yet, with their breathtaking diversity of colors and shapes, we feel their raw energy even when observing them from space, when their features are barely visible to the naked eye.

This awareness is perhaps because rivers are, first and foremost, invaluable sources of life. They are often described as ecological corridors. Across desert plains and mountain ranges, whether drawn by the human hand or by nature, rivers connect ecosystems and all living things. In Europe, Atlantic salmon swim upstream to reproduce in fresh water in the Pyrenees, and in Asia the Brahmaputra River flows down the slopes of the Himalayas to fertilize Indian valleys. Rivers of all types and kinds are also drawn across the landscapes of North America. Each river protects and shelters the cycle of life.

From space, it is impossible not to marvel at vast lakes, whether frozen, fresh or salty, and to recognize their fragility when these expanses dry up. Like the climate, numerous waterways are undergoing major and worrying changes. The Nile is now polluted by huge volumes of wastewater and industrial waste. The rising waters of the Mediterranean are salinizing the soils of its delta, making them uncultivable and uninhabitable. On a global scale, but also on a very local scale, it is necessary to become aware of and, above all, to take action to help ease a water crisis that is already producing dramatic impacts all over the planet.

Spot the Differences
Nature offers some exceptional optical illusions. Observe this lake in southern Africa. It is actually a river. Its resemblance to mountains is disturbing, isn't it? Its jagged banks betray its artificial and recent origins. It is, in fact, the reservoir of a dam created by an earth embankment; nature tends to create softer angles.

Next page
Red Veins
These magnificent red veins are at the mouth of the Betsiboka River in Madagascar. While certainly eye-catching, this vibrant color illustrates a worrying phenomenon found all over the planet: deforestation and, as a direct consequence, coastal erosion, which has destroyed the mangroves here. Without the tree roots to stabilize the soil, waves of sediment are flowing into the river and on to the ocean with every rainfall. On Earth, a forested area the size of the space station is disappearing every three seconds!

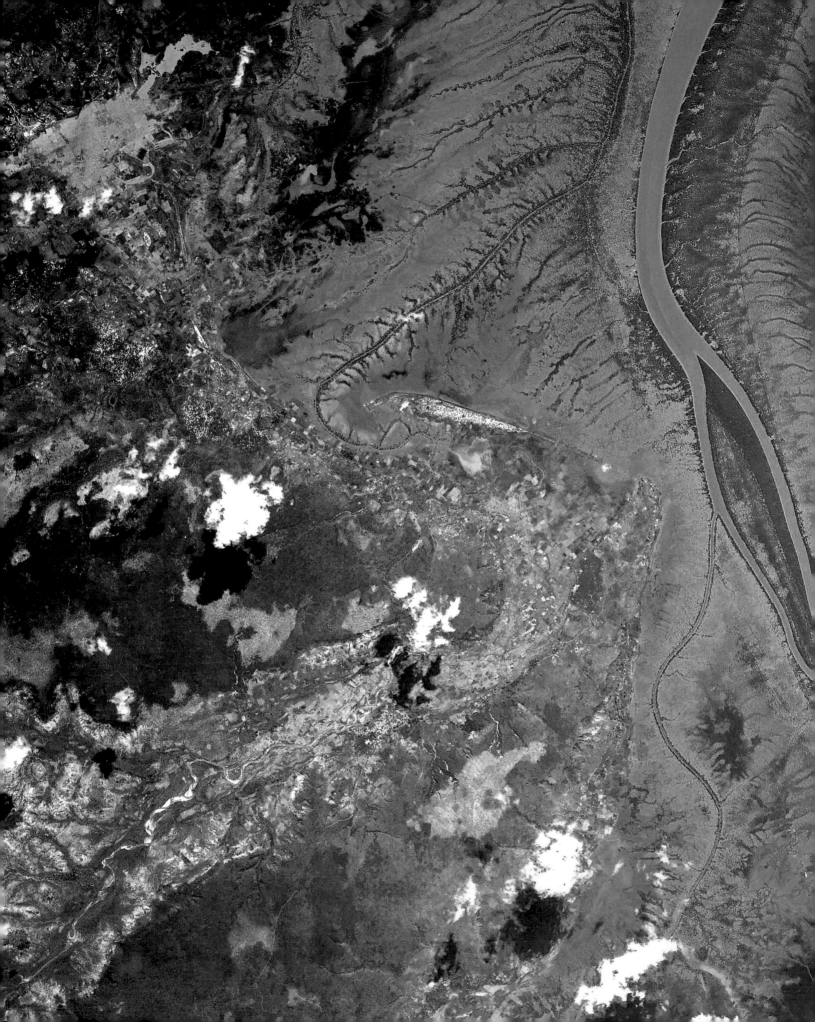

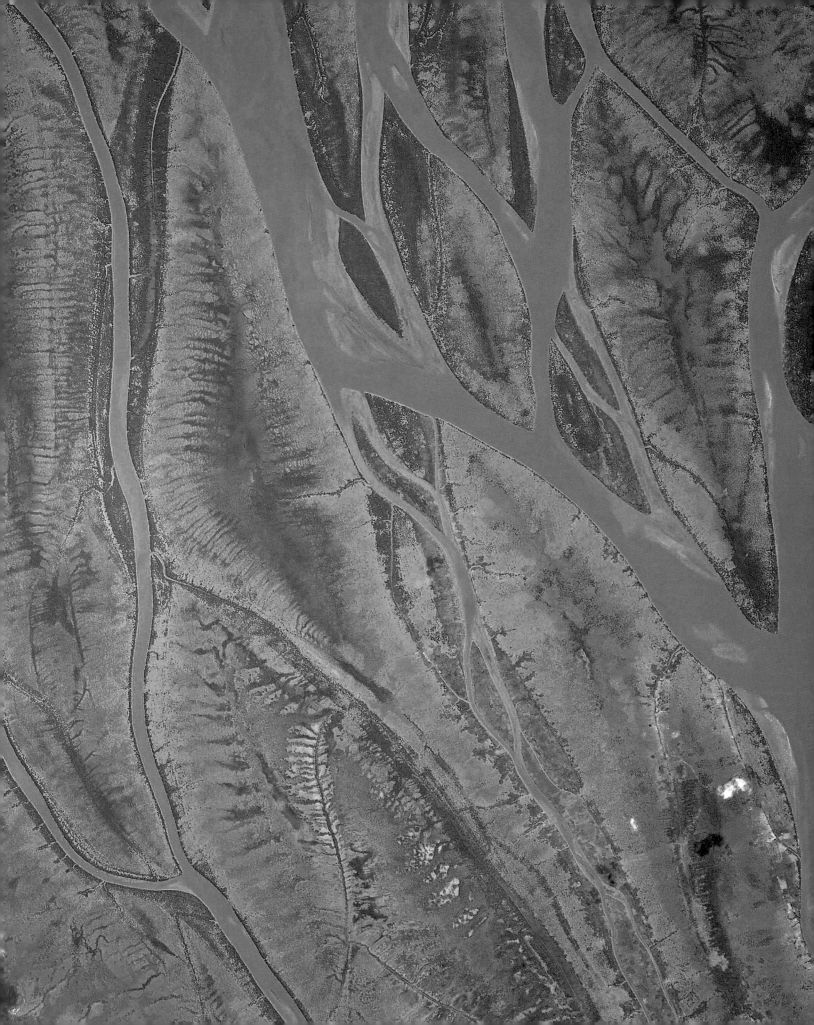

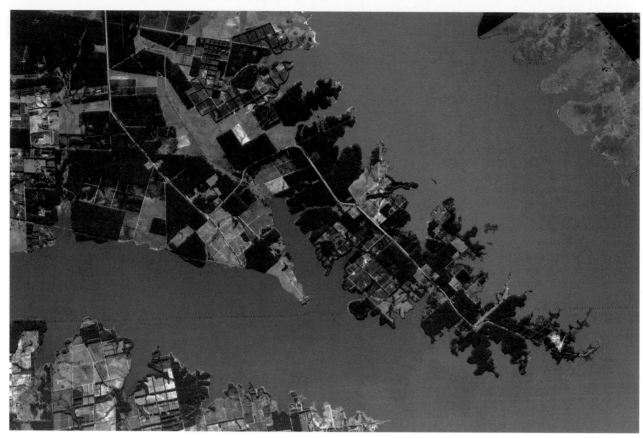

A Natural Border
The setting Sun creates beautiful
pastel colors in the landscape along
the Uruguay River. The river forms
the border between Argentina and,
not surprisingly, Uruguay, which share
a hydroelectric dam and the Salto
Grande Bridge, just downstream
from this location.

Wisps
The meandering Syr Darya River
in southern Kazakhstan seems to
be drawn with wisps of smoke. In
this region of desert steppes, it is
not surprising to see the few towns
and agricultural areas clustered
along the river. You can also see
irrigation canals and large plots
of land, probably for growing
cotton, whose intense cultivation
has unfortunately exhausted water
resources to the point of drying up
the nearby Aral Sea.

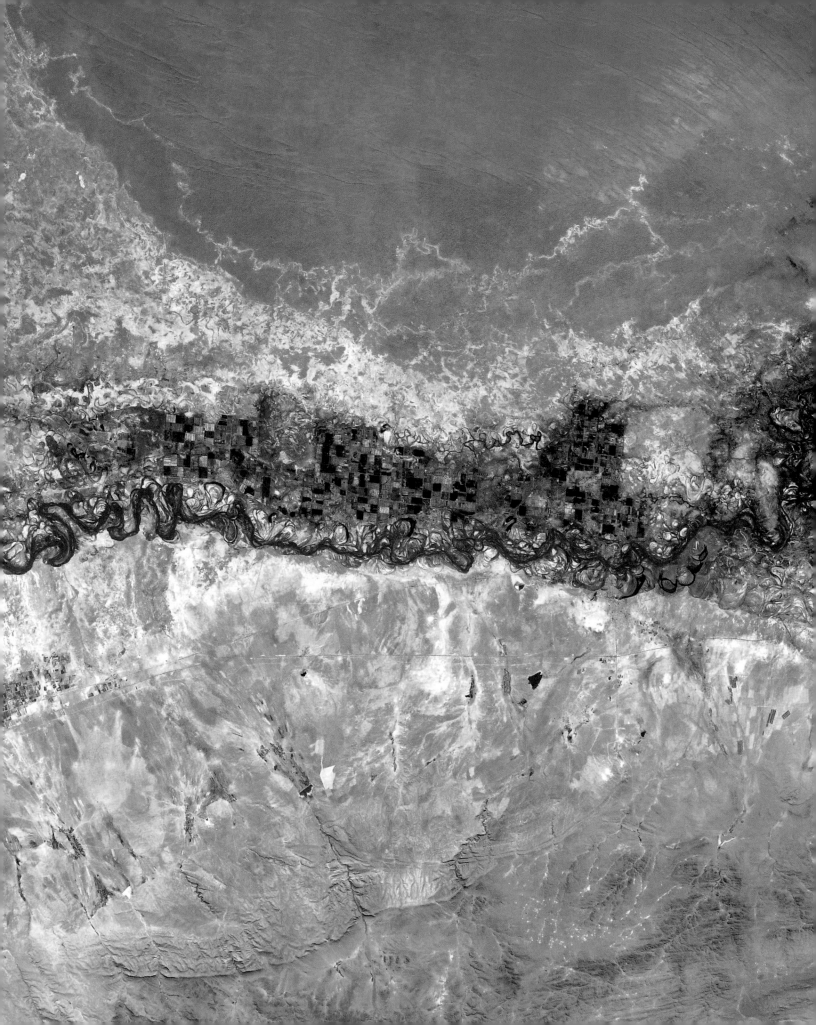

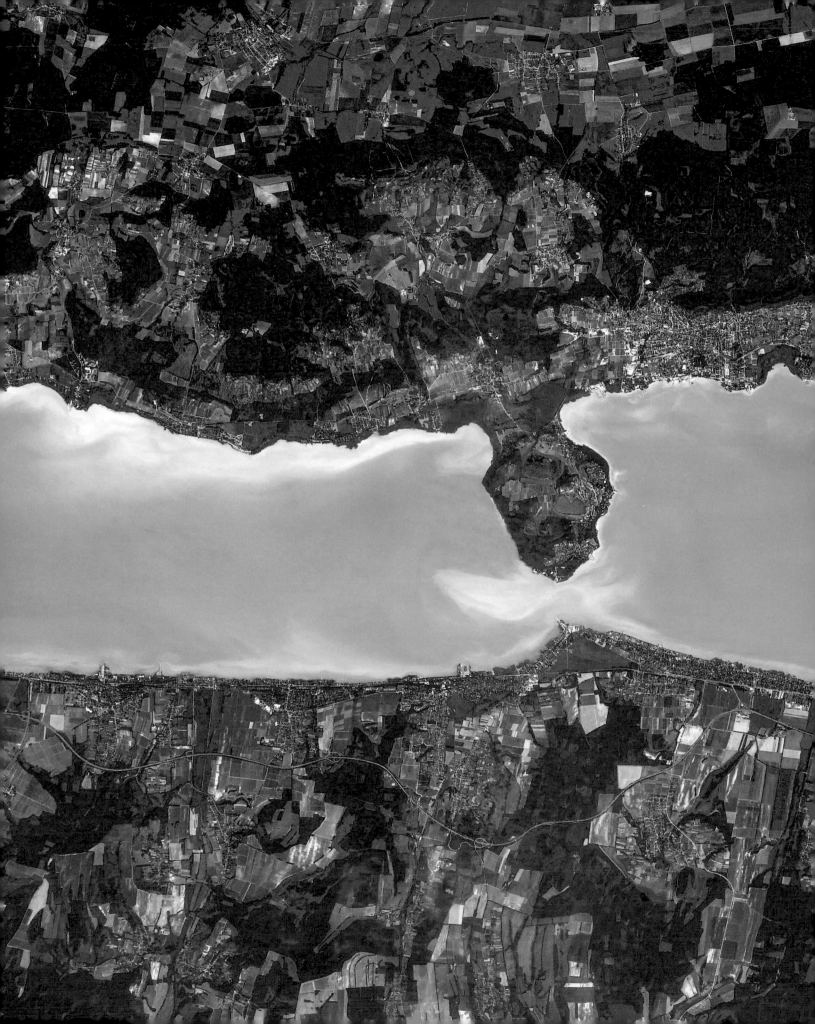

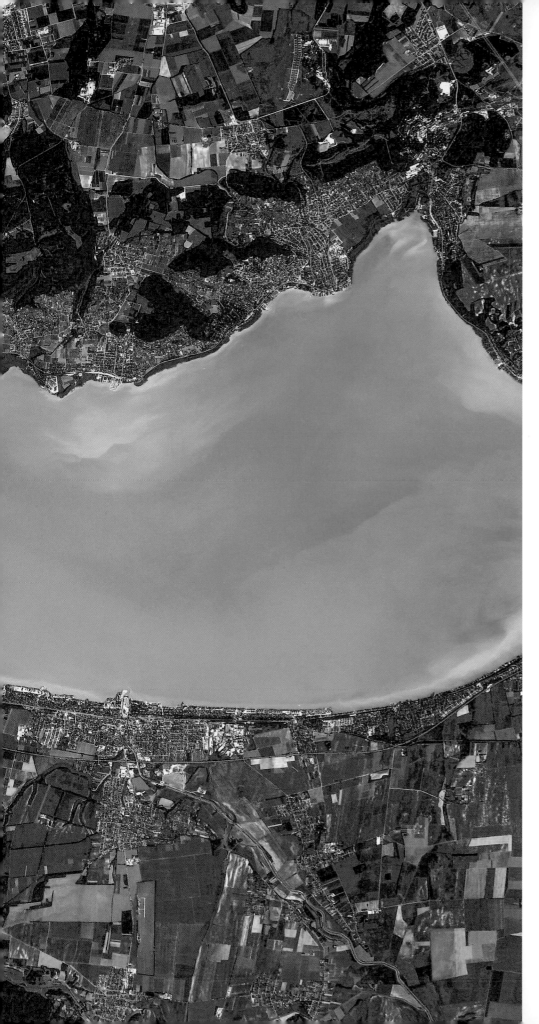

Lake Balaton
Lake Balaton in Hungary is instantly recognizable from space: It has a distinctive shape, but its color, between mint and turquoise, is the real eye-catcher! It is 50 miles (80 km) long and (you can't see this from the ISS) very shallow.

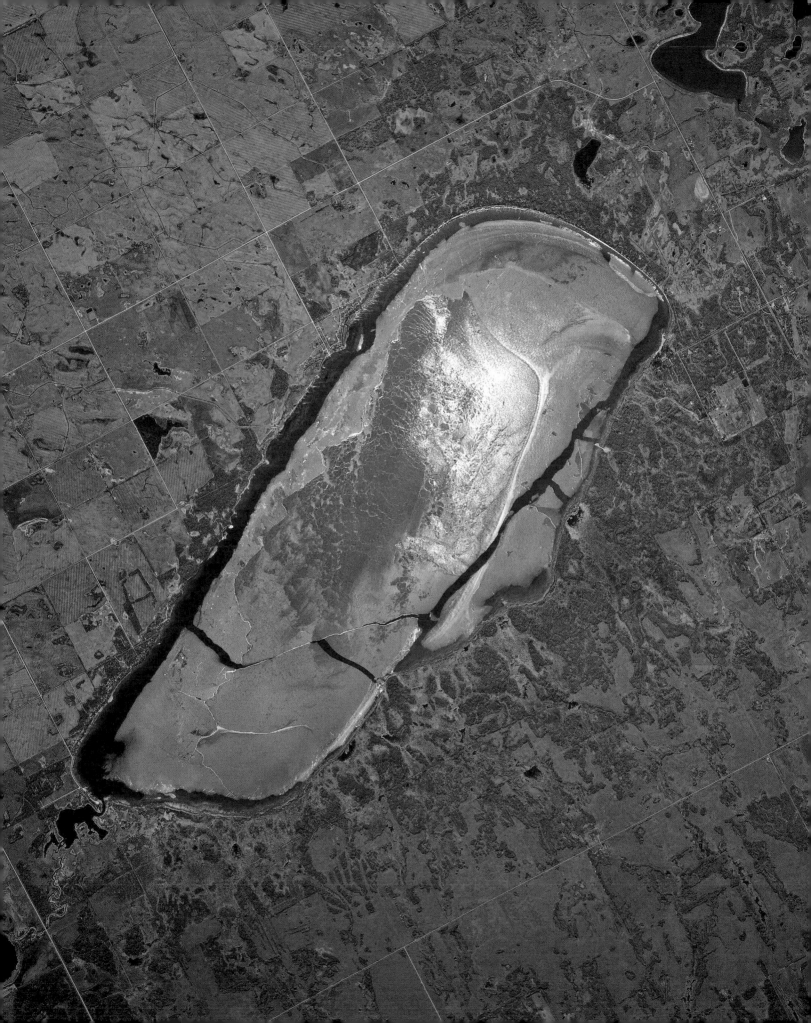

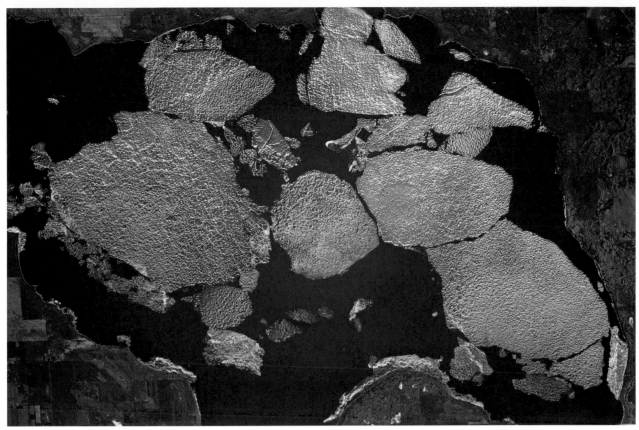

Clouds of Ice
Huge blocks of ice float on a frozen lake in Canada. I can't help but look for familiar shapes in them, like in clouds... The area looks peaceful, but it comes alive in the warmer months, when it's a haven for migratory birds.

Good Spirits
Looking at Good Spirit Lake in Saskatchewan, Canada, almost completely frozen, it is hard to imagine that in the spring and summer, it is a popular place for swimming and other water sports, when the vast brown expanse turns a vibrant green. The surrounding grid of roads and plots of land is a marvel of geometry.

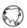

Next page
Turquoise
I am fascinated by how the blue of this lake created by the Karkheh Dam in Iran contrasts with the surrounding parched land. It is like a natural tribute to a great Iranian tradition of over 2,000 years, the production of precious turquoise.

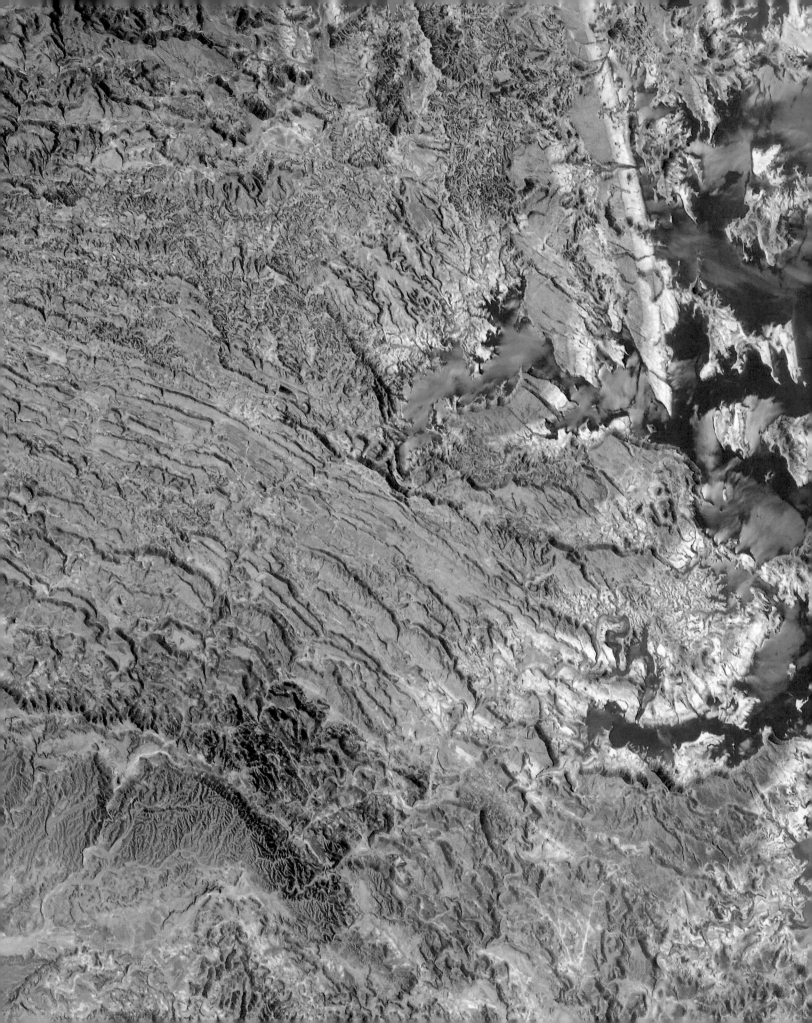

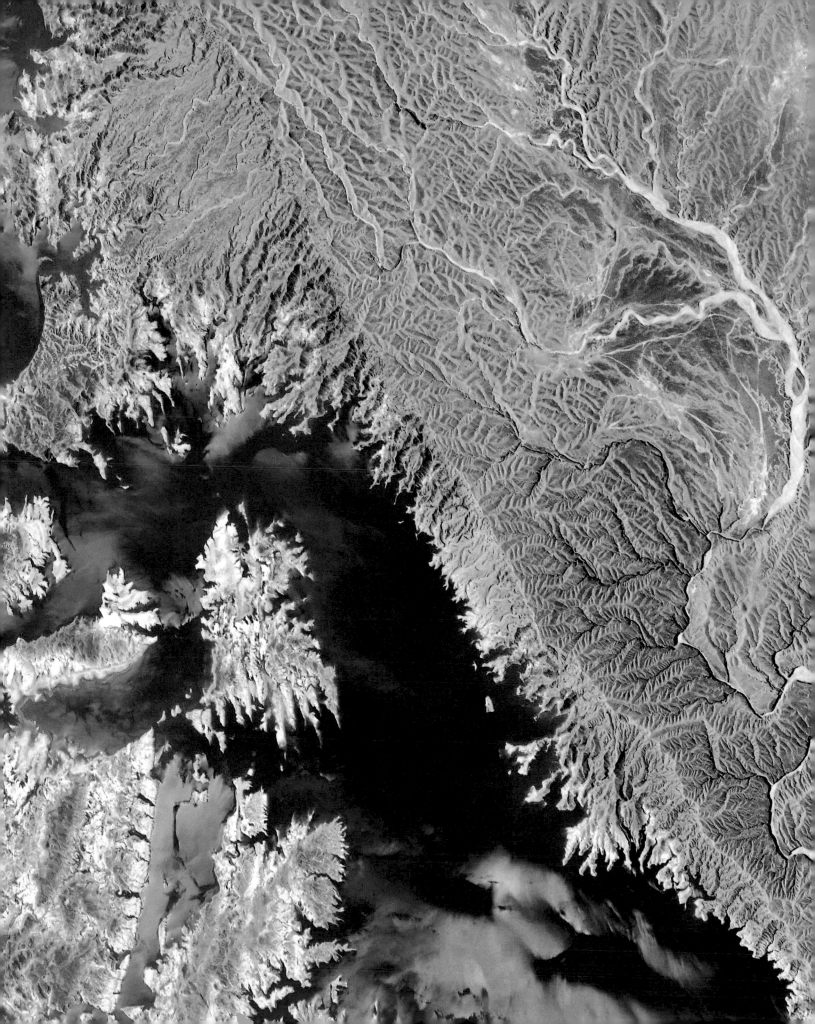

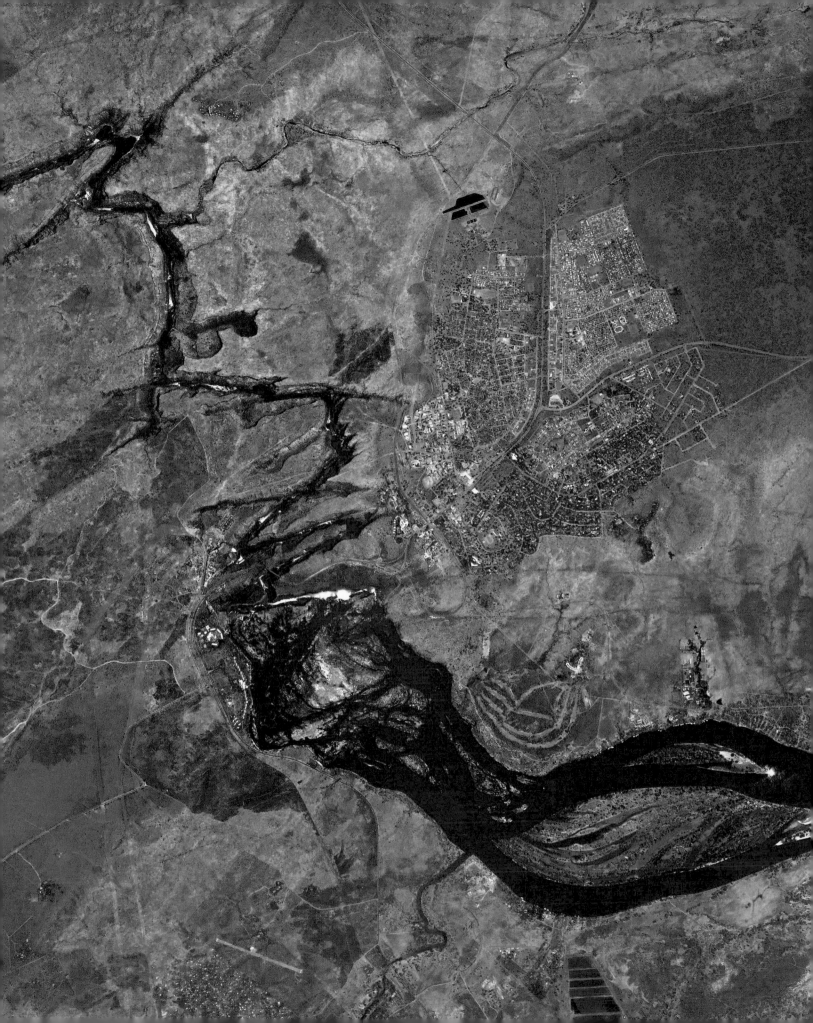

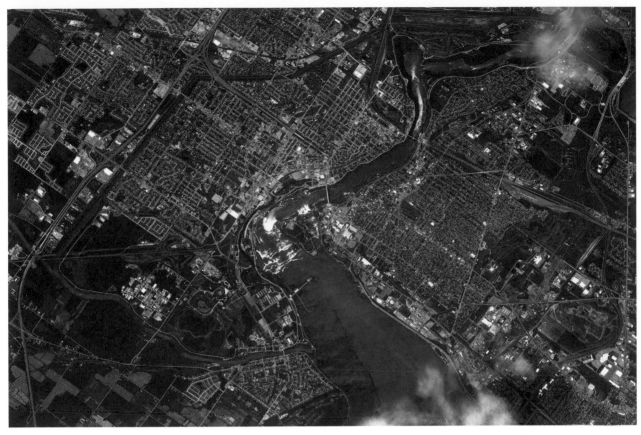

Niagara Falls
Niagara Falls, which sits half in the United States and half in Canada, has the largest water flow in the world (in volume of water per second). However, these are not the highest falls. The Salto Angel Falls in Venezuela boast a height of nearly half a mile (about 1 km)! The record for widest falls is held by Iguaçú, which separates Argentina and Brazil. The rapids downstream from Niagara Falls are clearly visible in the photo above, reminding us that the show doesn't stop at the curtains that form the falls!

And the Title Goes To...
The title holder for most beautiful waterfall in the world is fiercely contested. One contender is almost certainly Victoria Falls. These stunning falls create eddies along the Zambezi River and draw the border between Zambia and Zimbabwe. This photo, from late September, doesn't quite do them justice: The peak flow in April and May is much more impressive. The town on the Zimbabwe side is, not surprisingly, a tourist destination that provides a base from which to visit the falls.

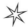

Next page
Watercolors
The setting Sun paints beautiful pastel colors on the landscape along the Paraná River in Argentina.

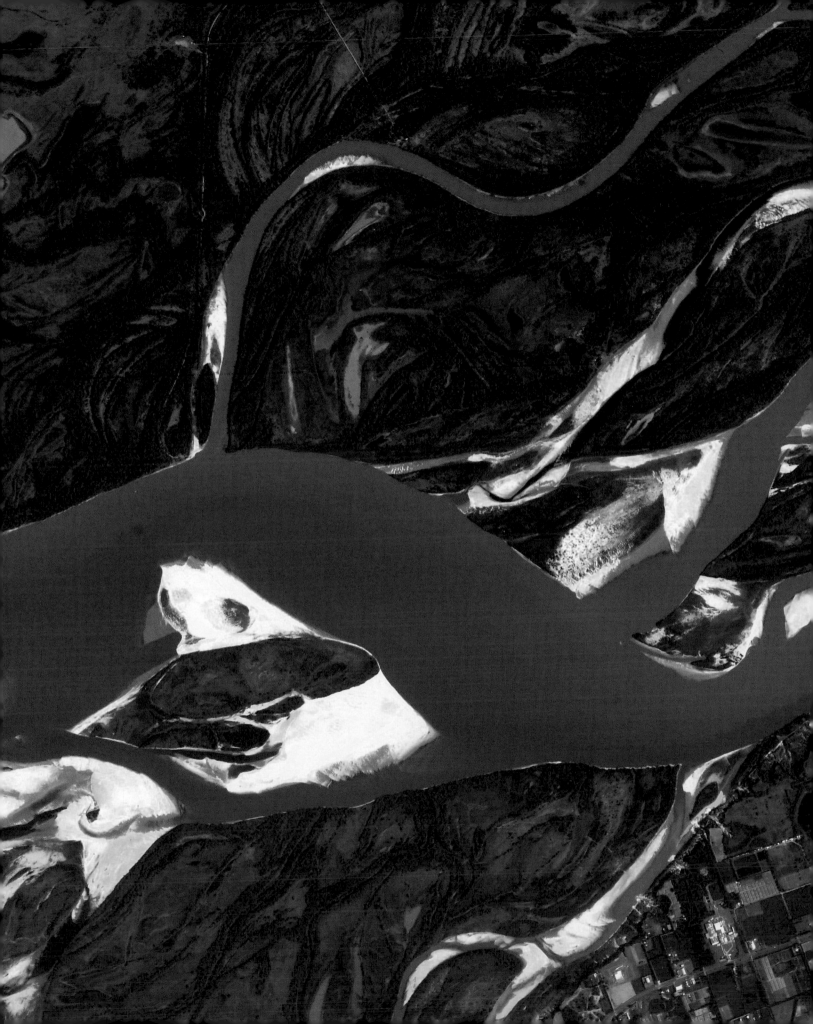

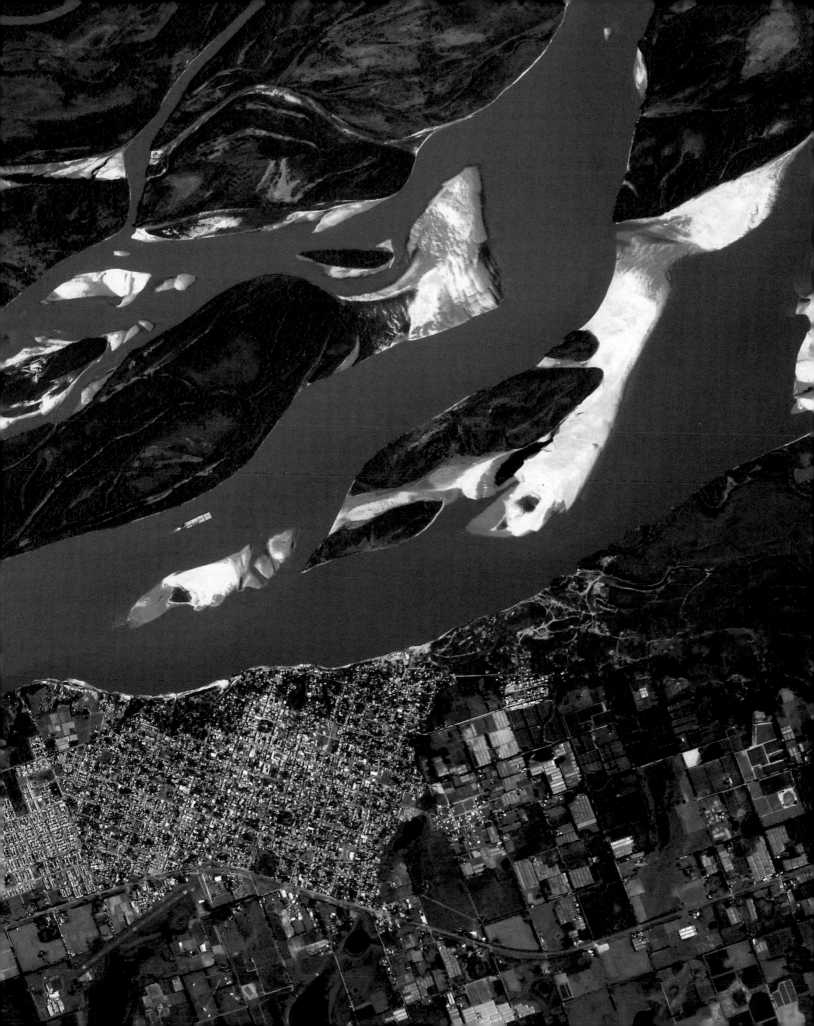

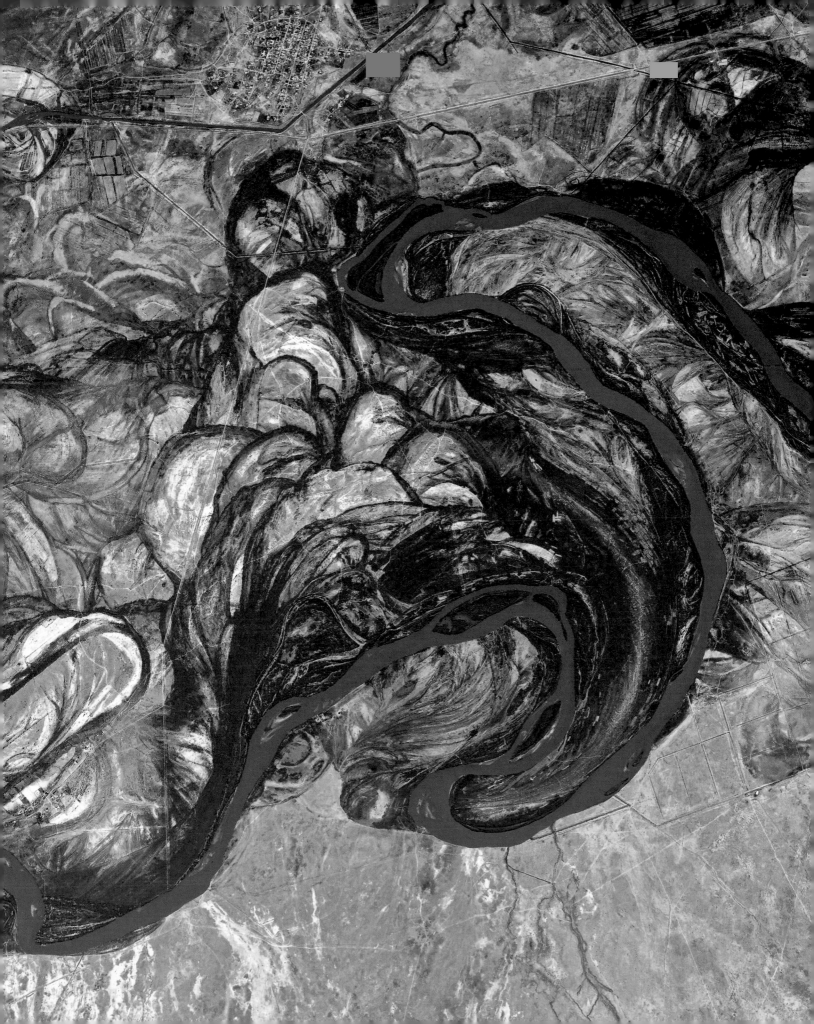

An Endorheic River

Central Asia's Syr Darya River is endorheic, meaning it does not flow into any sea or lake. It is literally closed and flows through evaporation and seepage. However, this was not always the case. It was once a crucial supply route for the Aral Sea, a famous brackish lake nearby, which is now almost dried up.

In this photo I find myself lingering on the meanders, the channels and bushy vegetation along the banks. The sinuous "dead arms" of the old meanders that are still visible hint at the shape of the river in the past — and in the future.

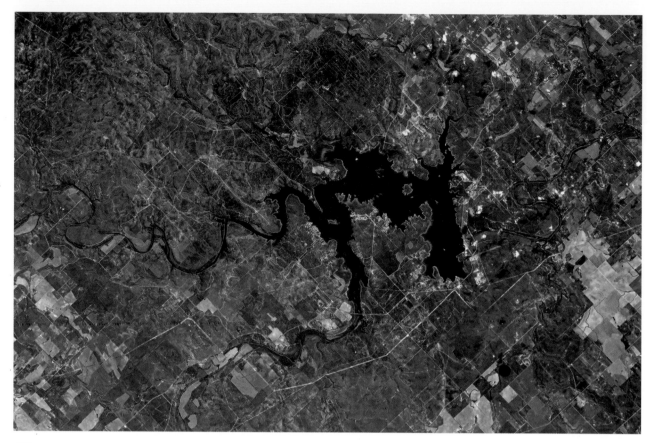

Patchwork
A river zigzags through West Texas, seeming to tear it apart. The eerie feeling is accentuated by the dark reflection of the water. The roads, meanwhile, form a luminous network of threads, as though trying to stitch the landscape back together.

Madagascar
This ruby-emerald duel in the Sambao River, Madagascar, is created by runoff from the region's red rocks, rich in iron oxide and alumina. The runoff is carried by the river and eventually finds its way to the sea. It's a natural phenomenon but still severely affected by erosion.

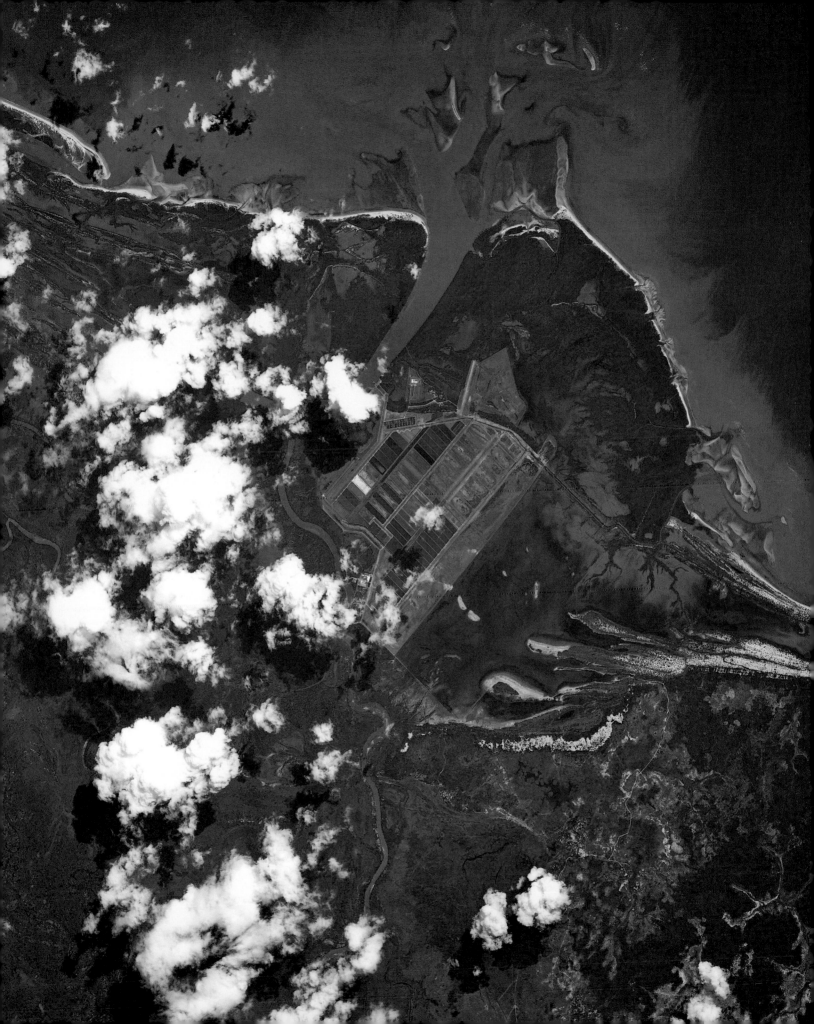

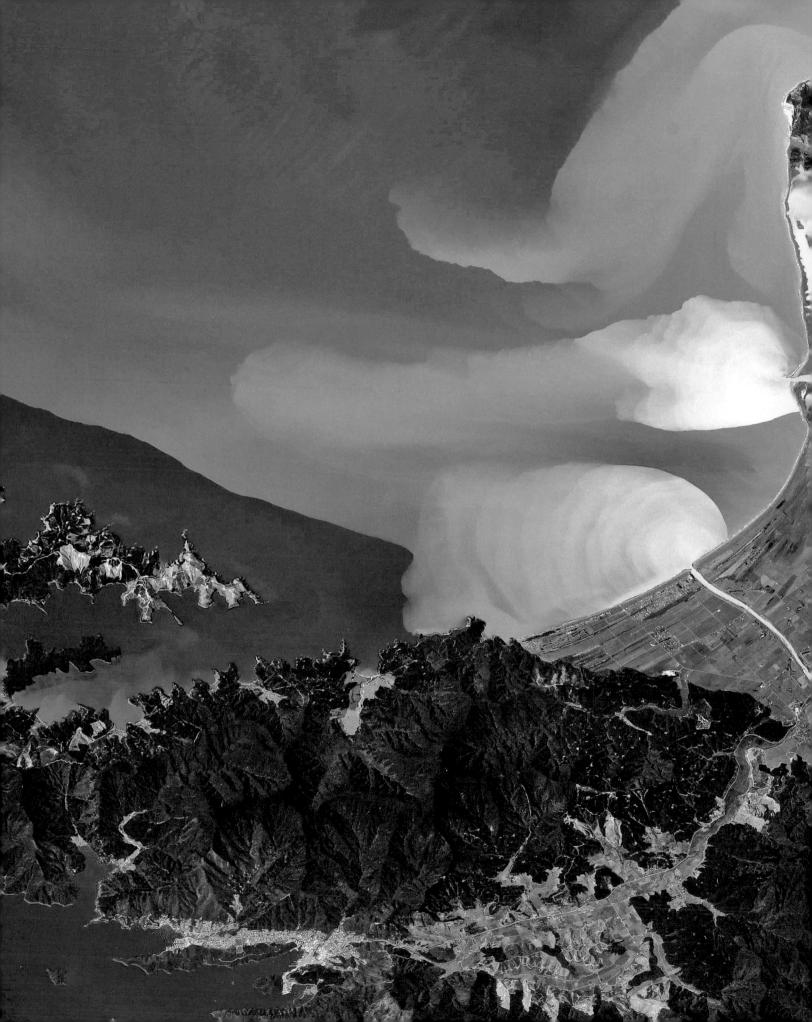

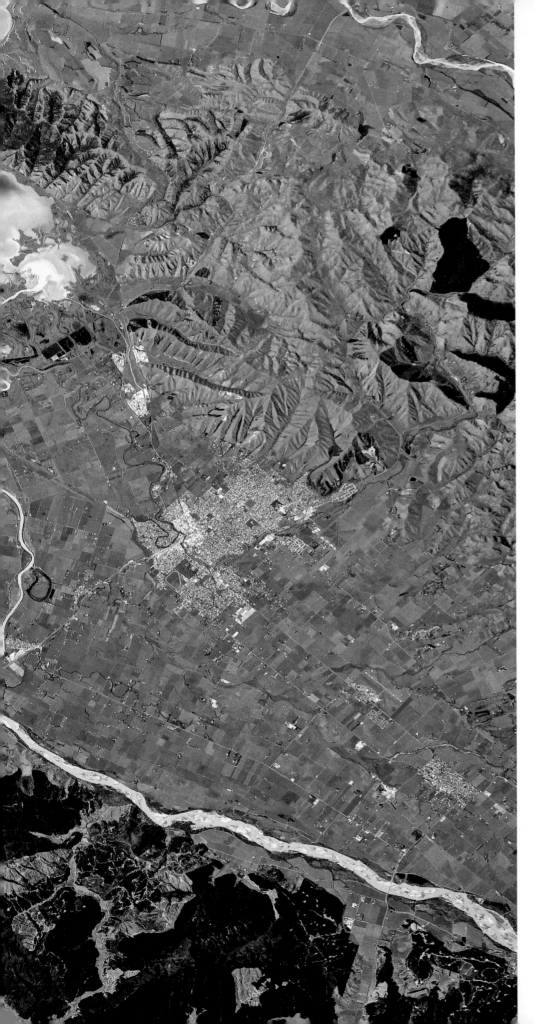

In the Steps of Lord of the Rings
The Wairau River flows through vineyards in Marlborough, New Zealand, creating a watercolor panorama as it enters the Cook Strait. The region's sunken valleys and beautifully contoured hills made it the ideal setting to bring *The Lord of the Rings* to the screen. Even from space you can sense the atmosphere of Middle Earth, the world imagined by J. R. R. Tolkien that has fascinated so many. It is hardly surprising that Peter Jackson thought of the landscapes of his native New Zealand when bringing Tolkien's world to life.

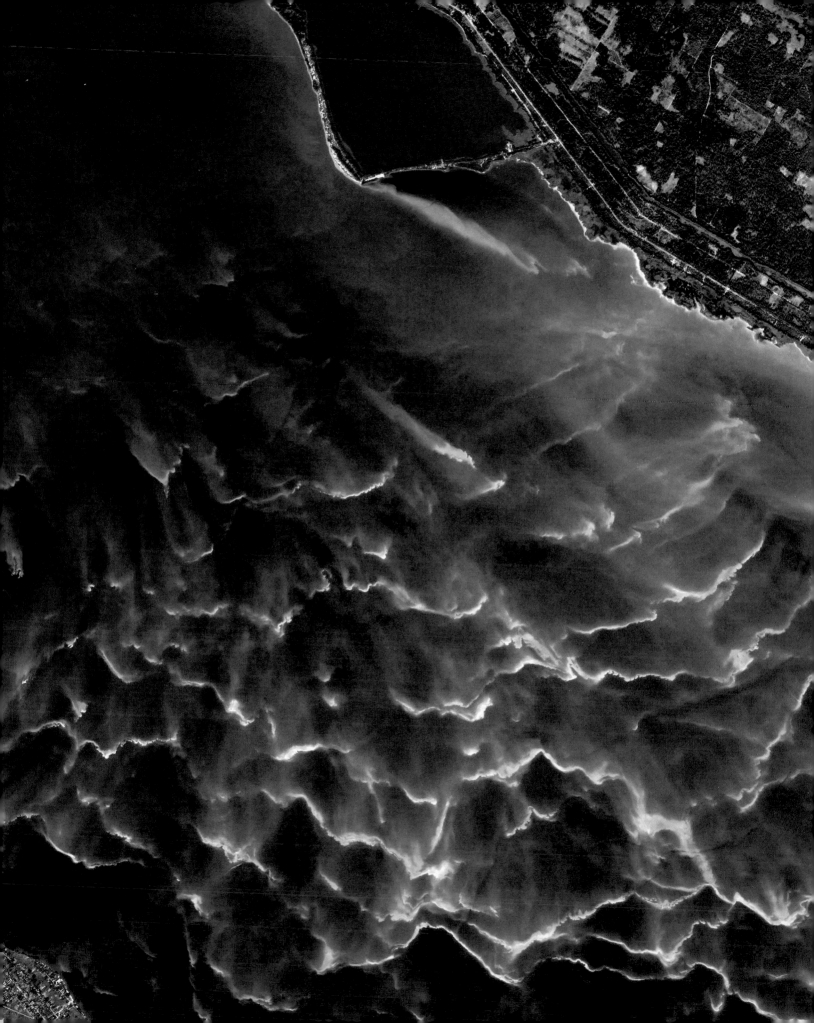

Whirlpools

Are these aurora borealis? No, these attractive swirls were drawn in the Kyiv reservoir by eddies from the Dnieper River. The reservoir sits upstream from the Ukrainian capital and downstream from the Chernobyl nuclear power plant.

The green color is due to an algae bloom, a phenomenon linked to the construction of dams, which can unbalance ecosystems, pollute water and increase water temperatures. The algae themselves are a beautiful sight, but they can emit toxins and monopolize the river's oxygen supply, at the expense of other organisms.

Lake Titicaca

Viewed from space, Lake Titicaca is quite impressive. Its 3,300 square miles (8,500 km²) look like a blue continent cut into the rocks of the Andes. It is the most important freshwater reserve in South America, and it also plays an important role in Andean mythology. The Uros, for example, built artificial islands there, which they inhabited. Although it is perched at an altitude of just over 13,000 feet (4,000 m), the lake is still threatened by pollution. Its entire ecosystem is being suffocated by chemicals, heavy metals and waste, which darkens its color. The main causes are urban development and sewage, toxic industrial and agricultural waste and overcrowding by tourists.

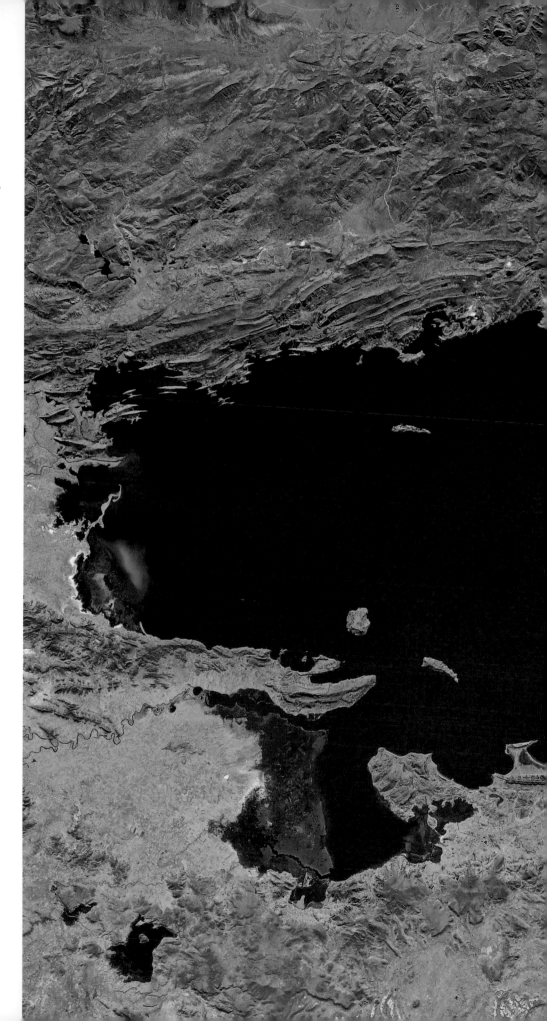

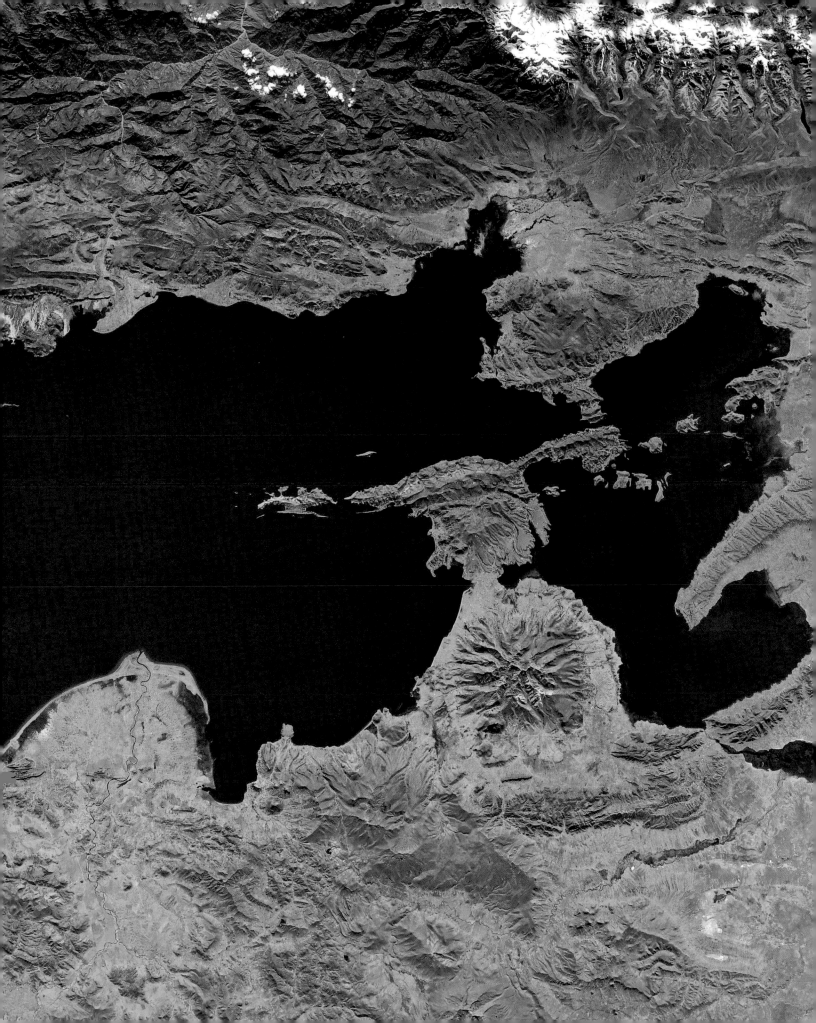

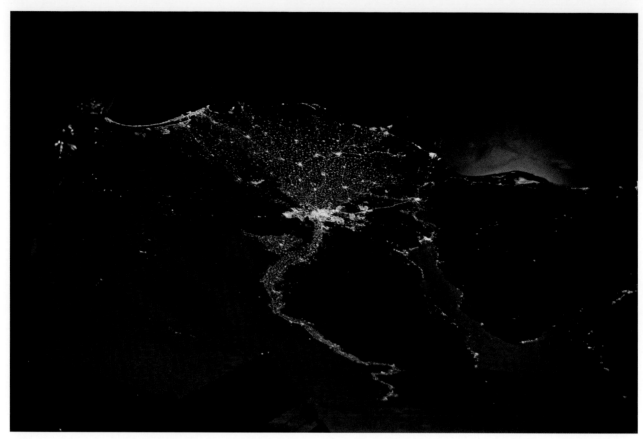

Night Fever
By night perhaps even more so than by day, the Nile and its delta are magnificent. Its shape is immediately recognizable from space, with lights following the course of the river all the way to the Mediterranean. The Moon, which here is opportunely reflected on Lake Bardawil, makes it possible to discern the outline of the Sinai Peninsula, even though it is plunged in darkness.

Next page
Flying over Kazakhstan
A peninsula separates Lake Balkhash, in Kazakhstan, into two surprisingly distinct sections. In the west, where it is particularly wide, it is a source of fresh drinking water, while its eastern segment is narrower and deeper and holds brackish water. Sustainable management is essential to prevent Lake Balkhash from suffering the same fate as the Aral Sea.

The Fertile Nile
The fertility of the banks of the Nile and its delta contrasts with the surrounding desert and the blue of the Mediterranean. From the station, one can better appreciate how this legendary river irrigates its section of the African continent.

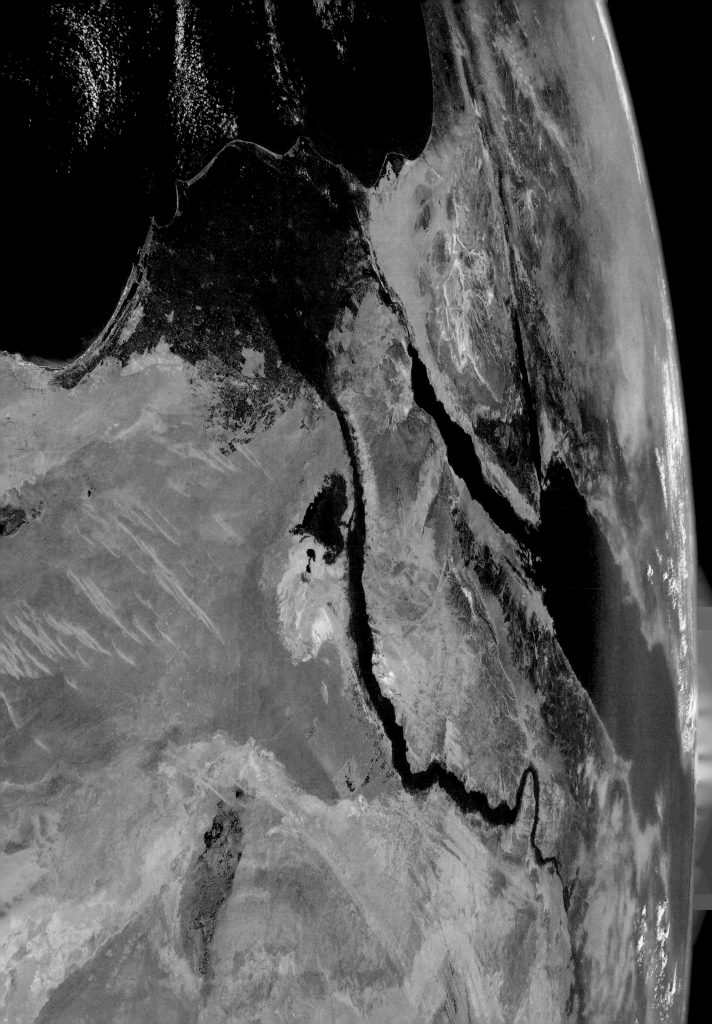

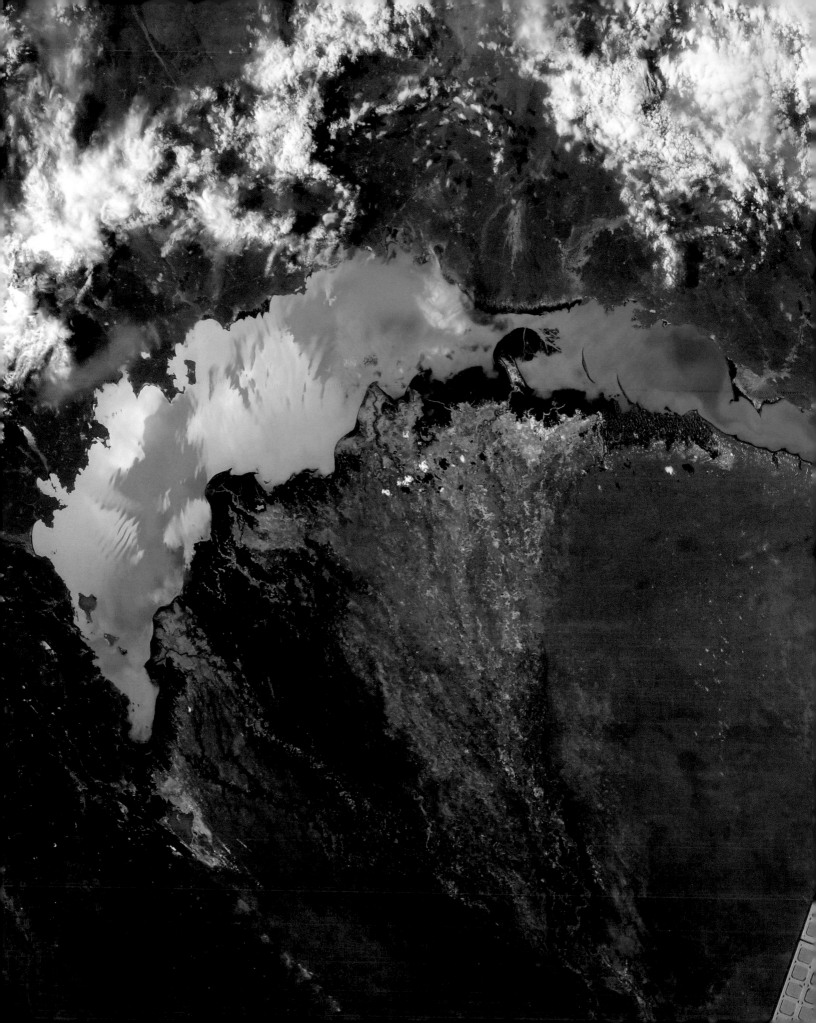

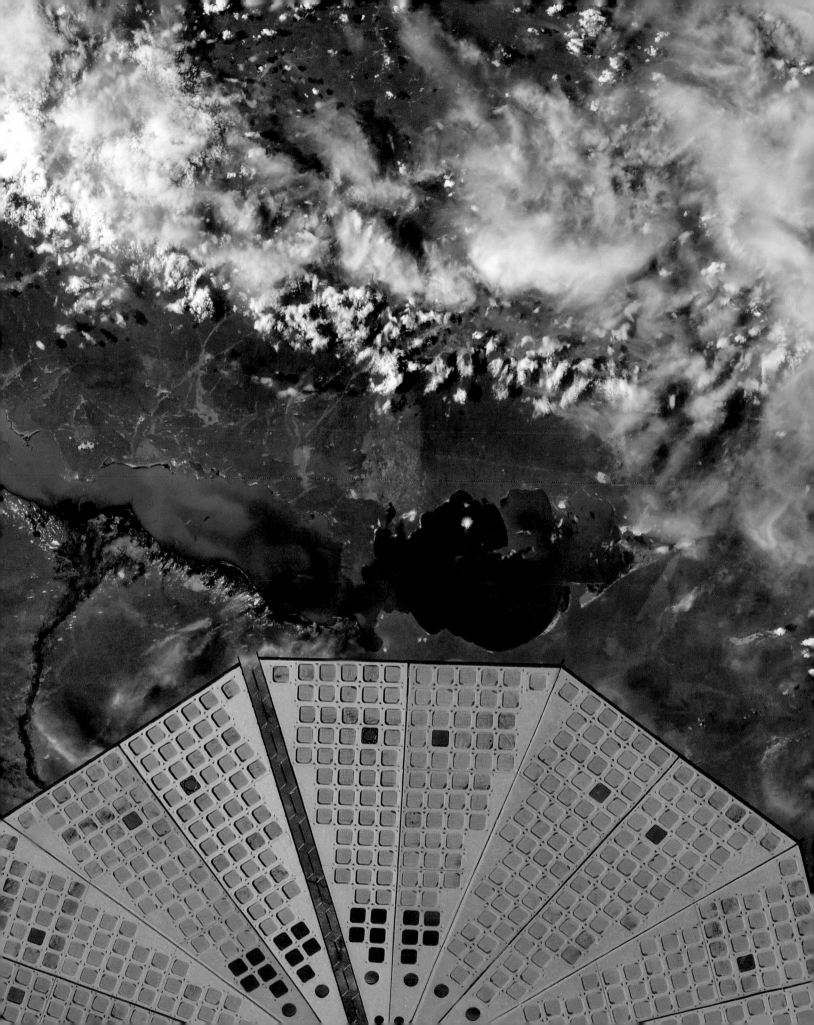

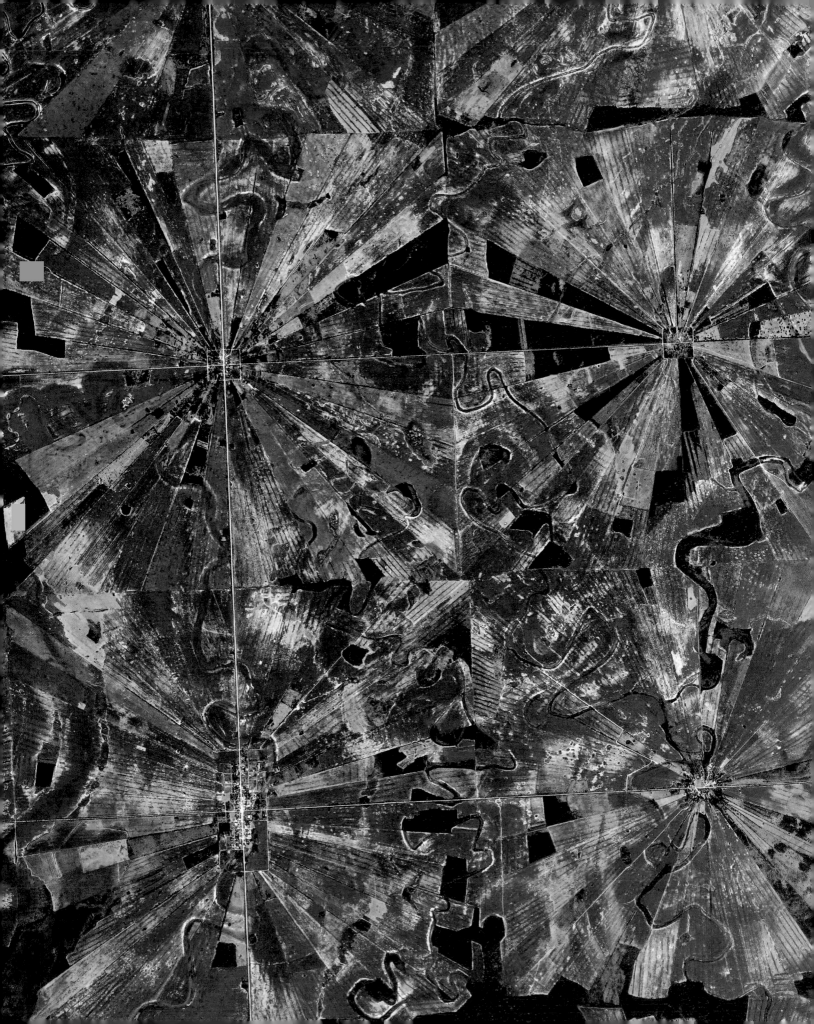

Soils

Earthbound Stars
These strange star-shaped patterns are actually agricultural lands in San Pedro Limón, Bolivia, where large areas of dry tropical forests have been cleared to make way for farming. The facilities in the middle of each field usually contain a church, a school and a soccer field. They are connected by a network of roads, which are the straight lines visible in the photo.

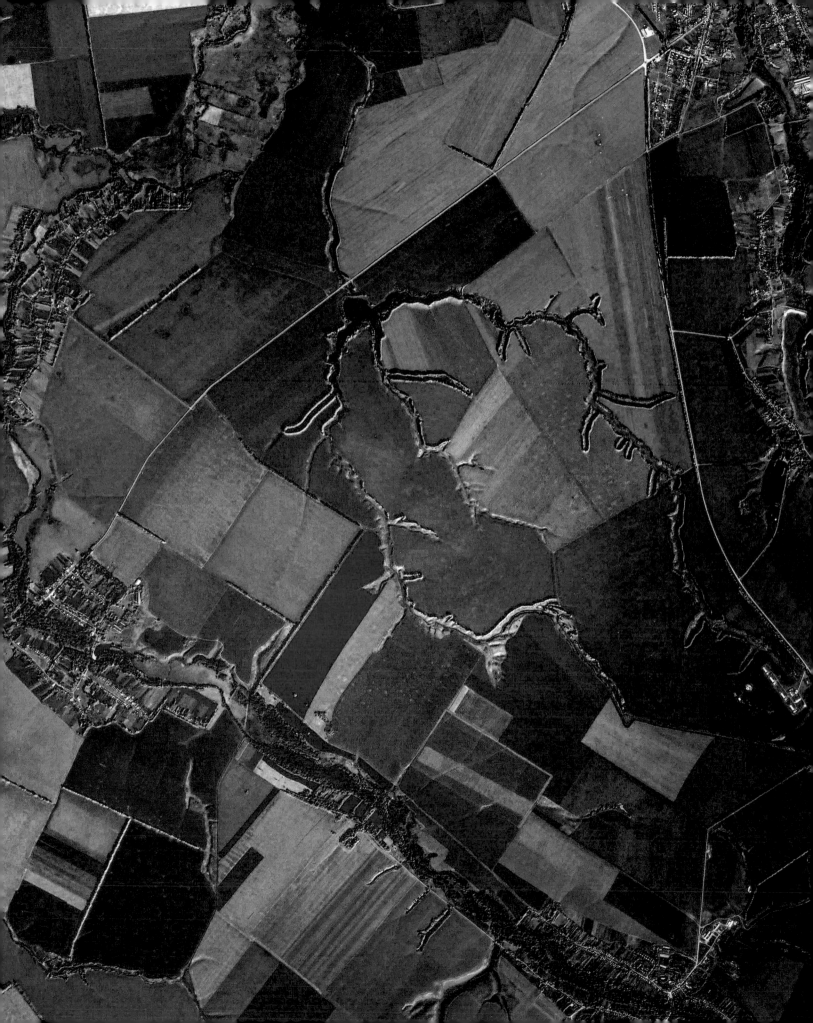

The Earth's soil is like a giant canvas on which both nature and humans paint, constantly reinventing the world around us. There is an infinite variety of rocks, humidity levels, temperatures, vegetation and topography across all latitudes, which can sculpt the land in thousands of different ways. And yet, the ground beneath our feet is so familiar to us that we sometimes forget its important ecological role.

Observing the Earth's soils from space better reveals their tremendous value. They provide habitats, food and fuel, but they also harbor a vast biomass and perform vital functions, such as storing carbon and filtering water.

Looking at the beauty of the planet's land masses from space, we also better understand that these resources are limited. This is true of fossil fuels, which I firmly believe cannot continue to play the same pivotal role in our future, but also of agricultural lands. The United Nation's Food and Agriculture Organization (FAO) has for many years been sounding the alarm about the disappearance of farmlands. While the Earth has various names and nicknames, the "blue planet" is almost certainly more fitting than "Gaia," a goddess associated with fertility. Fertile land accounts for less than 3 percent of the planet's surface, which is barely one-tenth of the land area — and it's shrinking.

Urbanization, desertification, chemical pollution (particularly fertilizers and pesticides), organic pollution (such as wastewater) and the development of agricultural lands are adding up and taking a toll, like so many of the challenges our planet is facing. Today, more than enough food is produced to feed all of humanity, yet hundreds of millions of people suffer from malnutrition. As the world's population continues to grow, we need to innovate in order to improve food production and distribution. But there is reason to hope: Humanity can so often find creative solutions to persistent problems. Yesterday humans used geoglyphs, and tomorrow we can conduct research, most notably in space. The ISS is home to many plants, both to feed personnel during future long-distance missions but also to help us learn how plants can better resist threats here on Earth.

An Open-Air Museum
An artist seems to have put some finishing touches on these fields in Eastern Europe. I sometimes feel like space travel has allowed me to visit the most beautiful museum ever imagined.

Next pages
Crossroads
Here is a color quite rare on our planet: the red of Namibia's soil. A mixture of sandstone and iron oxide creates this unusual hue. Nature streaked the landscape in one direction and humans in the other, by building a road.

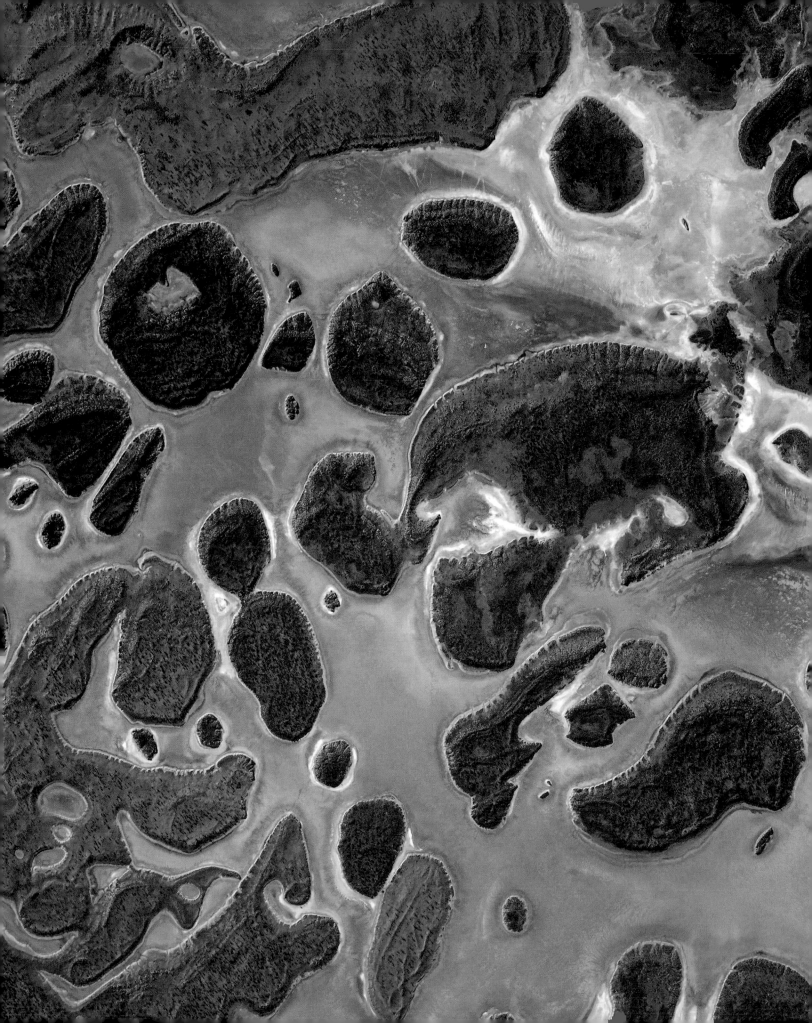

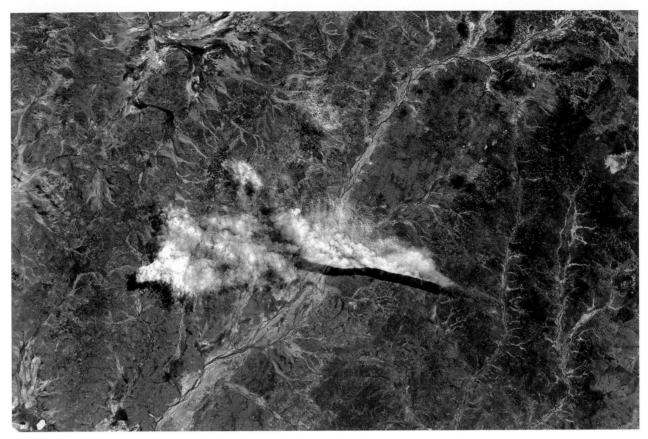

The Outback
The Australian Outback is a semi-arid hinterland that is sacred to Aboriginal Peoples. Its shades of red and ocher with touches of green spread out over thousands of miles. The land often seems to be deserted, but it teems with life, including camels and dingoes that have made these immense expanses their playground.

Islands of Land
Australia is home to many incredible landscapes. These islands dotting salt lakes in central Australia exemplify the country's astonishing terrain.

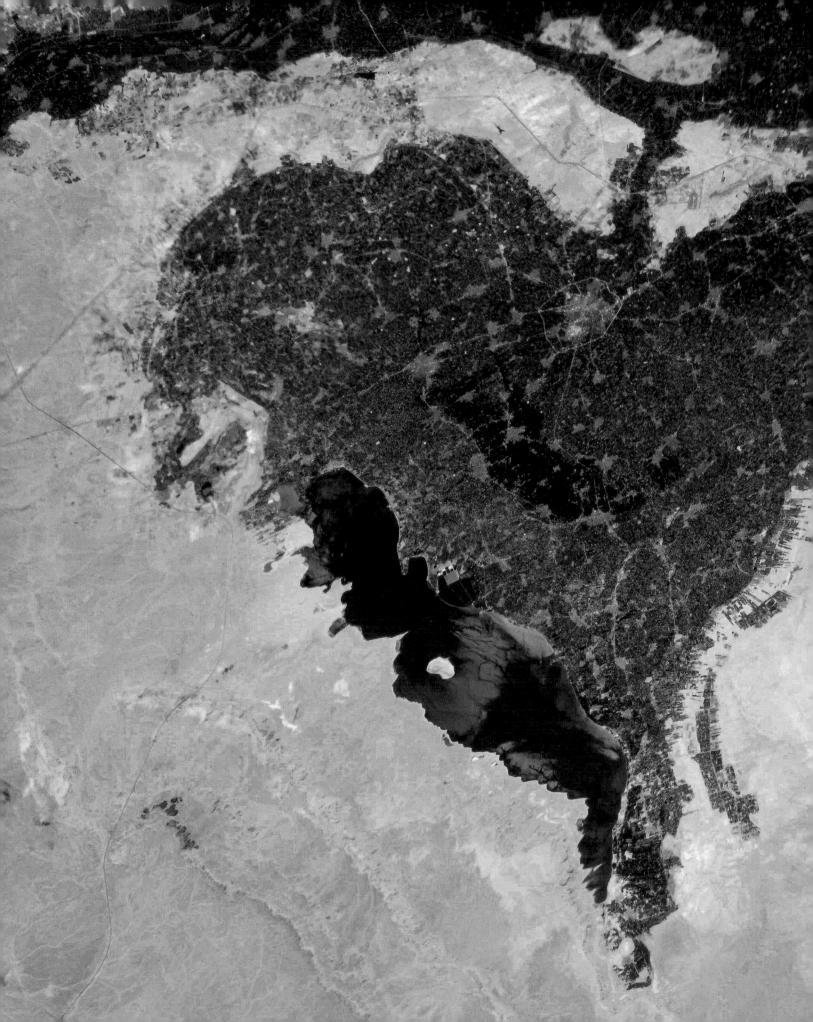

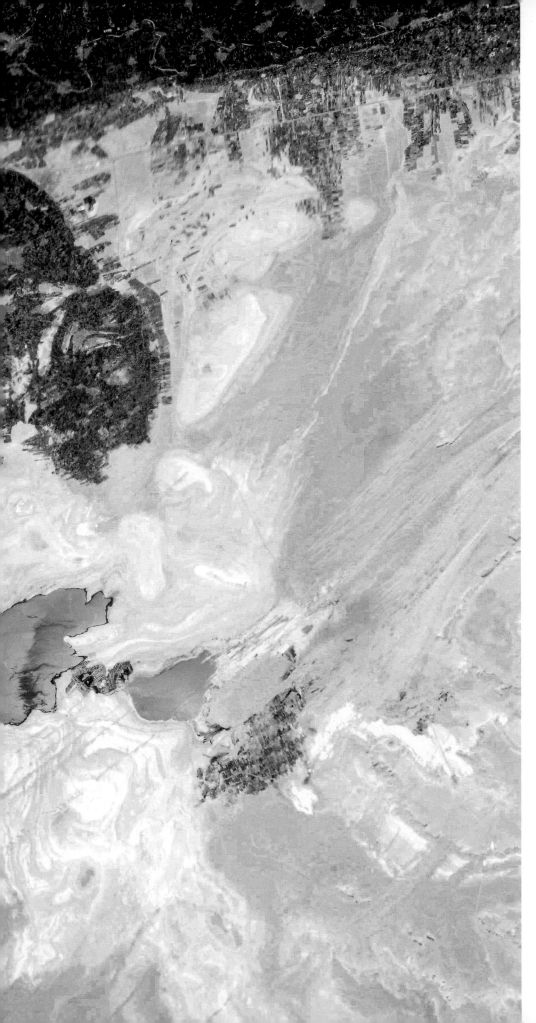

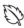

Did You Say Pareidolia?
Our brain's tendency to see familiar shapes in the world around us is called pareidolia. I saw a heart quite clearly while flying over this large oasis south of Cairo, Egypt. What I was actually observing is one of the world's oldest irrigation and sustainable water-management systems.

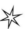

Agri/Culture
Agriculture is rarely an artistic pursuit, and yet, viewed from space, the colors and shapes it produces — often for very practical reasons — can inspire awe and wonderment. In Mexico and the southern United States, irrigation systems (or, sometimes, the lack thereof) seem to draw circles and squares across the landscape. These patterns remind me of De Stijl, constructivist and even Aboriginal artworks. In the two photos on the right, elongated fields in Eastern Europe look to me like marquetry work. The very dark colors contrast with the bright green hues, evoking fertility. Eastern Europe is one of the world's most important sources of chernozems, which are black soils rich in humus and nutrients that are ideal for agriculture.

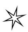

Next pages
A QR Code and Vinyl Records
From a distance, the image on the left looks to me like a QR code or modern art or, perhaps, a computer screen that has frozen. This amazing encryption is, in fact, plots of farmland in Canada. On the right, what appears to be a collection of vinyl records is actually irrigated fields in the middle of a very arid region of Saudi Arabia.

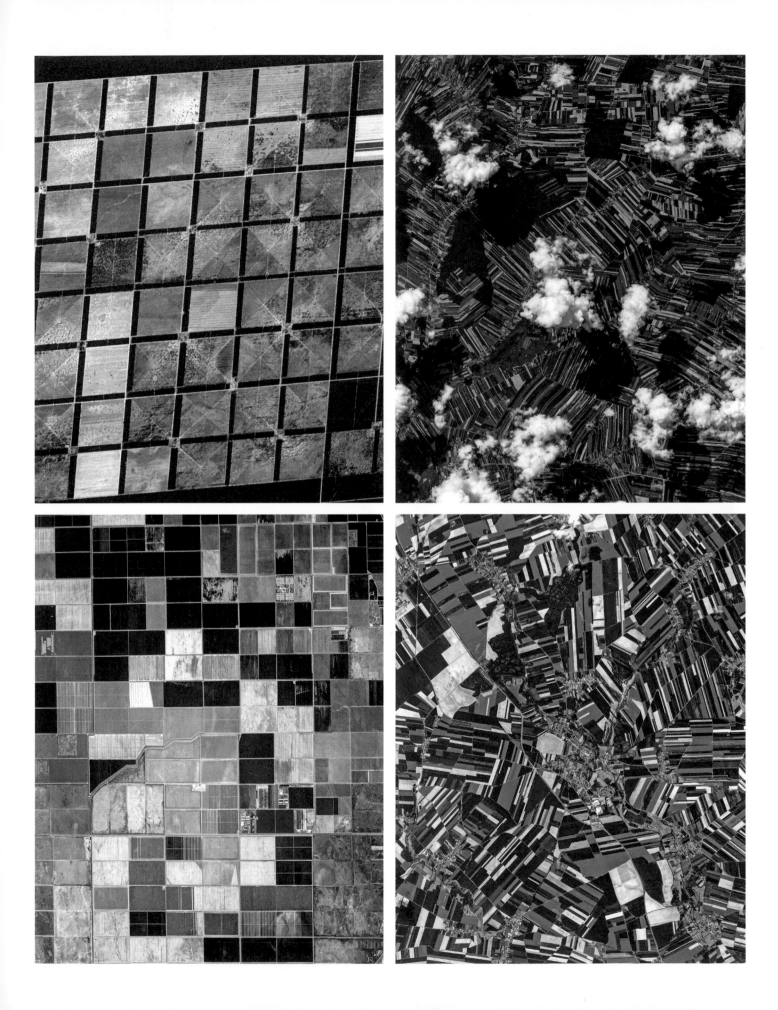

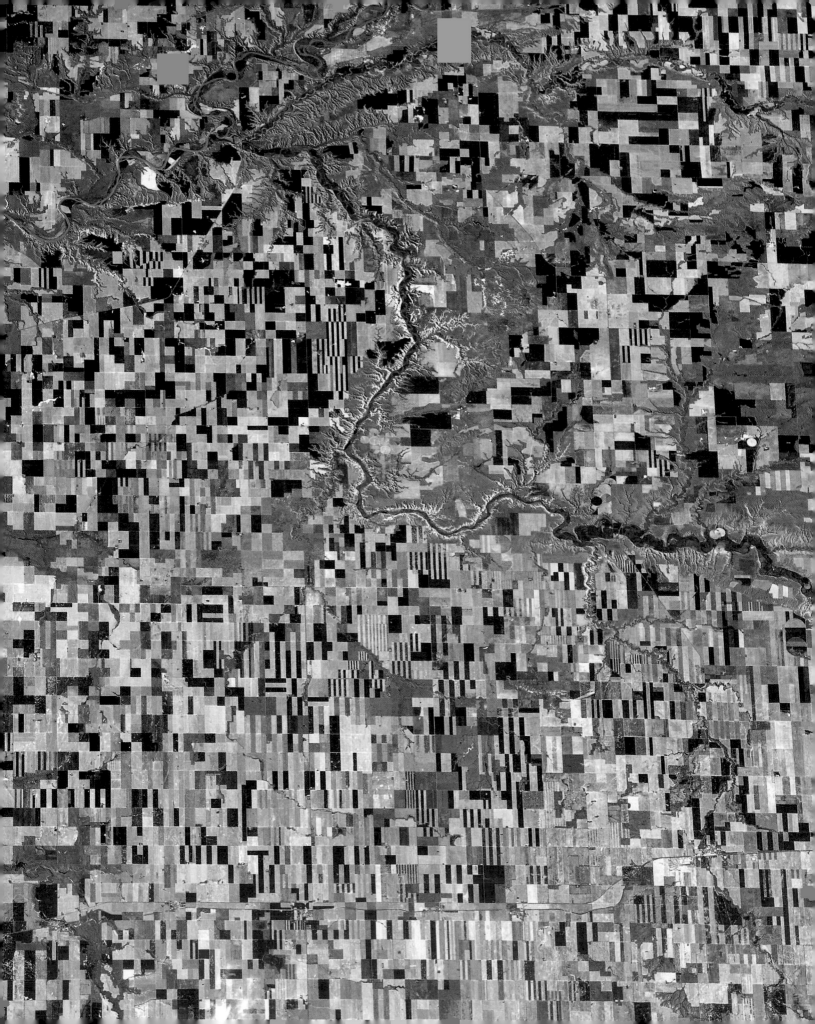

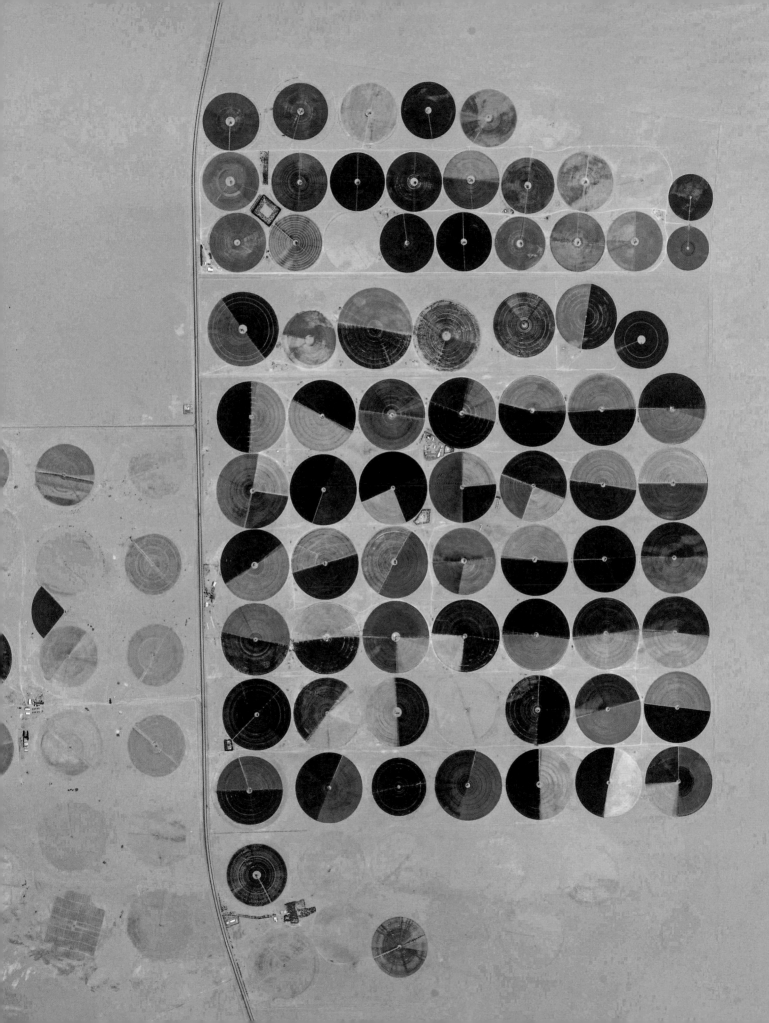

The Amazon
With its sea of dark trees dotted with clouds, the Amazon rainforest is easily recognizable from the ISS. Sadly, you can also clearly see the impact of deforestation, like razor sharp lines cutting out from the rivers and roads. One of the consequences of deforestation is a marked increase in erosion, as greater quantities of sediments are swept from the riverbanks and carried by rivers (hence their brown color) to the oceans.

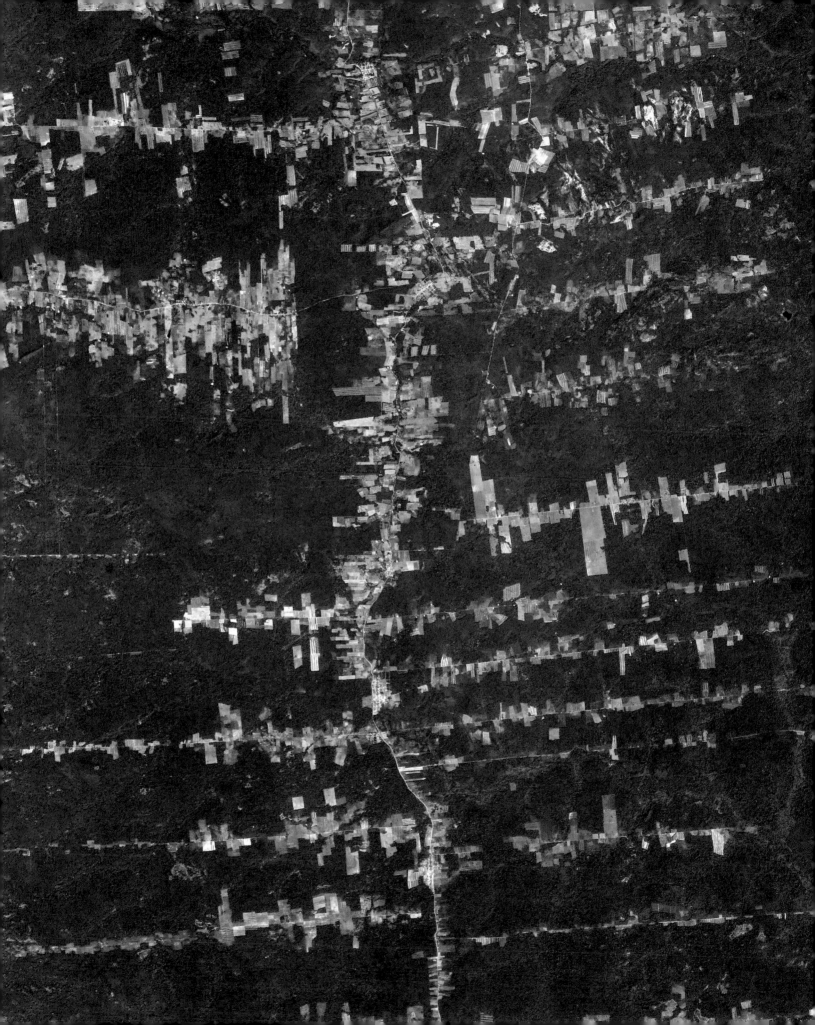

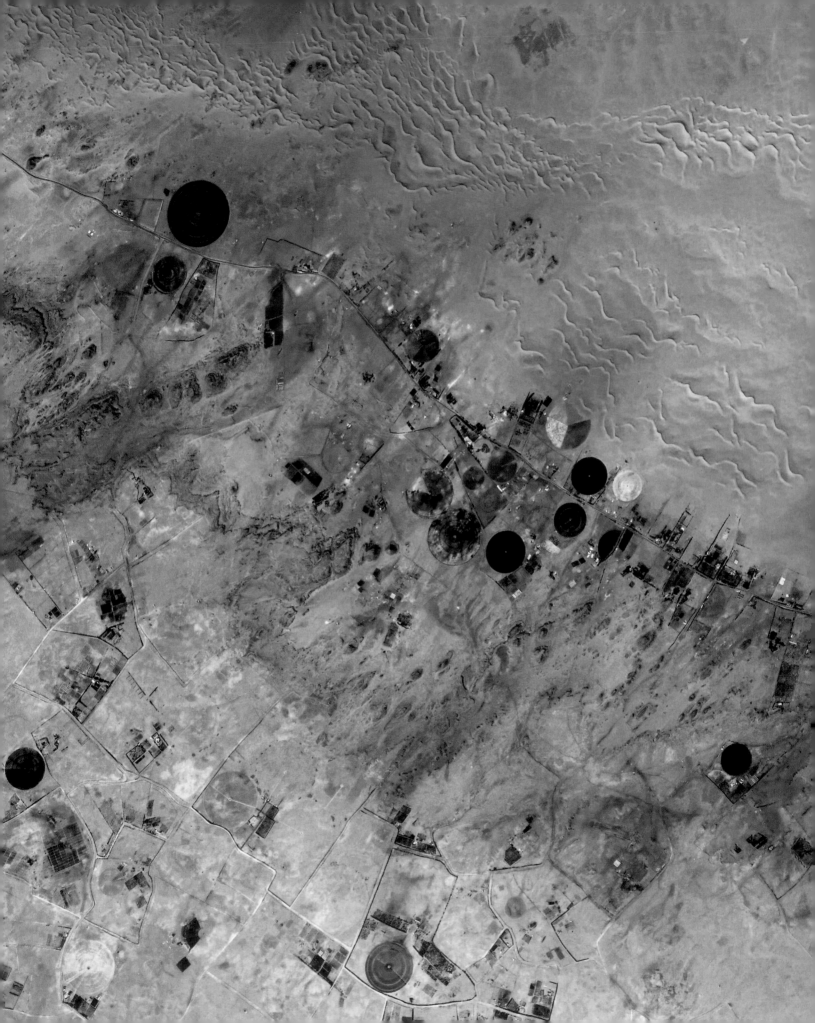

Arts and Culture
These small dots in the desert are fields in Saudi Arabia that are watered by center-pivot irrigation systems, in which water is spread over fields by a long, arm-like apparatus. While there may be innumerable differences in landscapes, climates and cultures across our planet, one thing is constant: the need to grow food, even in deserts. However, this type of irrigation is only possible through massive financial and technological investments and has ecological limitations. The water is extracted from deep aquifers that are all too quickly running out.

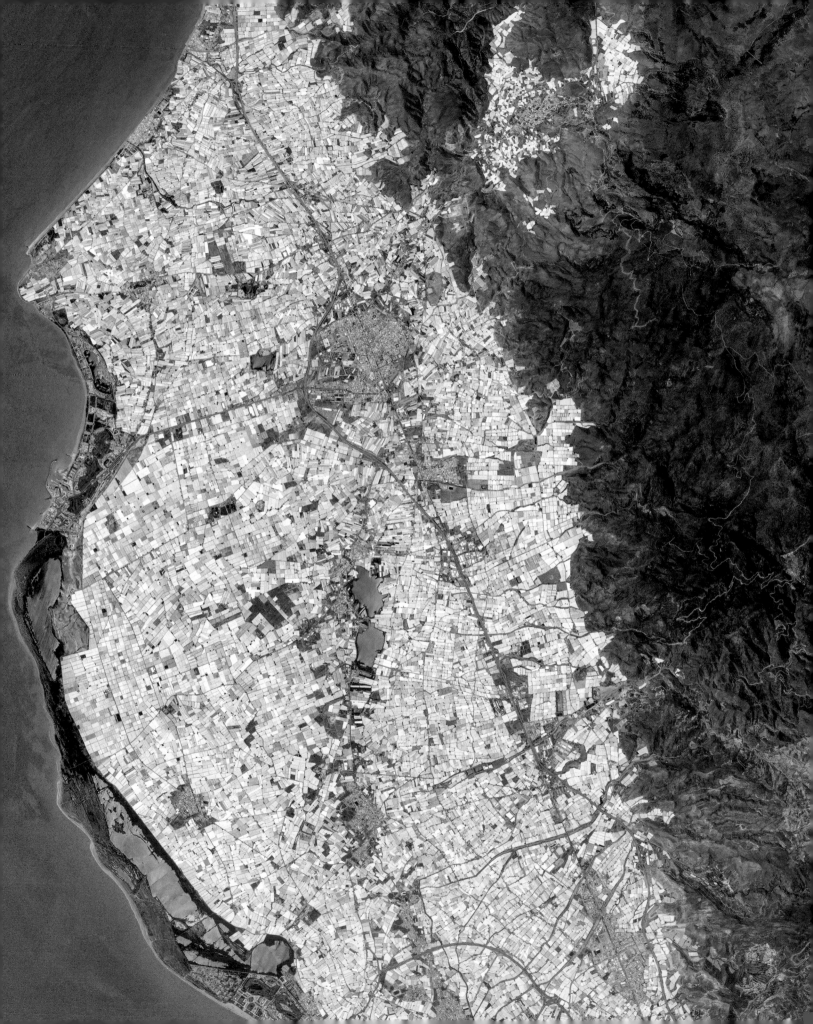

Greenhouses

The region of Almería in southern Spain is quite distinctive: The entire landscape is dotted with greenhouses, where fruits and vegetables are grown year-round. Seen from space, the structures shine brightly in the Sun. The Westland region in the Netherlands is quite similar. While the area sees much less light, its many greenhouses help farmers grow tomatoes much further north than nature would otherwise allow.

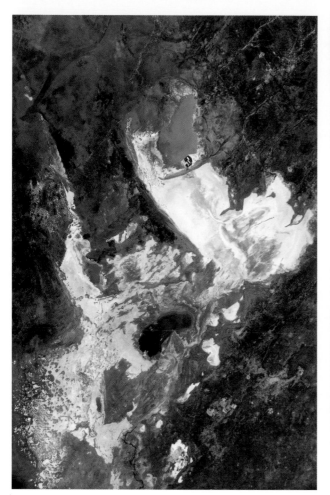

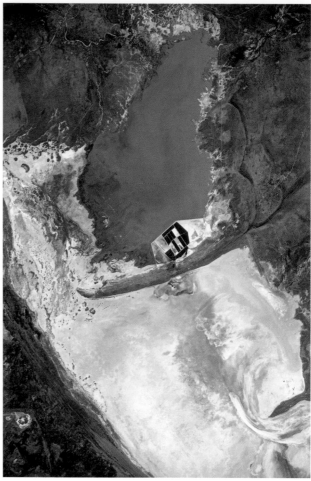

A Desert of Salt
Lake Makgadikgadi, a paleolake
in Botswana, Africa, is dry and
has become a huge salt desert of
aridity so extreme, only the majestic
baobabs seem able to endure it
(top left). However, during the wet
season (top right) it hosts elephants,
flamingos, thousands of zebras
and other wildlife. Salt marshes
also reform, providing a source for
water storage ponds; their red color
is created by sodium carbonate
(facing page).

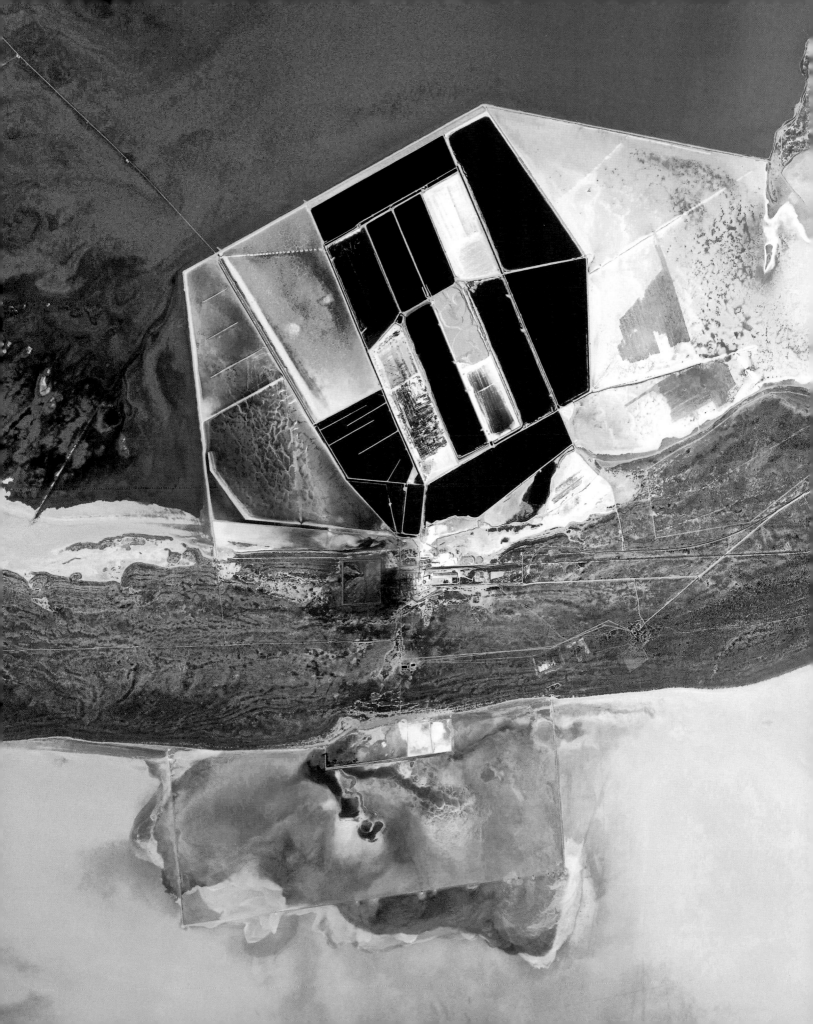

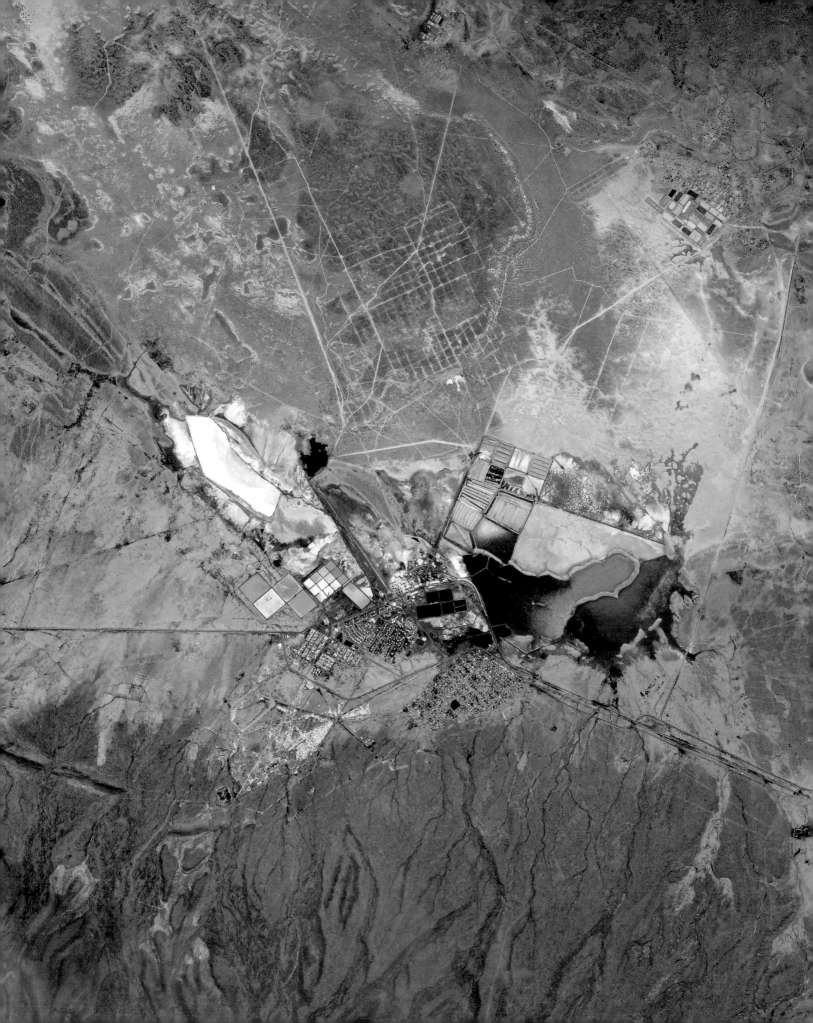

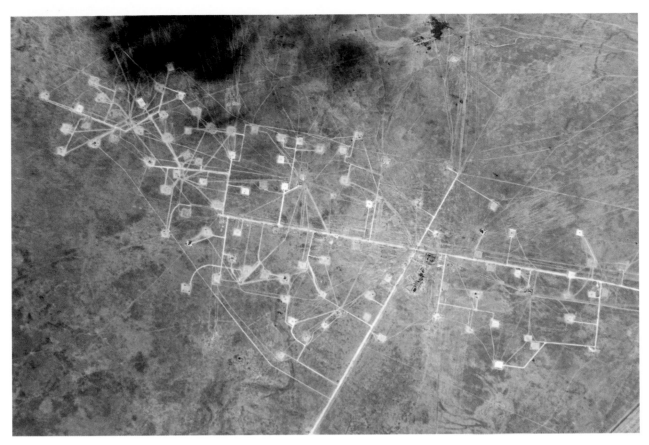

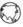

Daedalus
This photo shows hydrocarbon wells connected by roads in the south of Kazakhstan. This strange labyrinth seems to have been traced in the middle of a desert by Daedalus himself. While there's no lack of oil in the area, I certainly wouldn't want my car to break down if I was traveling here!

Cubism
In Mexico, salt marshes form almost fluorescent squares in the middle of sand-colored lands. Glancing at this photo quickly, you might think a cubist painter had drawn a macaque's face.

Geoglyphs

I had to wait several months before finally being able to take photos of the mysterious geoglyphs of Nazca, Peru. You can't see them with the naked eye from space, but I was advised to aim my lens at precisely the right spot. The result? Great lines that were drawn more than 2,000 years ago and are preserved today thanks to the region's extremely dry climate. If we could zoom in even more on this photo, we would see a spider, a hummingbird and many other designs. According to archaeologist Maria Reiche, nicknamed Lady Nazca as she dedicated much of her life to them, these lines could be evidence of early civilizations' astronomical calculations, much like a solar calendar.

Next pages
Red Chilies

Few countries offer landscapes as contrasted as Mexico, whose shapes and colors happily mingle here, creating a pretty patchwork. I don't know what gives the burgundy red fields their color, but I can't help but think of chilies!

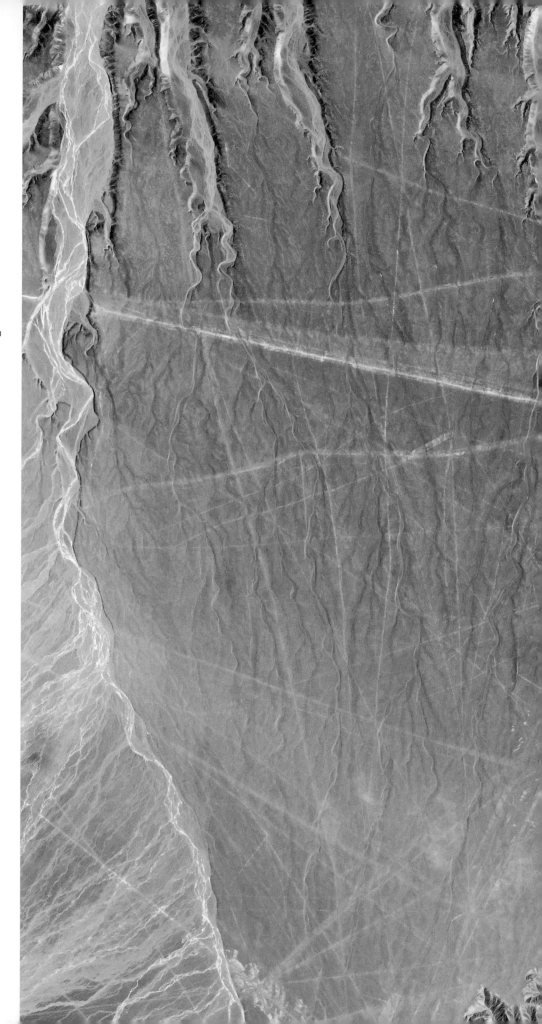

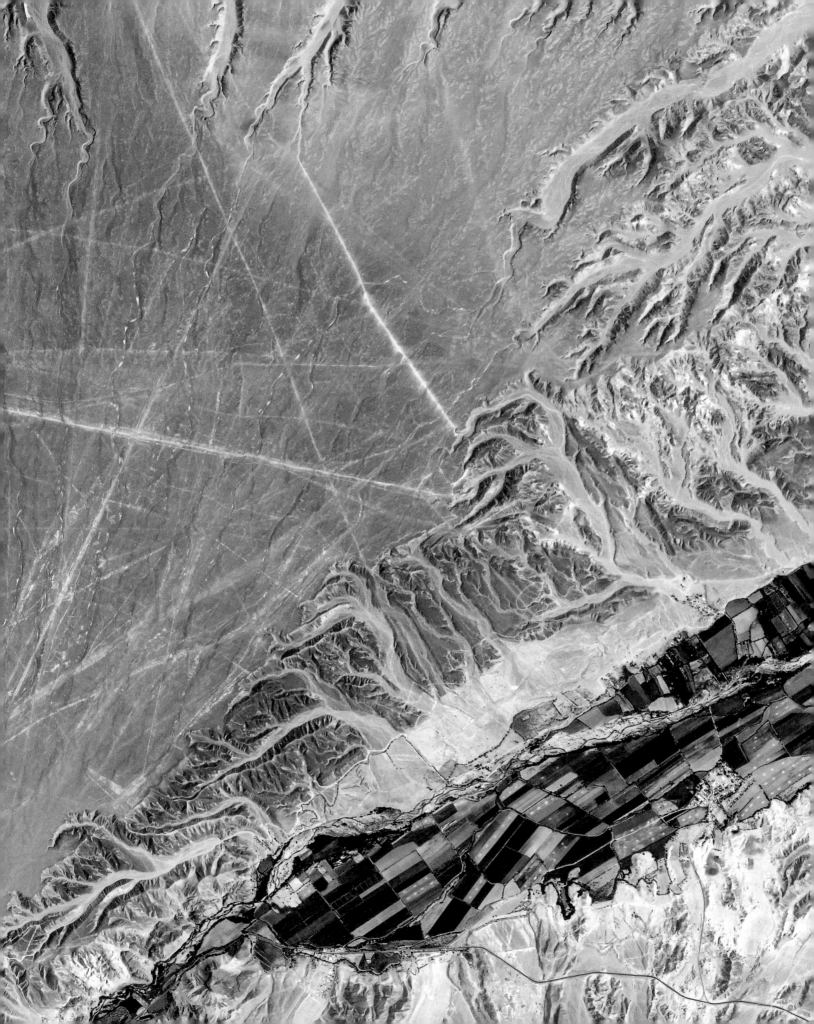

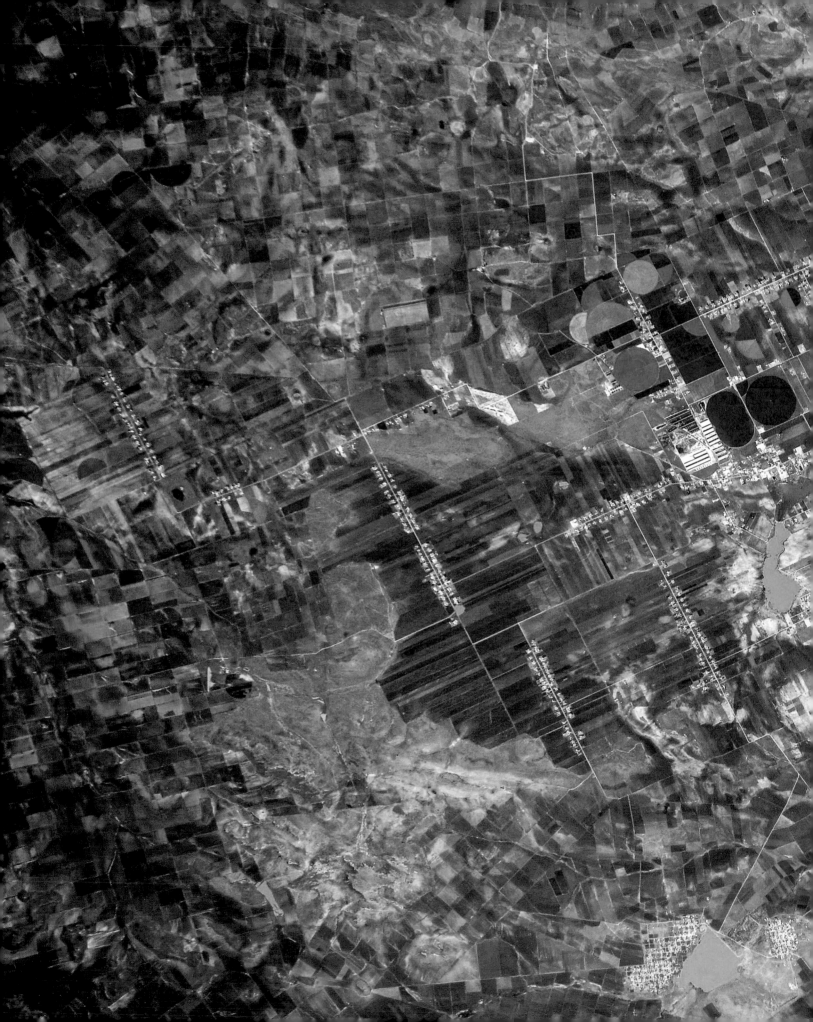

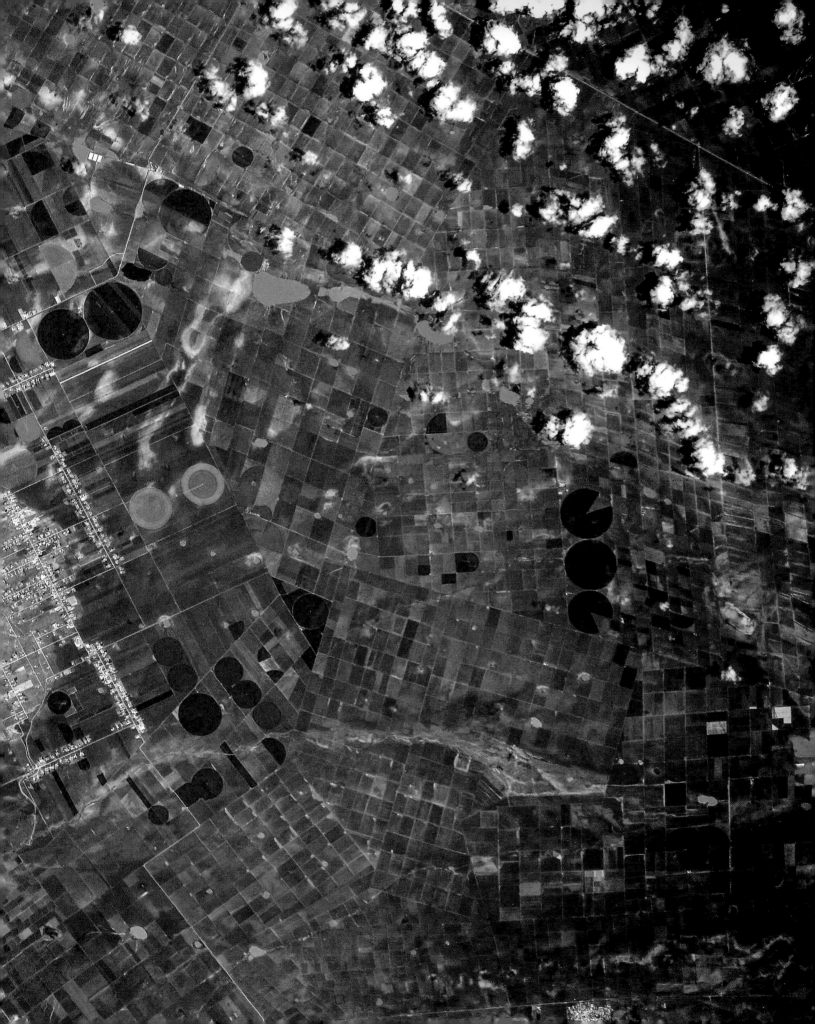

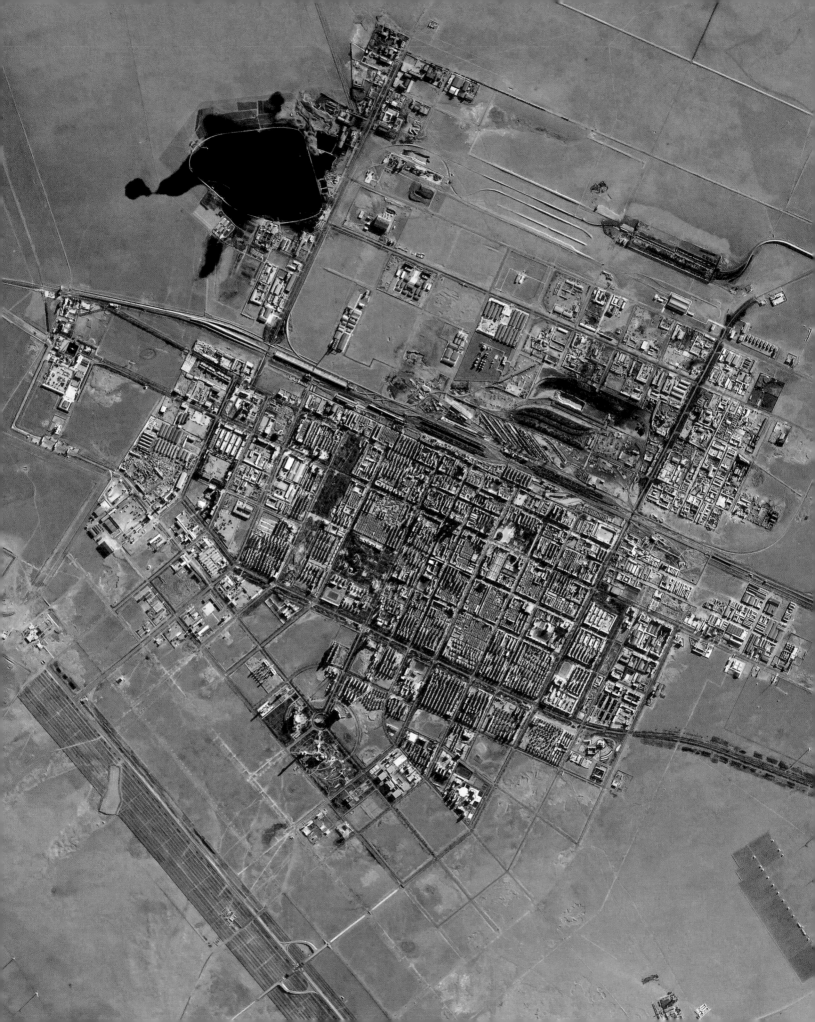

Cities

Train
These strange shapes and colors in the middle of the Gobi Desert caught my eye. It's the border city of Erenhot, between China and Mongolia, along the route of the Trans-Mongolian line of the Trans-Siberian Railway.

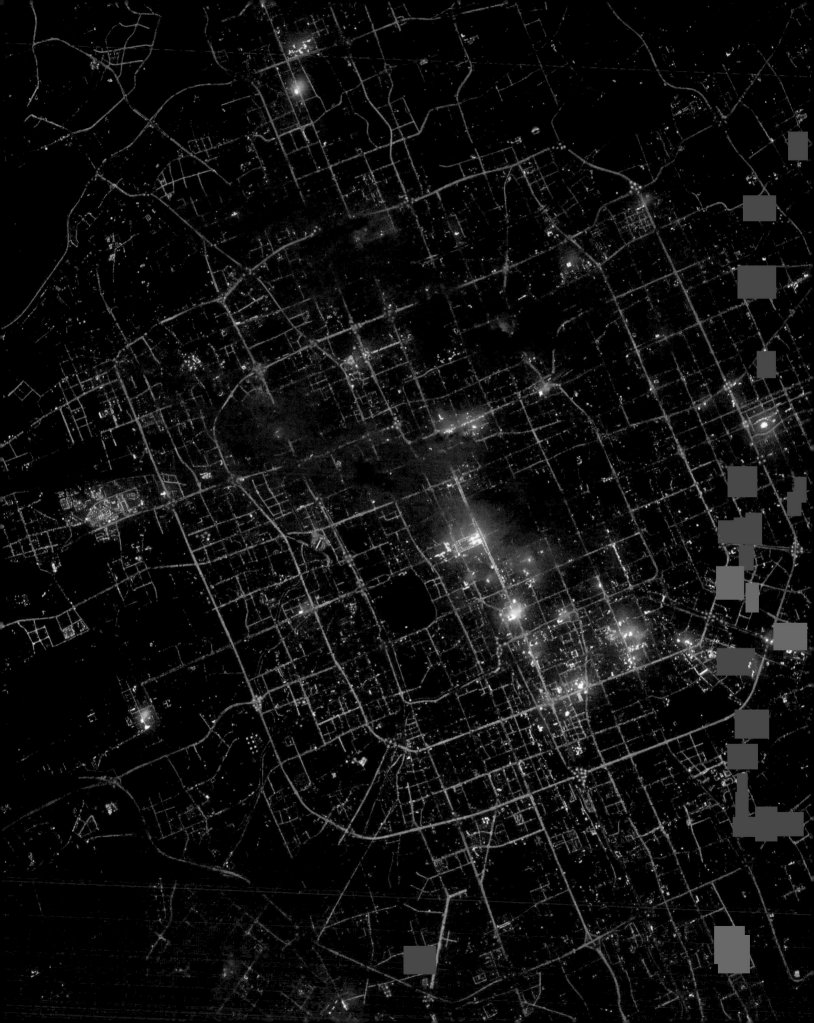

Every city tells a story. Some have sprung up in the middle of the desert, like Mecca and Las Vegas, while others prosper in symbiosis with important waterways, like New York and Conakry. Brand-new cities seem to appear in China regularly, while others in Europe date back to the 5th millennium BCE. Cities not only concentrate housing, transportation and economic opportunities, their lights attract hopes and dreams...

More than half of humanity now lives in urban areas. This is a fairly recent phenomenon in history. A little over a century ago, before the Industrial Revolution, almost the entire world's population lived in rural areas. From space, we can clearly see that urbanization is accelerating: According to the UN, seven out of ten people will be city dwellers by 2050.

Our planet is increasingly urbanized. This presents huge environmental challenges, including wastewater and waste management. Urban areas also produce two-thirds of the world's CO_2 emissions. The challenges are even more numerous in poorer nations, where urbanization is accelerating; for example, India alone has one-third of the world's 100 most polluted cities.

However, by associating, whether it be within a city or the ISS, people create more opportunities for cooperation. Together, it is possible to develop non-polluting transportation, sustainable housing, more efficient supply chains for food and other resources, energy savings and better protect coastlines.

Next pages
Holy City
Jerusalem's unique shapes and outlines create an almost mystical landscape. At the upper right edge of the densest area in this photo, two geometrical shapes stand out: the Temple Mount and the Esplanade of the Mosques, which are separated by the Western Wall (also known as the Wailing Wall). Rarely can one capture so much history in a single shot.

Ring Around the Roads
Beijing's famous ring roads draw very regular square patterns, surrounding the Forbidden City, which sits at its center.

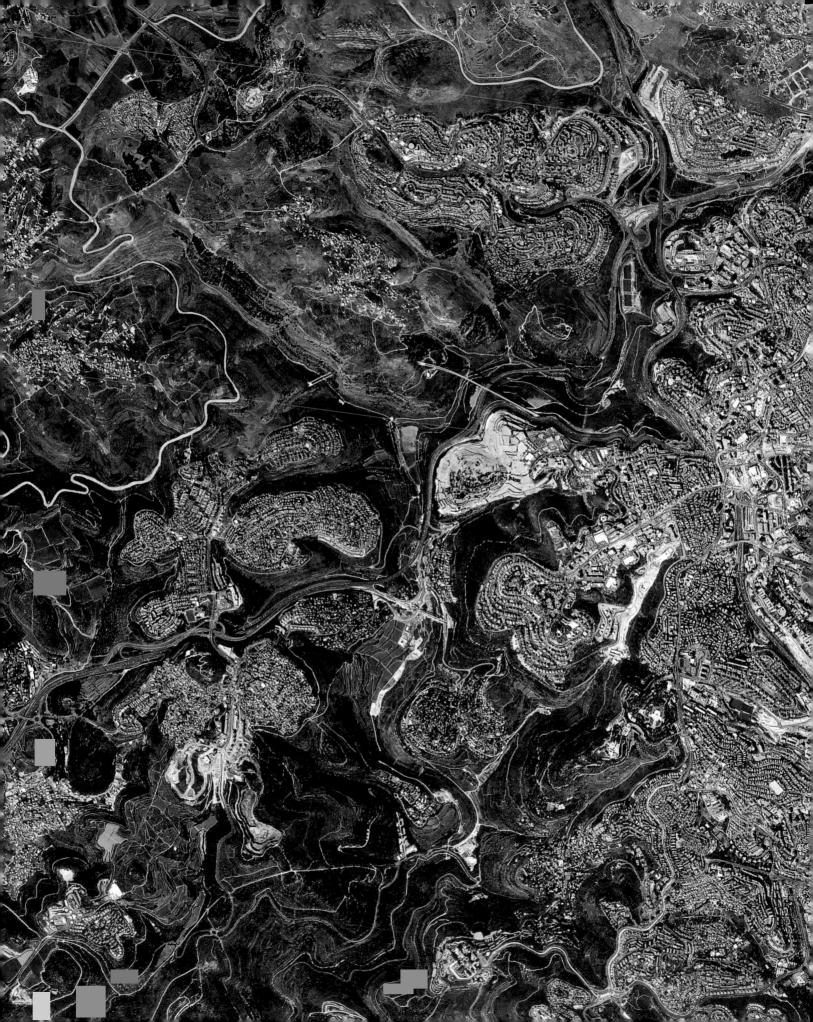

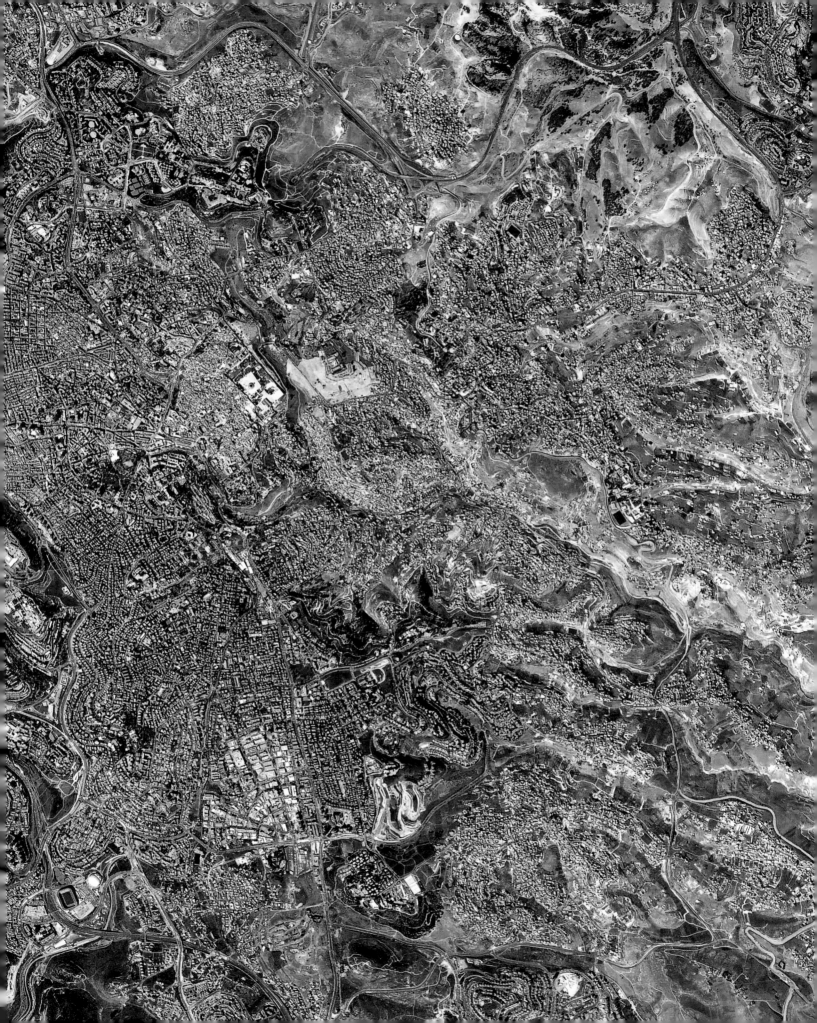

A Very Good Trip
This photo shows Las Vegas's more practical side! Its airport is very close to the center of town and the many casinos, which is certainly efficient...

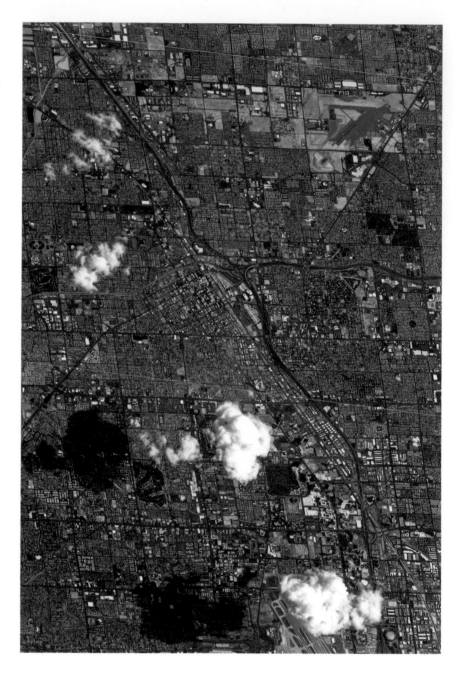

Another Very Good Trip
Las Vegas is much more animated at night, especially along the famous "Strip," where casinos and hotels are concentrated. Vegas is particularly easy to identify at night!

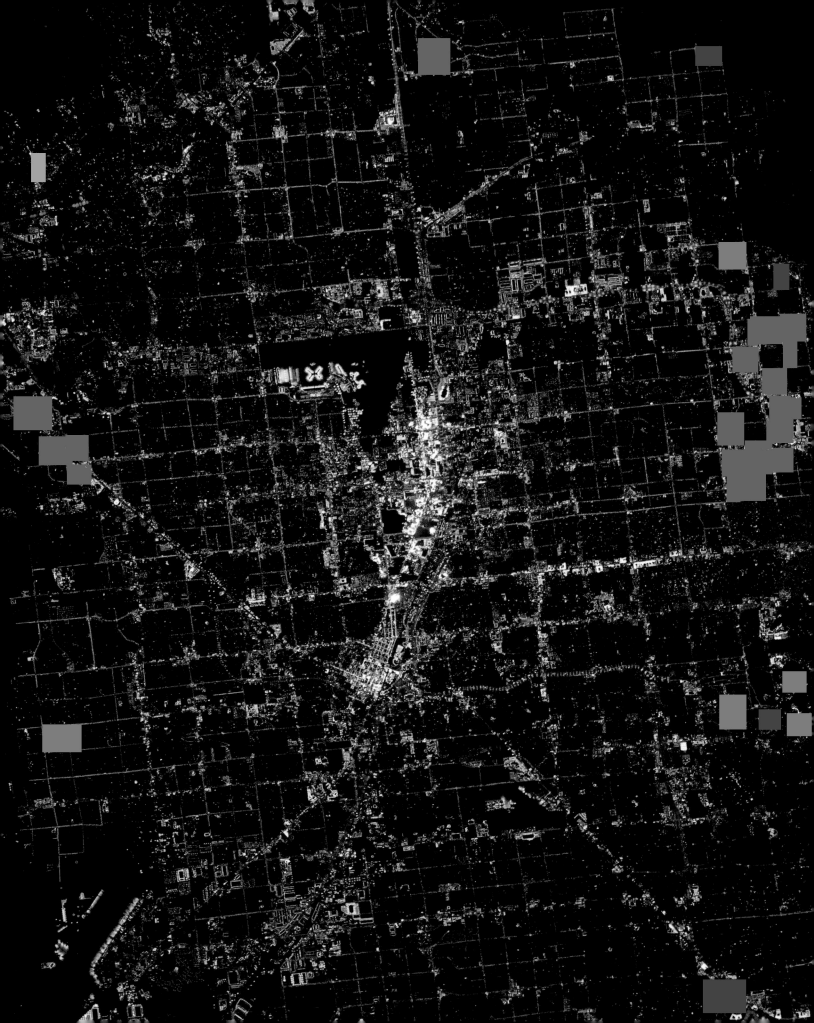

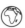

Giza
Here you can see both Cairo's sprawl and the famous pyramids of Giza. Egypt is certainly very photogenic.

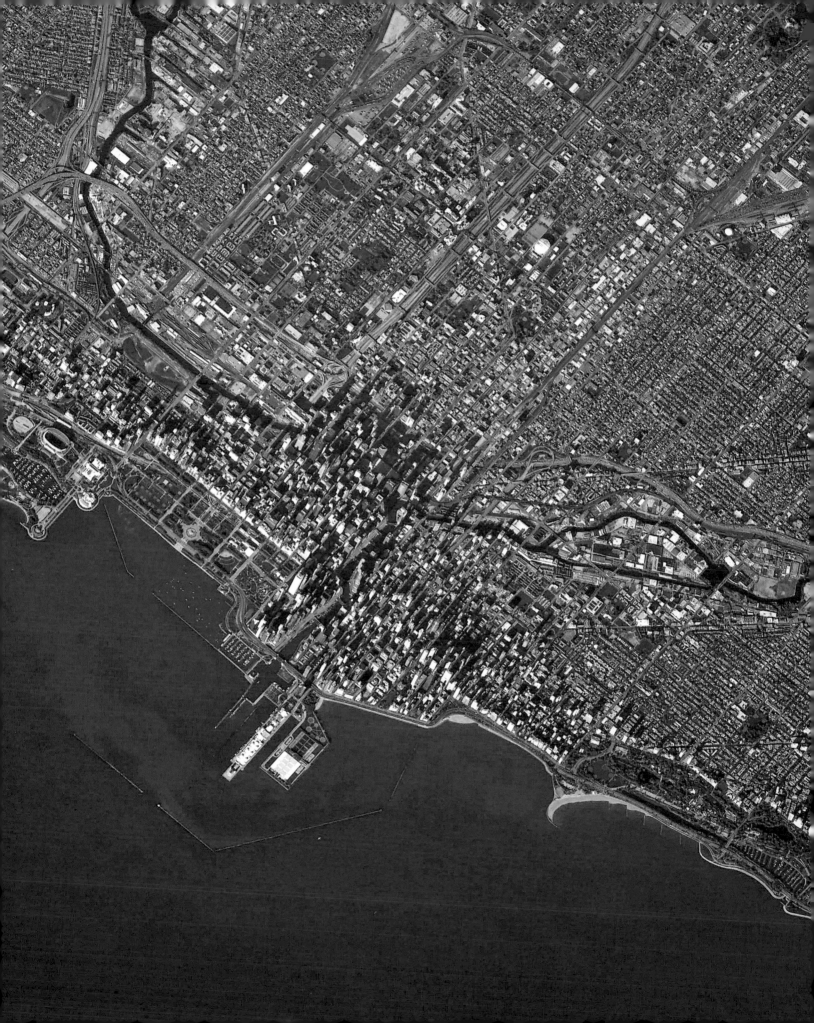

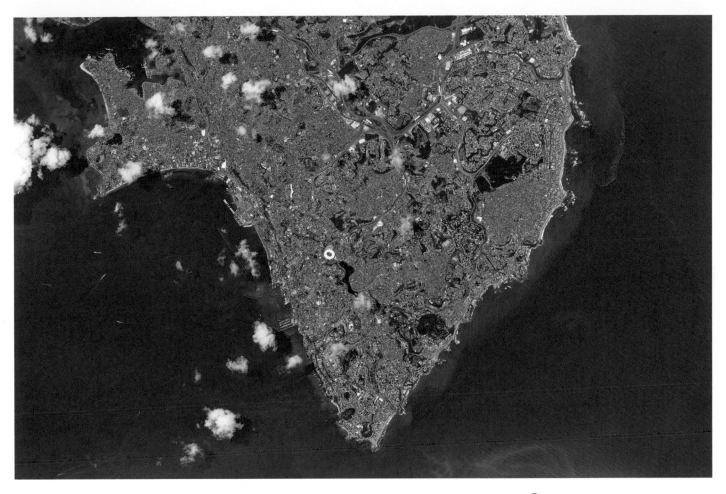

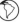

Soccer City
This photo does not do justice to
the charming and colorful streets of
Salvador de Bahia, Brazil, one of the
first colonial cities in the Americas.
It's also hard to distinguish the
280-foot (85 m) escarpment that
separates the upper and lower parts
of Salvador, which are connected
by an elevator. On the other hand,
Brazil's national passion is on full
display: The white circle that stands
out is, of course, a soccer stadium,
the Fonte Nova.

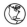

Skyscraper
The Port of Chicago is a gigantic
infrastructure on Lake Michigan, in
the heart of the inland sea formed
by the Great Lakes. Chicago is not
only the birthplace of skyscrapers in
America, but the world. The very first
one was built in the city in 1885.

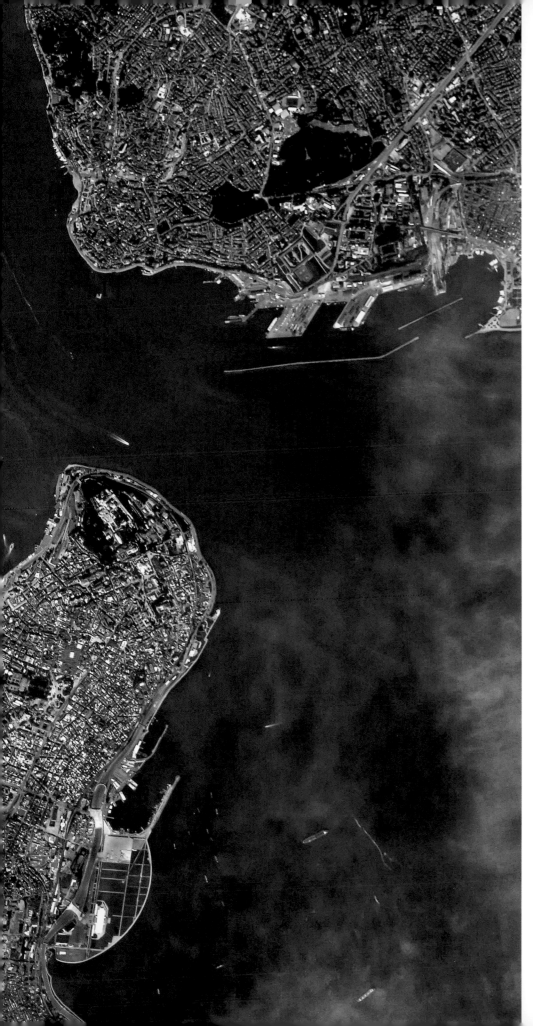

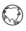

Istanbul

Ancient Byzantium, which became Constantinople and then Istanbul in the 1920s (in modern-day Turkey), is a city that straddles two continents. Its layout is indecipherable from space because it is so complex, but we can still distinguish some architectural treasures, including the Hagia Sophia, the Sultan Ahmed Mosque (known as the Blue Mosque), the Nef Stadyumu (Nef Stadium) and the Topkapi Palace. The Galata and Atatürk Bridges, which span the Golden Horn, are also visible. At the top of this photo, we can see how the Bosporus Strait provides access to the Black Sea, giving Istanbul its strategic importance.

Energy

Located on Africa's Cape Verde peninsula, Dakar, Senegal, is easy to spot from space. I'm reminded of the famed Aéropostale, the exploits of French aviator Jean Mermoz, the giants of Senegalese wrestling, the sculptures of Ousmane Sow... However, this jewel of the West African coastline is becoming increasingly urbanized and experiencing numerous environmental challenges as residents try to strike the balance between promoting economic prosperity and protecting fragile and unique fauna and flora.

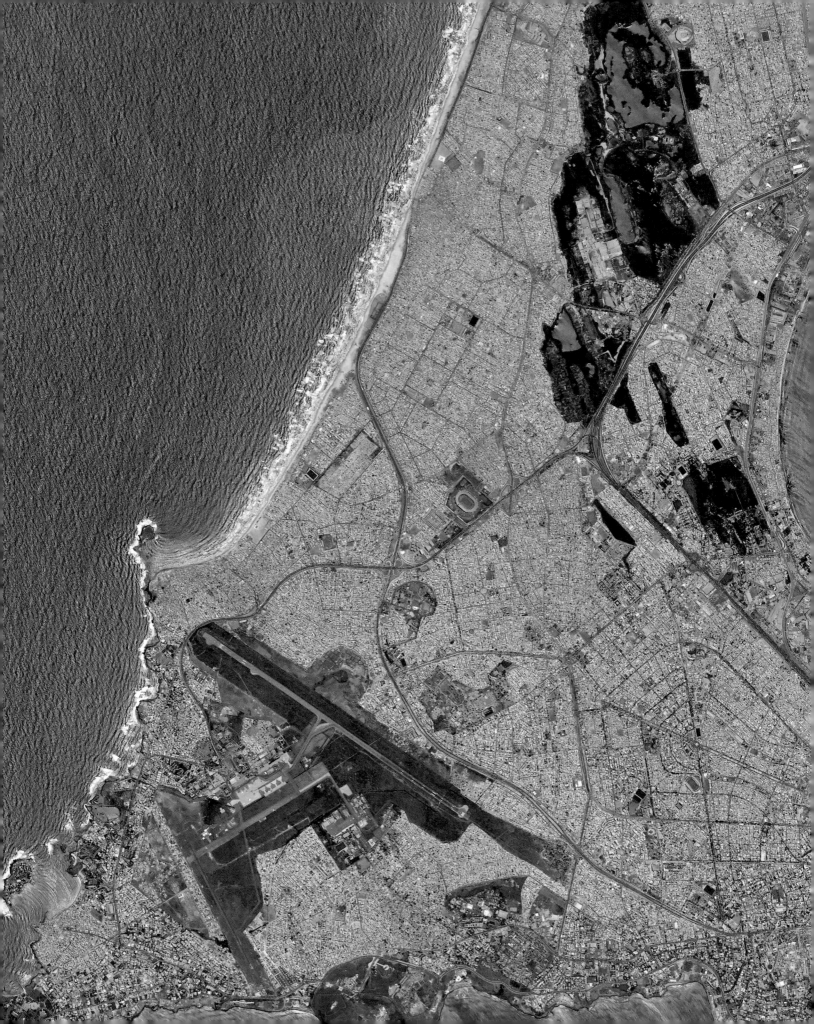

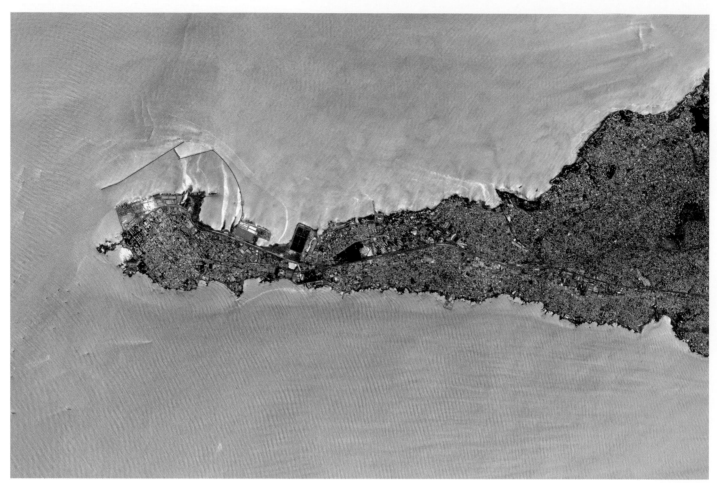

Density
The urbanization of Conakry, the capital of Guinea, Africa, began at its port. Houses and roads have since spread throughout the entire peninsula, toward the coast and beyond.

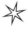

Sudan
What look like black flames and red-orange flares assailing the city of Ed Daein (in Darfur, western Sudan) are not, in fact, cause for concern. This "fire" is just an illusion. Another equally astonishing visual effect is created by the stark contrast between the very geometric layout of the streets and the desert that surrounds them.

Next pages
The Masks of Venice
Venice, its lagoon, its bridges, its canals... The floating city is easily recognizable from space, even as it changes as light shifts and is reflected differently by its many waterways. The acqua alta, regular floods due to the tides, may sometimes submerge the lower parts of the city, but they never take away its shimmering beauty, like a carnival mask.

247

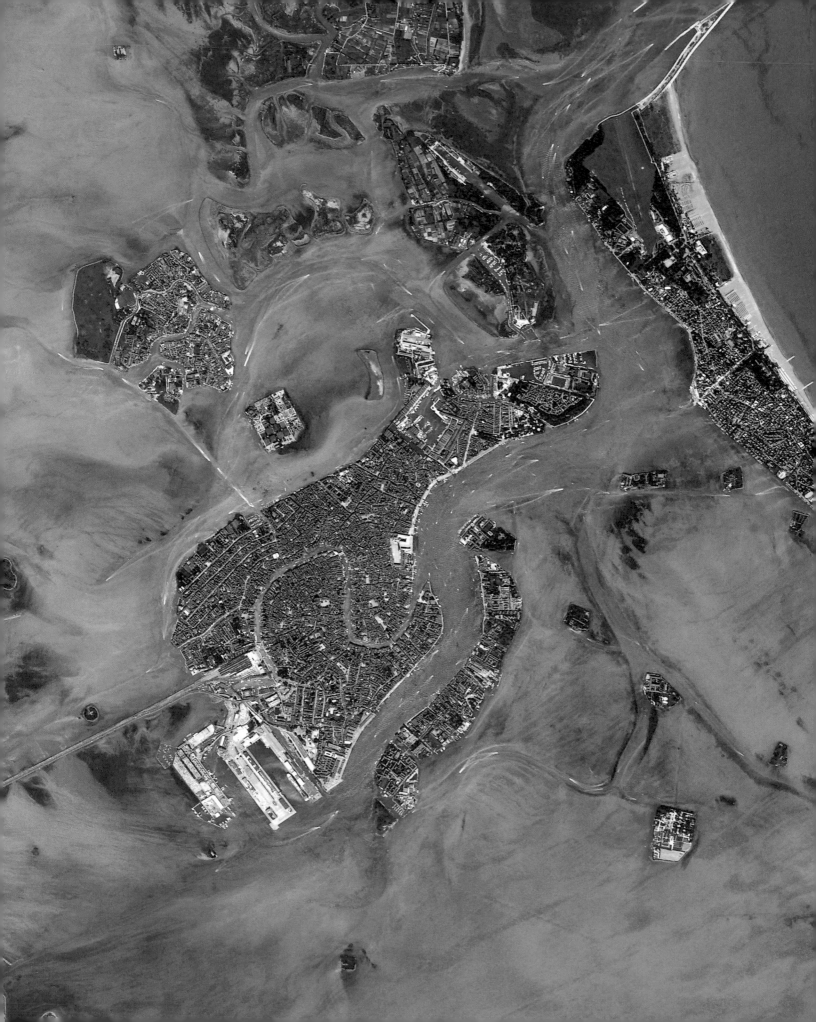

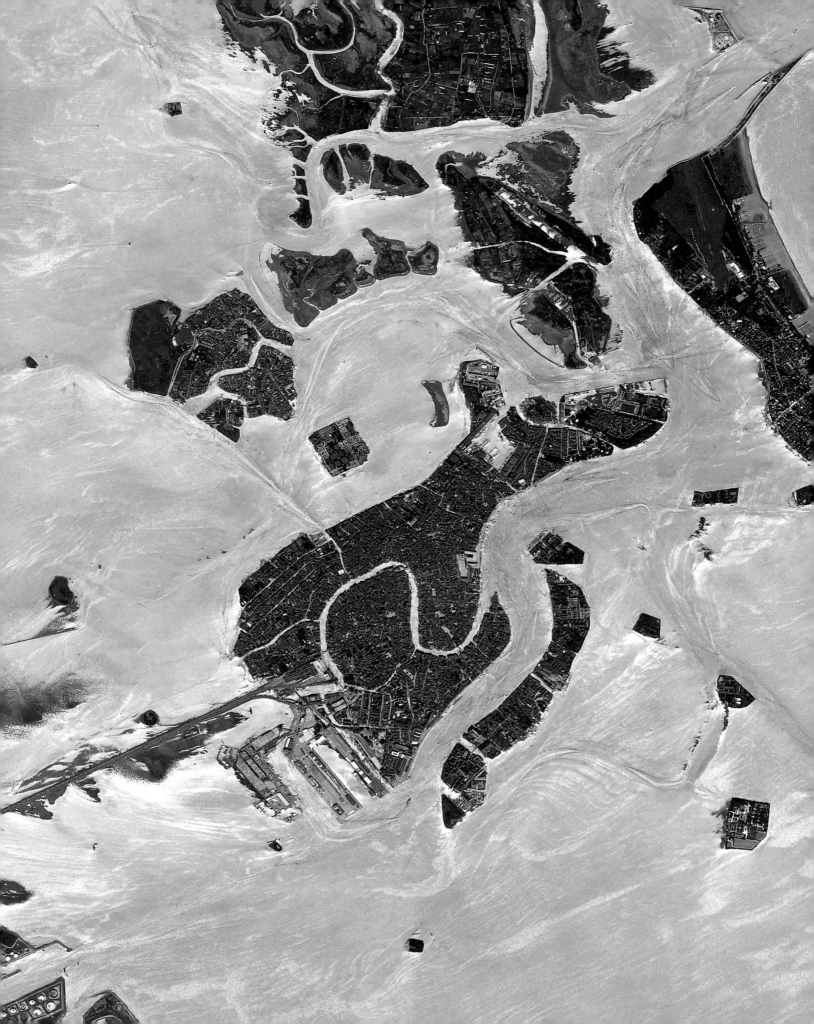

Doha and Aleppo
Seoul and Madrid
Kuwait and Kuala Lumpur
Space provides an excellent vantage point to compare cities around the globe. This is even more true at night, when their structures almost appear to luminesce. What is often most striking are the differently colored lights, sometimes even within the same city. This contrast is actually quite easily explained by the use of different types of streetlights, such as sodium vapor lights, fluorescent lights and LEDs.

The layout of streets is often quite informative: Old cities are usually structured in a concentric way, having been built along ramparts or walls around a specific feature, such as a hill or river, while more modern cities, such as major centers in China, the United States and the United Arab Emirates, are often built at right angles, which facilitates transportation and, no doubt, also asserts the order that humanity's hand has imposed on these once wild spaces.

Next pages
The Kaaba
Mecca was so bright that this photo is a little overexposed. I wanted the lights to be visible. Emerging out of the desert between the Sarawat Mountains and the Red Sea, Mecca is Muslims' most sacred city. The hajj, a pilgrimage practiced since the 7th century CE, is one of the five pillars of Islam. One can distinguish the Kaaba, a cube-shaped structure circled by around two million pilgrims every year, day and night. The Islamic tradition has two Kaaba: this earthly one, and a heavenly house for the angels.

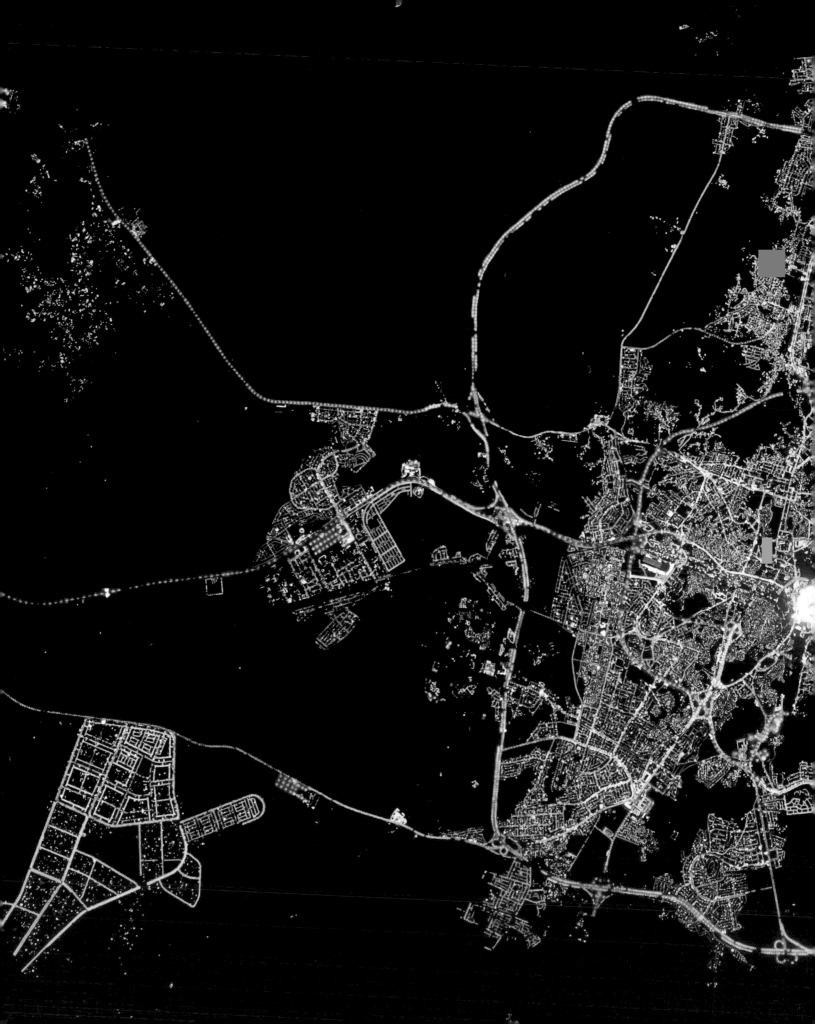

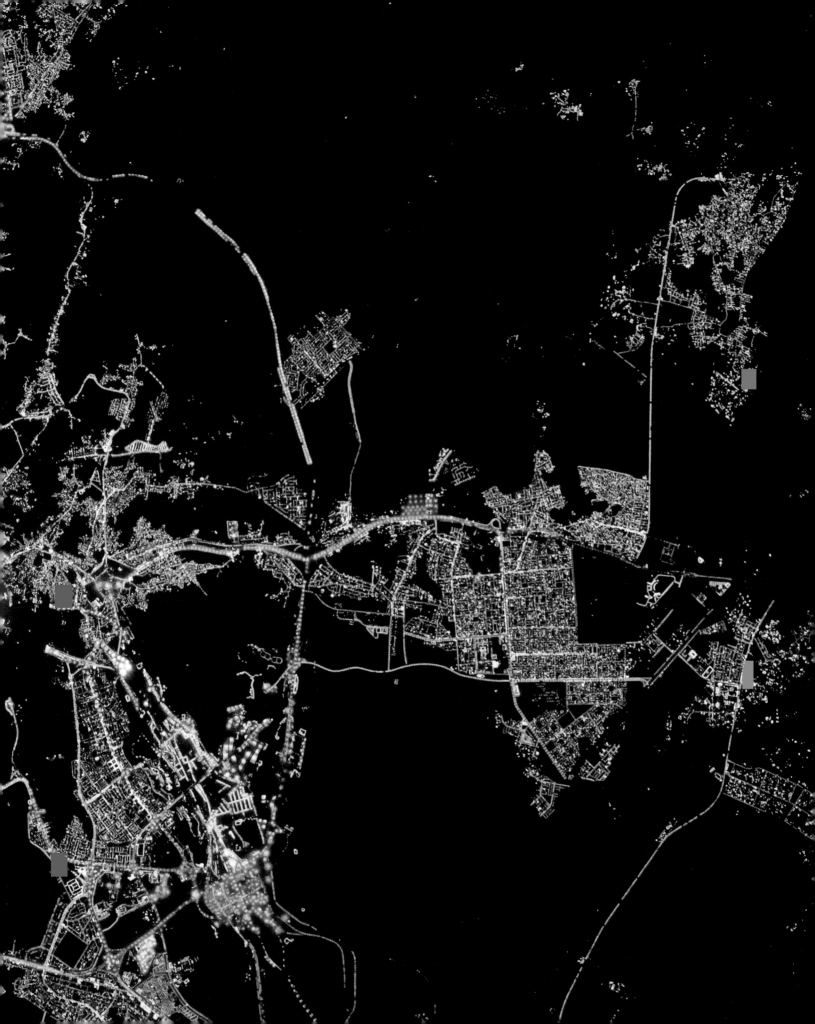

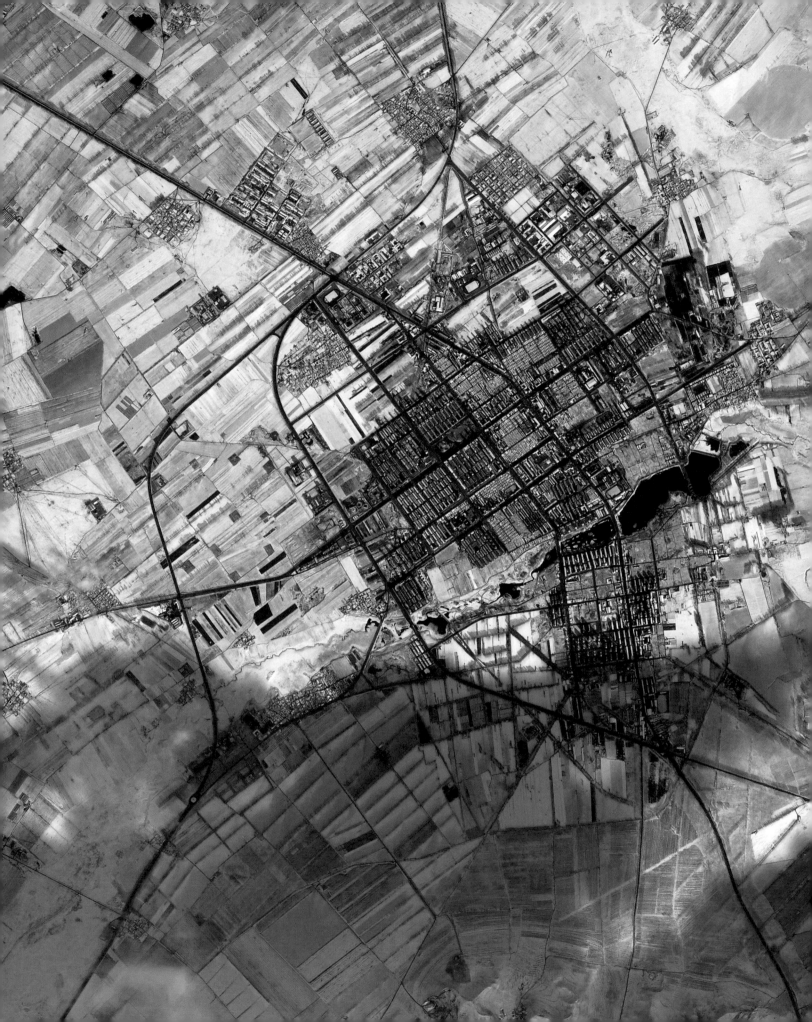

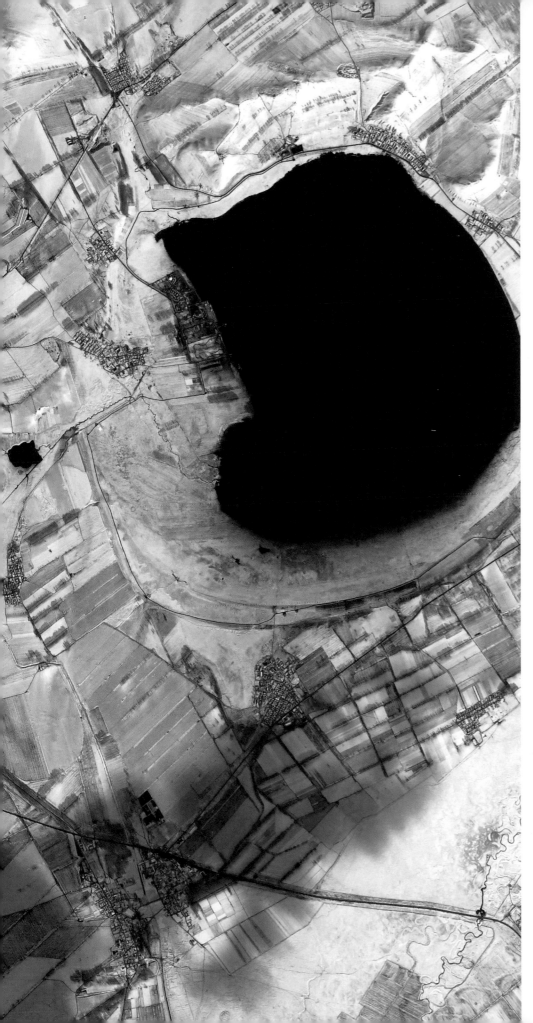

Summer Snow
Alpha was a summer (in the northern hemisphere) mission. While this didn't really affect the temperature inside the station (or outside it, for that matter), I saw many more snowy landscapes during my first mission aboard the ISS. As compared to the northern hemisphere, the southern hemisphere has much less land along the latitudes that receive snow during its winter. However, the northern hemisphere was not completely devoid of snow during its summer, as seen here in Xi'an, near Guyuan in northern China.

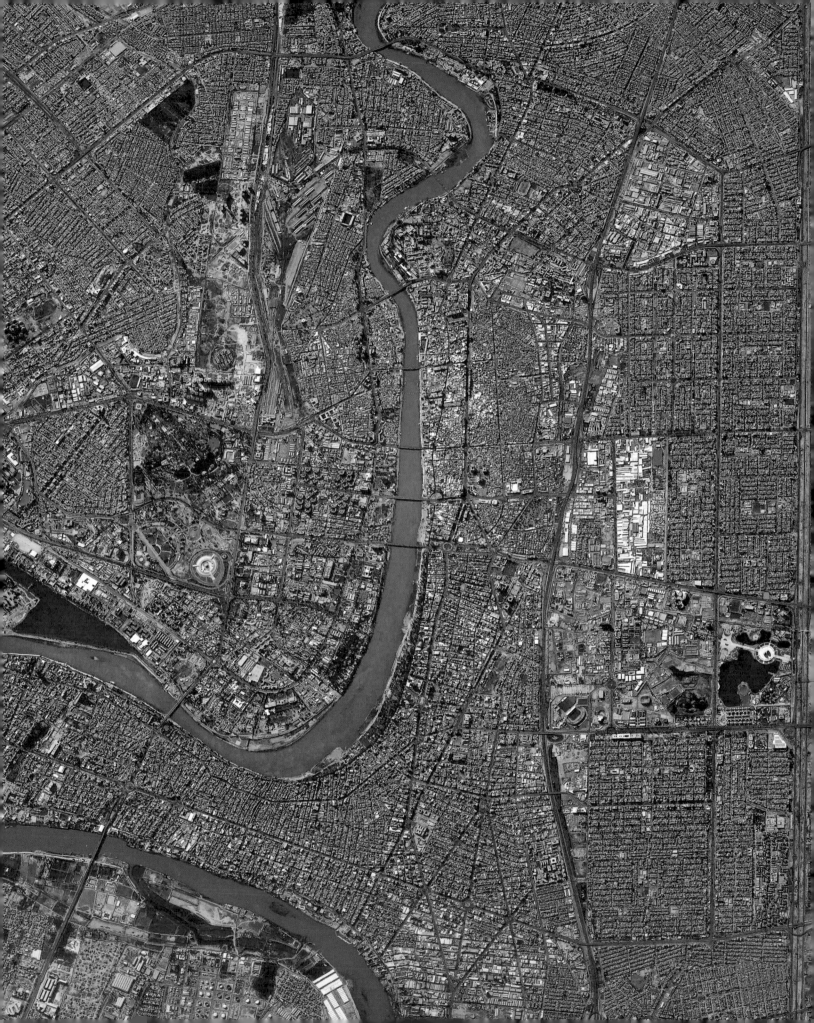

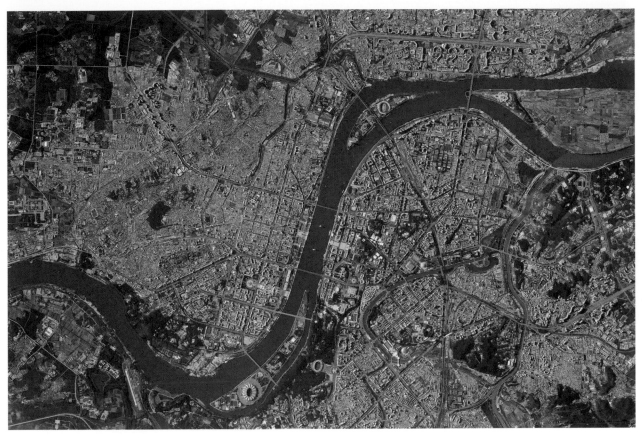

North Korea
Few people have the opportunity to zoom in on P'yongyang, which makes this shot a good opportunity to explore it — you and I will probably never get a closer look at the city. Crossed by the Taedong River, P'yongyang has a population of about 3.5 million. Like Seoul, its South Korean twin, it is much older than its current appearance might suggest. It had to be almost completely rebuilt after the bombings of the Korean War.

Peace
Despite its war-torn history, Baghdad, in the heart of the Fertile Crescent and ancient Mesopotamia in modern-day Iraq, looks almost serene in this photo. When it was founded in the 8th century CE, it was named Madinat as-Salam, which means "city of peace" in Arabic.

Next pages
Tokyo by Day and by Night
Tokyo is sprawling by day and dreamlike by night. Clouds covered the countless lights of the city, giving it this dim and hazy appearance.

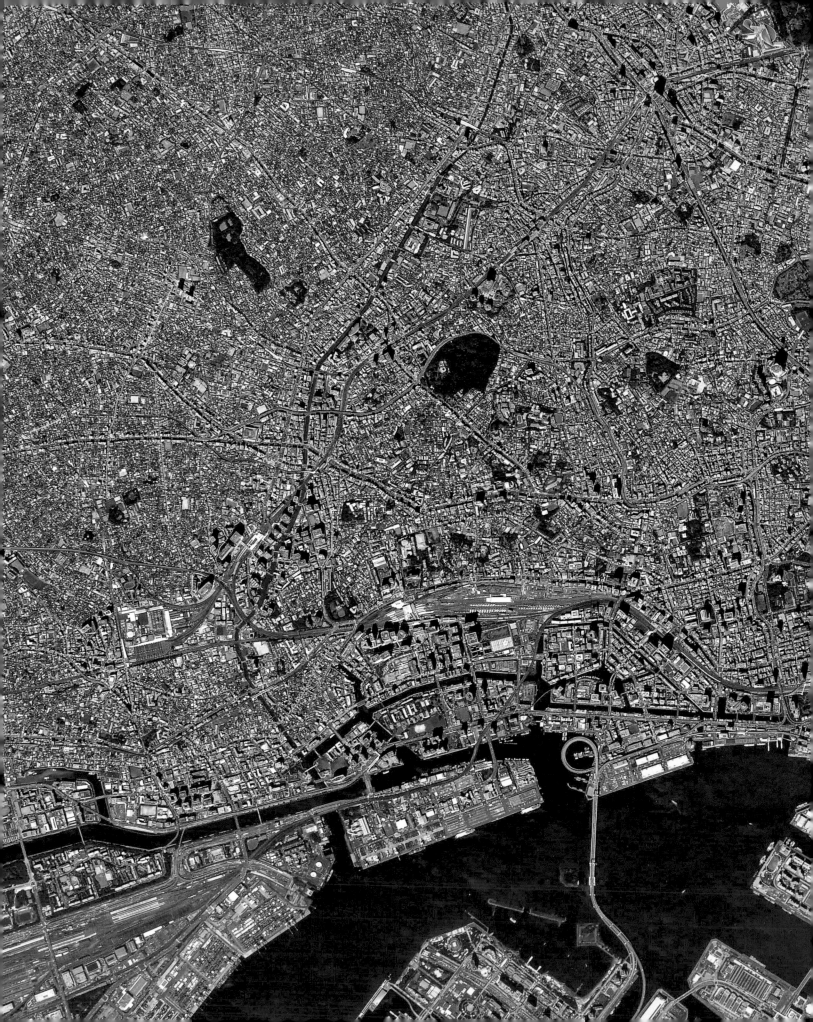

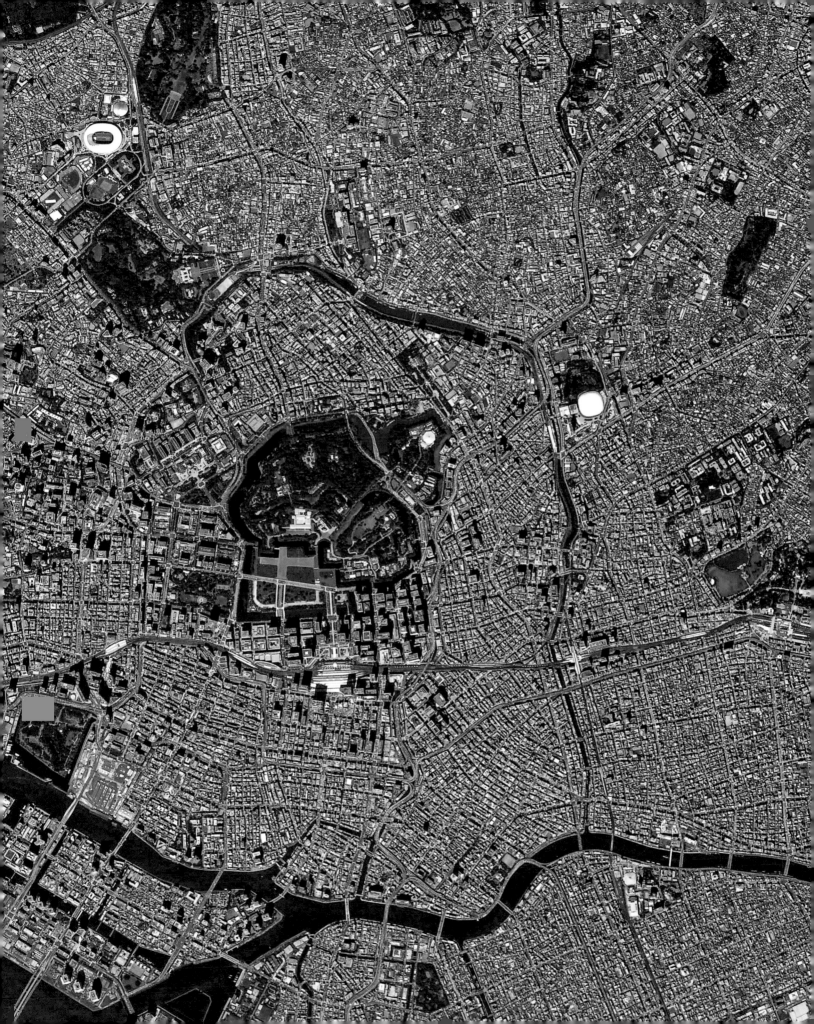

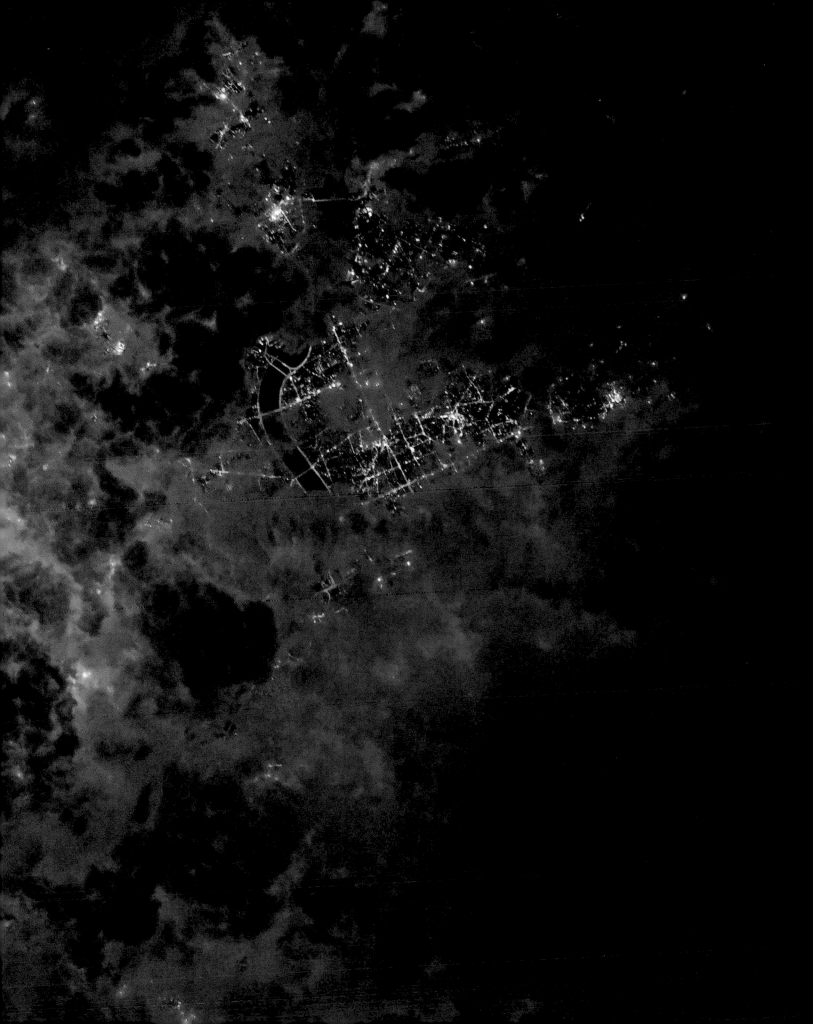

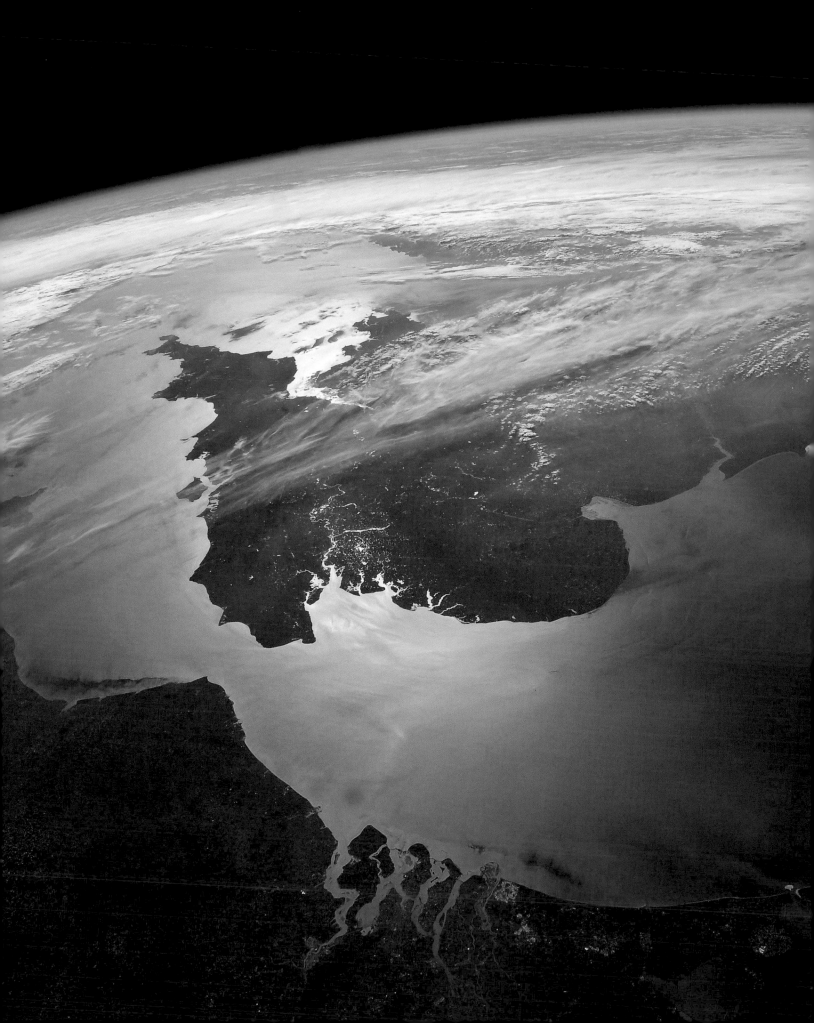

Borders

The United Kingdom
An early evening passage over the English Channel, with England lit by the setting Sun and Scotland under clouds.

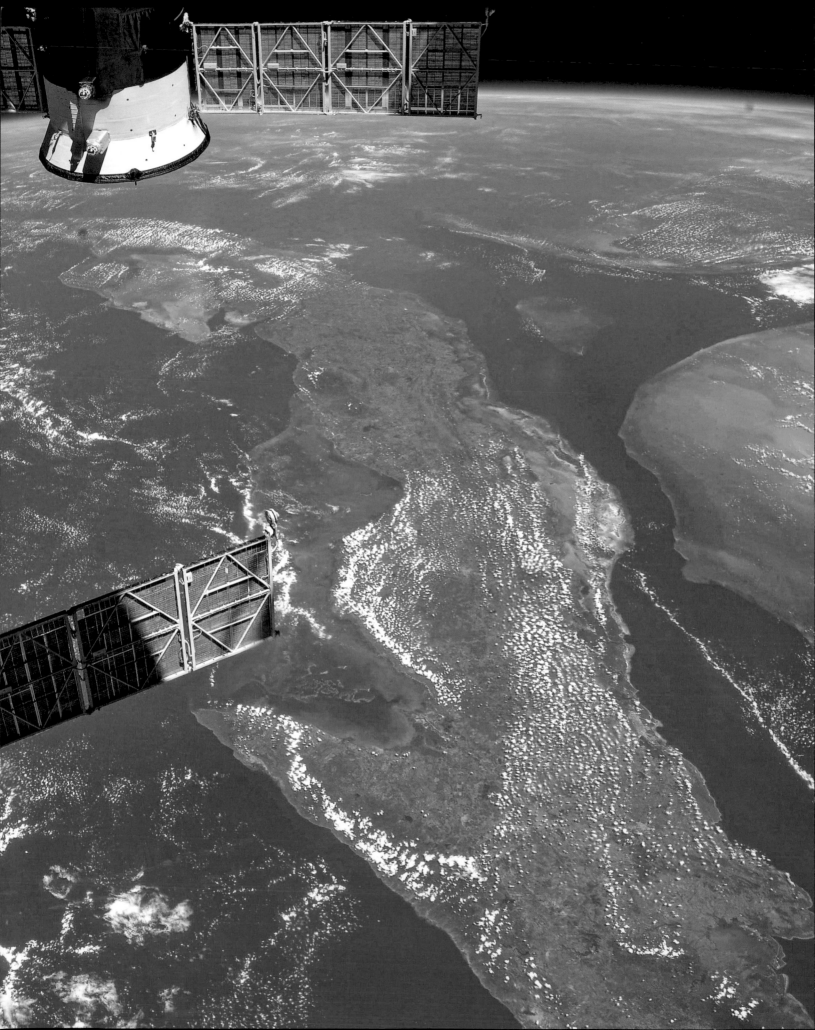

The ISS, a resounding success of international cooperation, is basically an assembly of different modules, each built in a different corner of the world by a variety of engineers, technicians and workers who do not speak the same language and have different cultures but who choose to share the values of space exploration. For ease of understanding among ourselves, it is customary to divide the station into "segments" based on the nationality of the builder. This is obviously a shortcut, since the ISS, even though it is the largest spacecraft ever built, is not marked by borders where you have to show your passport! On board, we are all members of the same crew.

From the station, we fly over both natural borders, such as rivers and mountain ranges, and those drawn by humans. They all reflect a rich and sometimes difficult history. Even if national borders do not extend into space (they only apply to land, sea and air), there is a strategic aspect to our activities in orbit. In space, there is a particular solidarity that can unravel even the strongest conflicts. The Outer Space Treaty, adopted in 1967, at the height of the Cold War, clearly specifies that all states "shall regard astronauts as envoys of mankind in outer space and shall render to them all possible assistance in the event of accident, distress, or emergency landing on the territory of another State Party or on the high seas."

This propensity for space travel to transcend borders is for me a real vector of hope. Seen from up there (and without minimizing the impact on victims), the trials and tribulations of diplomacy and quarrels between states sometimes seem trivial. Having succeeded in uniting in the name of positive and peaceful values in order to build this vessel that is almost beyond comprehension seems to me to be a formidable achievement, so much so that some people (even if the initiative did not succeed) have nominated the International Space Station for the Nobel Peace Prize.

Cuba
This view brings back memories... I first arrived at the ISS in 2016 in a Soyuz via this docking port. Oleg, Piotr and Mark's Soyuz is called "Yuri Gagarin" and flies over Cuba. I can't help but find that a hint of the 1960s inhabits this photo.

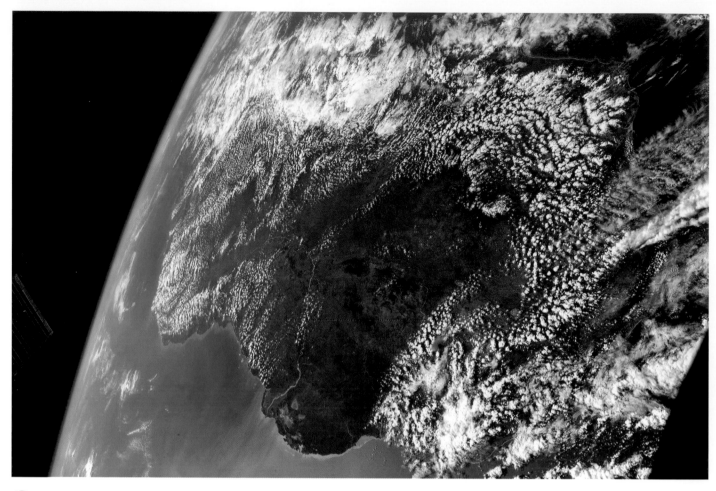

Madagascar
The island of Madagascar is so big that I had a hard time fitting it into the frame! The fifth-largest island in the world, Madagascar looks like a continent, even though it is slightly smaller than Texas and the Indian Ocean is its only border.

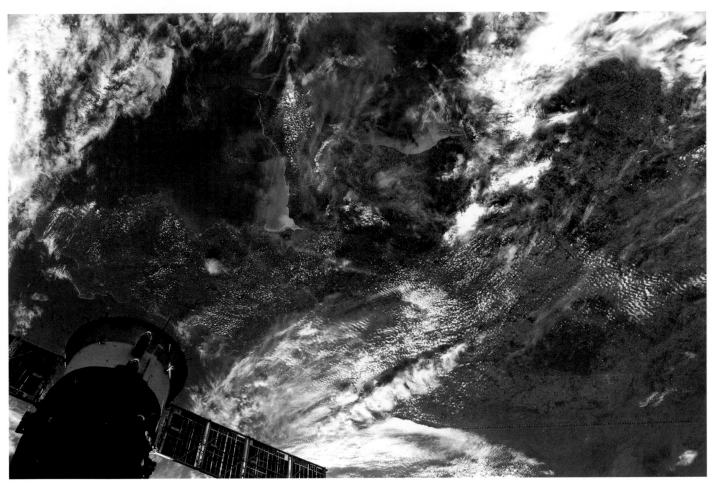

Brittany and Normandy
In orbit at 250 miles (400 km) above Earth, it is difficult to discern the border between Brittany and Normandy. The regions have a rather good-natured rivalry that centers around cider, Mont-Saint-Michel, butter and the weather!

Next pages
Rio Pequeño?
The city of El Paso has continued to expand near the Rio Grande, along the U.S.–Mexico border. On the other side of the river stands Ciudad Juárez, which is El Paso's Mexican neighbor. Both cities witness the river dry up every year. The runoff from melted snow in the surrounding Franklin Mountains is also dwindling.

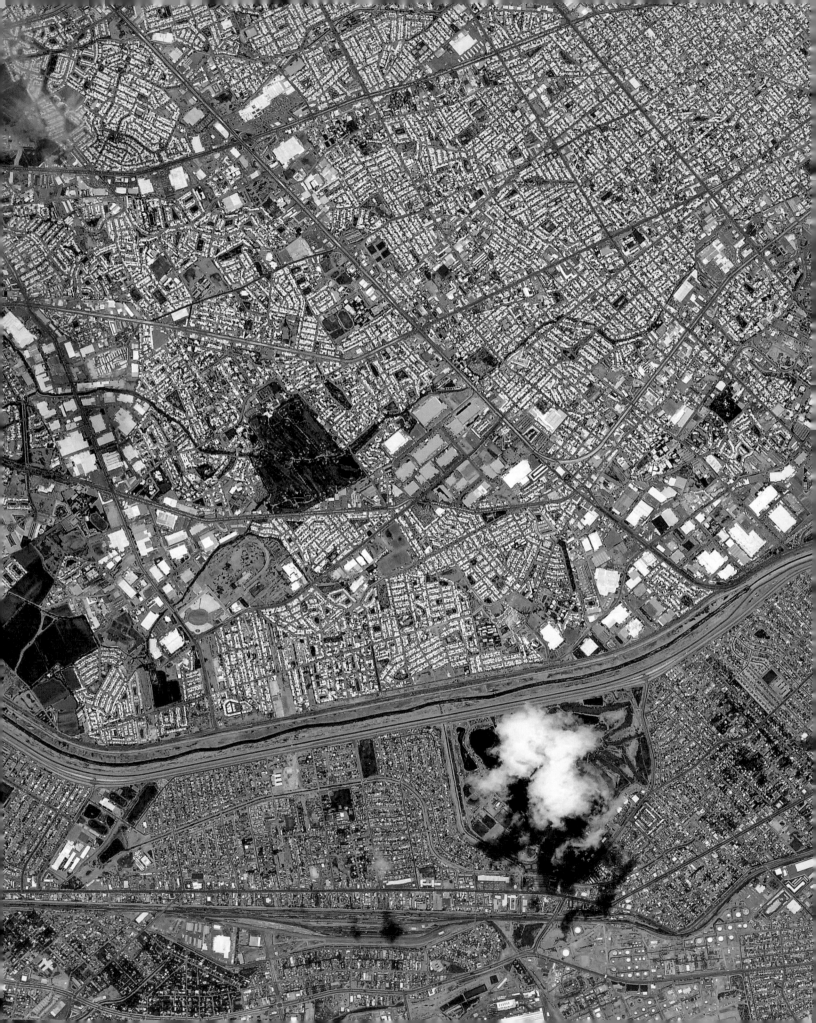

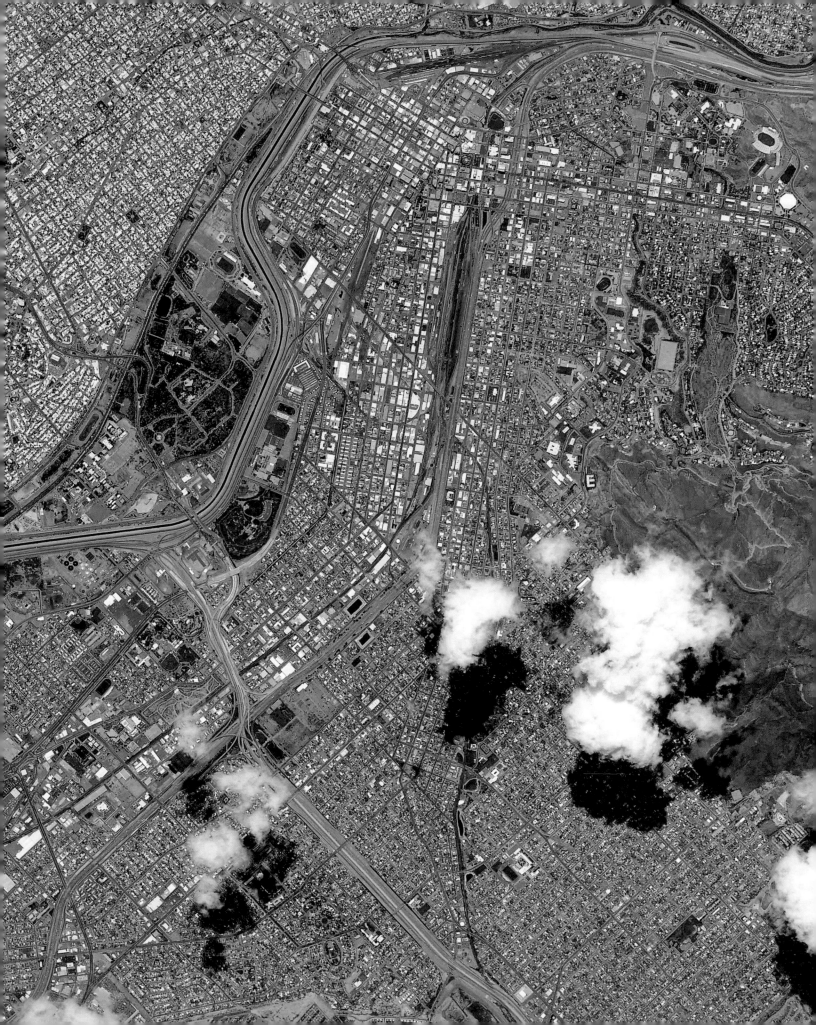

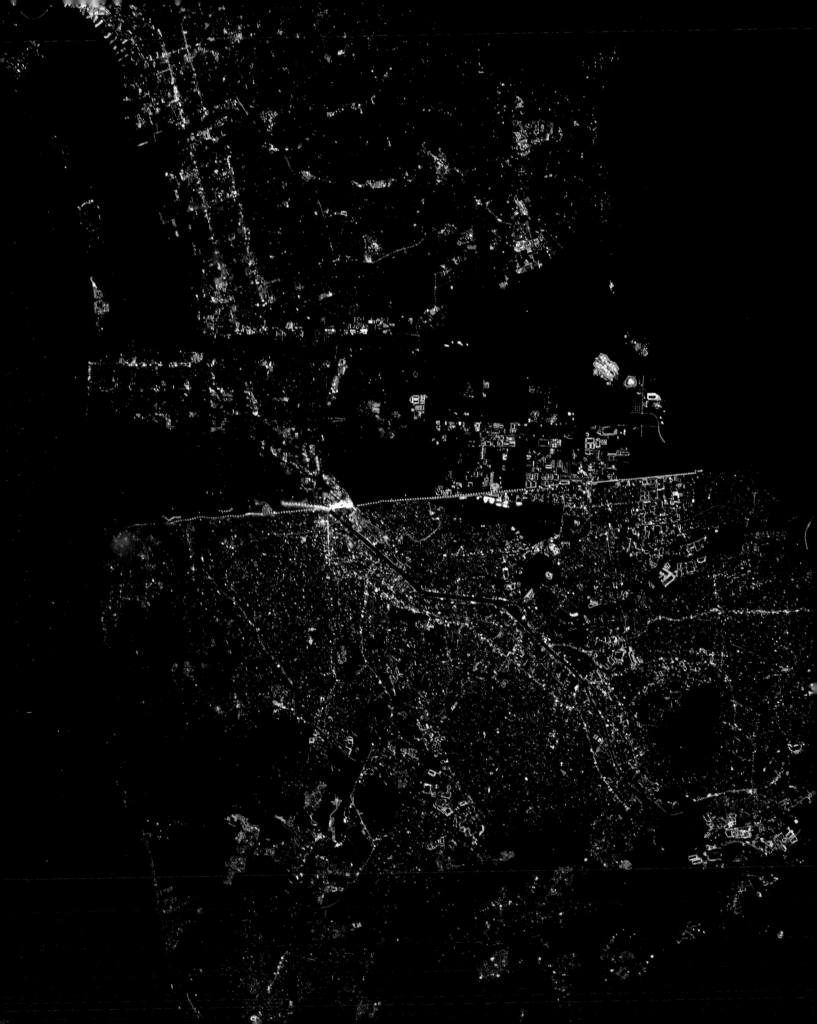

Southern California
The border between the United States and Mexico, night version: San Diego in Southern California and Tijuana in Mexico. The area is a highly guarded crossing point and is therefore lit up like a stadium. The difference in housing density (and street lighting) between the south and north can be clearly observed, surrounded by the classic natural border of the deep black ocean.

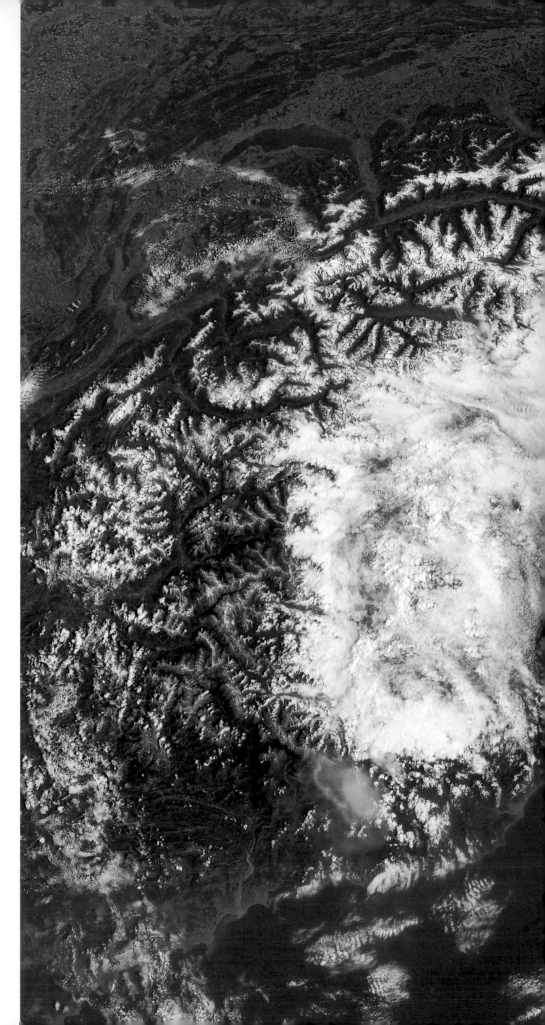

The Climatic Frontier
Looking at this photo, we can understand why the Alps are a huge climatic barrier, influencing the weather all over Europe and helping to form many of the major winds that blow across the continent. They are also a historical border, which has seen its share of epics and dramas, from Hannibal and his elephants centuries ago to today's migrants who cross them on foot in the snow in search of a better future.

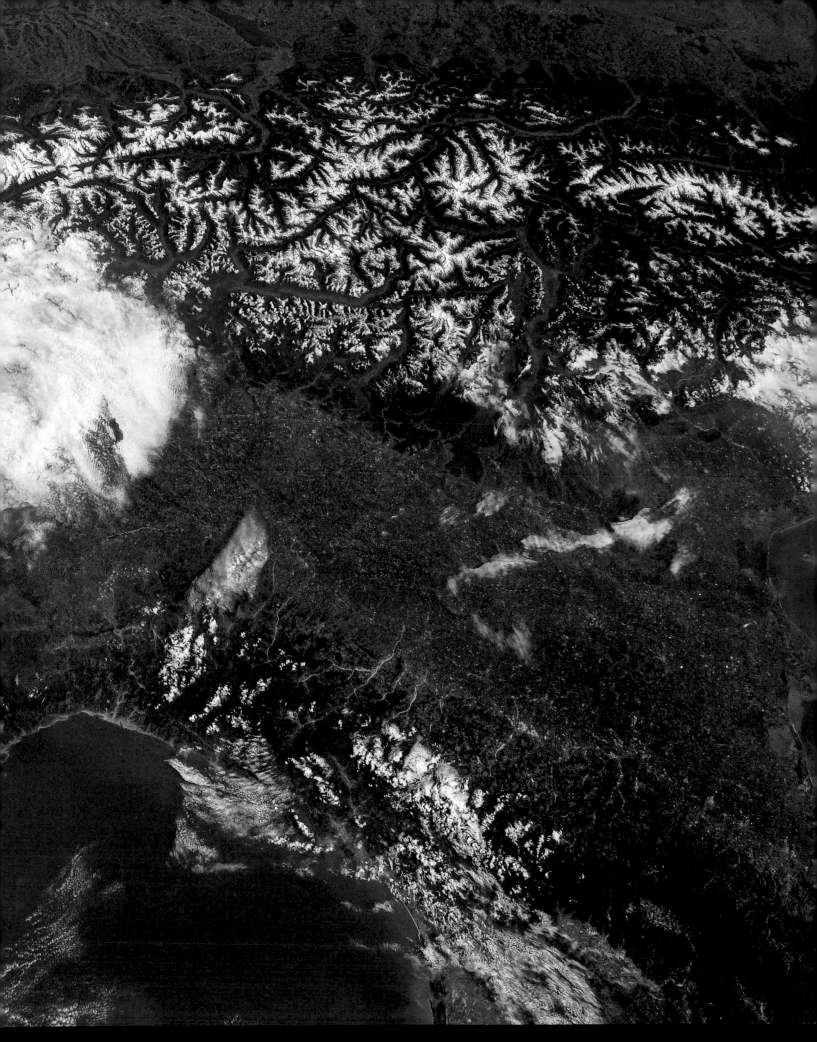

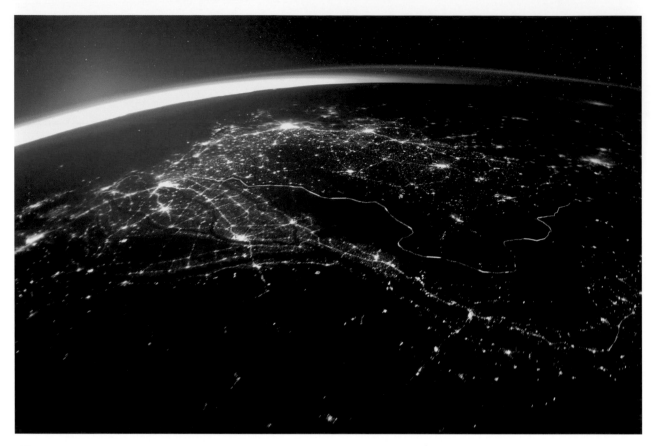

A Somber Garland

It is often said that borders are invisible from space, which is mostly true during the day. At night, however, some become particularly obvious. Pictured here is the border between India and Pakistan. It often seems that the more brightly lit the border, the more closed they are and the greater the tensions between the countries they separate.

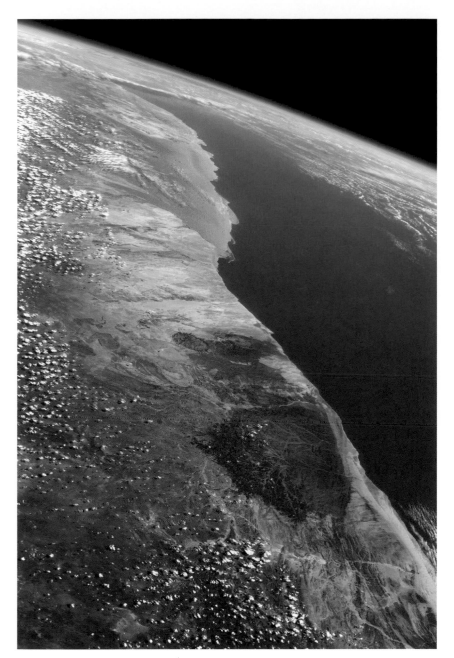

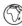

Southern Africa

The border that we see most often from the ISS is the one that separates land from sea. The contrast is striking when compared to the relatively invisible land borders such as the one also pictured here, which runs along the ground between Angola and Namibia. When the ISS's trajectory had us following a coastline, I felt like I was both at the bow of a ship and piloting a plane.

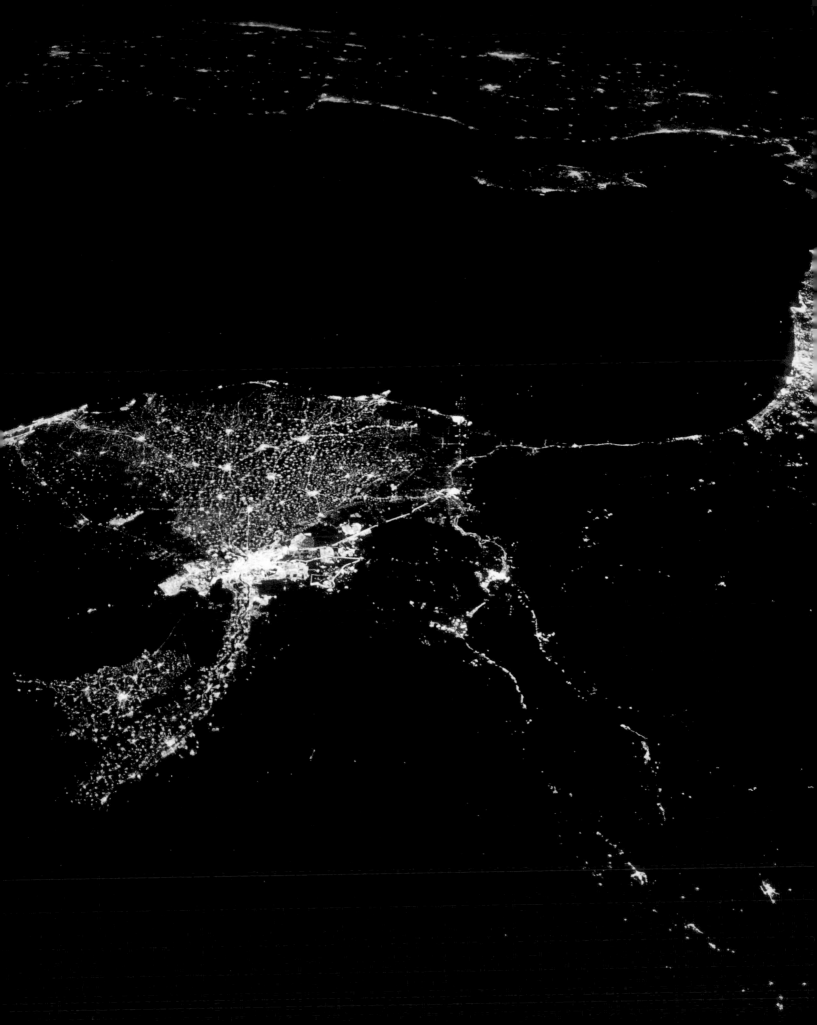

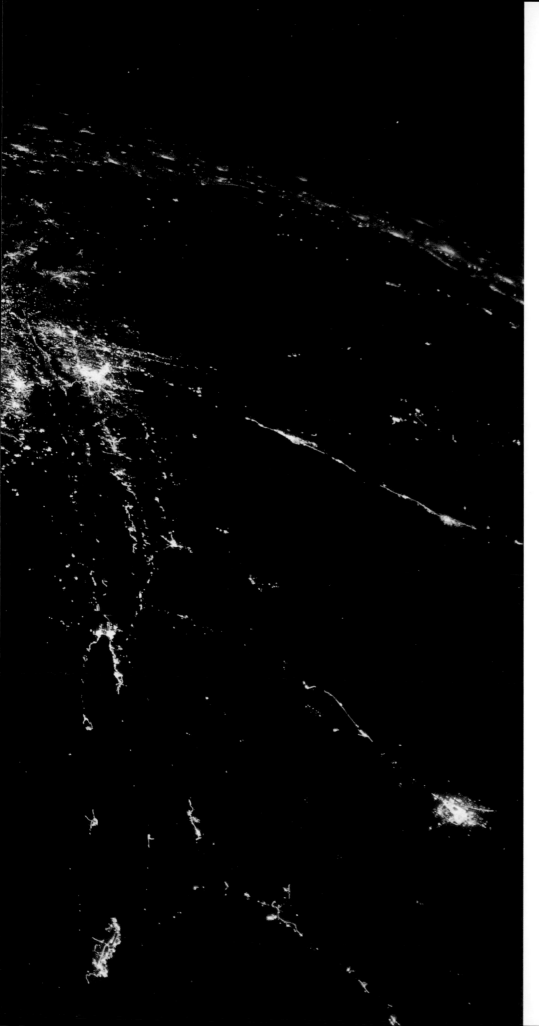

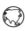

The Very Near East
Pictured here is Egypt's Nile Delta, Israel and other neighboring countries. While the relationships between Middle Eastern countries are vastly complex, the geographical distances that separate them are actually quite small.

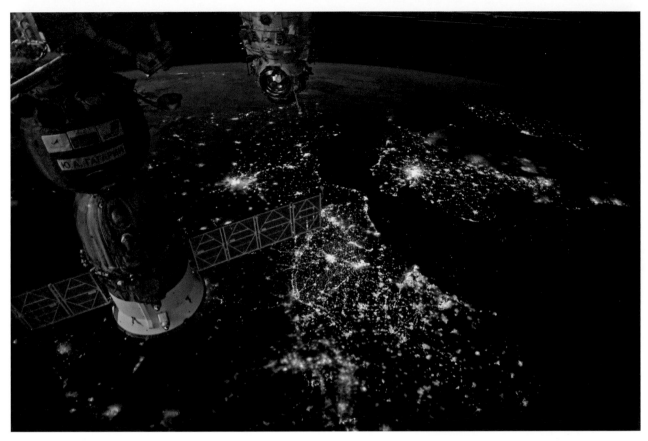

Night Drive
Pictured here is the English Channel bordered by France, Belgium, England and the Netherlands. An interesting change since my first mission has appeared along Belgian roads: Authorities have begun to replace the characteristically orange lights along their highways (seen here) with LEDs to reduce the country's energy consumption. The LEDs also create less light pollution.

Next pages
The Fortified Empire
From time to time, I'm asked whether the Great Wall of China is actually visible from space. At the risk of disappointing my readers, it is not visible with the naked eye. However, if you know exactly where to point your camera lens, you can take a photo of it. Despite the foggy weather, the wall can be clearly seen snaking along the ridges north of Beijing.

The Cradle of Civilization
The Middle East by night, including some of its brightest cities: Tel Aviv on the Israeli coast, and the multi-millennial cities of Jerusalem, Israel, and Amman, Jordan, further inland. The Dead Sea is hidden in the shadows somewhere in this shot.

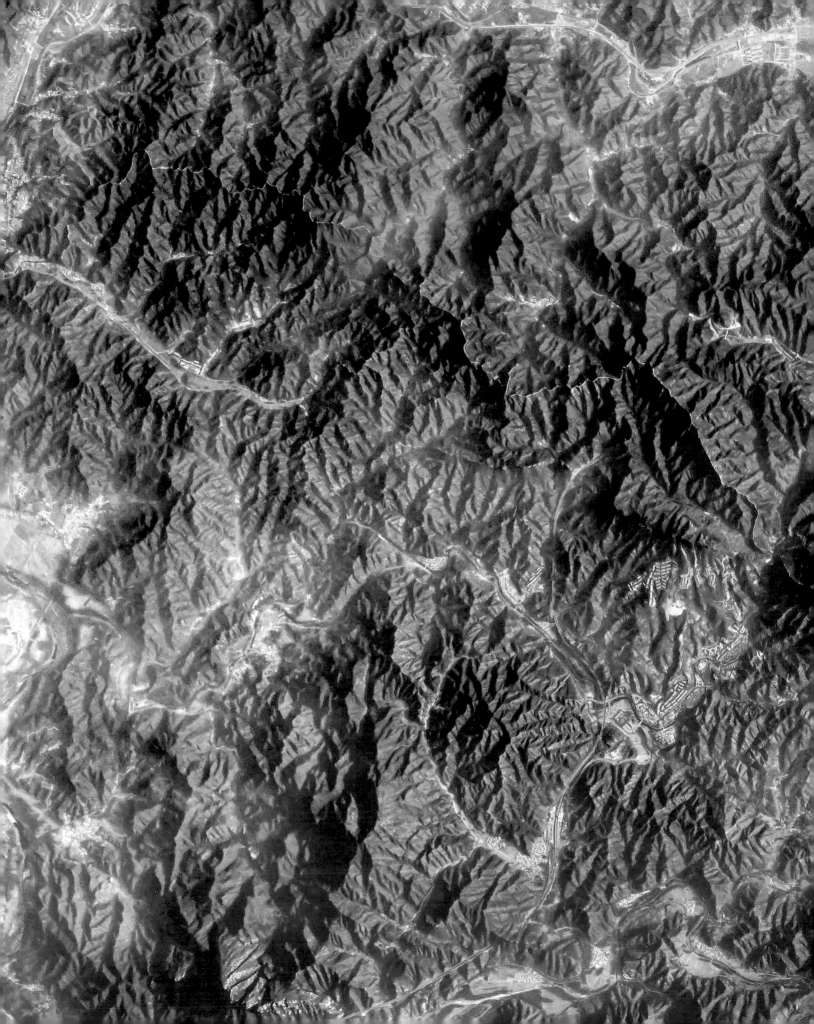

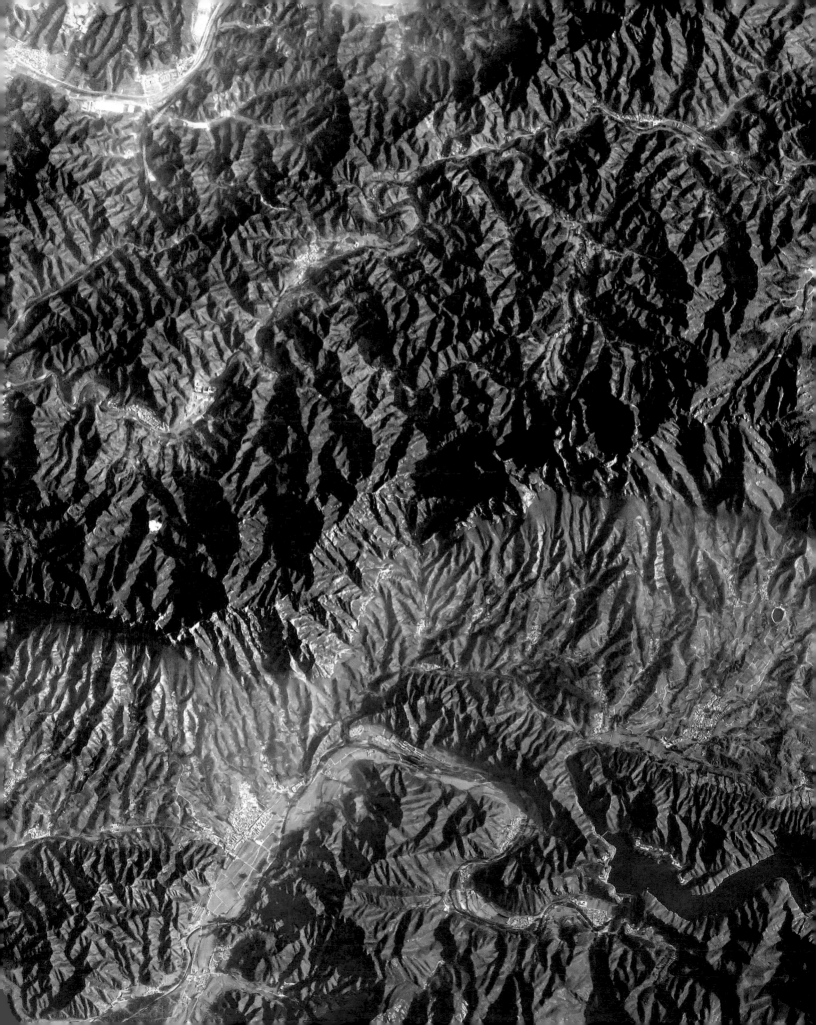

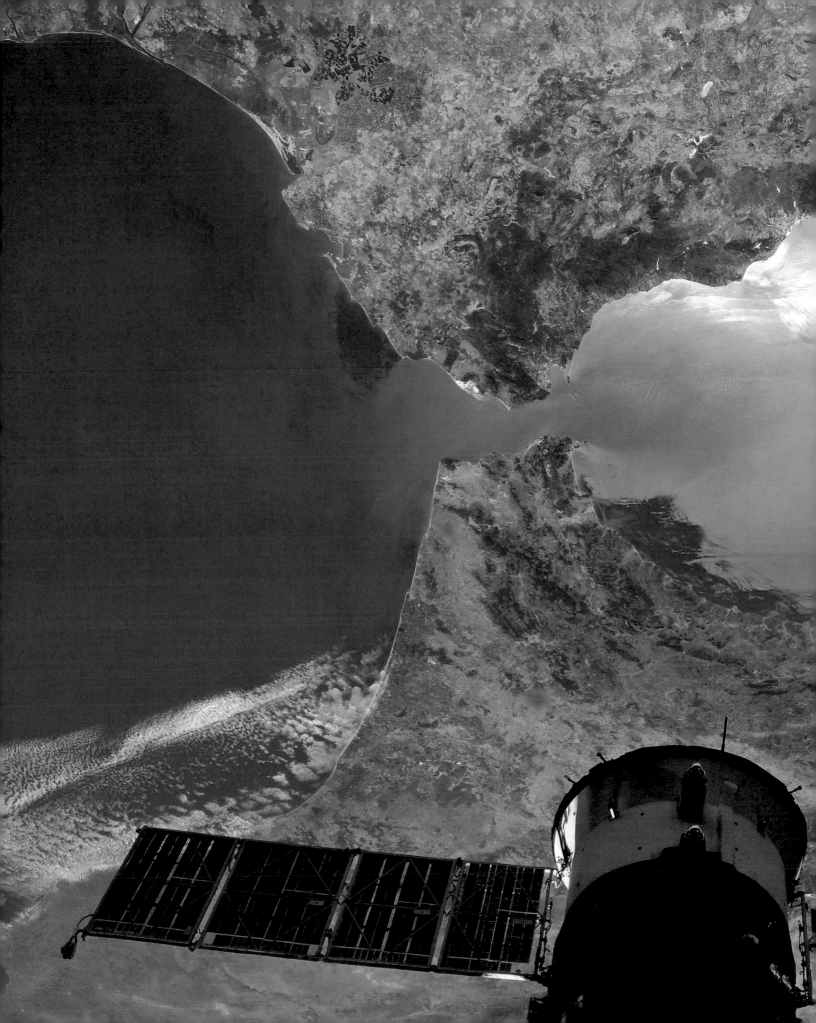

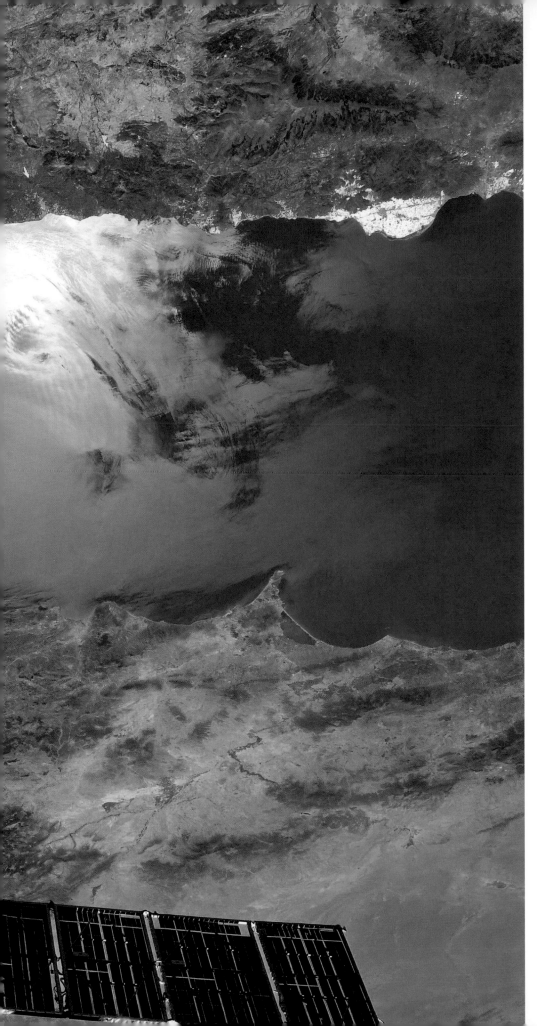

Michelangelo

The Strait of Gibraltar is a double border: between Europe and North Africa on the one side, and between the Mediterranean and the Atlantic Ocean on the other. There is something poetic about the way Morocco and Spain seem to be reaching out, as though wanting to touch fingertips. It reminds me of the famous scene on the ceiling of the Sistine Chapel painted by Michelangelo. The reality, however, is often much crueler for those who embark on this crossing in search of a better life.

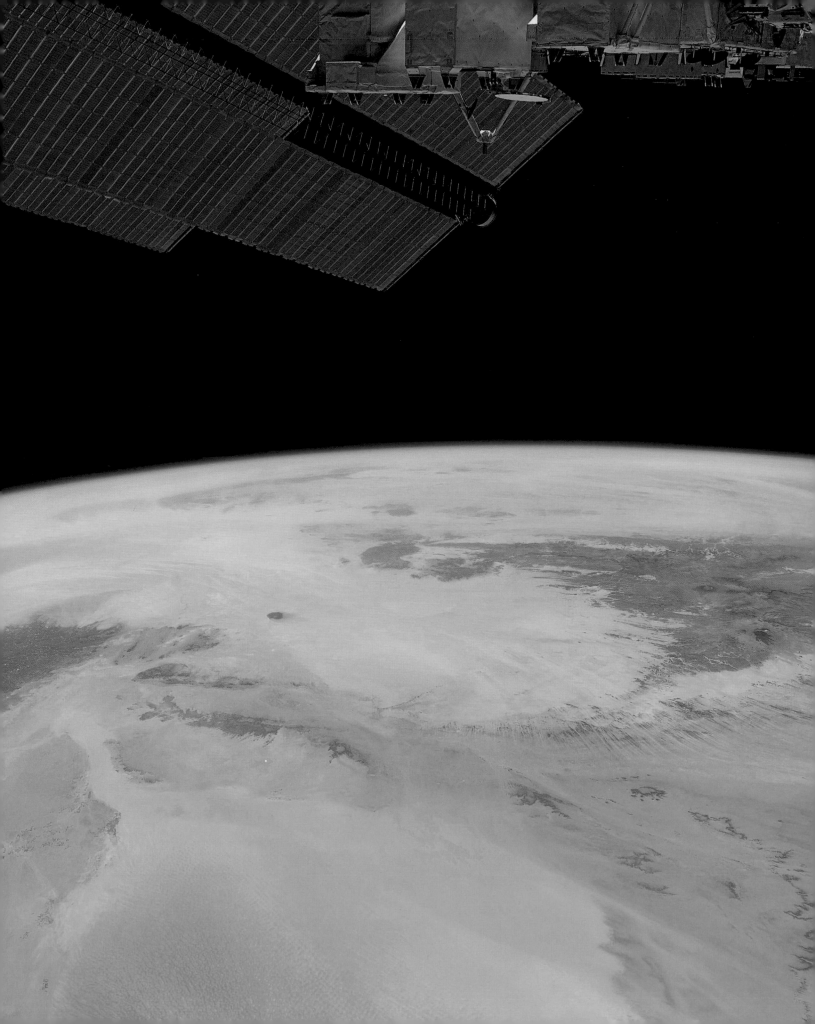

Deserts

Golden Highlights
Even the International Space Station takes on golden hues when light is reflected by the Sahara.

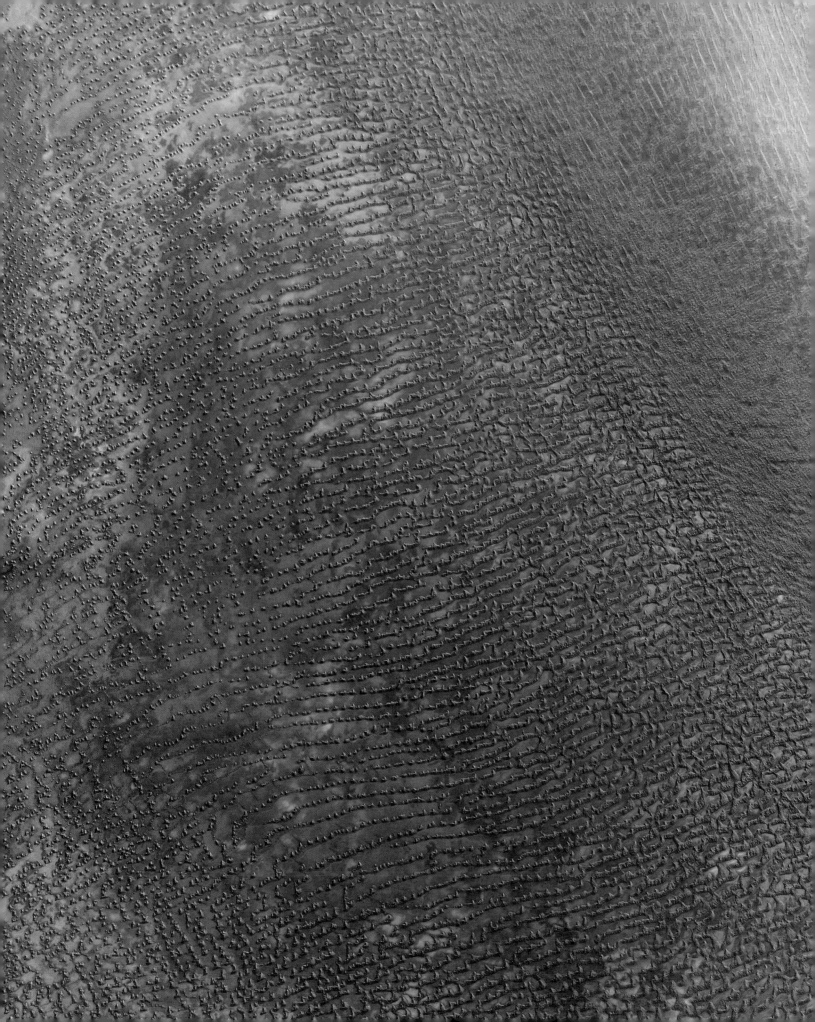

If you dream of visiting a Lunar or Martian landscape of wind-blown dunes and rocky expanses, a Dragon or Soyuz spacecraft may not be necessary: Head for a terrestrial desert. With their extreme conditions, Earth's deserts are probably the most accessible stand-ins for our neighbors in the Milky Way. Precipitation, though rare, cracks rocks as temperatures fluctuate, clouds cannot form due to the extreme aridity and the ground is polished as sand is carried by the wind.

Like oceans, deserts can help us measure the health of our planet. Desertification is increasing and being accelerated by climate change and certain agricultural practices, such as intensive irrigation, overgrazing and deforestation. As deserts advance, we are experiencing increasingly brutal droughts, the salinization of degraded soils and the disappearance of biodiversity. In and around every desert, competition for natural resources is intensifying between local populations. The human and social consequences — conflicts, radicalization, forced migration — are affecting the entire planet. Even though deserts are often sparsely inhabited and relatively inhospitable, we must protect them.

When I think of deserts, my thoughts often linger on the fascinating Sahara, illustrated here in numerous photos. I believe photographing the Sahara from space better shows its vastness, which is poorly represented by Mercator cartography, the standard system used for our world maps, which greatly underestimates the size of areas at lower latitudes. From space, we can better appreciate that the largest hot desert on the planet is as expansive as Australia and New Zealand combined and wider — at just over 3,000 miles (5,000 km) — than the distance between Los Angeles and New York City. One can imagine the Tethys paleo-ocean closing up some 7 to 11 million years ago, reducing itself to the Mediterranean Sea and ceding the rest of the area to the sublime Sahara.

Arrakis
Although Frank Herbert's best-selling book *Dune* was written before the first color satellite images of Earth were available, I'm sure this view is a fairly accurate representation of how he imagined his desert planet, Arrakis.

Next pages
Graphic Arts
There's nothing more varied than a desert! With each zoom, another universe is revealed. These ultra-graphic forms seem to be inspired by contemporary art.

An Extreme Desert

If you let your gaze wander over the Sahara, you will find rather phantasmagorical landscapes. They are splendid and intriguing, but some are so inhospitable that I will certainly never see them with my own eyes — and maybe nobody else will, either. The Sahara is a desert of extremes: There are only 8 million inhabitants across its 3 million square miles (8 million km²), only a few hundred plant species are able to survive there, and it encompasses an area of just under 400,000 square miles (1 million km²) where rain never falls.

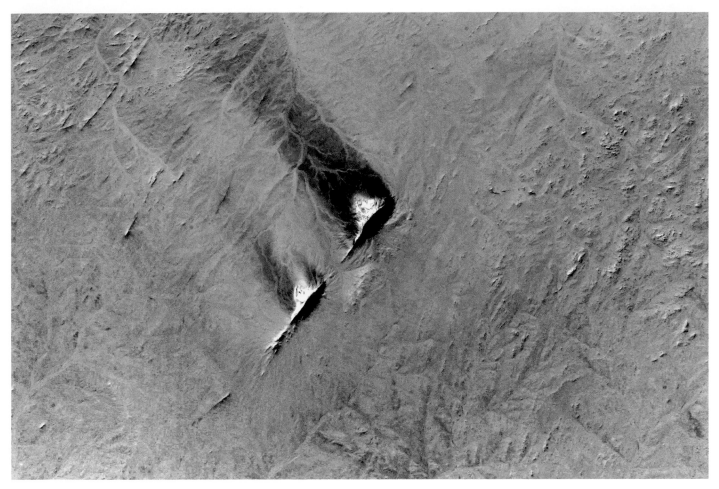

Shadows of Egypt
In the middle of the Egyptian desert, the sand and wind combine to produce mysterious shadows. One wonders if these formations are raised or sunken.

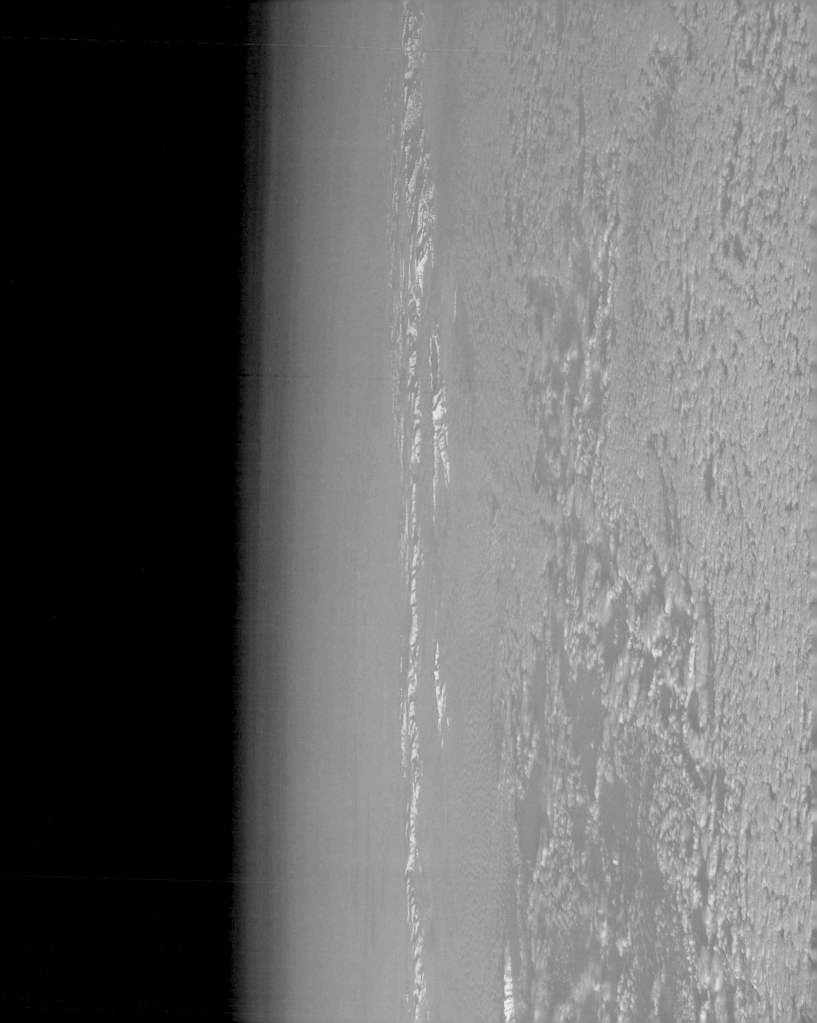

The Fifth Continent
These are not clouds but rather ice mountains
in Antarctica that are several miles high. This is
my only photograph of this polar desert, as I was
convinced that it was too far from our trajectory:
Antarctica is Earth's southernmost continent,
and our orbit confines us between about +55 and
–55 degrees of latitude. Antarctica is also Earth's
least populated desert. A bit like the International
Space Station, its only inhabitants are members of
scientific expeditions.

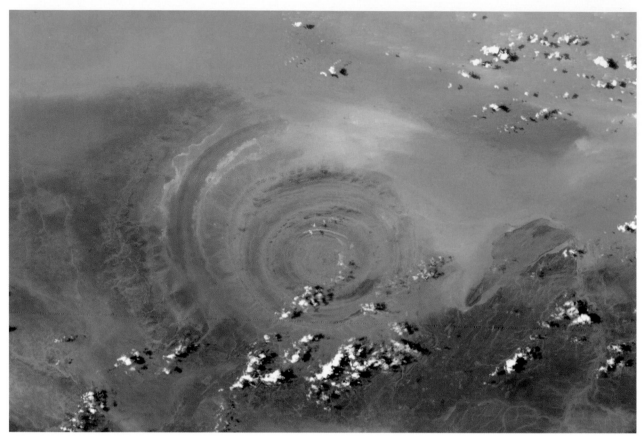

The Eye of the Sahara
The Richat Structure (also known as *Guelb er Richât* and the Eye of the Sahara), located in the Mauritanian Sahara, is a usual suspect in astronauts' photos. With its 30-mile (50 km) diameter and the nearly always cloudless sky above it, it is an ideal landmark to spot from space.

Theodore Monod
Scientists have long wondered about the Richat Structure, which can only be photographed in its entirety from space. The most widely accepted hypothesis is that it is a gigantic magma dome that collapsed on itself over time and through erosion. While flying over this strange structure, I often think of Theodore Monod, the humanist explorer born in Rouen, France, who was so passionately dedicated to the Richat Structure that he carried out his last expedition there at the age of 96.

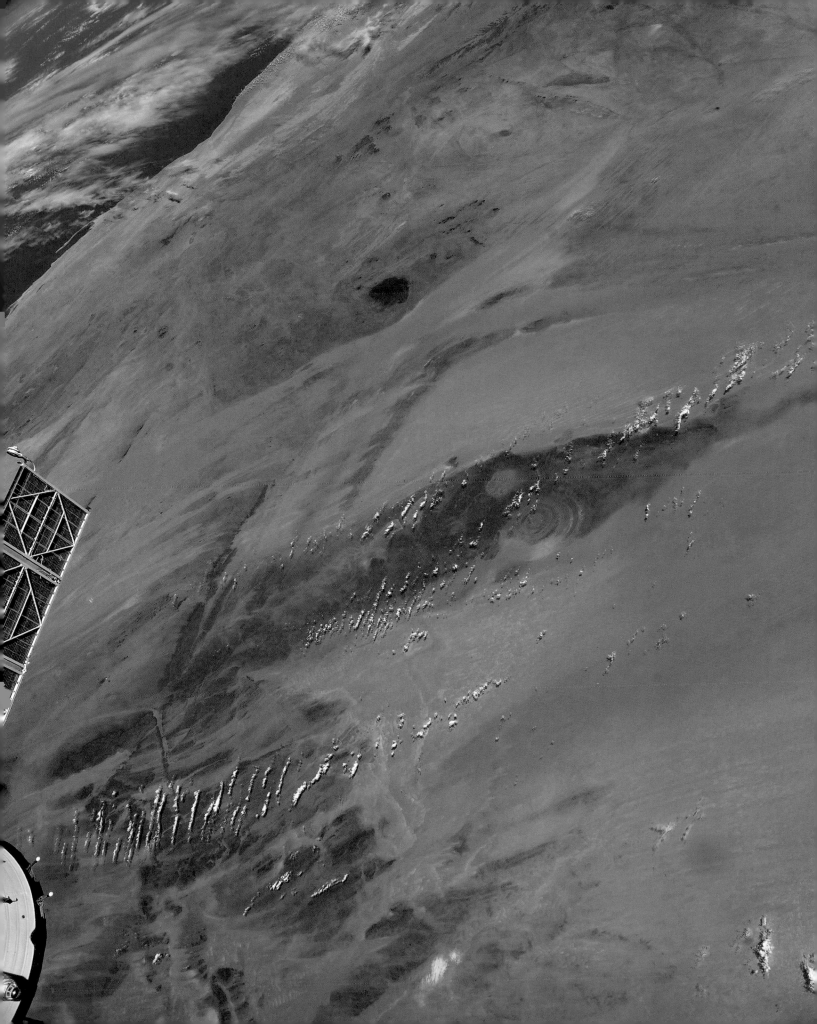

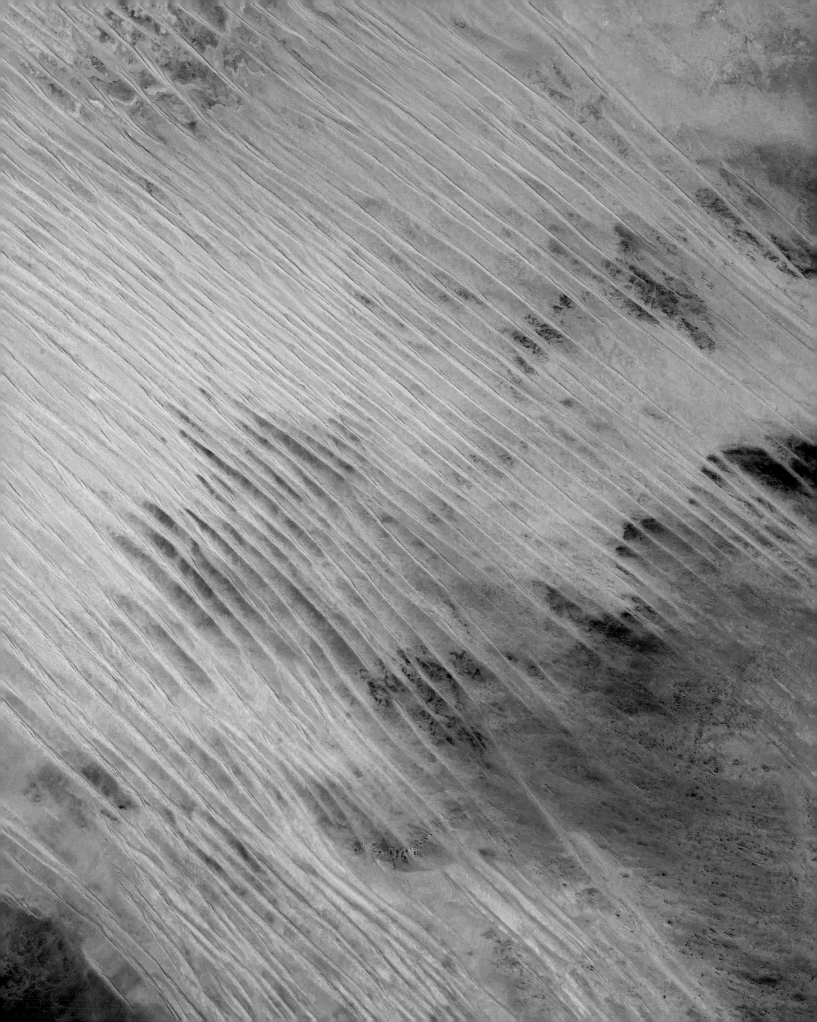

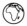

Dunes

Viewed from above, the Sahara seems to have been raked by the wind like a glorious Zen garden. Streaked with lines of ocher and beige sand, it seems almost to have been shaped by the human hand. This isn't the case, of course. Quite the opposite, in fact.

Humans are barely tolerated in the vast Sahara. The few who live there travel continuously in order to withstand the extreme conditions. This is how the Tuareg have lived, the so-called "blue people" of the Sahara, whose indigo clothing often colors their skin.

The dunes can give one vertigo, even if one is only observing them and not trying to climb them. Linear dunes can stretch for hundreds of miles, only rarely interrupted by rocky terrain. There are even giant dunes that can reach 1,300 feet (400 m) high.

But how are these desert mounds formed? Dunes are born when large expanses of dry sand are lifted and carried by the wind. As the winds die out, they deposit the sand.

The Saharan dunes are fascinating when viewed from space. They also allow us to better understand certain extraterrestrial phenomena. Linear dunes very similar to ours are found on Titan (Saturn's main natural satellite) and on Mars. On Earth, they are typical of areas swept by different winds blowing in several different directions at the same time. The Red Planet also has barchans that are the true twins of the Sahara's half-moon-shaped dunes, formed by a unidirectional wind.

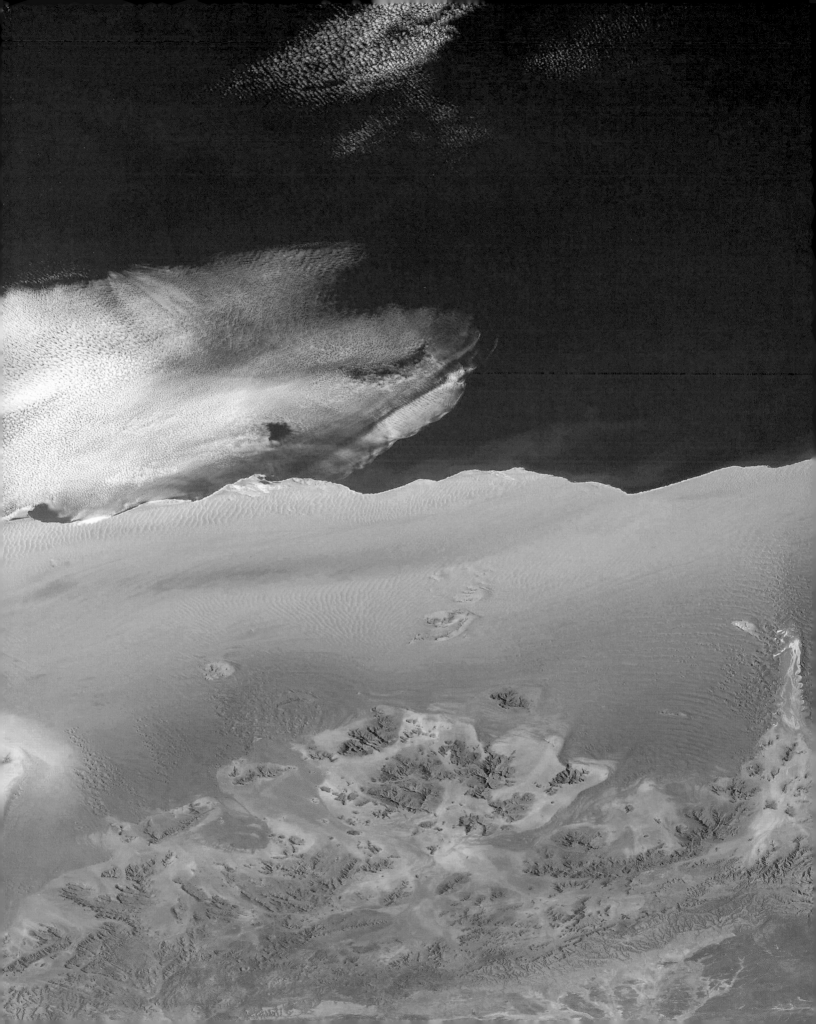

Contrasts
Namibian dunes with their intense
waves of red, white and orange sand
contrast beautifully with the blue of
the South Atlantic.

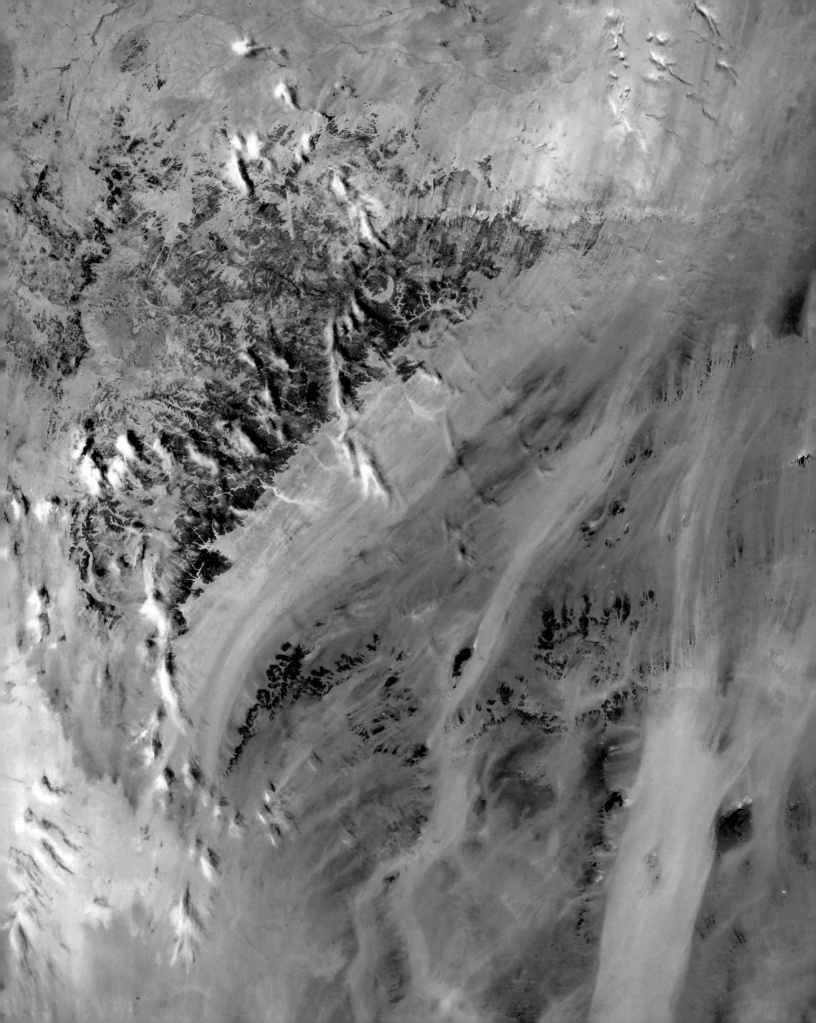

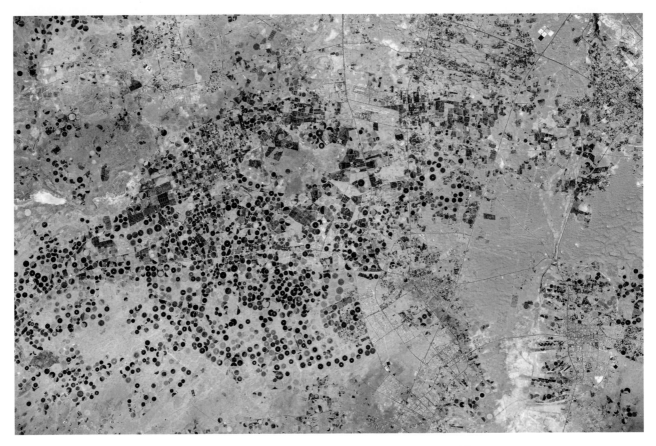

Circles and Squares
This Saudi desert is a study in incredible shapes and colors, but the sudden presence of circles and squares is certainly conspicuous. Which do you find more aesthetically pleasing, humanity's regular shapes or nature's more erratic forms?

Labyrinth
Tawny red and gray rocks, orange sand and touches of white clouds: flying over the Sahara, here a plateau in Chad, is never monotonous. One might even be tempted to look for the lost aviator of *The Little Prince* or perhaps the famous *gueltas*, where small amounts of water accumulate at the bottom of a labyrinth of canyons, which must be at least as extraordinary a find as a fictional character in the midst of such aridity.

301

Arid Lands
The small dots in this desert are irrigation systems. Saudi Arabia's population and land size are both about a quarter of the United States'. Despite costly attempts at irrigation, the arid desert climate does not allow the largest state in the Middle East to achieve food self-sufficiency.

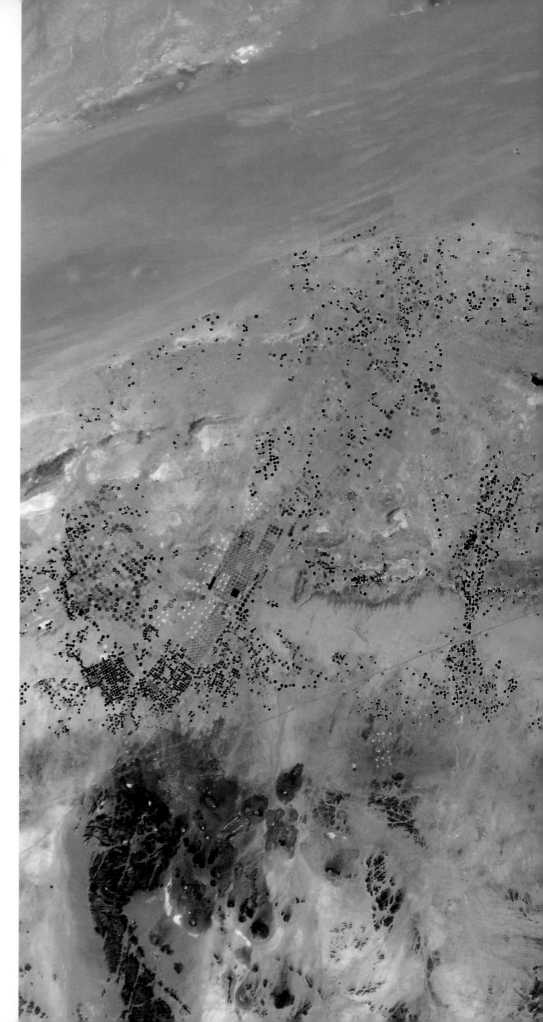

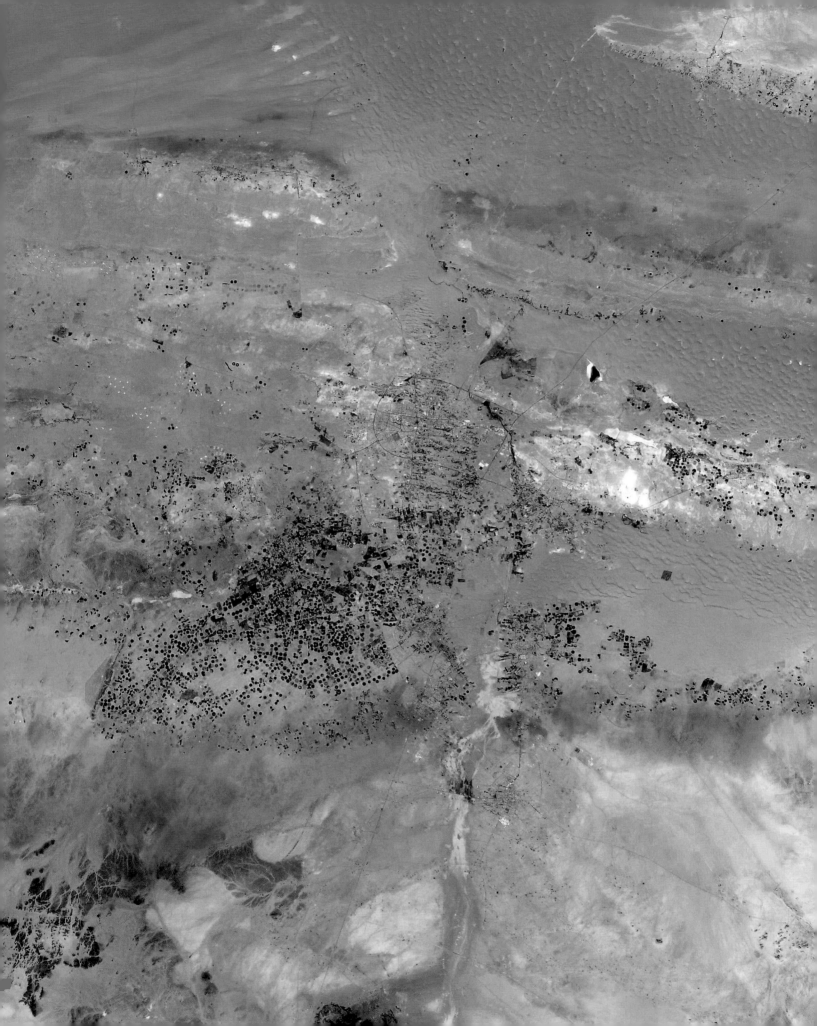

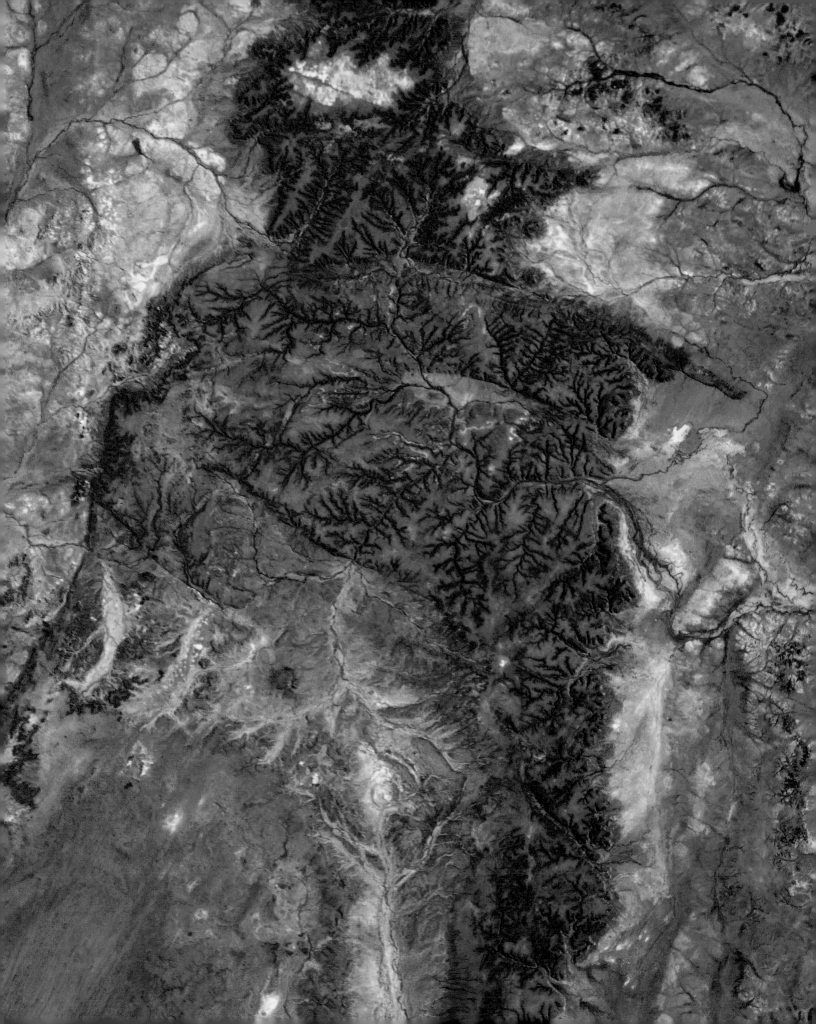

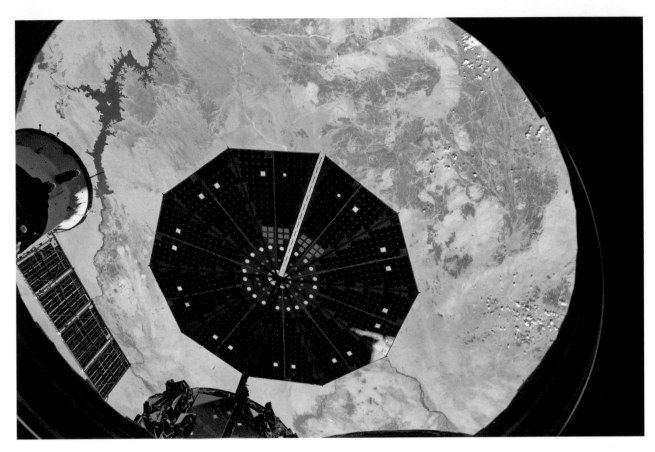

Soyuz and Cygnus
In front of the Cupola's largest window, the circular solar panels of the cargo vessel Cygnus look like a parasol planted in the middle of a desert. A Soyuz vessel is visible along the side.

Red Australia
As one moves inland, the blues of the Australian coast are transformed into the Outback, in all its shades of red and even purple crisscrossed by black veins and stained by immense expanses of almost white. There is almost no green. It looks supernatural!

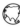

Next pages
Desert or Mountain?
These incredible pastel colors are in Elbourz, a mountain range that reaches 18,400 feet (5,610 m) and sits between Tehran in the south and the Caspian Sea in the north. According to an Iranian legend, the stars gravitate around these sacred mountains.

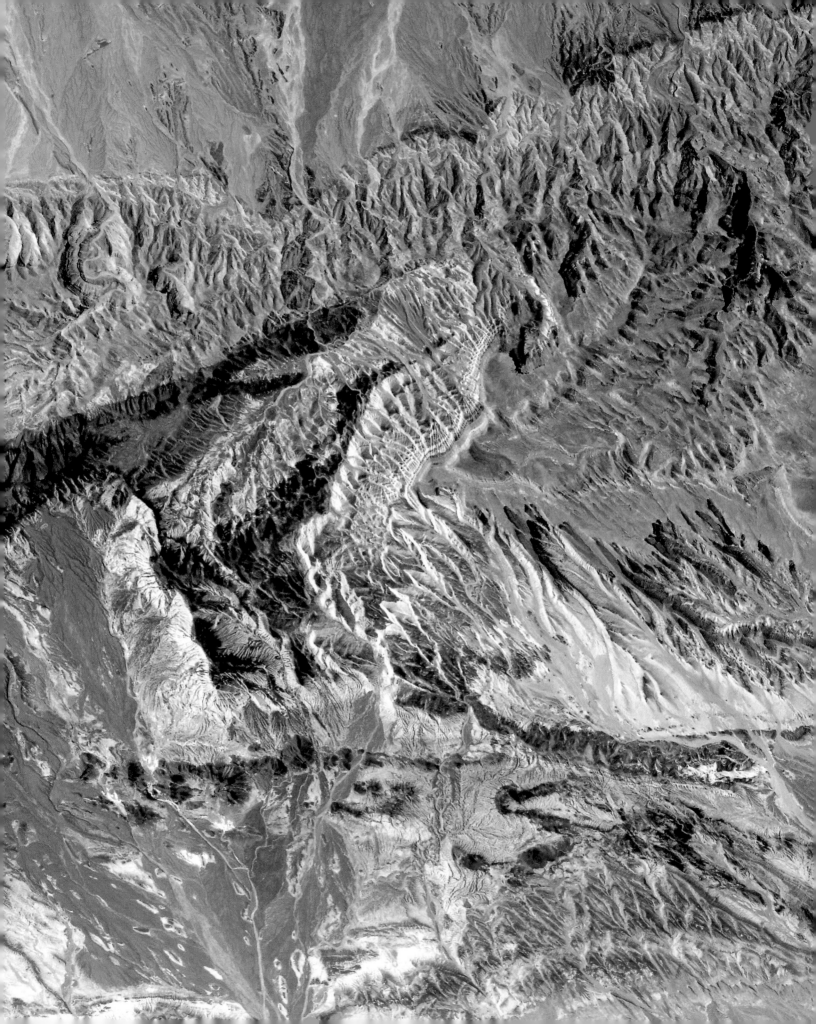

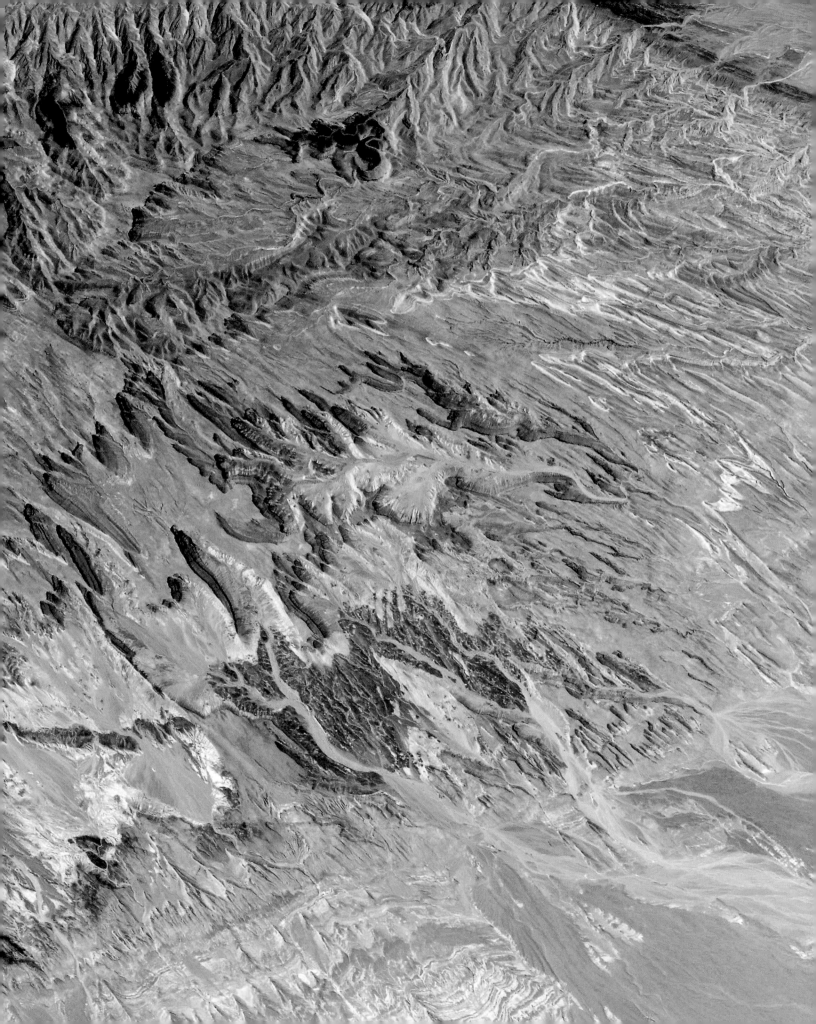

Mountains

Volcano or Mountain?
With its eternal snow cap, Mount
Ruapehu in New Zealand looks like
a simple mountain, but the opening
in its center reveals that it is a still
active volcano.

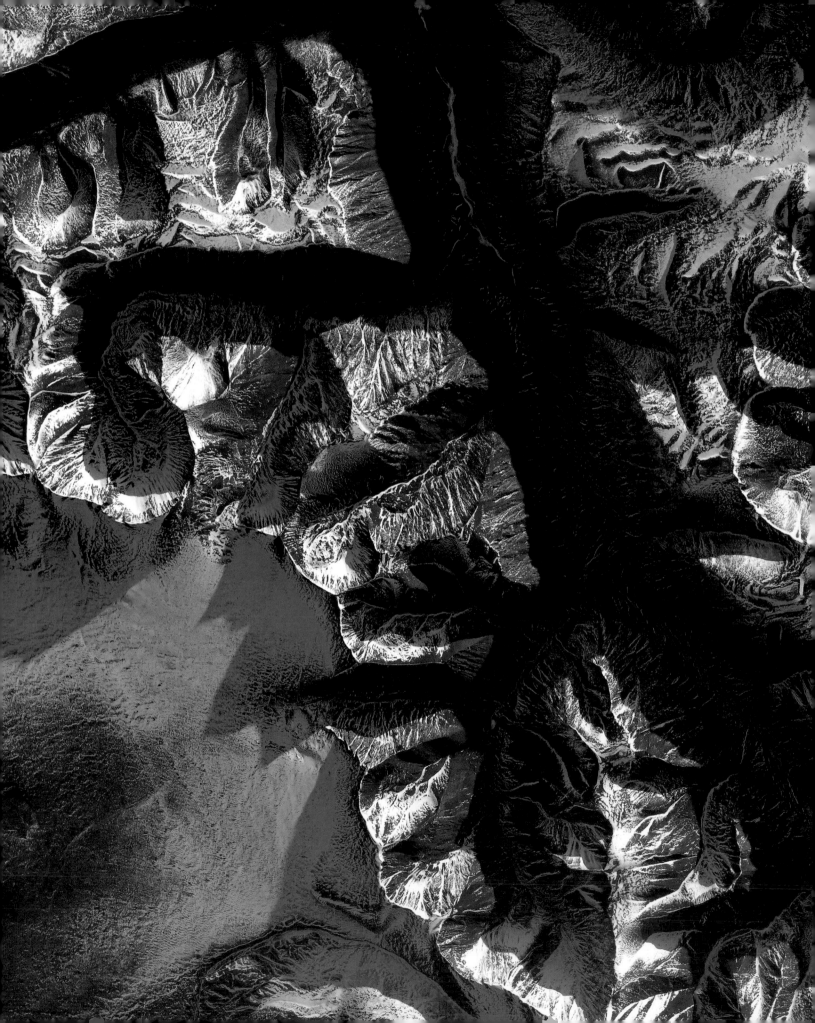

If there is such a thing as an especially satisfying subject to photograph from space, mountains and volcanoes would get my vote, particularly when the Sun is low, at the beginning or end of the day, and creates shadows that accentuate their contours.

The reliefs created by these towering landforms occupy a singular space on our planet. Firstly, they take up space in the literal sense: A quarter of our continents are covered by peaks. None, of course, reaches the nearly 14-mile (22 km) altitude of Mars's Olympus Mons, but when admiring the Rockies and Andes from space, one better understands the majesty of our mountain ranges.

These formations are also the stuff of dreams and the imagination. There are countless books, films and television programs about mountains and mountain climbing! Moreover, nearly every civilization has some form of sacred mountain to be honored and often even feared.

Today, however, it is the mountains that should fear humans, particularly the impact our activities are having on global warming. The glaciers in Tibet's high plateau, Asia's water tower, are melting at an alarming rate. The consequences are numerous and ominous: Billions of gallons of water are streaming into the oceans, leading to rising water levels; important habitats are being destroyed, threatening fauna and flora; and our reserves of fresh water are diminishing.

There are, fortunately, many ongoing initiatives to better protect mountains and volcanoes, which are far more fragile than they appear. One of the most original is found in New Zealand, where an agreement signed in 2017 between the government and local Maori made Mount Taranaki, a volcano, a legal personality, in its own right and with legal protection.

Next pages
Everest
Mount Everest reigns supreme! Spotting a particular peak in a mountain range from space is often quite difficult. In the immensity of the Himalayas, what distinguishes one summit from the next? From space, they all seem... small.

Winter Is Leaving...
In the mountains of Mongolia, Central Asia, the snows are withstanding spring temperatures.

311

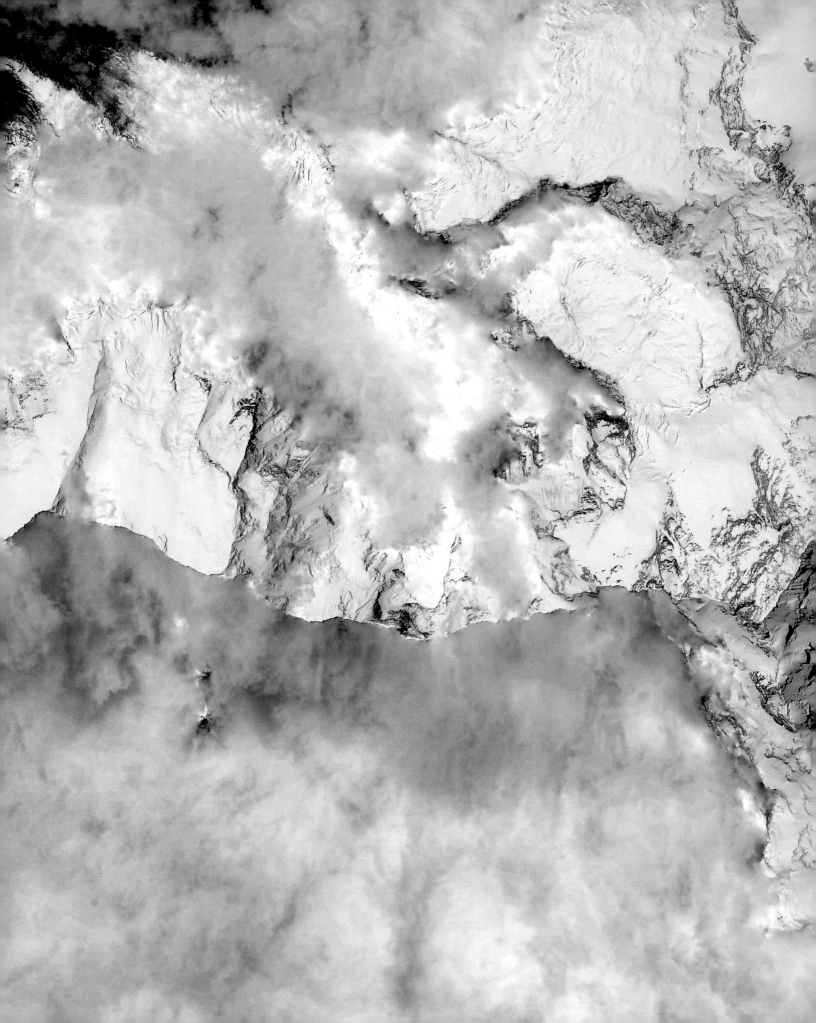

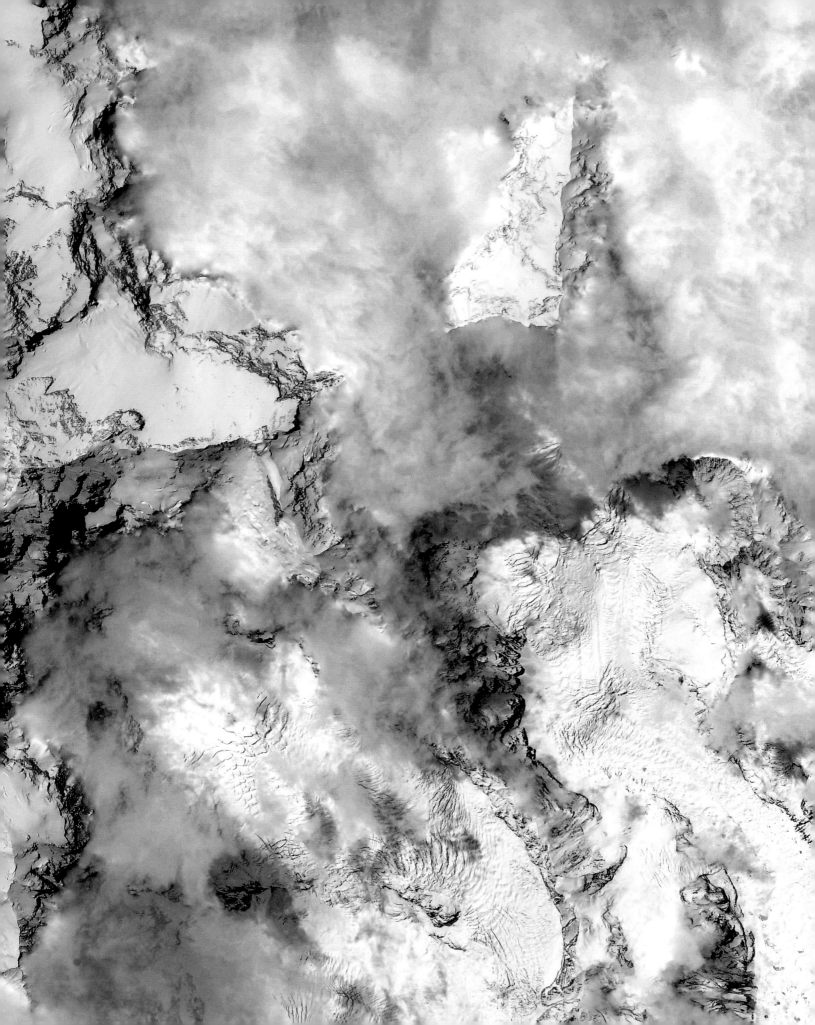

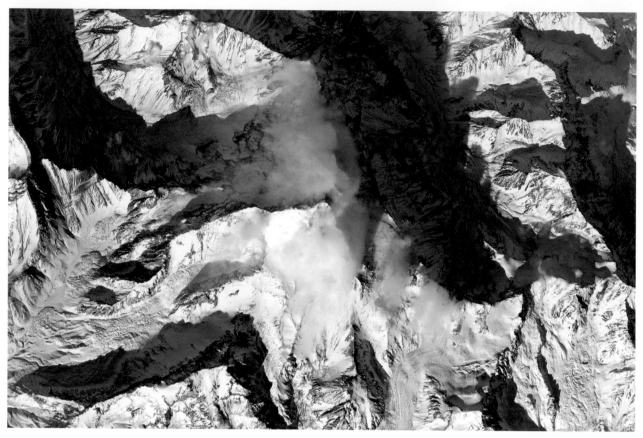

Bucket List
At 22,841 feet (6,962 m), the
Aconcagua in the Andes, Argentina,
is the highest peak in South America.
It is still on my list of summits to climb
on foot, rather than from space...

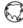

At the Summit
There may not be any competitions
or gold medals for mountains, but
the Himalayas outperform all other
landforms in terms of the altitude of
its peaks: Nine out of the ten highest
peaks in the world are found in the
Himalayas, and all top out over
26,000 feet (8,000 m). K2, the
second highest peak in the world, is
part of the nearby Karakoram Range.

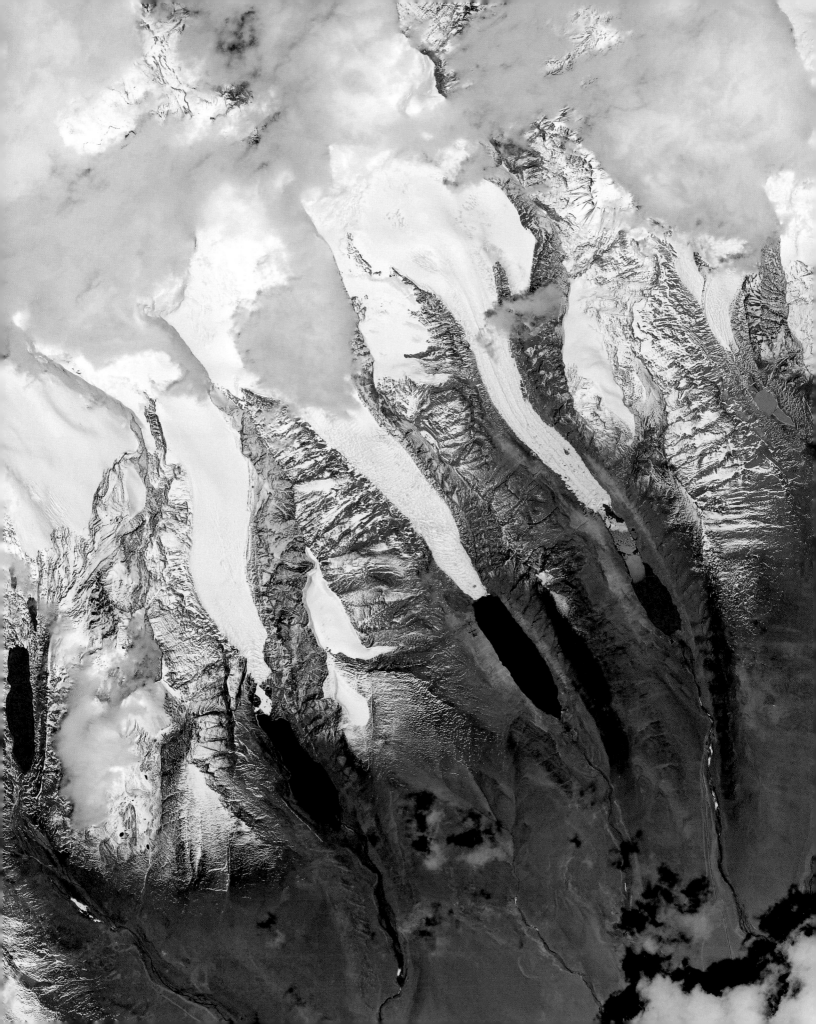

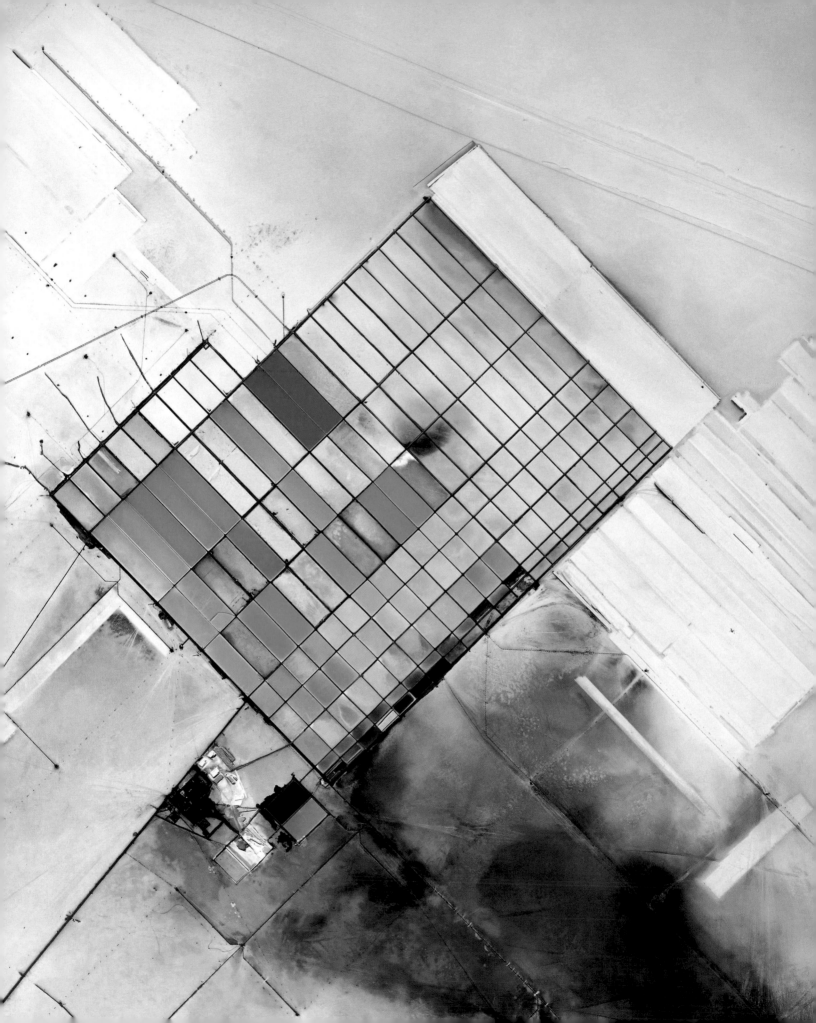

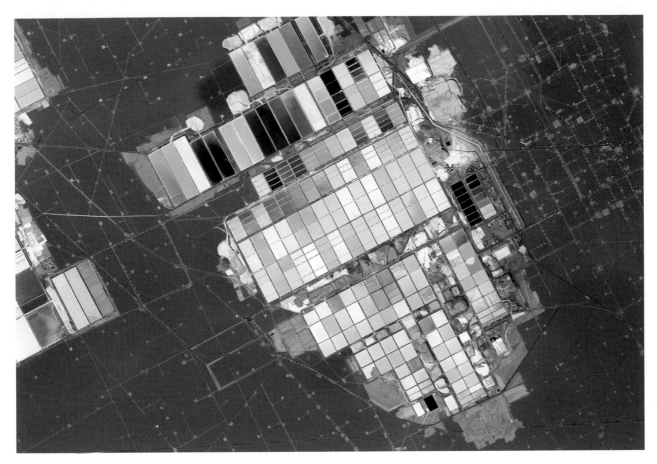

Salt Marshes
Here's a bit of eye candy I captured while flying over the Andes. These salt marshes, with their many shades of green laid out in a grid, are perched in the mountains. I find they look a bit like a Mondrian painting. I love to zoom in on salt marshes using different magnifications to fully appreciate their immensity.

In the Details
I can't help but wonder why this photo looks so clear. Is it because these mountains are high and therefore closer to my lens? Or is it (more likely) because the very dry air is creating few distortions? In any case, we can see humans' work almost step by step, as they've dug deeper and deeper into this copper mine in Peru, like ants digging a nest.

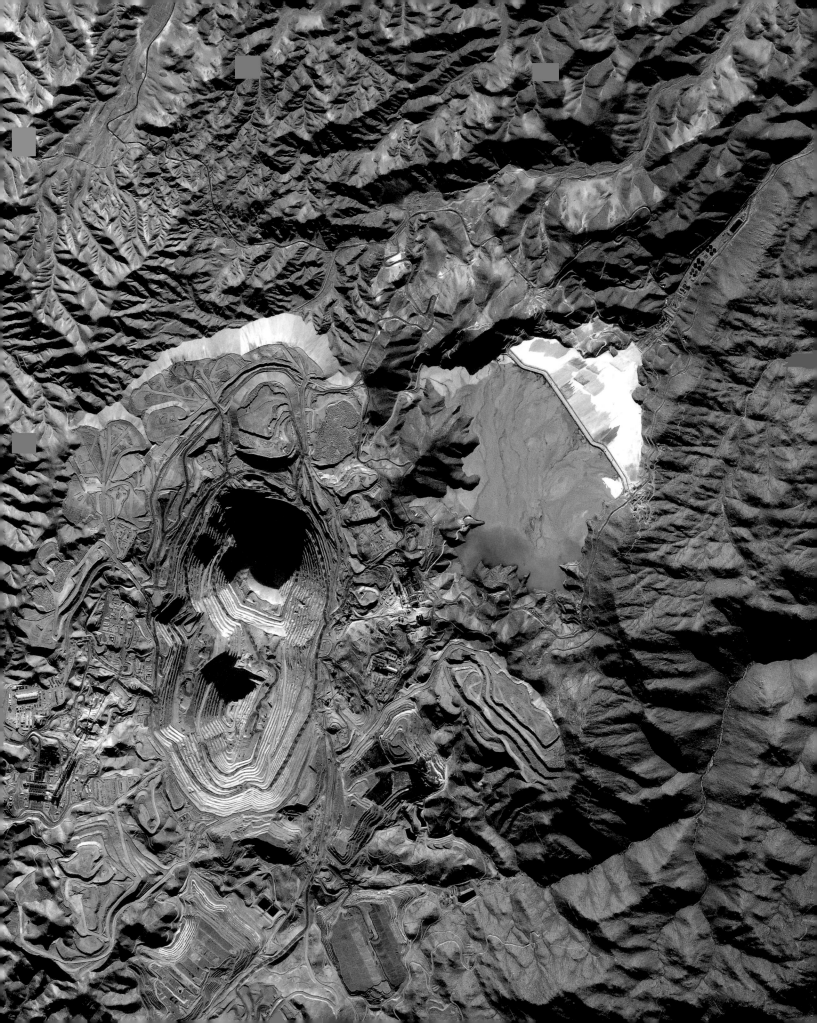

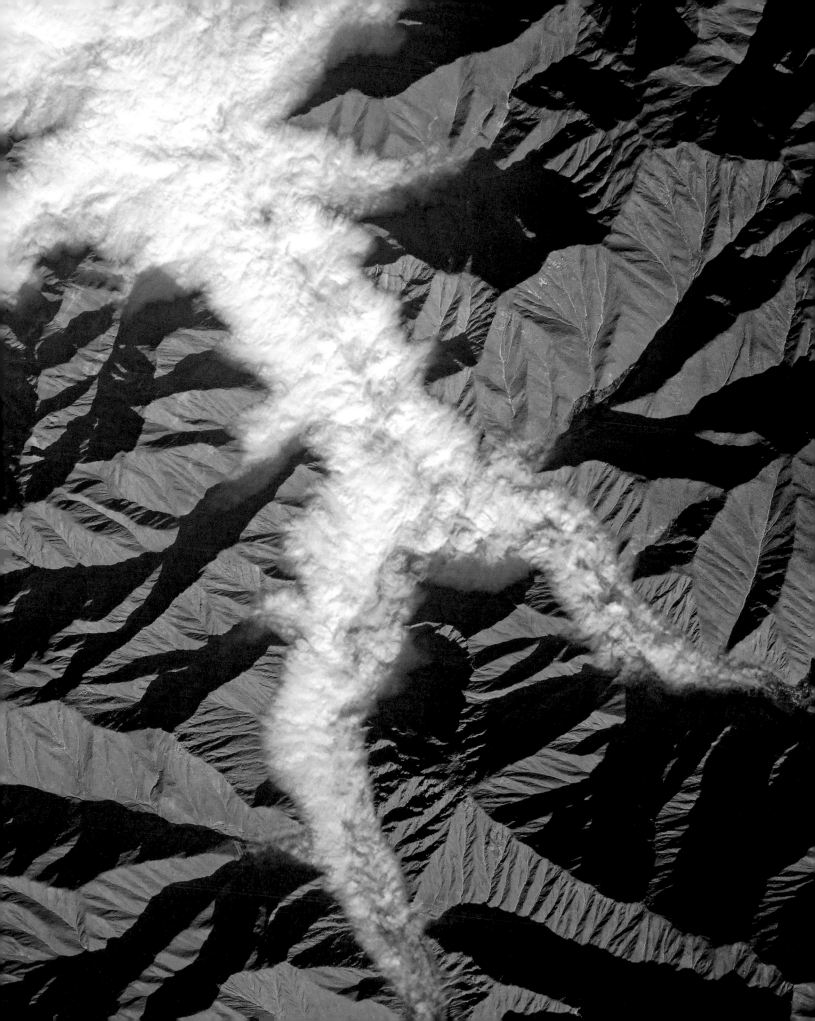

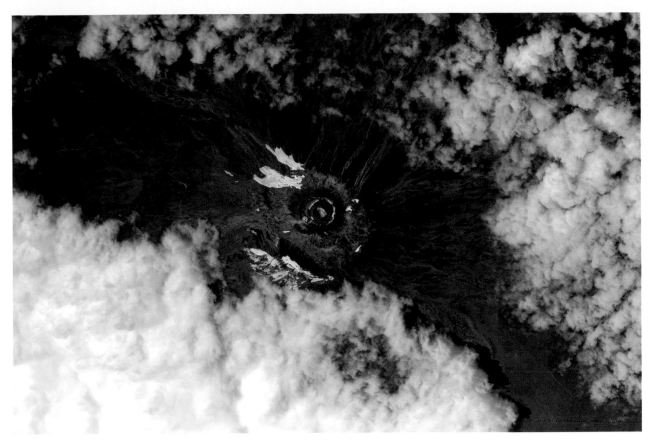

The Melted Snows of Kilimanjaro
Kilimanjaro is Africa's highest peak and is made up of three volcanoes. Set upon by global warming and deforestation, its ice cap is expected to completely disappear within 10 to 30 years.

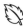

Next pages
Ebb and Flow
This large and beautiful flowing body is a composite photo of the Upsala Glacier in Argentina. Like many other glaciers, it serves as a benchmark for observing the melting of ice and the rising water levels that inevitably result. These phenomena are studied from space, as are a large number of climate variables that are monitored by Earth observation satellites.

Similarities
When you step back, landscapes that at first glance seem very different reveal their similarities. It can be quite surprising. For example, these mountains in Peru emerge from the clouds in exactly the same way as land around certain rivers in Southern Africa.

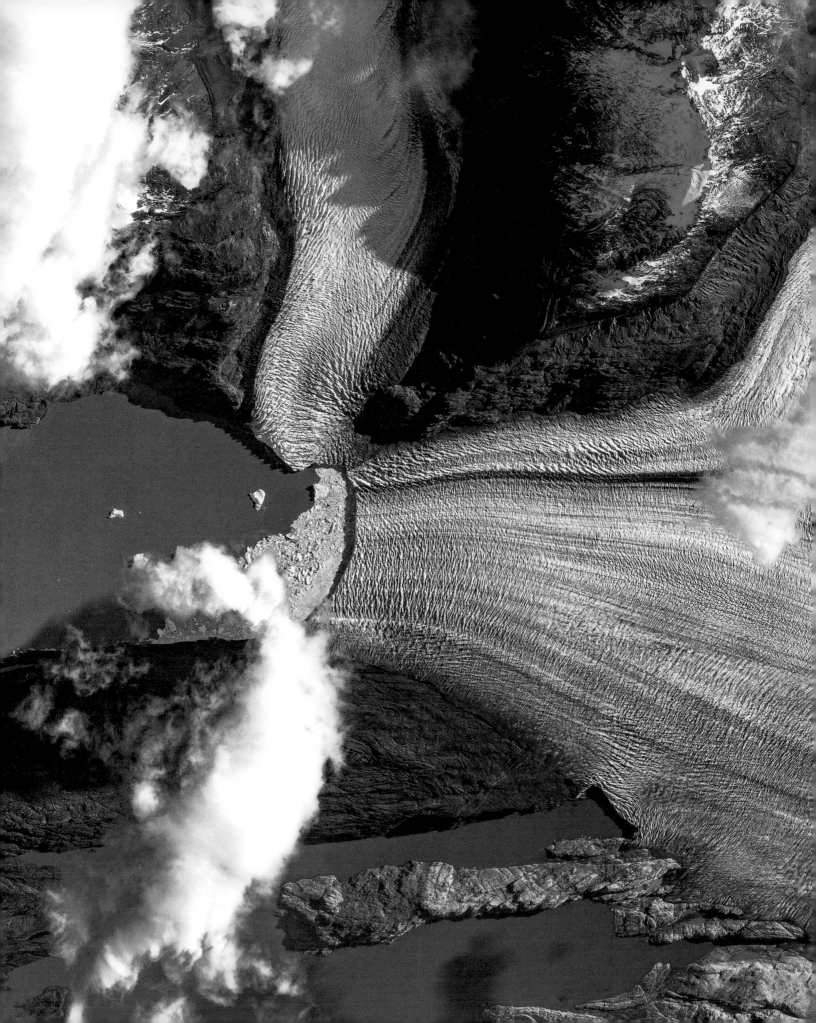

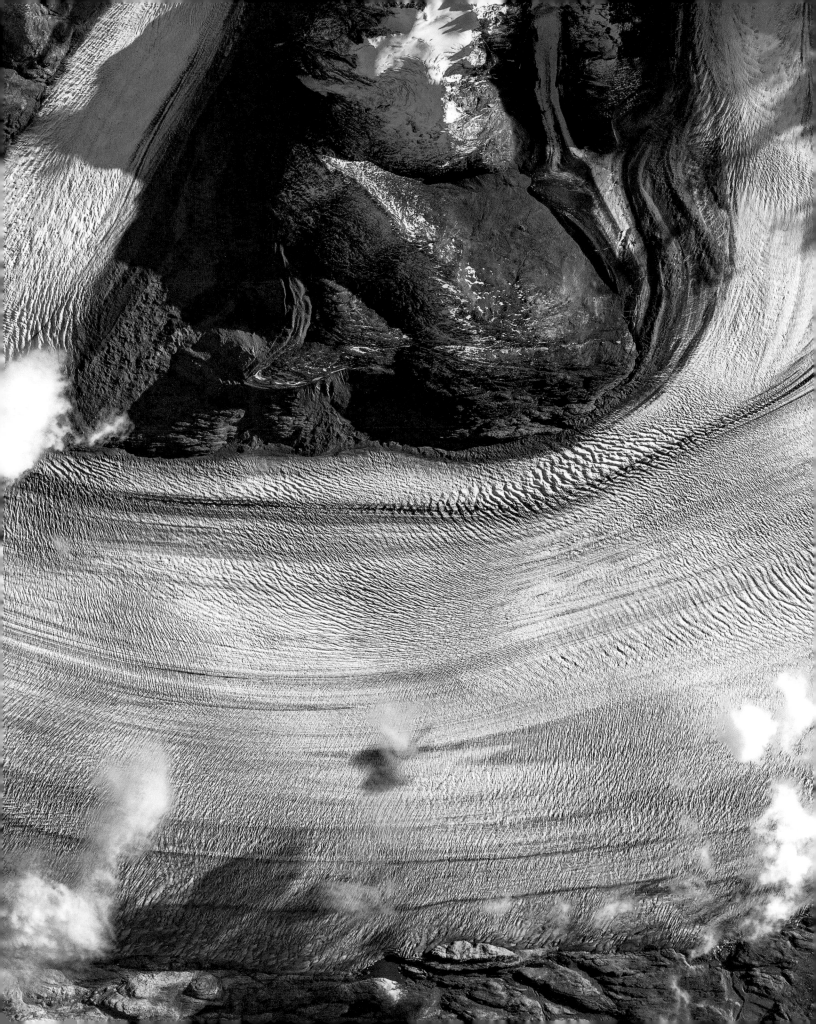

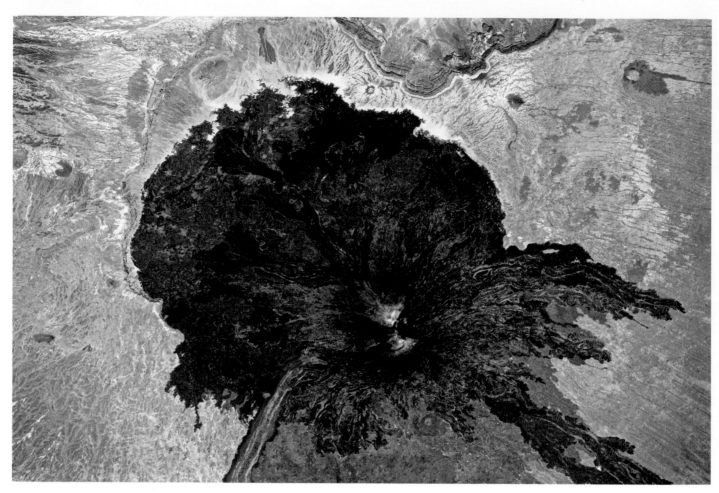

A Rorschach Test
These lava flows seem to come
straight out of a Rorschach test. This
is Tarso Tousside, an unmistakable
volcanic mass in the Sahara, in Chad.

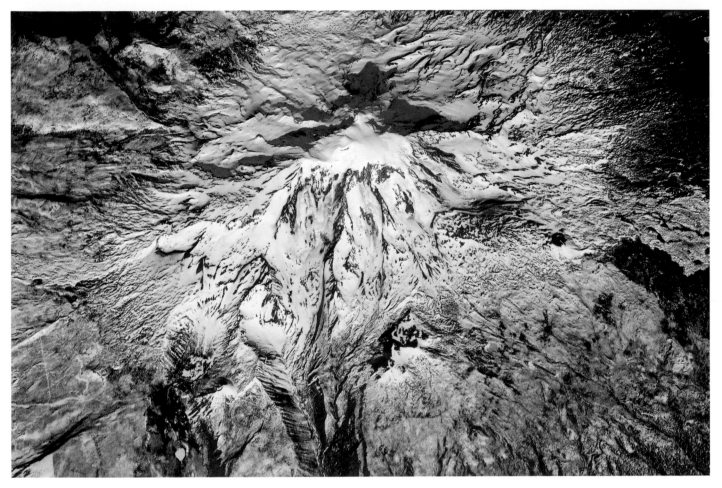

United States
Near the infamous Mount St. Helens in the northwestern United States, Mount Adams has been inactive for more than a thousand years. It is not, however, completely extinct, and the surrounding populations are still at risk of its reawakening and the melting of its ice cap.

Next pages
Compass
The circumference of Mount Taranaki, in New Zealand, is remarkable. It is so regular, it looks like it was drawn with a compass.

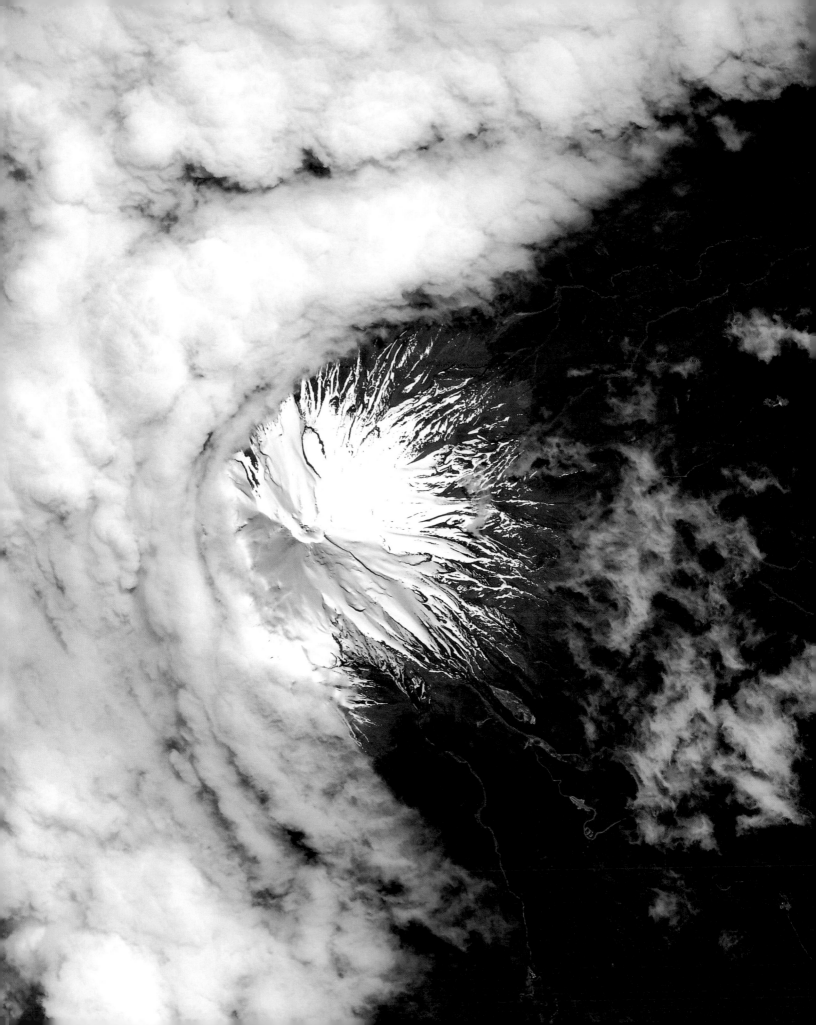

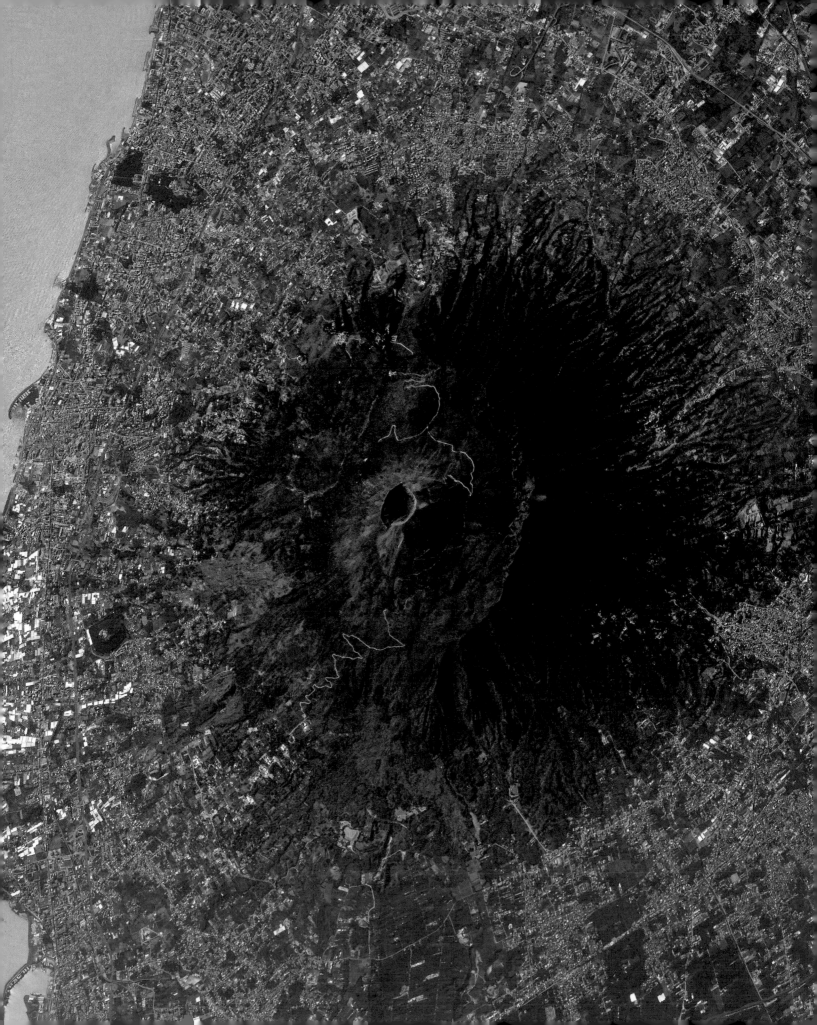

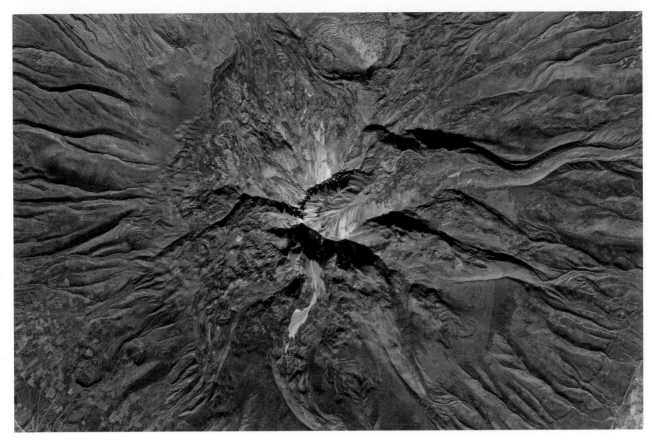

A Crowning Glory
This volcano in Bolivia is crowned with a pink-orange glow and sits on the edge of a salt sea that stretches out beyond the frame. Within the majesty of the Andes, it is an everyday sight.

Playing with Angles
Here we can see Mount Vesuvius and Naples, Italy. Mountains and volcanoes always look more spectacular when photographed at a slight angle rather than straight on: It accentuates their shape and relief. As a bonus, the Sun is reflected on the water and the glass roofs of the surrounding greenhouses, sprinkling the image with brilliant highlights.

Uluru

From the top of Uluru's 1,142 feet (348 m),
you are looking out over 500 million years of
history. Australia's most famous rock, once more
commonly known as Ayers Rock, is an inselberg,
an isolated mountain that was created by
resisting erosion and that, despite its monolithic
appearance, is the exposed section of a vast
underground rocky complex. It is a sacred place
for the local Aboriginal Peoples and is included
in the UNESCO World Heritage List for both its
natural and cultural value.

Kata Tjuta
Kata Tjuta is a mass of sandstone
domes not far from Uluru. The two
sites form Ulura-Kata Tjuta National
Park and were once more commonly
known as Ayers Rock and the Olgas,
names given to them by the area's
British colonizers. Like many such
sites around the world, they are
now generally referred to by their
historical names.

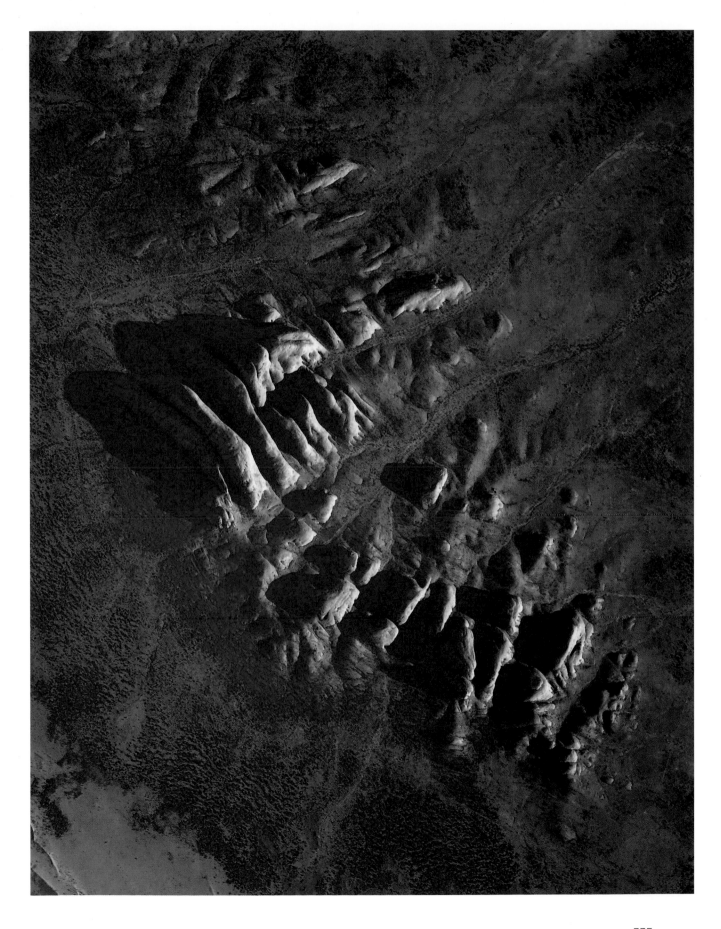

Last Lights
While the Earth's rotation has plunged most of this area into darkness, some very high Andean peaks are still lit by the very last rays of the Sun and resist the shadows, reflecting flamboyant shades of orange and yellow before eventually receding into the darkness.

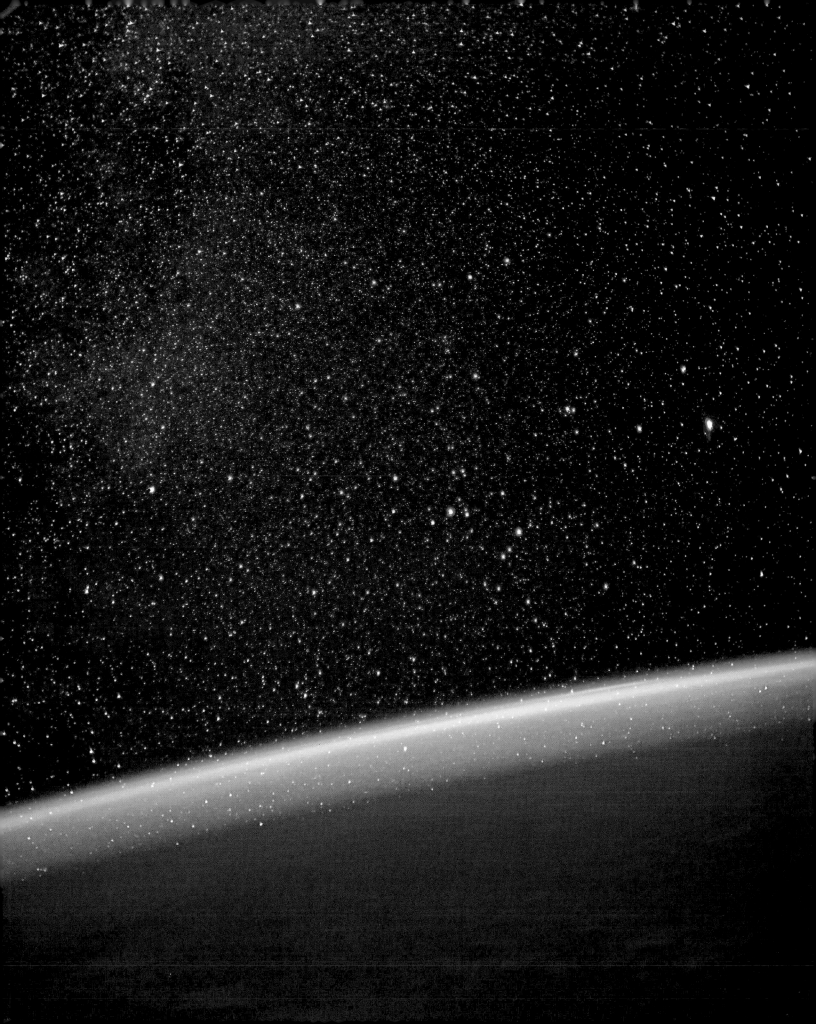

Night

Stars

"For some, who travel, the stars are guides. For others they are nothing but small lights. For others who are scholars they are problems. For my businessman they were gold. But all these stars are silent. You will have stars like no one has…" — Antoine de Saint-Exupéry, *The Little Prince*

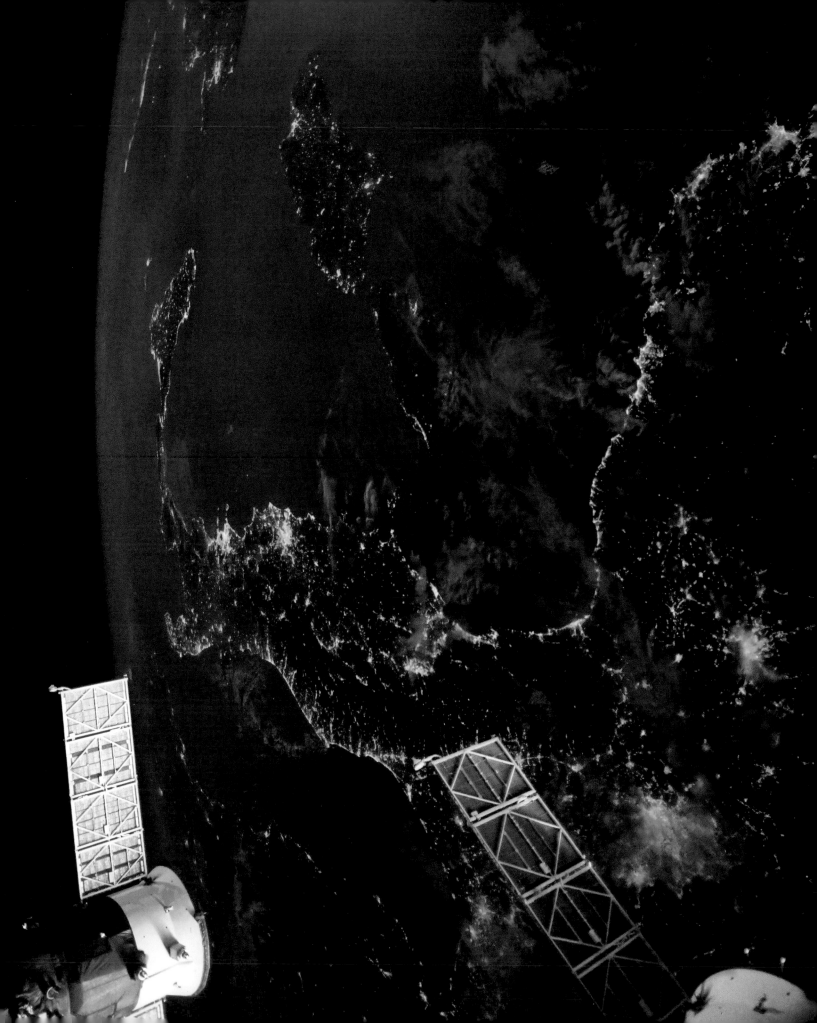

During a six-month mission aboard the International Space Station, we have thousands of opportunities to explore the night. In addition, far, far away from Earth, another night, one of dark matter and dark energy, remains a mystery.

Many scientists, particularly those who study the sky, are advocating that we reduce the amount of light pollution on Earth. Since the development of artificial lighting, humans have increasingly become aware of its harmful effects on flora and fauna (especially at night), biotopes and biological rhythms. The amount of energy being wasted should also be an important concern for us all.

Humans have a complex relationship with the night. It's widely considered to be a time of rest, but it can also be fraught with ancient fears, devoted to serenity or celebrated with festivities. It is associated with myriad legends and myths, some quite terrifying. On Earth, we generally consider that night has fallen when the Sun is 6 degrees below the horizon, marking twilight and when public lighting normally turns on. But astronomy enthusiasts have their own definition of night, often referred to as "astronomical night": the moment when it is dark enough to observe the stars, when the Sun is 18 degrees below the horizon. This is when the constellations and the multitude of twinkling dots that characterize our night sky appear in all their poetry, if the sky is dark enough for the eye to discern them.

Night photography is exciting, but it is very challenging for any astronaut. First, the ISS does not have a single window that points upward from which one can photograph stars. You have to bend your neck or be satisfied with a horizontal view. Moreover, when you point your lens toward Earth, you have to find well-lit areas along your trajectory, which are the only subjects that can be photographed from 250 miles (400 km) away in the dark, provided, of course, that clouds don't spoil the fun. And even when aiming at an ideal location (usually a large city), you are looking at Earth vertically and moving at well over 17,000 miles per hour (28,000 km/h). It is essentially a luminous carpet of tiny dots that passes by at top speed under your feet.

Adjusting the brightness, color balance and shutter speed, not to mention simply finding a stable position behind the lens, are real technical challenges. But when everything works and the photo captures city streets so clearly you could swear its daylight, one feels a unique happiness, like successfully performing a magic trick.

Italy by Night
Just a few clouds cover the boot of Italy along with Sardinia and Corsica, with their immediately recognizable outlines that stand out perfectly on the Mediterranean Sea.

Next pages
Hypnotic
Europe is, by far, the most illuminated continent, which allowed me to take nighttime time-lapse photos, long exposures and photo stacks such as this one. The camera captured 70 images, each lasting 2 seconds. The stars and city lights continued to move, drawing very short lines rather than appearing as dots. When these photos were electronically stacked, creating a computer-generated image, these very short lines more or less joined, creating dotted lines that traced the movements of the sky in relation to the station, or vice versa. The effect is rather hypnotic!

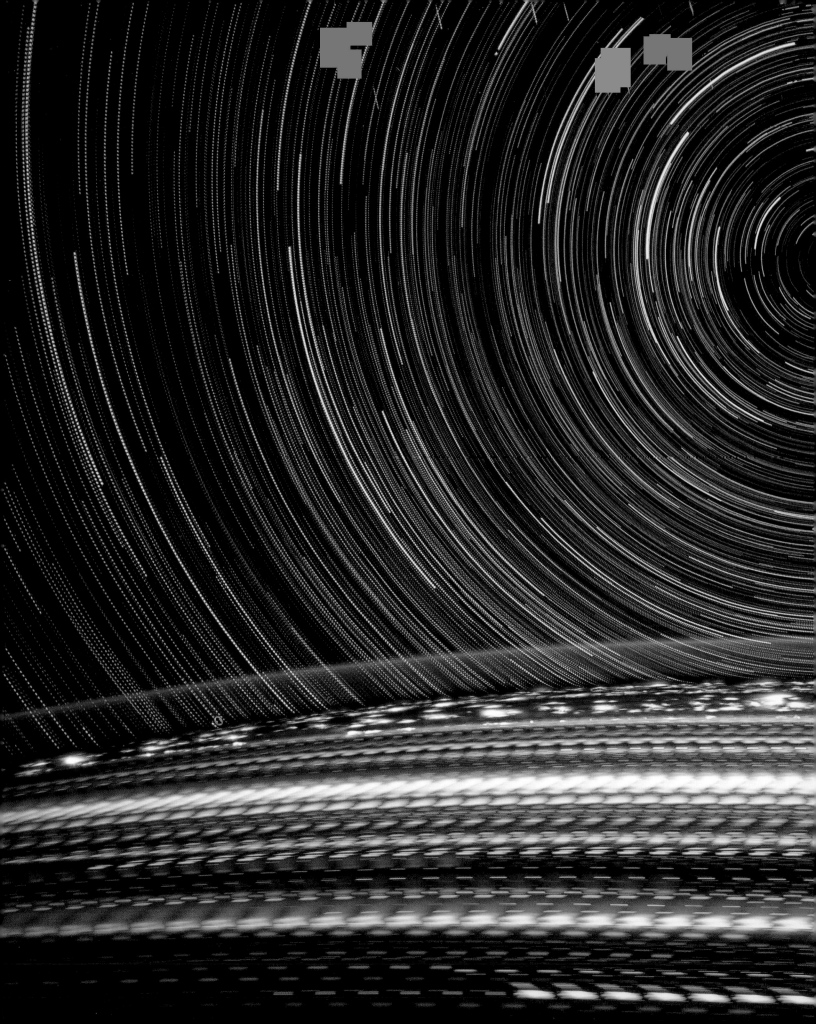

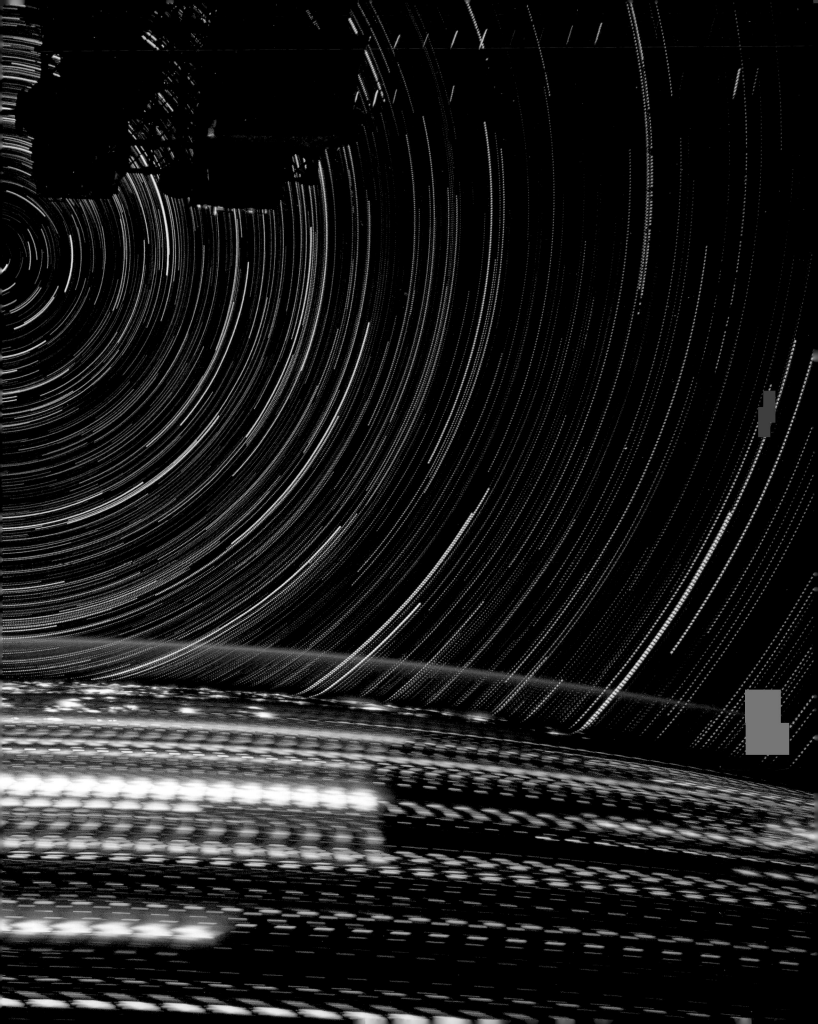

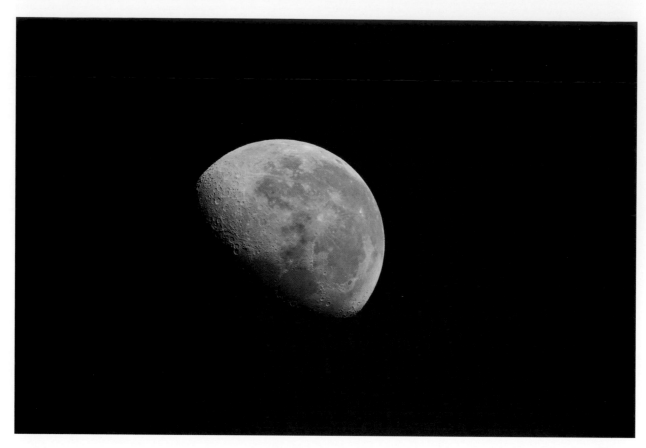

Point of View

The Moon sits on a bluish background lit by the fading twilight before the Sun disappears completely behind Earth. I took this photo from the station's Russian segment, which has windows along the sides in addition to those facing Earth. It provides a much more convenient view of space and the Moon in particular. Here we have a magnificent view of the lunar seas and craters, including the Sea of Tranquility, partly in shadow, where human beings took their first steps outside our planet. It will hopefully not have escaped your attention that space agencies have begun focusing on the Moon with greater ambitions and more sophisticated equipment, including stations in orbit, on-the-ground resources and satellite navigation and telecommunications systems.

Orders of Magnitude

The Sun's mass is 300,000 times that of Earth, and it is only a small star compared to some of the giants in the Milky Way, which is itself far from competing with the gigantic galaxies that have been observed by the Hubble Space Telescope and James Webb Space Telescope thousands of light-years away. Beware of vertigo when contemplating these orders of magnitude!

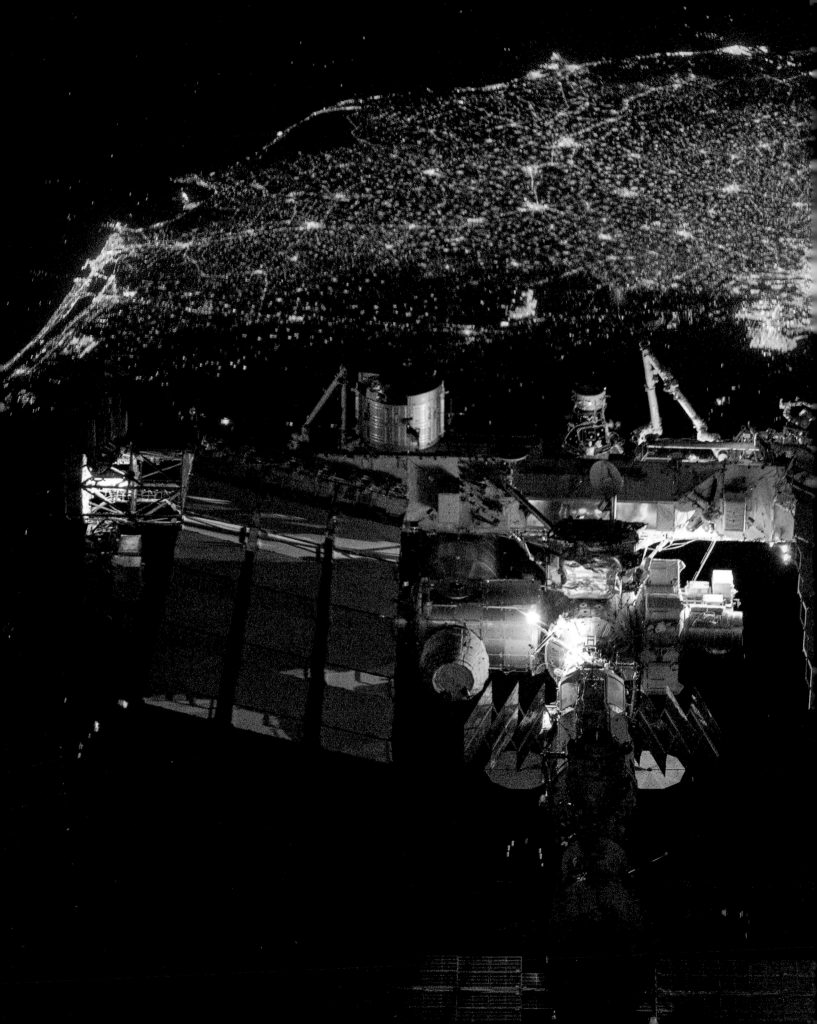

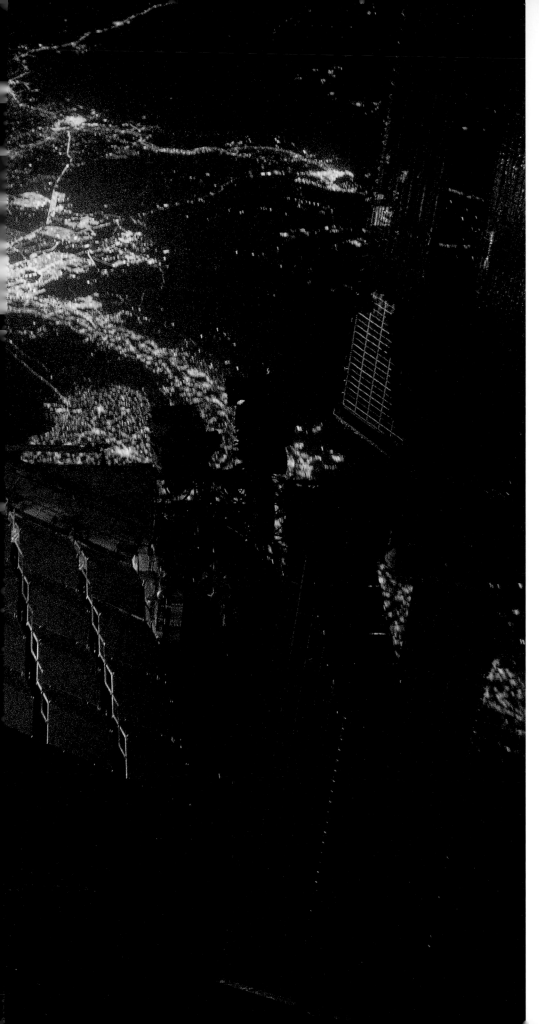

Our Cosmic Felucca
The perspective in this photo almost makes it look as though the International Space Station is sailing at night on the waters of the Nile Delta. With its 354-foot (108 m) length and 243-foot (74 m) width, the ISS is admittedly 10 times bigger than an Egyptian felucca, but that's pretty insignificant on a cosmic scale.

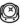

Aquarium
One of our teammates, Megan, was sitting in the Cupola when the 360-degree ISS Experience camera, attached to the end of a robotic arm, came to take a look inside. It reminded me of my last underwater training with NASA. Fish are sometimes attracted to the light emitted from a submersible's portholes, which is often the only light source in the environment.

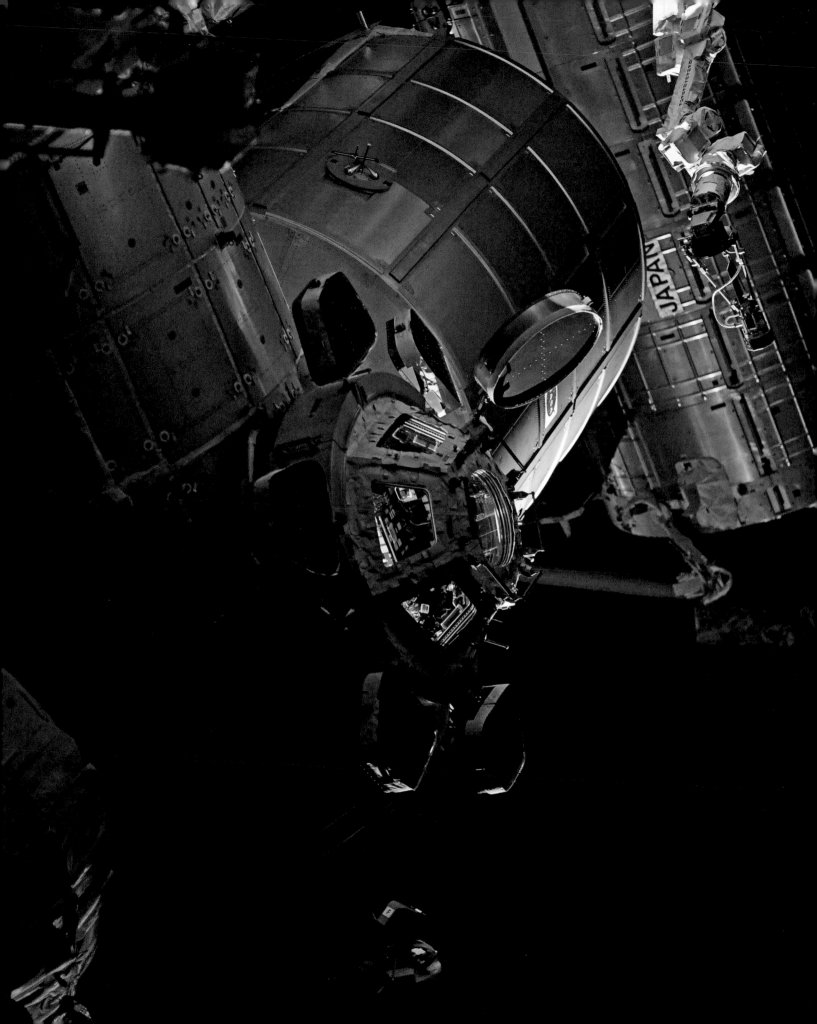

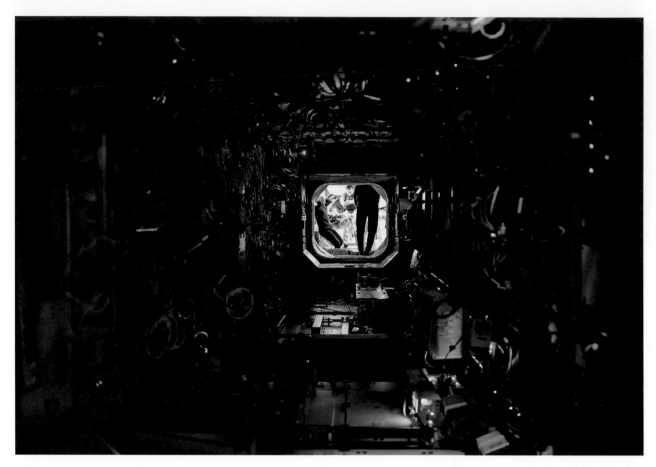

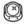

Interior, Nighttime
In the heart of the ISS, day and night coexist. Some areas are plunged into darkness while the crew is active in other modules.

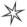

Special Effects
You might think that the weather on Earth is not really a concern for astronauts, but it certainly affects our photos! On summer nights, when the sky is clear, Earth appears covered by a luminous carpet whose patterns are drawn by the cities and major roads that connect them. A few storm clouds turn up the volume at the show. No need for special effects when you have access to a space station!

Sprite
I took this photo during a time-lapse sequence I shot over Europe. By chance, I captured a lightning strike and sprites in the upper atmosphere. Sprites are a rare and very short light phenomena, which makes them difficult to photograph and study. These "upward" flashes had remained a legend for decades. Pilots had described them, but scientists were not convinced they existed. Today we know that sprites, elves, blue jets and giant jets really do exist and might affect climate.

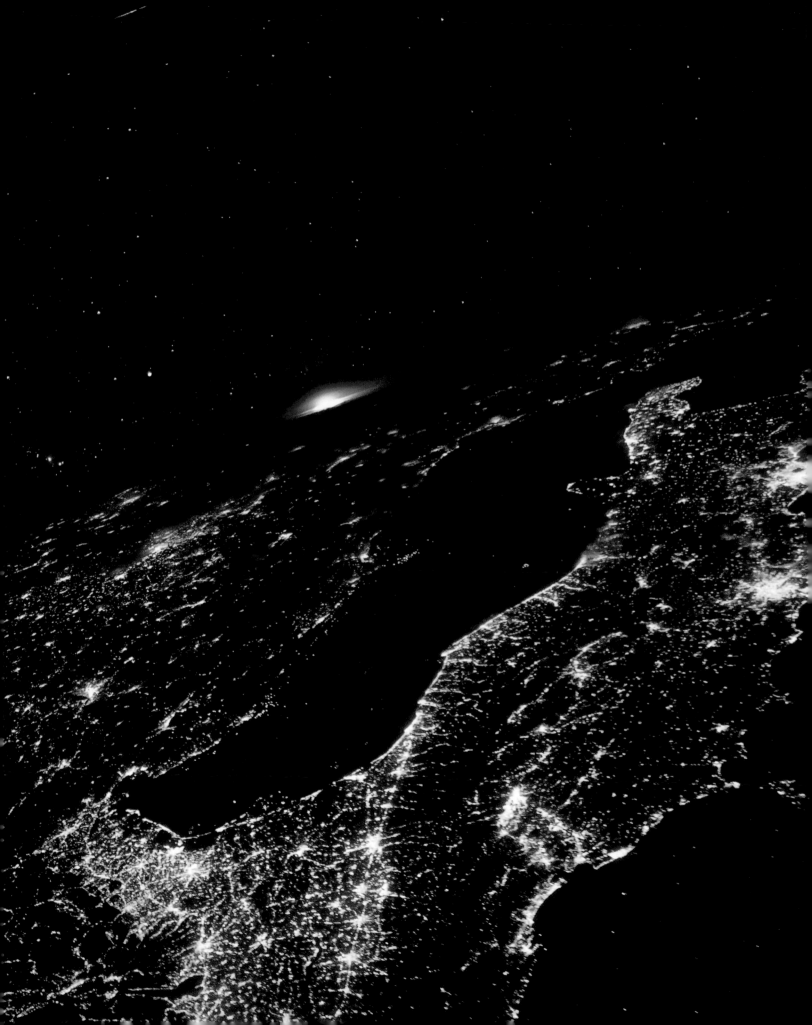

PANORAMA

New York

Europeans first named it New Angoulême, under King Francis I of France, then it became New Amsterdam when the Dutch were in control, and it finally acquired the name New York from the British in 1664. Today, the Big Apple is a world-class, multi-cultural city. It's always breathtaking to view the shadows its buildings cast on the Hudson River from the height of the ISS.

The City That Never Sleeps
At night, New York seems to express all of its eccentricities and contrasts. Times Square sparkles with thousands of lights along the edge of Central Park, which forms a perfectly dark rectangle.

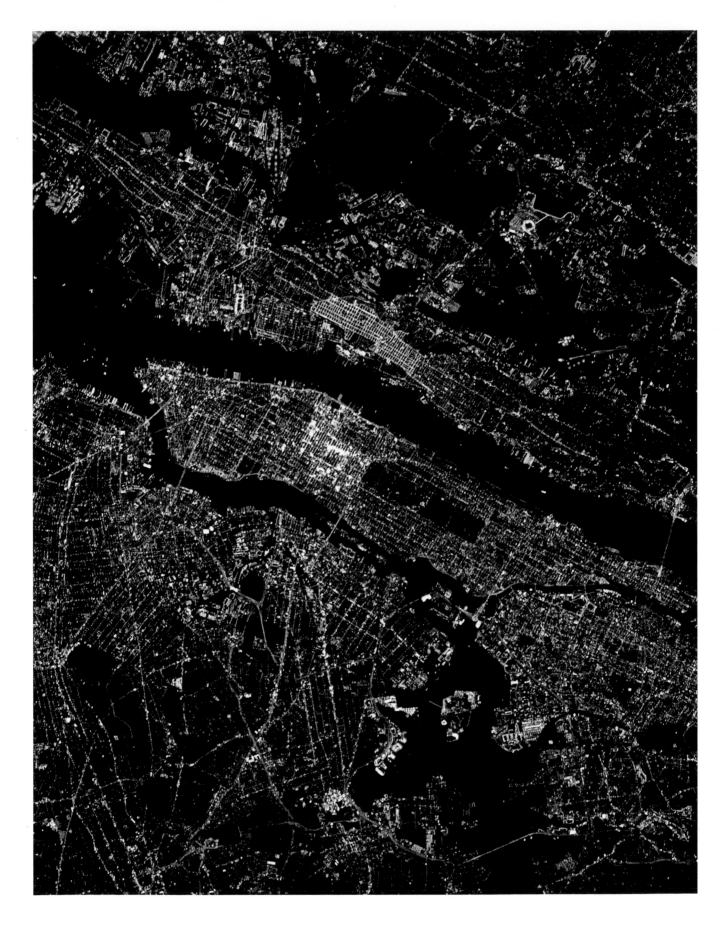

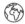

Moorings

With its navigation lights on, this Dragon cargo ship looks almost like any other ship reaching a port. And yet, after a 20-hour journey to the ISS, it must complete the final phase of its arrival in several steps, approaching smoothly and then docking automatically, all at an altitude of around 250 miles (400 km) while traveling at speeds over 17,000 miles per hour (28,000 km/h).

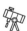

Small Concerns

This gradient reveals the atmosphere's layers. I took this photo from the Cupola with some difficulty. (I missed many before capturing this shot.) I had to keep the shutter open as long as possible to catch enough light, otherwise you wouldn't be able to see anything, and at the same time I had to stay absolutely still so that the photo wouldn't be blurred — mission almost impossible when traveling over 17,000 miles per hour (28 000 km/h)! These are the photographer's concerns when laboring in space...

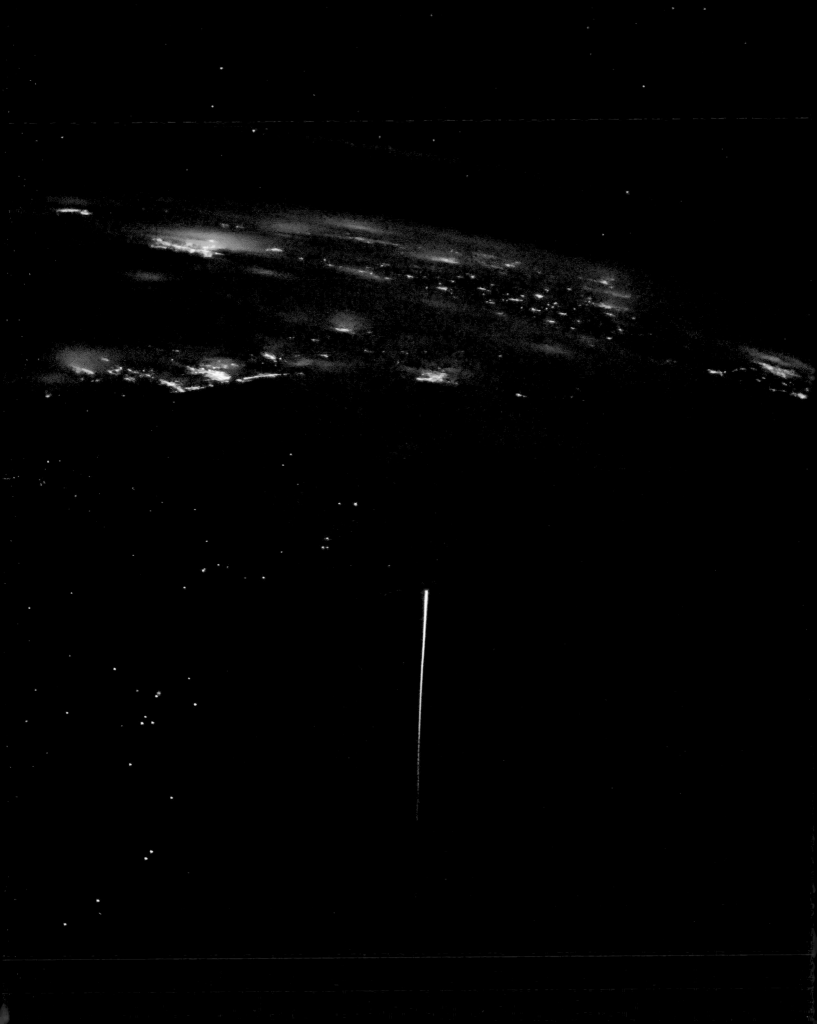

Make a Wish
The Crew-1 spacecraft returns to Earth, holding our colleagues Shannon, Mike, Victor and Soichi at the beginning of our own mission. It looks rather like a shooting star, doesn't it? Perhaps people in the southern United States and northern Mexico, who would have been able to see it with the naked eye, made a wish...

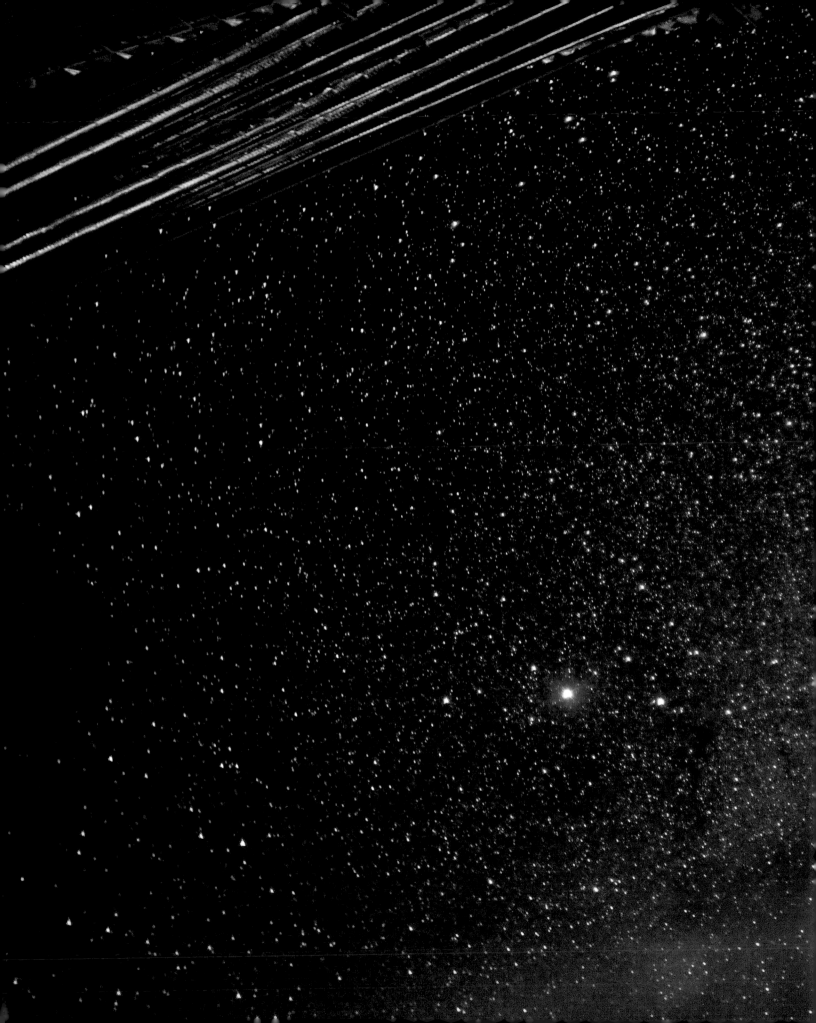

Van Gogh
Van Gogh painted *The Starry Night* while looking up at the sublime sky over Provence. What would he have painted had he set up his easel in the Cupola?

Table
of Contents

Dawn and Auroras

pp. 16 ⟶ 45

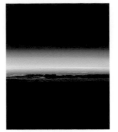

ISO 800 16.0 1/1000
Nikon D5 460 mm
MAY 20, 2021
p. 16

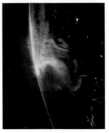

ISO 8000 1.4 0.4
Nikon D5 24 mm
NOVEMBER 4, 2021
p. 18

ISO 10000 1.4 1/20
Nikon D5 28 mm
JULY 23, 2021
pp. 20-21

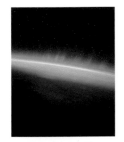

ISO 12800 1.2 0.5
Nikon D5 58 mm
AUGUST 2, 2021
p. 22

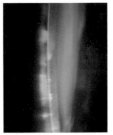

ISO 10000 1.2 0.5
Nikon D5 58 mm
AUGUST 2, 2021
p. 23

ISO 10000 1.4 0.5
Nikon D5 24 mm
AUGUST 15, 2021
pp. 24-25

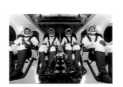

NOVEMBER 7, 2021
pp. 27-30

ISO 10000 2.8 8
Nikon D5 32 mm
SEPTEMBER 28, 2021
p. 31

ISO 10000 1.4 1/4
Nikon D5 28 mm
SEPTEMBER 8, 2021
p. 33

ISO 10000 1.4 0.4
Nikon D5 28 mm
OCTOBER 12, 2021
pp. 34-35

ISO 10000 1.4 1
Nikon D5 24 mm
AUGUST 7, 2021
p. 36

ISO 10000 1.4 0.4
Nikon D5 24 mm
OCTOBER 14, 2021
p. 37

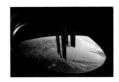

ISO 200 8.0 1/8000
Nikon D5 140 mm
JUNE 15, 2021
pp. 38-39

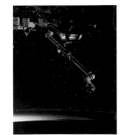

ISO 12800 5.6 3
Nikon D5 62 mm
JULY 20, 2021
p. 40

ISO 12800 2.8 1/25
Nikon D5 28 mm
JUNE 29, 2021
p. 41

ISO 8000 1.2 1.3
Nikon D5 58 mm
OCTOBER 31, 2021
p. 42

ISO 10000 1.4 1
Nikon D5 24 mm
NOVEMBER 4, 2021
p. 43

ISO 4000 8.0 1/5025
Nikon D5 24 mm
MAY 20, 2021
pp. 44-45

The Blue Marble

pp. 46 ⟶ 59

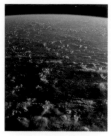

ISO 500 · 13.0 · 1/640 · Nikon D5 · 40 mm
MAY 14, 2021
p. 46

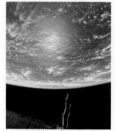

ISO 125 · 2.8 · 1/6410 · Nikon D5 · 17 mm
MAY 25, 2021
p. 48

ISO 400 · 14.0 · 1/1252 · Nikon D5 · 28 mm
JUNE 15, 2021
pp. 50–51

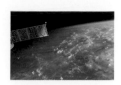

ISO 500 · 10.0 · 1/400 · Nikon D5 · 62 mm
MAY 14, 2021
p. 52

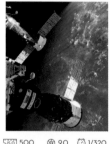

ISO 500 · 9.0 · 1/320 · Nikon D5 · 28 mm
MAY 14, 2021
p. 53

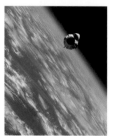

ISO — · Nikon D5 · 28 mm
NOVEMBER 7, 2021
p. 54

ISO 125 · 13.0 · 1/640 · Nikon D5 · 70 mm
AUGUST 30, 2021
p. 55

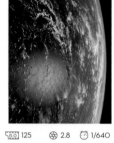

ISO 125 · 2.8 · 1/640 · Nikon D5 · 22 mm
MAY 25, 2021
p. 56

ISO 100 · 8.0 · 1/1252 · Nikon D5 · 35 mm
MAY 1, 2021
p. 57

ISO 400 · 10.0 · 1/1603 · Nikon D5 · 140 mm
MAY 9, 2021
p. 58

ISO 1250 · 18.0 · 1/1252 · Nikon D5 · 24 mm
APRIL 30, 2021
p. 59

Clouds

pp. 60 ⟶ 93

ISO 400 · 18.0 · 1/640 · Nikon D5 · 50 mm
OCTOBER 30, 2021
p. 60

ISO 400 · 11.0 · 1/400 · Nikon D5 · 95 mm
JUNE 11, 2021
p. 62

ISO 200 · 11.0 · 1/500 · Nikon D5 · 70 mm
OCTOBER 17, 2021
pp. 64–65

ISO 400 · 29.0 · 1/60 · Nikon D5 · 210 mm
JUNE 5, 2021
p. 66

ISO 400 · 11.0 · 1/1603 · Nikon D5 · 140 mm
JUNE 24, 2021
p. 67

ISO 800 · 10.0 · 1/1250 · Nikon D5 · 28 mm
JUNE 15, 2021
p. 68

ISO 800 · 10.0 · 1/801 · Nikon D5 · 24 mm
AUGUST 17, 2021
p. 69

ISO 400　　10.0　　1/8000
Nikon D5　　175 mm
SEPTEMBER 2, 2021
pp. 70-71

ISO 200　　13.0　　1/640
Nikon D5　　200 mm
OCTOBER 17, 2021
p. 72

ISO 800　　2.8　　1/4000
Nikon D5　　70 mm
MAY 26, 2021
p. 73

ISO 800　　10.0　　1/3205
Nikon D5　　1150 mm
AUGUST 28, 2021
pp. 74-75

ISO 800　　16.0　　1/1252
Nikon D5　　1150 mm
JULY 7, 2021
p. 76

ISO 800　　10.0　　1/4000
Nikon D5　　50 mm
AUGUST 20, 2021
p. 77

ISO 800　　8.0　　1/2000
Nikon D5　　400 mm
MAY 14, 2021
pp. 78-79

ISO 400　　20.0　　1/250
Nikon D5　　16 mm
SEPTEMBER 19, 2021
p. 80

ISO 400　　14.0　　1/1000
Nikon D5　　800 mm
APRIL 27, 2021
p. 81

ISO 400　　11.0　　1/801
Nikon D5　　95 mm
JUNE 24, 2021
p. 82

ISO 3200　　10.0　　1/8000
Nikon D5　　24 mm
AUGUST 17, 2021
p. 84

ISO 800　　10.0　　1/3205
Nikon D5　　1150 mm
AUGUST 20, 2021
p. 85

ISO 800　　8.0　　1/6410
Nikon D5　　1150 mm
OCTOBER 4, 2021
pp. 86-87

ISO 200　　8.0　　1/801
Nikon D5　　70 mm
AUGUST 6, 2021
p. 89

ISO 800　　8.0　　1/4000
Nikon D5　　1150 mm
AUGUST 17, 2021
pp. 90-91

ISO 200　　10.0　　1/1252
Nikon D5　　240 mm
JUNE 15, 2021
pp. 92-93

Storms

pp. 94 ⟶ 125

ISO 125　　10.0　　1/801
Nikon D5　　16 mm
JULY 4, 2021
p. 94

ISO 400　　10.0　　1/1252
Nikon D5　　24 mm
SEPTEMBER 7, 2021
p. 96

ISO 800　　10.0　　1/4000
Nikon D5　　50 mm
AUGUST 18, 2021
pp. 98-99

ISO 400 · 10.0 · 1/2506 · Nikon D5 · 380 mm · AUGUST 29, 2021 · p. 101	ISO 400 · 10.0 · 1/2000 · Nikon D5 · 28 mm · SEPTEMBER 7, 2021 · pp. 102–103	ISO 100 · 5.6 · 1/2000 · Nikon D5 · 28 mm · AUGUST 28, 2021 · p. 105	ISO 400 · 10.0 · 1/2000 · Nikon D5 · 16 mm · AUGUST 28, 2021 · pp. 106–107	ISO 12800 · 1.2 · 0.5 · Nikon D5 · 58 mm · JULY 30, 2021 · p. 108
ISO 12800 · 1.4 · 0.3 · Nikon D5 · 28 mm · SEPTEMBER 5, 2021 · p. 109	ISO 25600 · 2.8 · 1/100 · Nikon D5 · 400 mm · MAY 10, 2021 · p. 111	ISO 25600 · 2.8 · 1/100 · Nikon D5 · 400 mm · MAY 10, 2021 · p. 111	ISO 25600 · 2.8 · 1/100 · Nikon D5 · 400 mm · MAY 10, 2021 · p. 111	ISO 25600 · 2.8 · 1/100 · Nikon D5 · 400 mm · MAY 10, 2021 · p. 111
ISO 25600 · 2.8 · 1/100 · Nikon D5 · 400 mm · MAY 10, 2021 · p. 111	ISO 20000 · 2.8 · 1/200 · Nikon D5 · 400 mm · MAY 8, 2021 · p. 111	ISO 3200 · 10.0 · 1/8000 · Nikon D5 · 34 mm · JUNE 29, 2021 · pp. 112–113	ISO 100 · 10.0 · 1/400 · Nikon D5 · 31 mm · MAY 2, 2021 · pp. 115–118	ISO 400 · 20.0 · 1/250 · Nikon D5 · 16 mm · SEPTEMBER 19, 2021 · p. 119
p. 120	ISO 200 · 10.0 · 1/400 · Nikon D5 · 70 mm · JUNE 13, 2021 · p. 122	ISO 200 · 10.0 · 1/400 · Nikon D5 · 70 mm · JUNE 13, 2021 · pp. 124–125	**Seas and Oceans** pp. 126 ⟶ 145	ISO 400 · 2.8 · 1/8000 · Nikon D5 · 70 mm · APRIL 28, 2021 · p. 126

ISO 200 7.1 1/1603
Nikon D5 800 mm
APRIL 28, 2021
p. 128

ISO 400 10.0 1/1252
Nikon D5 28 mm
AUGUST 27, 2021
pp. 130-131

ISO 800 10.0 1/2506
Nikon D5 170 mm
AUGUST 18, 2021
p. 132

ISO 800 16.0 1/1000
Nikon D5 50 mm
AUGUST 17, 2021
p. 133

ISO 400 16.0 1/801
Nikon D5 24 mm
JUNE 15, 2021
p. 135

ISO 500 13.0 1/1603
Nikon D5 400 mm
JULY 3, 2021
pp. 136-137

ISO 800 8.0 1/4000
Nikon D5 400 mm
SEPTEMBER 23, 2021
p. 138

ISO 800 8.0 1/3205
Nikon D5 400 mm
SEPTEMBER 23, 2021
p. 139

ISO 800 16.0 1/1000
Nikon D5 210 mm
AUGUST 17, 2021
p. 140

ISO 800 16.0 1/1000
Nikon D5 16 mm
MAY 2, 2021
p. 141

ISO 500 8.0 1/2000
Nikon D5 1150 mm
JUNE 15, 2021
p. 142

ISO 800 11.0 1/1603
Nikon D5 1150 mm
JUNE 8, 2021
p. 143

ISO 400 10.0 1/2000
Nikon D5 50 mm
AUGUST 30, 2021
pp. 144-145

Coasts

pp. 146 ⟶ 169

ISO 800 16.0 1/1000
Nikon D5 50 mm
OCTOBER 9, 2021
p. 146

ISO 400 8.0 1/1603
Nikon D5 1200 mm
MAY 30, 2021
p. 148

ISO 200 7.1 1/1252
Nikon D5 70 mm
APRIL 29, 2021
pp. 150-151

ISO 200 7.1 1/1603
Nikon D5 800 mm
APRIL 28, 2021
p. 153

ISO 200 10.0 1/1252
Nikon D5 200 mm
APRIL 29, 2021
pp. 154-155

ISO 800 10.0 1/801
Nikon D5 1150 mm
MAY 22, 2021
p. 156

ISO 500 · 10.0 · 1/1252 · Nikon D5 · 1150 mm
AUGUST 13, 2021
p. 157

ISO 800 · 8.0 · 1/4000 · Nikon D5 · 1150 mm
JUNE 14, 2021
pp. 158–159

ISO 500 · 13.0 · 1/640 · Nikon D5 · 28 mm
MAY 14, 2021
p. 160

ISO 800 · 22.0 · 1/320 · Nikon D5 · 58 mm
JUNE 1, 2021
p. 161

ISO 800 · 16.0 · 1/1000 · Nikon D5 · 35 mm
SEPTEMBER 23, 2021
p. 162

ISO 320 · 16.0 · 1/400 · Nikon D5 · 35 mm
SEPTEMBER 22, 2021
p. 163

ISO 400 · 11.0 · 1/1000 · Nikon D5 · 1600 mm
JUNE 3, 2021
pp. 164–165

ISO 500 · 10.0 · 1/1000 · Nikon D5 · 1150 mm
JULY 1, 2021
p. 166

ISO 500 · 10.0 · 1/2000 · Nikon D5 · 1150 mm
AUGUST 2, 2021
p. 167

ISO 200 · 11.0 · 1/800 · Nikon D5 · 24 mm
SEPTEMBER 28, 2021
pp. 168–169

Rivers

pp. 170 ⟶ 201

ISO 200 · 1/1603 · Nikon D5 · 800 mm
APRIL 28, 2021
p. 170

ISO 800 · 10.0 · 1/1603 · Nikon D5 · 1150 mm
JULY 7, 2021
p. 172

ISO 200 · 5.6 · 1/1603 · Nikon D5 · 800 mm
APRIL 28, 2021
pp. 174–175

ISO 500 · 10.0 · 1/1000 · Nikon D5 · 1150 mm
JULY 9, 2021
p. 176

ISO 800 · 10.0 · 1/2000 · Nikon D5 · 70 mm
JULY 30, 2021
p. 177

ISO 500 · 10.0 · 1/1000 · Nikon D5 · 400 mm
JUNE 18, 2021
pp. 178–179

ISO 200 · 5.6 · 1/1000 · Nikon D5 · 800 mm
APRIL 27, 2021
p. 180

ISO 200 · 6.3 · 1/1000 · Nikon D5 · 800 mm
APRIL 27, 2021
p. 181

ISO 500 · 10.0 · 1/1252 · Nikon D5 · 1150 mm
JULY 30, 2021
pp. 182–183

ISO 800 9.0 1/5025 Nikon D5 1150 mm
SEPTEMBER 23, 2021
p. 184

ISO 400 9.0 1/1603 Nikon D5 1150 mm
JUNE 4, 2021
p. 185

ISO 500 10.0 1/1000 Nikon D5 1150 mm
JULY 9, 2021
pp. 186–187

ISO 500 10.0 1/1252 Nikon D5 1150 mm
JULY 30, 2021
p. 188

ISO 200 7.1 1/1603 Nikon D5 800 mm
APRIL 28, 2021
p. 190

ISO 800 8.0 1/4000 Nikon D5 400 mm
SEPTEMBER 23, 2021
p. 191

ISO 800 8.0 1/2000 Nikon D5 1150 mm
AUGUST 8, 2021
pp. 192–193

ISO 400 13.0 1/320 Nikon D5 70 mm
JULY 9, 2021
p. 194

ISO 12800 2.8 1/20 Nikon D5 40 mm
MAY 26, 2021
pp. 196–197

ISO 200 10.0 1/640 Nikon D5 28 mm
APRIL 27, 2021
p. 198

ISO 500 14.0 1/801 Nikon D5 31 mm
JUNE 1, 2021
p. 199

Soils

pp. 202 ⟶ 229

pp. 200–201

ISO 800 10.0 1/1252 Nikon D5 1150 mm
JULY 22, 2021
p. 202

ISO 800 8.0 1/1603 Nikon D5 1150 mm
OCTOBER 9, 2021
p. 204

ISO 400 13.0 1/640 Nikon D5 290 mm
SEPTEMBER 23, 2021
pp. 206–207

ISO 800 8.0 1/1603 Nikon D5 1150 mm
MAY 14, 2021
p. 208

ISO 400 10.0 1/1000 Nikon D5 65 mm
MAY 9, 2021
p. 209

ISO 400 16.0 1/500 Nikon D5 170 mm
MAY 1, 2021
pp. 210–211

ISO 500 10.0 1/1000 Nikon D5 1150 mm
JULY 9, 2021
p. 213

Row 1

ISO 800 · 10.0 · 1/3205 · Nikon D5 · 1150 mm · JUNE 9, 2021 · p. 213

ISO 800 · 8.0 · 1/3205 · Nikon D5 · 1150 mm · AUGUST 17, 2021 · p. 213

ISO 800 · 10.0 · 1/2000 · Nikon D5 · 1150 mm · JUNE 9, 2021 · p. 213

ISO 100 · 16.0 · 1/80 · Nikon D5 · 140 mm · JUNE 3, 2021 · p. 214

ISO 400 · 10.0 · 1/1252 · Nikon D5 · 1150 mm · JUNE 23, 2021 · p. 215

Row 2

ISO 800 · 8.0 · 1/2506 · Nikon D5 · 400 mm · JULY 22, 2021 · p. 217

ISO 800 · 8.0 · 1/3205 · Nikon D5 · 1150 mm · AUGUST 18, 2021 · pp. 218–219

ISO 500 · 10.0 · 1/2000 · Nikon D5 · 95 mm · SEPTEMBER 19, 2021 · p. 220

ISO 500 · 10.0 · 1/2000 · Nikon D5 · 290 mm · SEPTEMBER 19, 2021 · p. 222

ISO 500 · 8.0 · 1/3205 · Nikon D5 · 1150 mm · SEPTEMBER 19, 2021 · pp. 222–223

Row 3

ISO 800 · 8.0 · 1/5025 · Nikon D5 · 1150 mm · AUGUST 17, 2021 · p. 224

ISO 500 · 11.0 · 1/1603 · Nikon D5 · 1600 mm · MAY 29, 2021 · p. 225

ISO 800 · 11.0 · 1/1603 · Nikon D5 · 1150 mm · MAY 25, 2021 · pp. 226–227

ISO 640 · 10.0 · 1/1252 · Nikon D5 · 500 mm · AUGUST 7, 2021 · pp. 228–229

Cities

pp. 230 ⟶ 261

Row 4

ISO 800 · 10.0 · 1/1000 · Nikon D5 · 1150 mm · MAY 6, 2021 · p. 230

ISO 12800 · 2.8 · 1/60 · Nikon D5 · 400 mm · JULY 27, 2021 · p. 232

ISO 800 · 8.0 · 1/3205 · Nikon D5 · 1150 mm · AUGUST 18, 2021 · pp. 234–235

ISO 800 · 8.0 · 1/5025 · Nikon D5 · 1150 mm · AUGUST 17, 2021 · p. 236

ISO 8000 · 2.8 · 1/60 · Nikon D5 · 400 mm · AUGUST 27, 2021 · p. 237

| ISO 800 · 8.0 · 1/3205 · Nikon D5 · 1150 mm · AUGUST 17, 2021 · pp. 238–239 |
| ISO 400 · 8.0 · 1/1252 · Nikon D5 · 1150 mm · MAY 5, 2021 · p. 240 |
| ISO 800 · 13.0 · 1/1603 · Nikon D5 · 1150 mm · OCTOBER 30, 2021 · p. 241 |
| ISO 400 · 8.0 · 1/1603 · Nikon D5 · 1200 mm · MAY 30, 2021 · pp. 242–243 |
| ISO 400 · 14.0 · 1/1603 · Nikon D5 · 1150 mm · APRIL 29, 2021 · p. 245 |

| ISO 200 · 10.0 · 1/1250 · Nikon D5 · 200 mm · APRIL 29, 2021 · p. 246 |
| ISO 200 · 6.3 · 1/1603 · Nikon D5 · 800 mm · APRIL 28, 2021 · p. 247 |
| ISO 400 · 11.0 · 1/801 · Nikon D5 · 1150 mm · JUNE 3, 2021 · p. 248 |
| ISO 400 · 11.0 · 1/1000 · Nikon D5 · 1150 mm · JUNE 3, 2021 · p. 249 |
| ISO 8000 · 2.8 · 1/50 · Nikon D5 · 400 mm · SEPTEMBER 20, 2021 · p. 250 |

| ISO 20000 · 2.8 · 1/80 · Nikon D5 · 400 mm · MAY 5, 2021 · p. 250 |
| ISO 10000 · 2.8 · 1/50 · Nikon D5 · 400 mm · SEPTEMBER 8, 2021 · p. 250 |
| ISO 12800 · 2.8 · 1/40 · Nikon D5 · 400 mm · JULY 24, 2021 · p. 250 |
| ISO 8000 · 2.8 · 1/50 · Nikon D5 · 400 mm · SEPTEMBER 20, 2021 · p. 250 |
| ISO 10000 · 2.8 · 1/60 · Nikon D5 · 400 mm · AUGUST 5, 2021 · p. 250 |

| ISO 20000 · 2.8 · 1/80 · Nikon D5 · 400 mm · MAY 8, 2021 · pp. 252–253 |
| ISO 800 · 10.0 · 1/2000 · Nikon D5 · 1150 mm · MAY 6, 2021 · pp. 254–255 |
| ISO 500 · 8.0 · 1/1603 · Nikon D5 · 1150 mm · JUNE 13, 2021 · p. 256 |
| ISO 800 · 10.0 · 1/2000 · Nikon D5 · 1150 mm · AUGUST 15, 2021 · p. 257 |
| ISO 400 · 10.0 · 1/1000 · Nikon D5 · 1150 mm · AUGUST 10, 2021 · pp. 258–259 |

📷 12800 ⬡ 2.8 ⏱ 1/40
📷 Nikon D5 ▭ 400 mm
JULY 27, 2021
pp. 260-261

Borders

pp. 262 ⟶ 283

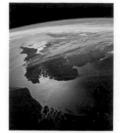

📷 500 ⬡ 16.0 ⏱ 1/1000
📷 Nikon D5 ▭ 28 mm
JUNE 1, 2021
p. 262

📷 100 ⬡ 10.0 ⏱ 1/400
📷 Nikon D5 ▭ 31 mm
MAY 2, 2021
p. 264

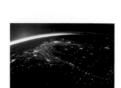

📷 200 ⬡ 22.0 ⏱ 1/160
📷 Nikon D5 ▭ 25 mm
MAY 23, 2021
p. 266

📷 800 ⬡ 10.0 ⏱ 1/3205
📷 Nikon D5 ▭ 28 mm
AUGUST 12, 2021
p. 267

📷 500 ⬡ 10.0 ⏱ 1/2000
📷 Nikon D5 ▭ 1150 mm
AUGUST 1, 2021
pp. 268-269

📷 12800 ⬡ 2.8 ⏱ 1/60
📷 Nikon D5 ▭ 400 mm
JULY 20, 2021
p. 270

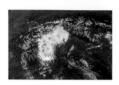

📷 800 ⬡ 10.0 ⏱ 1/5025
📷 Nikon D5 ▭ 28 mm
JUNE 15, 2021
pp. 272-273

📷 8000 ⬡ 1.4 ⏱ 0,5
📷 Nikon D5 ▭ 24 mm
SEPTEMBER 15, 2021
p. 274

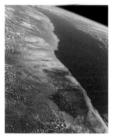

📷 200 ⬡ 9.0 ⏱ 1/1000
📷 Nikon D5 ▭ 70 mm
APRIL 27, 2021
p. 275

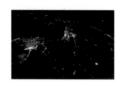

📷 12800 ⬡ 1.4 ⏱ 1/15
📷 Nikon D5 ▭ 24 mm
JULY 27, 2021
pp. 276-277

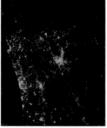

📷 12800 ⬡ 2.8 ⏱ 1/20
📷 Nikon D5 ▭ 45 mm
MAY 26, 2021
p. 278

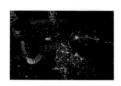

📷 8000 ⬡ 1.4 ⏱ 1/10
📷 Nikon D5 ▭ 24 mm
SEPTEMBER 15, 2021
p. 279

📷 800 ⬡ 10.0 ⏱ 1/1000
📷 Nikon D5 ▭ 1150 mm
MAY 6, 2021
pp. 280-281

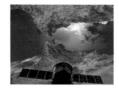

📷 800 ⬡ 16.0 ⏱ 1/1000
📷 Nikon D5 ▭ 28 mm
AUGUST 5, 2021
pp. 282-283

Deserts

pp. 284 ⟶ 307

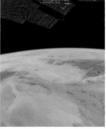

📷 200 ⬡ 7.1 ⏱ 1/1000
📷 Nikon D5 ▭ 28 mm
MAY 1, 2021
p. 284

📷 500 ⬡ 10.0 ⏱ 1/1000
📷 Nikon D5 ▭ 58 mm
SEPTEMBER 19, 2021
p. 286

📷 500 ⬡ 8.0 ⏱ 1/2252
📷 Nikon D5 ▭ 1150 mm
SEPTEMBER 19, 2021
pp. 288-289

ISO 500 10.0 1/1000
Nikon D5 210 mm
SEPTEMBER 19, 2021
p. 290

ISO 1600 11.0 1/3205
Nikon D5 1150 mm
MAY 22, 2021
p. 291

ISO 100 10.0 1/250
Nikon D5 210 mm
JULY 14, 2021
p. 292

ISO 400 16.0 1/500
Nikon D5 210 mm
MAY 1, 2021
p. 294

ISO 100 8.0 1/1252
Nikon D5 28 mm
MAY 1, 2021
p. 295

ISO 800 16.0 1/801
Nikon D5 70 mm
MAY 25, 2021
p. 296

ISO 400 10.0 1/1000
Nikon D5 70 mm
JUNE 27, 2021
pp. 298–299

ISO 1000 16.0 1/1252
Nikon D5 28 mm
APRIL 28, 2021
p. 300

ISO 800 10.0 1/2506
Nikon D5 210 mm
AUGUST 18, 2021
p. 301

ISO 800 10.0 1/2506
Nikon D5 50 mm
AUGUST 18, 2021
pp. 302–303

ISO 400 10.0 1/1000
Nikon D5 240 mm
MAY 9, 2021
p. 304

ISO 200 16.0 1/125
Nikon D5 28 mm
APRIL 27, 2021
p. 305

ISO 500 11.0 1/1252
Nikon D5 1150 mm
JULY 30, 2021
pp. 306–307

Mountains

pp. 308 ⟶ 337

ISO 400 9.0 1/3205
Nikon D5 1150 mm
SEPTEMBER 23, 2021
p. 308

ISO 800 10.0 1/801
Nikon D5 1150 mm
MAY 6, 2021
p. 310

ISO 500 14.0 1/1603
Nikon D5 1150 mm
MAY 31, 2021
pp. 312–313

ISO 400 11.0 1/1603
Nikon D5 1150 mm
JUNE 2, 2021
p. 314

ISO 500 14.0 1/1603
Nikon D5 1150 mm
MAY 31, 2021
p. 315

ISO 800 10.0 1/2506
Nikon D5 1150 mm
AUGUST 21, 2021
p. 316

ISO 800 · 10.0 · 1/3205 · Nikon D5 · 1150 mm — JULY 22, 2021 — p. 317

ISO 800 · 14.0 · 1/801 · Nikon D5 · 1150 mm — AUGUST 21, 2021 — p. 319

ISO 640 · 8.0 · 1/2506 · Nikon D5 · 1150 mm — AUGUST 8, 2021 — p. 320

ISO 800 · 9.0 · 1/8000 · Nikon D5 · 1150 mm — SEPTEMBER 23, 2021 — p. 321

ISO 1250 · 16.0 · 1/1252 · Nikon D5 · 400 mm — MAY 8, 2021 — pp. 322–323

ISO · 11.0 · 1/1603 · Nikon D5 · 800 mm — APRIL 28, 2021 — p. 324

ISO 400 · 10.0 · 1/1603 · Nikon D5 · 1150 mm — MAY 1, 2021 — p. 325

ISO 400 · 9.0 · 1/2506 · Nikon D5 · 1150 mm — SEPTEMBER 23, 2021 — pp. 326–327

ISO 500 · 10.0 · 1/1252 · Nikon D5 · 1150 mm — AUGUST 13, 2021 — p. 328

ISO 500 · 10.0 · 1/1000 · Nikon D5 · 1150 mm — JULY 9, 2021 — p. 329

ISO 800 · 8.0 · 1/1000 · Nikon D5 · 1150 mm — MAY 14, 2021 — pp. 331–334

ISO 800 · 8.0 · 1/1000 · Nikon D5 · 1150 mm — MAY 14, 2021 — p. 335

ISO 800 · 8.0 · 1/100 · Nikon D5 · 1150 mm — AUGUST 17, 2021 — pp. 336–337

Night — pp. 338 ⟶ 365

ISO 8000 · 1.2 · 1.3 · Nikon D5 · 58 mm — OCTOBER 31, 2021 — p. 338

ISO 12800 · 1.4 · 1/20 · Nikon D5 · 24 mm — JULY 23, 2021 — p. 340

SEPTEMBER 21, 2021 — pp. 342–343

ISO 2000 · 8.0 · 1/1252 · Nikon D5 · 1200 mm — MAY 1, 2021 — p. 344

ISO 10000 · 1.2 · 1.3 · Nikon D5 · 58 mm — OCTOBER 31, 2021 — p. 345

ISO 20000 · 4.5 · 1/5 · Nikon D5 · 80 mm — NOVEMBER 8, 2021 — pp. 346–347

ISO 5000 · 1.4 · 1/40
Nikon D5 · 85 mm
AUGUST 23, 2021
p. 349

ISO 3200 · 1.4 · 1/50
Nikon D5 · 28 mm
APRIL 29, 2021
p. 350

ISO 10000 · 1.4 · 1/4
Nikon D5 · 28 mm
SEPTEMBER 7, 2021
p. 351

ISO 12800 · 1.4 · 0.3
Nikon D5 · 28 mm
SEPTEMBER 5, 2021
p. 353

ISO 800 · 8.0 · 1/2000
Nikon D5 · 1200 mm
JUNE 18, 2021
pp. 355–358

ISO 8000 · 2.8 · 1/50
Nikon D5 · 400 mm
SEPTEMBER 27, 2021
p. 359

ISO 8000 · 1.4 · 1/5
Nikon D5 · 28 mm
AUGUST 30, 2021
p. 360

ISO 12800 · 1.2 · 0.5
Nikon D5 · 58 mm
JULY 30, 2021
p. 361

ISO 65535 · 6.3 · 1/30
Sony ILME-FX3 · 600 mm
p. 362

ISO 10000 · 1.2 · 1.3
Nikon D5 · 58 mm
OCTOBER 31, 2021
pp. 364–365

Geographic Index